Vivienne Westwood

Claire Wilcox

V&A PUBLICATIONS

First published by V&A Publications, 2004
V&A Publications
160 Brompton Road
London SW3 1HW
Distributed in North America by Harry N. Abrams, Inc., New York

Claire Wilcox asserts her moral right to be identified as the author of this book

Art Director: Vivienne Westwood
Design assistants: Joe and Beata De Campos
Designed by Nigel Soper
V&A photography by Richard Davis, V&A Photographic Studio

ISBN 978 1 851 77405 0
Library of Congress Control Number 2003110739

18 17 16 15 14 13 12 11
2012 2011 2010 2009

Every effort has been made to seek permission to reproduce those images
whose copyright does not reside with the V&A, and we are grateful to the
individuals and institutions who have assisted in this task. Any omissions are
entirely unintentional, and the details should be addressed to V&A Publications.

Front cover illustration: Photograph by Rankin. Originally published in *Pop* Magazine.
Back cover illustration: Photograph by Gavin Bond. Le Flou Taillé, A/W 2003–4.

Printed in Singapore

V&A Publishing
Victoria and Albert Museum
South Kensington
London SW7 2RL
www.vam.ac.uk

Contents

this woman was once a PUNk

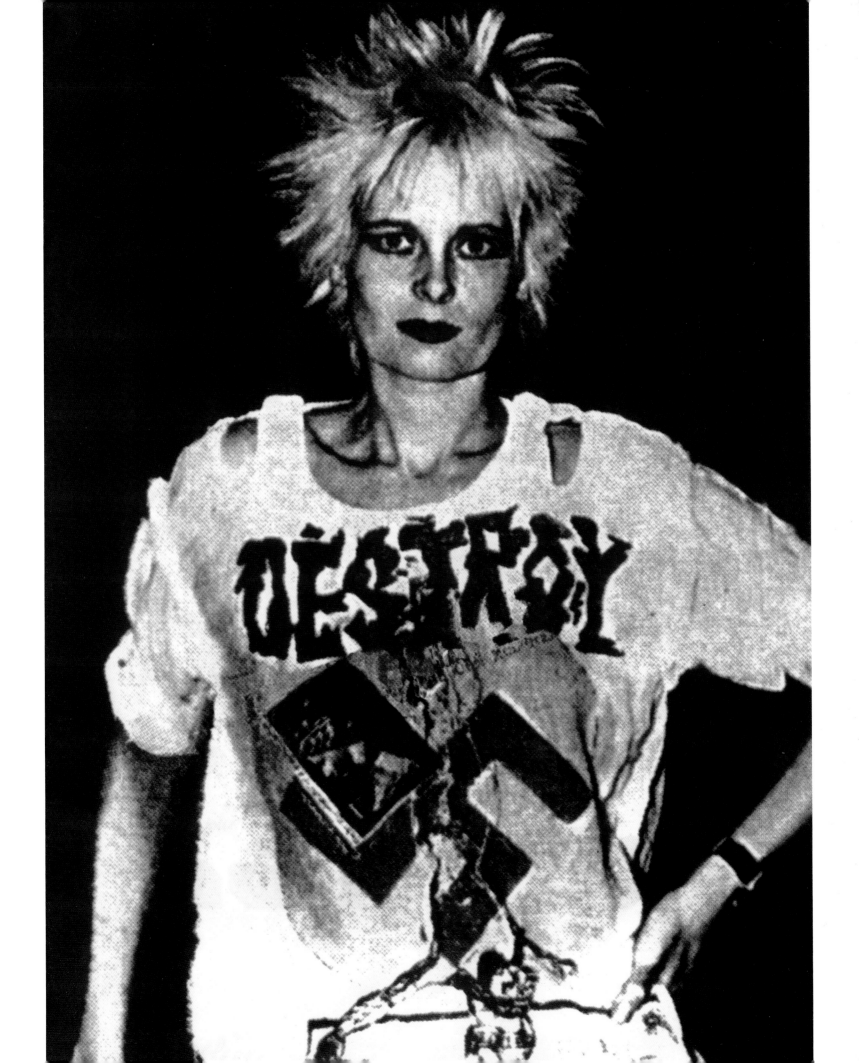

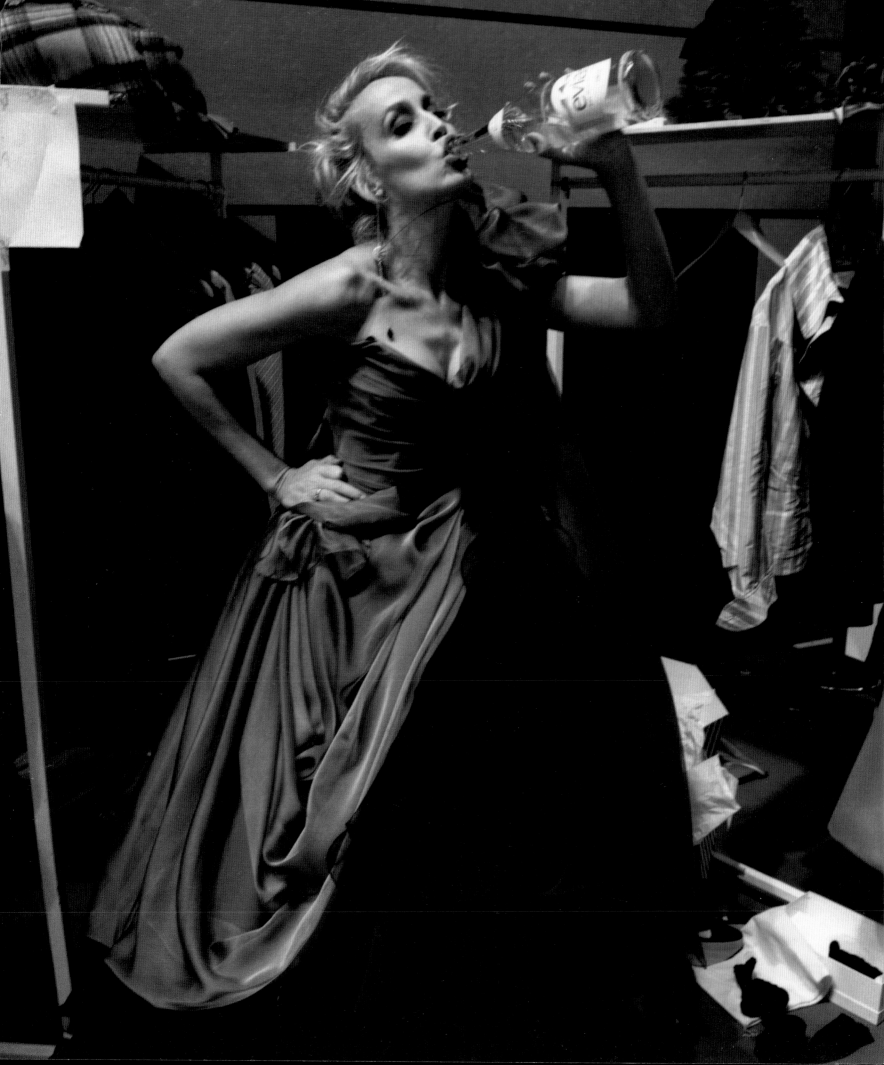

Foreword

My book is finished except for this introduction. (The deadline was yesterday). It represents my work as a fashion designer from September 1970 until now: 33 years.

Never having found time to do a book, I had come to realize that the only way I would get round to it was to combine it with a retrospective of my work. When I spoke to the V&A about four years ago, they had already been discussing the very idea of a major exhibition of my fashion.

The selection of images is in the main chronological, starting with the time when Malcolm McLaren and I opened our shop 'Let it Rock'.

I love all my collections, especially the latest ones and the choice is nothing to do with which are the most important. Sometimes one picture says it all.

Bearing in mind the form of the book the choice was very much determined by what looked good after what. At the same time I wanted to show people how exciting the world of fashion can be by presenting the different ways it is communicated: stills from a catwalk show, backstage photographs, editorial in magazines and newspapers, beauty shots, advertising. Added to this are the formal photographs taken by the V&A on mannequins to demonstrate the details of the fabric and cut of some of my tailored suits.

We tried to put a genie into a bottle and so we had to concentrate on the main focus. The book therefore epitomizes my ladies' fashion over 33 years.

We could only suggest some of the ephemera by including one or two invitations; jewellery, accessories and knitwear could hardly be featured except when they occur as contributing to an outfit. Our other lines we did not even think about. And as far as our menswear, well! My first catwalk shows included men so there you see them. Apart from this I managed to squeeze in one blue-eyed angel almost at the end of the book.

Talking of men, Andreas Kronthaler, my husband, works with me on the Gold Label, as our high fashion ladieswear is called. When two people have different talents but are equally strong it is difficult to say who does what. The suit on page 180 is an example of his work, which he happened to do without me, but this is unusual and that is why it is mentioned. Usually the work is a cooperation and the two of us reach a level that I could not reach alone.

Murray Blewett is the designer who has worked longest on my team, on accessories and now with me on the Red Label. Apart from this I know he had been keeping an eye over the years on my archives of clothes and photographs. I had no idea how vast and organized and complete these were. It is a marathon of dedication on his part and I thank him entirely for the pleasure he afforded me when we came to work on this book and the forthcoming exhibition together. We just had to select – everything was there.

It has been a sovereign pleasure to work with the V&A. This so professional team of women of clear vision has managed to direct and support me in our mutual goal of presenting the best possible book and exhibition.

Finally, reviewing the book I suddenly noticed that, except in one tiny corner, it has so happened that we had not included any of our splendid pictures of Jerry Hall. What would my book be without her? To get an idea of how Jerry can feel, imagine her taking a moment to spray herself with perfume – total glamour, posed backstage, ready for the catwalk. Then, Wow! And so here she is.

I dedicate this book to Gary Ness, to the lamp of his intelligence and to freedom for Leonard Peltier.

Vivienne Westwood, Saturday 1 November, 2003

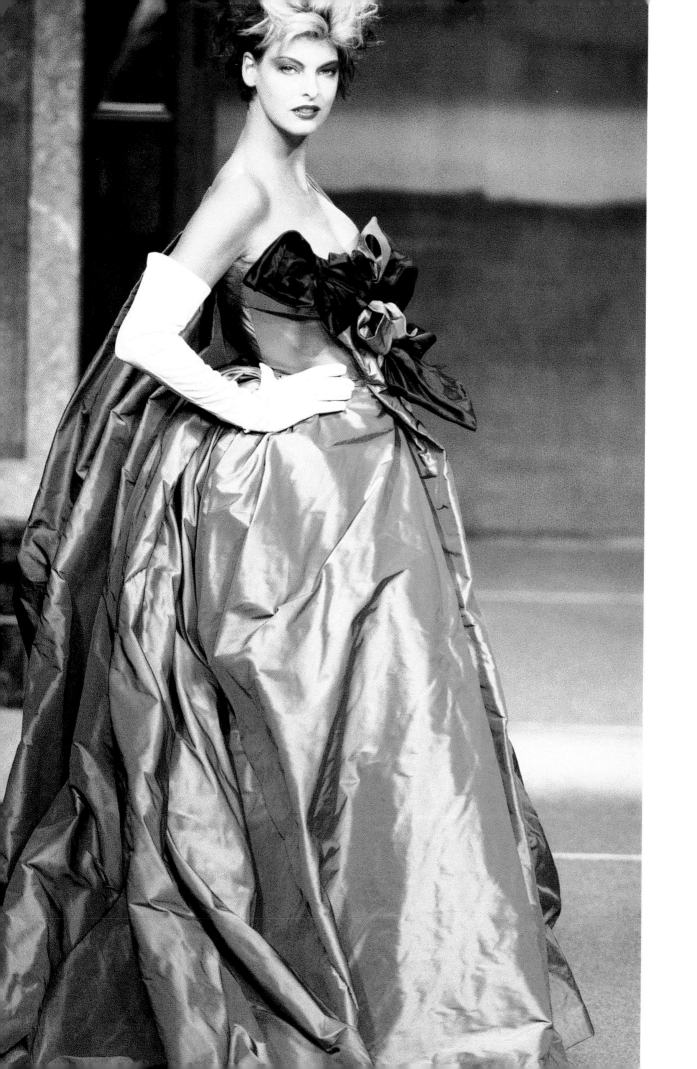

Vivienne Westwood: 34 years in fashion

'It wasn't that I purposely wanted to rebel, I wanted to find out why it had to be done one way and not another.'

Over the last 34 years Vivienne Westwood has been at the centre of British fashion and one of its most inventive and influential designers. She was described as one of six designers, including Yves Saint Laurent, Giorgio Armani, Emmanuel Ungaro, Karl Lagerfeld and Christian Lacroix 'who are true twinkling stars … From them, all fashion hangs by a golden thread,'[1] by John Fairchild, editor of *Women's Wear Daily*, in 1989; and in 1990 and 1991 Westwood was named British Designer of the Year. Vivienne Westwood's life has been driven by a great intellectual curiosity; she once said: 'The only thing I really do believe in is culture.'[2] Westwood's career in fashion was galvanized by her partner, Malcolm McLaren. Their working relationship lasted from 1970 until 1983, and memorably launched Punk. Fashion became for her 'a baby I picked up and never put down'.

Since the 1980s, Westwood has forged her own inimitable path. From the loose, unstructured geometry of the early collections to the technically challenging tailoring of the 1990s, the progression of her work largely reflects her systematic exploration of the history of cutting. 'My work is rooted in English tailoring,' Westwood said, and described her process as 'learning through action'. Her approach has always been practical, driven by a curiosity about how things work, starting in the 1970s when she taught herself to make Teddy-boy clothes by taking apart 1950s originals. Her careful study of the structure of historical costume in museum archives such as the Victoria and Albert Museum's, and in the paintings of Boucher and Watteau in the Wallace Collection, is driven by a delight in the puzzle-like complexities of dress. Like a student of painting who learns through the academic exercise of copying classical art, Westwood believes in scholarship and craft. She once said: 'I am a great believer in copying – there has never been an age in which people have so little respect for the past.'

Westwood's revelation is that fashion is profoundly enriched by renewal and reinvention, and she believes this to be a radical departure. 'When you look into the past, you start to see the standards of excellence, the good taste in the way things were done, put together, formed. By trying to copy technique, you build up your own technique.' Speaking of her 1995 collection, Vive La Cocotte, she said 'I was able finally to produce a silhouette that had never been done before, nor could it have been, because it was a synthesis put together in the present.' This historicism is woven into the fabric of Westwood's clothes. 'I'm not trying to do something different,' she reflected, 'I'm trying to do the same thing but in a different way.'

Westwood's unique mix of practicality and inventiveness, her fascination with silhouette and the way that her fabrics – English tweeds, tartans, cotton gingham, silk taffeta – are manipulated with such verve, result in dynamic fashion. Often copied and always ahead of her time, her designs encapsulate a particular Britishness, a fearless unconformity combined with a sense of tradition. From the early Seditionaries clothes to her grand ball gowns of recent years, Westwood's belief that 'You have a much better life if you wear impressive clothes'[3] is irrefutable.

EARLY YEARS

'Clothes are inevitable. They are nothing less than the furniture of the mind made visible.' James Laver [4]

Vivienne Isabel Swire was born in Glossop, Derbyshire on 8 April 1941, the first of three children. Although the family home was modest – 'my mother was a cotton weaver, my father's family were shoe-makers' – Westwood explains that her parents were both 'very bright, clever people with lots of initiative'[5]. Vivienne always liked fashion and recalls her first sight of Christian Dior's New Look, launched just after the war in 1947. 'We lived in a row of cottages between two villages and this woman was walking from Tintwistle past our house down to Hollingsworth. I remember my

mum saying, "She's got the New Look on, come and have a look." She thought it was horrible, with this long coat down to her ankles.' The impression stayed with Westwood, however, and in later years she has paid tribute to Dior in many collections. As a teenager in the '50s, she made many of her own clothes – such as a long, fitted black wool 'New Look' dress – and customized her grammar-school uniform to emulate the new pencil skirt; 'It was a new thing, putting that on was such a symbol of sexuality.'

Having grown up in the post-war period, a self-sufficiency and dislike of waste are still central to Westwood's character. She recalls making a sleeveless shift with a single seam and darts from exactly one yard of fabric, and one of her delights in later years was utilizing an 'ethnic' cut based on squares so that no fabric was wasted. She discovered C&A in Manchester and chose her own things from then on, remembering in particular an outfit of pink blouse, navy bolero jacket and lime green gloves, while every Friday she would go after school to an indoor market to buy earrings. She bought a large pair of fabric daisies and stuck them on to earring clasps and went dancing. 'My friends thought I was silly, but I wouldn't listen to them.' Her mother remembered: 'Even at 16 she would wear unusual clothes.' From early on Westwood was a confident dresser, saying, 'I always wanted to cut a dash.'

In the late 1950s the Swire family moved to Harrow in north-west London in search of a better life. Westwood took the move in her stride: 'If you're born in the North it does give you confidence. You're in a small spot and the world is your horizon. In London you feel your back's to the wall from the very beginning.'[6] At 16, she left school and started a foundation course at Harrow School of Art, moving from fashion to silver-smithing, 'because they made things' rather than simply drawing, but left after a term 'because I really didn't know how a working-class girl like me could possibly make a living in the art world.' She later supported herself by selling jewellery in the Portobello Road and jewellery remains important to her collections; Westwood's work was recently featured in the V&A exhibition *Tiaras* (March – July 2002). She then worked in a factory, saving up to train as a primary school teacher, and in 1962 she met her first husband, Derek Westwood, at a dance hall. She recalled her teaching days: 'I

enjoyed teaching the little ones most of all, they were the only ones who liked to go to school. I left school after two years because Ben was born and then eventually I left his father and went back to teaching. By that time I was living at the Oval and various places in South London. The schools were incredibly terrible in those days. They didn't have enough teachers, and I was often teaching 90 children.' Westwood's early training as a teacher remains important; she has the conviction that 'A good teacher is someone who fires people by their enthusiasms' and today holds the post of Professor of Fashion at the Berliner Hochschule der Kunstestill.

1965–74

'I was excited by this idea of taking culture to the streets and changing the whole way of life, using culture as a way of making trouble.' Malcolm McLaren [7]

In 1965 Vivienne Westwood met Malcolm McLaren, and a relationship began that was to electrify twentieth-century fashion, music and graphic design. Speaking in the early 1980s Westwood explained his attraction, 'Malcolm's a one-off. He was fascinating and mad, and it was as though I was a coin and he showed me the other side.'[8] McLaren was born in 1946 in Stoke Newington, London; his family ran a small clothing factory and his grandmother had been a diamond merchant in Hatton Garden. Between 1964 and 1971, he attended drama school and various art colleges, absorbing the radical currents of the time. He said, 'I learnt all my politics and understanding of the world through the history of art.'[9] McLaren and fellow student and graphic designer Jamie Reid were particularly drawn to Guy Debord's *Societé de Spectacle*.[10] Published in 1967, the book contained a collection of subversive aphorisms and contradictory texts, such as 'Be reasonable, demand the impossible,' which later provided material for the language of Punk. Westwood recalled: 'I felt there were so many doors to open, and he had the key to all of them. Plus he had a political attitude and I needed to align myself.'[11] Westwood had visited the National Gallery when she first came to live in London: 'I ran out because it reminded me of a Catholic church with all those crucifixes'. She continued to visit galleries with McLaren and recalled, 'I wanted to escape my own

upbringing – Malcolm did help. He introduced me to things that excited me and made me think.'

McLaren's anti-authoritarianism was a guiding principle but he effortlessly combined this with a love of fashion, saying 'It's the thing that makes my heart beat.' Westwood affirmed: 'Malcolm has always been totally fascinated by clothes. They're the most important thing in his life, really.'[12] In the late 1960s London was populated with numerous boutiques such as Oxus, Granny Takes a Trip and Hung on You at 430 King's Road, Chelsea, which sold a mixture of ethnic and hippie clothes. Neither McLaren nor Westwood identified with this predominantly middle-class movement. 'We were interested in rebellion – we felt that the hippie movment had waned, and we were never interested in their clothes.' Malcolm spent all his grant on clothes for Vivienne, including gymslips from John Lewis's school uniform department and a rubberized mac from Cordings, the traditional British outfitters in Burlington Arcade, which she wore with pearls. But the pair were soon drawn to the hard, tailored Teddy-boy look, with its parody of upper-class Edwardian menswear style. In 1969 Tommy Roberts's shop Mr Freedom took over the premises at 430 King's Road and began to sell Pop-art take-offs of 1950s clothes.[13] Vivienne bought a pair of tight leopard-print velvet trousers there and made herself circle and pencil skirts, which she wore with short socks and stilettos. McLaren recalled that she 'was like a bright peacock, a walking traffic light, though she never thought of herself as beautiful.'[14] He encouraged her to have her hair cut short and she bleached and razored it, a prototype punk look said to have influenced David Bowie. Westwood said of McLaren, 'He took me by the hand and made me more stylish.'[15]

By 1971, McLaren had amassed a collection of rock 'n' roll records from Brick Lane market and *Exchange & Mart*. He opened a stall at the back of vintage American clothing store Paradise Garage, which had taken over 430 King's Road and called it 'Let it Rock' (see p.35). Dressed in a single-breasted drape jacket with velvet trim and crepe-soled brothel creepers, McLaren looked 'home-grown and working-class, not adapted, just like a real old Ted.'[16] Westwood recalled, 'Malcolm liked what was active about rock 'n' roll. He had a dislike of the older generation and liked this idea of kids running wild in the 1950s. Malcolm described rock 'n' roll as "the jungle beat that threatened white civilization".'[17] When Paradise Garage closed, the pair inherited its 1950s juke box and took over the whole shop. They painted the corrugated iron fascia black, with fluorescent pink paper letters spelling out Let it Rock (see p.38). Inside, the walls were covered with James Dean memorabilia, stills from '50s films and pages ripped from pin-up magazines featuring models wearing skimpy clothes. To the original stock of old 78s, radios, Brylcreem and rock fanzines, they added original 1950s clothing found in the suburbs – shirts still folded up in their packets, drape jackets and leather ties with plastic sleeves for pin-up cards. Westwood went to Teddy-boy dances and pubs such as the Black Raven in North London, made copies of drainpipe trousers and fastidiously took apart vintage garments to understand the '50s cut. The drape coats were made up by East End tailor Sid Green in bright colours. She recalls: 'I made Malcolm a pair of Lurex drainpipe trousers and then I made 12 more. I started making mohair jumpers for the girls – you couldn't even buy mohair then. I loved the beatnik idea of wearing a man's sweater with tights.'[18] Westwood's knitwear has always been innovative and the early mohairs eventually evolved into the matted and unravelling sweaters associated with Punk (see p.43).

Although Let it Rock was so successful that it provided the clothes for the revivalist film *That'll Be The Day* (directed by Claude Whatham, 1973) with Ringo Starr and David Essex, by the time the film was released McLaren and Westwood had turned their attention to another sectarian form of clothing – biker gear. In 1972, 430 King's Road was branded with a skull and crossbones and renamed 'Too Fast to Live, Too Young to Die', after James Dean. McLaren introduced second-hand jeans, customized leather and double-breasted Zoot suits with padded shoulders and pegged trousers, and the couple designed glitter 'Dominator' and 'Triumph' T-shirts. They tried to sell the collection in New York; on the trip, Vivienne wore a stretch tweed catsuit, a knitted mohair bra with diamante straps and a pair of 'principal boy' boots from Freed's ballet shop. Although the clothes didn't sell, Vivienne and Malcolm met the group the New York Dolls who were to inspire McLaren to become increasingly involved with music rather than fashion.

Westwood and McLaren continued working together on

customizing garments for 430, although Vivienne, being more practical, did most of the work. For Let it Rock they had bought striped and plain black T-shirts which Vivienne converted – ripping, knotting, cutting holes and rolling and stitching the sleeves down. Working from her kitchen table, she then began a series of extraordinary T-shirts collaged with feathers, nipple-revealing zippers, studs, chains, potato prints and found objects, emulating the bikers' improvisatory, anti-fashion style (see p.39). The 'Venus' T-shirt had armholes edged with sections of bike tyres and trimmed with horsehair, while one of the most sinister (and highly collectable) series was lettered with boiled chicken bones, finely drilled and sewn on. 'First of all we wrote "rock", then we wrote "fuck", then somebody came and commissioned one – he wanted "perve" written on it.'

Relatively affordable and with a provocative message, the T-shirts became the point at which cult fashion, sex and politics met, and were the perfect insignia of dissent for McLaren and Westwood. In 1975, they were prosecuted under the obscenity laws for 'exposing to public view an indecent exhibition' for a T-shirt showing two naked cowboys; others proved even more offensive, such as the 'Cambridge Rapist' and 'Paedophilia' T-shirts. As Westwood explained, 'My job is always to confront the Establishment to try and find out where freedom lies and what you can do: the most obvious way I did that was through the porn T-shirts.'[19] According to Jon Savage, who documented the rise of Punk in his book *England's Dreaming*, one of the most important T-shirts was entitled 'You're gonna wake up one morning and *know* what side of the bed you've been lying on!', which listed Westwood and McLaren's loves and hates, and became a manifesto for the increasing numbers of young fans who congregated at 430.[20] This politicization of clothing set the scene for Punk via the next venture into a field that McLaren knew would provoke still more outrage: 'It started with an interest in any form of youth revolt, so that involved Teddy-boys and Rockers. Then we brought the sex element into it.'[21]

1974–5

'The only reason I'm in fashion is to destroy the word "conformity". Nothing's interesting to me unless it's got that element.'[22]

Westwood and McLaren's focus thus shifted to another fashion minority. By 1974, 430 had been renamed SEX, spelt out in large pink letters with Thomas Fuller's aphorism 'Craft must have clothes but Truth loves to go naked' scrawled above the door. The interior was sprayed with pornographic graffiti, hung with rubber curtains and stocked with all-in-one body suits, leather mini skirts, chains, padlocks, fishnets and stilettos – even leather underwear. Marco Pirroni, of the pop group Adam and the Ants, recalls: 'The King's Road shop Vivienne ran with Malcolm was unlike anything else going on in England at the time. The country was a morass of beige and cream Bri-Nylon and their shop was an oasis. I went in every week. If you shopped there, you didn't go anywhere else. If you were 14 in 1974, it took great liberalism and bravery to wear rubber in the street. Vivienne used to be in the shop wearing black leatherette trousers and no make-up apart from two purple lines on her eyebrows. She looked fantastic.' The ironic appropriation of this forbidden clothing – 'rubber-wear for the office' as McLaren described it – literally brought it out into the daylight; Westwood saw a kind of loveliness in its incredible particularity. 'All the clothes that I wore that people would regard as shocking, I wore them because I just thought I looked like a princess from another planet, I just thought I looked incredible in these clothes. I thought I couldn't look better.'

SEX was intimidating; it mixed the idea of an open-doored fashion boutique with the closed world of perversity and attracted an extraordinary mix of clientele: voyeurs and prostitutes mixed with young proto-punk King's Road shoppers. Described by Adam Ant as 'one of the all-time greatest shops in history,'[23] SEX soon had a shop assistant who became a tourist attraction in her own right. 'She eclipsed every other thing in sight. We were absolutely overwrought. Jordan was just like a goddess,' recalled club-owner Michael Costiff.[24] Jordan braved the commuter train from Seaford wearing rubber clothes, a beehive hairstyle and theatrical make-up, daily confronting societal expectations about

beauty and femininity (see pp.40–1). As Evans and Thornton wrote in 1989, in *Women in Fashion*, 'Punk's awesome manipulation of sexual clichés threatened the time-honoured codes that governed women's appearance on the street.'[25] Jordan attracted so much attention that British Rail put her in a first-class compartment for her own protection.

1976–80

'The point of this stylistic extremism is simple: it polarizes. Through alienation it creates a sense of community. Identity through outrage.' Peter York [26]

Looking back on those years, McLaren described SEX as 'a haven for the disenfranchised which, in turn, helped to create the phenomeon known as punk rock.'[27] A complex amalgam of various stylistic influences, Punk had its roots in the streets of London and the music scene of New York, which McLaren and Westwood had visited in 1973. Richard Hell and the group Television customized their clothes, razored their hair and painted poetry graffiti over their bodies while the New York Dolls, whom McLaren briefly managed, made their own decadent outfits. To this Westwood and McLaren added elements from the torn clothes of the pin-ups in Let it Rock, the chains, zips and individualist customization of Rocker gear, and the rubberwear and bondage garments of SEX. The result, in 1977, was another name change for 430 King's Road, to Seditionaries. In this incarnation, the shop supplied the sartorial identity for the Punk movement.

For Seditionaries, Westwood and McLaren transformed the straps and zips of obscure sexual fetishism into fashion. Westwood recalls: 'I've always worked through a process of research. The punk rock thing came out of the fact that I got so intrigued, when I started to make clothes in rubber-wear in SEX, by all those fetish people and the motives behind what they did, that I really went into the whole research of it. I wasn't content with thinking: "Oh, I'll just do something that looks a bit like what they wear." I wanted to make exactly what they wore, or get them to make it … that's where all the straps and things came from. You can never create anything in a vacuum. It comes out of chaos really, but that chaos

is something you're continually piecing together and discovering.'[28] Westwood made bondage trousers out of black sateen[29] or wool complete with black towelling 'nappies' and restricting straps. Many people who wore these trousers remember how good they felt, and the fact they were not constricting, but liberating. Her muslin shirts were cut from two squares of fabric with long, straitjacket-like sleeves, stencilled in red, black and white, with an off-centre neck-hole and jangling D-rings; they quickly became tattered, only adding to the effect. Savage wrote that Seditionaries was 'the only modern look' of the 1970s. 'If the first punks had thrown up every youth style since the war and then stuck it together with safety pins and panache, Seditionaries avoided retro yet caught the confusion: the look – both in the original and the imitations – spread throughout the world.'[30]

Paul Cook, one of the Sex Pistols, recalls: 'It was an intense time and there was a lot of violence directed at punks, particularly from football fans who used to be around Chelsea on Saturdays. Vivienne and Malcolm McLaren's shop was one of the few places you could hang around without feeling uncomfortable. The band was formed there from people who used to come in or work there at the weekends. We were never told what to wear, but we had free rein in the shop, particularly when it was re-named Seditionaries and we could wear the bondage trousers and the clothes with straps and zips.'[31]

McLaren's passion for rock'n'roll had been matched in Let it Rock and Too Fast to Live, Too Young to Die by his enthusiasm for the distinctive clothes of the Teddy-boys and Rockers. He saw the potential power that clothing had to sell music and exploited its ability to make the wearer feel part of a tribe. As Westwood recalls: 'Malcolm's idea of why the 2-Tone thing [an amalgamation of Teddy-boy revival, ska and reggae] did so well is because of the clothing. The clothing is always so important. I mean, you couldn't imagine the punk rock thing without clothing – it was so easy for some bank clerk to wear – all of a sudden you've got loads of people who've never stuck their neck out before thinking they can wear what's fashionable. That's why it caught on.'[32] Within weeks of the Sex Pistols' first gigs, their live television interview with Bill Grundy in December 1976 (in which they shocked the nation with their language and behaviour), and DJ

John Peel's radio shows, Punk began to have an effect on the way people looked. Jamie Reid's Suburban Press helped to disseminate the movement's troubling message with posters that bore immediately recognizable ransom-note lettering, and stickers that exhorted 'Keep Warm This Winter – Make Trouble'. For the Sex Pistols' single 'God Save the Queen', released in 1977, the year of the Silver Jubilee, Reid defaced an official Cecil Beaton royal portrait. Westwood explained: 'The safety pin in the lip of the Queen was saying: "You too can be a punk".'

One of the single most important Seditionaries garments was the Anarchy shirt (see p.42), which set the tone for the whole collection, for Westwood stresses that these clothes were a fashion idea created by a fashion designer. She recalls: 'When I came to do the Anarchy shirt I painted and sewed this Karl Marx label on it. I had it hidden in the bottom of the airing cupboard and Malcolm found it one day. He said, "That's it, this is the beginning of what we should be doing"; it looked like a shirt for an urban guerrilla. He said "We have to do this in line, shape and form, not just in graphics", so that's when we started doing all this bondage, and he got very excited about this shirt.' The shirt was printed with black hand prints and the phrase 'We are not afraid of ruins', a slogan of the Italian Fascist movement. Westwood typically made these confrontational garments with loving care. Each one was a missive, and Malcolm pushed her further. 'When I was with Malcolm, he wanted to shock – and he believed in it. I was worried about things, such as wearing a swastika on your arm, but Malcolm, being Jewish, had his reasons for wanting to do that kind of thing. We weren't only rejecting the values of the older generation, we were rejecting their taboos as well.'

Christopher Breward, Reader in Historical and Cultural Studies at the London College of Fashion, wrote of McLaren and Westwood: 'Their pulling together of sado-masochistic bondage paraphernalia, Nazi military decorations, and clothing associated with the nursery or the asylum, produced a surreal commentary on the anarchic tendencies of sartorial display. In imbuing these combinations with a fierce talismanic power, Westwood paid subconscious homage to the process of bricolage described by the anthropologist Lévi-Strauss in his examinations of the fetishistic uses made of artefacts by primitive societies.'[33] Westwood concurs:

'The safety pins definitely had an analogy in Third World culture, like putting feathers in your hair … or people in Africa who made necklaces out of old car hub caps.'[34] This non-Western approach to detritus and collage continued for several years in collections that included rusty Vim-lid buttons, broken knives and forks, toggles made of bullets and rubber penis-shaped buttons. Although Westwood is not normally associated with the work of the recent 'deconstructivist' movement in fashion design, as Alison Gill pointed out in *Fashion Theory* (1998), the sartorial modes that Westwood and McLaren touched on in their early years are exactly those that inform such designers as Raf Simons and Martin Margiela. 'Counter-cultural fashion has been marked by its ability to uncover taboo practices and mess with normative gender or class coding, in a sense bringing taboo practices like sado-masochism and explicit nudity, or the infusion of working-class signs, to the surface of clothing.'[35]

One of the most significant factors of Punk was that it gave licence for women to dress assertively, unlike the predominantly male clothes of the Teds and Rockers. Westwood approved of her ideas being taken up by punk rock fans who could not afford her clothes (for they were never cheap) and improvised with bin liners and home-dyed hair. She even acknowledged that Zandra Rhodes' couture version of a ripped and tattered punk dress (V&A: T.66–1978) was in the same spirit. 'I didn't mind Zandra copying the punk rock thing because she did it in her own way.'[36] Other shops, however, used Westwood's ideas but without the attention to quality and detail of design that was characteristic of all the SEX and Seditionaries clothes.

The Sex Pistols – who, for McLaren, 'were an idea, not a band' – attained the No. 1 position in June 1977 in the British pop charts with 'God Save the Queen', although it was not permitted to play the record on the radio or sell it in high-street shops, and local councils banned live performances. As McLaren said, 'That was a great victory against the Establishment.' Ten years later, Westwood was to look back on those years and agree: 'Punk did change youth ideas because it was a celebration. Rebellion, autonomy, swastikas. It was a great stand against authority.'[37] She remembered: 'I was very angry but I'm not saying the other punk kids were – they liked to run around that way. It's exactly what

young kids want to do. When I look back on it, I see it as a heroic attempt to confront the older generation.'[38]

Inevitably, Punk was eventually absorbed and disarmed by the mainstream, and Westwood became disenchanted. 'I got tired of looking at clothes from this point of view of rebellion – I found it exhausting, and after a while I wasn't sure if I was right. I'm sure that if there is such a thing as the "Anti-Establishment" – it feeds the Establishment.'[39] Westwood, now in her early 40s, turned her attention to subverting the Establishment from within.

1980–1

'With these clothes, you want to look rakish, you want to look like you can walk down the street feeling like you own it and you're Jack-the-Lad or whatever. You need to do that – you know fashion's just life, and I do believe that appearances are everything.'[40]

In 1980, Westwood and McLaren's interests began to diverge – McLaren's more towards music, Westwood's to fashion. They continued to exchange ideas and settled on using Westwood's name for the fashion, 'because it was more English'. Punk seemed like a dead end: 'We wanted to get out of the underground tunnel feeling of England, that dark feeling. After Seditionaries I didn't know what to do, and Malcolm just looked at what was happening on the streets and he saw people wearing fancy dress and old clothes, just like they did in Paris in 1972. He said: "Do something romantic, look at history." And I realized that I'd only looked at my own lifetime's culture and all the rebelliousness.'[41]

The early 1980s proved to be a key period in Westwood's creative development. 'Up until the Sex Pistols and Punk Rock I'd never thought of myself as a designer, I just thought of myself as helping Malcolm out on his projects.'[42] By this time, however, her individual style was crystallizing, typified by an exactitude, interest in cut and form, exaggeration and restriction – elements that have characterized her work ever since. As a teenager she was 'the last person amongst all my friends to shorten my skirts in the 1960s – I wouldn't do it, I thought the proportion didn't look nice,' and throughout her career she has made rather than followed trends. Some years later she was to comment: 'Historically, clothes have

been about changing the shape of the body. Fashion has been about having a restriction, and about often radically changing the look of the body. Anything else I consider style, just putting things together that aren't anything to do with fashion.'[43]

Again 430 shed its name and image and settled on its final apotheosis. The interior was remodelled, a mix between a lurching galleon and Dickens' Old Curiosity Shop, with small windows, a low ceiling with a chandelier, sloped decking floor and clothes displayed on a procession of simple metal crosses made from plumbing pipes. The fascia had a slate gable and a large clock displaying 13 hours, the hands travelling rapidly back in time. A brass plaque informed the visitor that this was 'World's End' (named after that part of Chelsea, where a pub called World's End stood). Westwood enjoyed the fact that red London buses often had World's End as their destination. The clothes' labels depicted an arm brandishing a pirate's cutlass, and was lettered 'Westwood', 'McLaren' and 'Born in England'.

With the Pirate collection, the pair cast a new spell with swashbuckling clothes of highwaymen, dandies, buccaneers and pirates (see pp.46–53). Westwood began her technical research into historical dress in earnest; unlike McLaren, whose inspiration came from his travels round the world as well as from the street, she remarked: 'My stimulus is always intellectual.' It was at this point that she began to look at history for ideas and techniques. She started her research in the National Art Library in the Victoria and Albert Museum, looking at historical costume patterns in Norah Waugh's book *The Cut of Men's Clothes*. One of the first Pirate garments was the billowing unisex shirt. 'I started work on the Pirate collection utilizing a shirt pattern that had been used for 500 years. It was the most traditional, ordinary kind of thing you could make. I made one up and thought, "Now I've got to start thinking what I can do with this," like making one sleeve longer than the other. Then Malcolm came in and said: "It's brilliant, use it as it is." He was a great person for using and abusing ideas that already existed.'[44] Since then, Westwood has often found inspiration in historical menswear, from the plain tailoring of eighteenth-century English gentlemen, to hunting 'pinks' and the traditional men's suit, still made in fine woollen suiting in Savile Row today. Westwood recalled: 'When I did the

Pirate collection I'd seen an engraving of a pirate whose trousers were too big and they were all kind of rumpled about the crutch … I wanted to do that, but I couldn't pull that trouser off until I found a book[45] that showed how people made breeches in those days, and I found that the shape of the trousers was quite, quite, different. Once I realized that, I got my look. I wanted that rakish look of clothes which didn't fit.'[46] Westwood was intrigued by what had been deemed sexually attractive in the past and saw that in order to understand it she had to reconstruct the clothing faithfully. 'I really got a breakthrough, because their priorities were totally different from our priorities: they didn't want to cut a tight trouser that neatly defined the two cheeks of your bum. They weren't interested in that. They were interested in sexuality in a totally different way. And I only found it out by research really.'[47]

Although the Pirate clothes had already been on sale in World's End, they were shown as the first collection on the catwalk at Olympia in Spring 1981 to the accompaniment of cannon fire and McLaren's rap music. The invitation depicted a young girl with gold teeth and nipples and rags in her hair wearing a 'squiggle' print shirt and holding a Sony Walkman, for McLaren had persuaded Sony to lend them personal stereos – the latest technology – for the show (see p.47). Again the look was promoted through his band, Bow Wow Wow. One of their songs was called 'C30, C60, C90, Go!', in the spirit of pirate radio and illegal taping that the personal stereos encouraged. Adam Ant, meanwhile, wore World's End clothing and 'Apache' make-up suggested by McLaren in his 1981 highwayman video 'Stand and Deliver'. The Pirate collection, like Punk, was unisex and it eschewed the masculine, fitted profile of the early 1980s, offering an alternative, ragamuffin look, flat shoes and layers. It entered the bloodstream of mainstream fashion immediately. The 'eyeliner and ruffles' of the New Romantic movement which became so popular at this time, as Boy George described it, was worn in clubs such as Steve Strange's Club for Heroes, echoing the 'Clothes for Heroes' plaque outside Seditionaries. As John Galliano said, 'It's impossible to think of the bands, the music and the spirit of both Punk and the New Romantics without Vivienne's work.'[48]

In 1983, Valerie Mendes, formerly Chief Curator of the V&A's Textiles and Dress department, acquired the Museum's first World's End garment, a specially made Pirate outfit with yellow brocade jacket and trousers, patterned shirt and scarf, boots and Pirate hat for the opening of the V&A's new Dress Gallery (T.334–1982). She said: 'It was very daring to get the Pirate costume because it was a break away from haute couture. We had been aware of Vivienne Westwood for some time and from then on were gradually able to acquire her relatively regularly.' The Pirate outfit has remained in the Dress Court for the last 20 years, always a focus of attention. 'Of all the things I am proud about more than anything else,' Westwood revealed, 'it's that my clothes are in the V&A.'[49]

The V&A has continued to collect Westwood clothes. For the Streetstyle exhibition in 1994–5, the curator Amy de la Haye acquired a significant menswear collection worn by Rupert Michael Dolan and given by David Barber; and in 2003, with the aid of the National Art Collections Fund and the Friends of the V&A, the Museum acquired one of the largest collections of Westwood clothes in existence, which belonged to the club impresarios Michael and the late Gerlinde Costiff. Curator Sonnet Stanfill highlighted the collection's significance: 'It represents nearly a lifetime's acquisition of one of Britain's most important designers by two of her best and most loyal customers.' Michael added: 'Gerlinde would be so pleased to think that the clothes we both wore and adored will now be in the V&A's collection. I hope, in turn, they will inspire young designers to be as courageous and inventive as Westwood.'[50]

The Costiffs had attended the Pirate show, and Michael remembers it vividly. 'It was the most extraordinary thing you'd ever seen, it was absolutely magical. It was so luxurious, there was the glitter of gold, that whole swashbuckling, heroic feeling; it was stunning, particularly at that grey time – it was something you'd never seen before, never expected. Vivienne had been up until then very monochrome, black-on-black was the slogan for so long. To see that colour, the *gold*.'[51] Jon Savage wrote in *The Face*, 'The clothes are superb: inverting style codes in a way that's both subtle and shocking … A jacket uses a traditional sports jacket cloth, yet is cut medievally, with the sleeves slashed to reveal a dazzling flash of orange patterned satin.'[52] For Westwood, Pirate was about a metaphorical escape from an island, the triumph of gold over

black. The Pirate clothes started to attract a wider audience through fashion magazines, and World's End supplied shirts, sashes and petticoat drawers for the up-market shop Joseph. Although Punk had received a great deal of media coverage and certain stylists such as *Vogue*'s Grace Coddington were following her closely, the fashion world had up until then regarded Westwood as a subversive shop-owner rather than a serious designer.

Her increasing divergence from Malcolm McLaren coincided with a meeting in 1977 with Gary Ness, a Canadian painter and reader. Westwood described their relationship as 'like a wonderful school … whatever I'm interested in, Gary has a book on it, or will find a painting or a poem on a related theme. He can always point me in the right direction to learn more about it, or suggest a complementary area of study.' Ness has continued to provide help and inspiration throughout her career, even assisting with the creation of her first perfume, Boudoir. He devises the titles of her collections and helps to write the accompanying statements. Ness introduced her to European painting, in particular Titian and Vermeer, the writing of Bertrand Russell and Aldous Huxley and the music of Chopin and Ravel. Just as she taught herself tailoring, so she began her self-education through the 'golden-ness' of past culture. She had said of the Punks, 'They had to start to step out and look rich. In the same way they got the Punk clothes on their backs, they now have to go one step further and start looking golden and rich and in control, or potentially in control. I don't believe in closing in. You don't make people want to change things by making them realize how poor and humiliated they are … you have to make people feel great before you get change.'[53] It was from this point on that Westwood thought of herself as a designer. 'I realized that I didn't have to qualify my ideas. I could do anything I liked, it was only a question of how I did it that would make it original. I realized then that I could go on for ever.'[54]

1981–4
Nostalgie de la Boue

In 1982 *Women's Wear Daily* described London as 'a teeming fashion market-place buzzing with ideas. They bounce off the streets and out of the prodigious art colleges.'[55] That year Westwood launched her second collection, Savage (S/S 1982) (see pp.54–6). She showed prints with geometric patterns derived from Native American Indian saddlebags, leather frock coats, foreign legion hats worn back-to-front with eye slits, soft leather bag boots, bowler hats with padded headbands so that they looked too big, 'petti-drawers' and shorts. The catwalk models were styled with body paint, with mud plastered into their hair. 'The Savage collection … was simply wonderful, combining rich decorative patterns in a very exciting way,' Valerie Mendes recalls. 'From the Museum's point of view we wanted to include her work very much; she is at the forefront of ideas, her impact on the cut of clothes has been considerable and, while her ideas can be extreme, her clothes are wearable.'[56]

Although the balance of Westwood and McLaren's creative partnership was changing, Vivienne still gave credit to Malcolm. 'He edits my work, sorts out my story, unscrambles my programming and gives me an avenue of approach.'[57] Westwood's third collection, Buffalo (A/W 1982–3, also called 'Nostalgia of Mud') incorporated primitivist and Rastafarian elements. McLaren explained, 'What's interesting about England right now is that there's a definite movement to get involved with the Third World; to wear an African dress, and put it with a Dominican hat, throw in some Peruvian beads, and wear make-up like one of the tribes in New Guinea – simply because we have to go even further to demonstrate that we want to get out of this island mentality, this village we live in, and relate ourselves more to those taboos and magical things we believe we've lost.'[58]

Buffalo was shown in London, and in Paris at Angelina's, the famous *salon de thé* on the rue de Rivoli, to the sound of Appalachian square dance folk music. The collection featured sheepskin jackets, twisted and asymmetrical cuts using tattered materials, fall-down socks, fabric-covered boots, huge felt 'Mountain' hats with dents, and big swirling layered skirts with

'woodcut' figurative borders. The under-petticoats, made of fragile wadding and patchily stained brown, were inspired by a picture of dancing Peruvian women with babies on their backs, 'Big women, who live in a space of their own, waiting for the world to grow up.'[59] Westwood, ever practical, said of the wadding: 'It's fragile stuff. If I had one on now, I might get up and leave a bit on the edge of the chair. So I'm selling them with a packet of replacements and a note saying: "You are going to leave little bits behind like a sheep leaves bits of wool on barbed wire." '[60]

In the programme Westwood scrawled: 'I long for some information so I concern myself with finding some good questions to ask … is mud my middle name?', and then exhorted the reader to 'Take your mother's old brassière and wear it undisguised over your school jumper and have a muddy face.' The concept of the bra as outerwear, which Westwood attributes to McLaren, was inspired by documentary pictures of a woman who had painted a brassière onto herself, and another who proudly wore an old bra with nothing on top. The idea of using corsetry techniques for outerwear had been explored earlier in the century by intrepid designers, most notably Charles James,[61] and has been echoed by others since, from Jean Paul Gaultier's spiral stitched satin cone brassières worn by Madonna on her 'Blonde Ambition' tour in 1989, to Comme des Garçons' collection of 2001. The Japanese designers Rei Kawakubo and Yohji Yamamoto had their first shows in Paris in 1981; at the time of Buffalo their impact was being felt in Western fashion, despite its initial hostility to their asymmetrical forms, sombre colours and flat shoes. Westwood's unfitted look, with its muddy colours (see pp.60–1), was in sympathy with the Japanese aesthetic, however, and her tattered 'Hobo' image was echoed in Comme des Garçons' 1982 'holes' sweater (V&A: T.167&A–1985). But as Harold Koda, Curator of the Costume Institute at the Metropolitan Museum of Art, observed, the aesthetic and conceptual meaning of the 'rips' in Kawakubo's sweater differed from the political and satiric meaning of the London street style made famous by Westwood and McLaren. 'Japanese designers like Kawakubo and Yohji Yamamoto were drawing on an entirely different tradition when they experimented with cutting asymmetrically.'[62]

In March 1982, at the same time as the Buffalo collection was shown, Westwood and McLaren's second shop opened. Nostalgia of Mud, in St Christopher's Place, London W1, was titled after the French expression '*nostalgie de la boue*' or 'nostalgia for the gutter'. The fascia of the shop was clad with a map of the world (see pp.58–9) and the interior was styled like an archaeological dig; visitors descended on recycled scaffolding to an earth floor and bare boards, and a heaving 'mud' pond. Voodoo-like artefacts styled by Westwood from debris were scattered around. Valerie Mendes commented: 'It was so astounding to visit, totally unique in the retail world, and, in my experience, it has never been matched.'[63] It was to close, however, only two years later.

Westwood was now on the Paris fashion circuit and Buffalo was followed by Punkature (S/S 1983). At the time, she said: 'I'm not interested in tailoring, but in the pull and push of the garment against the body. I start with the material. I put a couple of slits in a square, make sleeves out of the slits and some gussets to give room, and then I try it on to see where it touches the body. Where a garment touches the body determines the way you stand and move, and what your body can do physically is what you are about.'[64] Just as Punk had inspired a DIY aesthetic, so Westwood's dynamic rectangular constructions spawned a host of home-made versions: 'That's when London street fashion really got going; all these kids in art schools who couldn't cut patterns suddenly thought "I could make things out of squares", and they all went mad.' With its emphasis on distressed and inexpensive fabrics Punkature was like a futuristic interpretation of Punk, complete with safety pins and skirts printed with scenes from *Blade Runner*. The V&A later acquired a 'kitchen sink' cardigan from the collection (V&A: T.366–1985) made from purple dyed dishcloth with patchwork pockets and huge rusty Vim-lid buttons.[65]

Westwood recalls: 'I was working in my studio wearing a tube of the stuff that you clean car windows with – double stockinette … I wore this thing because I was continually trying on things that I made; I had this tube that I could just slip in and out of.'[66] The tube skirt (see p.64) was one of Westwood's most successful and commercial designs, but the concept was so simple and effective that it was soon added to the list of garments that have become public fashion property. Westwood is more than aware of this: 'It's just a tube of fabric, and no one had made one before, the idea of

a sweatshirt or jersey tube. You could wear it around your body, however you wanted it, but I liked it really low, ankle-length. I liked this falling-down look, with a bare tummy and a cropped top. It was a very important look. It was to do with hip-hop. That's what that tube skirt was all about, it was to do with that whole gang thing – it's completely street. I loved the way you felt so cool wearing it.'

For the next collection, Witches (A/W 1983–4), Westwood recalls, 'I went to America to talk to Keith Haring and get some of his art, using it with fluorescent and dark backgrounds with hieroglyphics … space-invader type images [see p.68].'[67] Haring had presented Westwood with two large sheets covered in his drawings, inviting her to use them as she wanted. She felt his work was like 'a magical, esoteric sign language.' Witches featured huge cream waterproofed cotton mackintoshes worn with knitted jacquard bodies and tube skirts in washed-out navy blue and fluorescent pink, like firework paper. The macs, apparently complicated but made from simple rectangles of fabric, showed off Westwood's cutting skills, as did the short, square-cut, double-breasted Chico jacket (inspired by Chico Marx, and first shown in sheepskin in Buffalo) that was central to the collection (see p.198). It was teamed with a matching navy skirt with a white tubular stretch upper part attached to a lower section of pleated wool, and completed with a pointed Chico hat. Witches was also the first catwalk show to feature customized trainers with three tongues (see p.69). With a rap music soundtrack and strobe lighting, Westwood described the freeze-frame effect of the Witches show as 'like sequences of things, where people are dislocated somehow at the same time that they're moving.'

By 1984 Westwood had moved to Italy with her new business partner, Carlo d'Amario (today manager of her company). She designed Hypnos (S/S 1984) at his house in the Alps. The collection featured sleek garments made out of synthetic sports fabric in fluorescent pinks and greens, fastened with rubber phallus buttons (see p.70). It was selected to be shown in Tokyo at Hanae Mori's 'Best of Five' global fashion awards, along with collections by Calvin Klein, Claude Montana and Gianfranco Ferre.

Hypnos was followed by Clint Eastwood (A/W 1984–5), a collection that hankered after the wide open spaces seen in Western films: 'Sometimes you need to transport your idea to a world that doesn't exist and then populate it with fantastic looking people.' It featured huge macs, as in Witches, garments smothered in Italian company logos and Day-Glo patches inspired by Tokyo's neon signs, worn with platform shoes by Patrick Cox (see p.71). Punk still permeated fashion in the 1980s, particularly in Westwood's designs, since it was part of her own fashion history – references to it still crop up in her collections today. As she said in an interview for *Blitz* magazine, 'Punk is definitely part of my history. I'll never get rid of that, but let me tell you what I think street clothes are. They presume that there is an Establishment, and that they are therefore "Anti-Establishment".[68] She added: 'I used to believe that there was a door to kick down, but now I know it's not there at all. There are just jumps along the way.'[69]

1984–6

'I've never thought it powerful to be like a second-rate man. Femininity is stronger, and I don't understand why people keep plugging this boring asexual body.'[70]

The Mini-Crini collection (S/S 1985) was shown in the Cour du Louvre, Paris, and the Limelight nightclub, New York, and marked a change of direction for Westwood (see pp.72–5). 'This was one of those cardinal points when you stop doing one thing and start doing something else. A change of direction. I wanted to make things that fitted. I'd been keeping this idea of the crini for a year or two, for when I could make use of it properly.' Westwood had first conceived the idea for the crinoline in 1978, inspired by a performance of the ballet *Petrushka*, and was confident about its potential. 'I was never trying to present my ideas at a time I thought was right, but I did know when things would be a success, like the corset and the crinoline. You have to have a sense of what's right. I absorb enough of what's going on in the world – I must have some sense of it, even though I don't read magazines.'

Westwood's abbreviated crinoline in cottons and lightweight tweeds was formed in the same way as its nineteenth-century precedent but combined humorously with the modern mini, using Minnie-Mouse-like prints, such as giant white polka dots on red

and stars and stripes, that recalled the T-shirts sold by Mr Freedom in the late 1960s. Westwood said of the crini: 'It's made out of fake plastic whalebone, and when you sit down it just collapses around you, so you don't even notice it. Even if you're on a crowded tube, it always springs back after being squashed.'[71] In its original form the crinoline reached a point of extremity that appealed to Westwood, who had discovered early in her career that sex appeal and absurdity were very close: 'There was never a fashion invented that was more sexy, especially in that big Victorian form. How great to come into a room and occupy six feet of space, or have chairs invented for you.'[72]

Westwood used the mini-crini as both an undergarment and an overgarment. 'The thing that really interests me is when it's used as an undergarment, as it's intended to change the shape of women's clothes. For the last ten years clothes have had shoulder-pads and tight hips – that's supposed to be the sexy look, the inverted triangle – but I think people want more feminine fitting. Women want to be strong but in a feminine way. These dresses give you balletic posture and are very, very elegant. You feel like a ballerina … it gives you presence and swings in the most sexy way.'[73] Westwood's mini-crini operated in a similar fashion to a ballerina's tutu, moving and swaying, constantly revealing areas of flesh. 'Sometimes it's quite stiff and sometimes it's really wiggly, depending on the fabric.'[74]

Her concern to alter posture and movement had often been achieved by specially designed footwear, from the early days of SEX, when she designed high, spiked fetishistic shoes, to the flat, wrapped boots of Buffalo. In Mini-Crini, she wanted to achieve poise and elevation as well as movement. Introducing her laced Rocking Horse shoes, she said: 'I wanted these little childish shoes, like sandals but a bit like clogs. They had to have a little platform – they rocked a bit. They were important in the collection.' Also important, and a key element of the following collection, Harris Tweed, were the sweet, fitted jackets worn with the mini-crinis. 'The inspiration for these jackets was the Queen as a little girl with her Princess coat. You can still get these children's coats – like a school coat – in Harrods. So it was the coat that I wanted and then I just made a little cut-off version for the jacket.' Westwood's emphasis on the hip and natural shoulders accentuated the waist

and bust, and was accordingly womanly, in contrast to the masculine styles of the 1980s.

In 1986 Westwood returned to England, while Carlo d'Amario remained in Italy. He firmly believed that the only way for Vivienne Westwood to grow as a company was to manufacture in Italy. He continued to work on securing the financial support and production partnerships necessary for the company to become what he now proudly refers to as 'our *maison*'.

1987
'I still adore what remains of the British tradition in clothes.'[75]

In 1986 Westwood re-opened 430 King's Road (which had been shut up for a year), stocking it with samples from Mini-Crini, and set about creating her next collection, Harris Tweed (A/W 1987–8), named after the woollen fabric hand-woven in the Western Isles of Scotland and created from her flat in Clapham (see pp.76–87). The collection continued the childish look inspired by the Queen's Princess coat and reinforced by a chance sighting: 'My whole idea for this collection was stolen from a little girl I saw on the tube one day. She couldn't have been more than 14. She had a little plaited bun, a Harris Tweed jacket and a bag with a pair of ballet shoes in it. She looked so cool and composed, standing there. Everyone around her was being noisy and rowdy, but she looked quite serene. She looked lovely.'[76]

She now created one of her most important and influential collections, setting the tenor of her work for the next ten years. Shown at Olympia in Spring 1987 to the accompaniment of classical music and traditional brass bands, Harris Tweed was Westwood's first show for two-and-a-half years. Although the move towards a more traditional, fitted look had started in the summer Mini-Crini collection, she could now further explore the potential of British fabrics and styles in Harris Tweed. As it was a winter collection, Westwood included thorn-proof tweeds, gaberdines and knits that are so suited to Britain's inclement weather, produced in English mills and on Scottish looms. She paid homage to the tailoring traditions of Savile Row and the jacket she designed then, named the Savile jacket, still features in her collections today.

Throughout her career, Westwood has appreciated and revived silhouettes, fabrics and colours that others have overlooked. In this case, she used natural fabrics at a time when most fashion was driven by ease of care and wear. To the heathery mix of Tattershall check, red barathea, velvet and Harris Tweed, she brought in a gentle parody of establishment styles – the clothes of boarding schools, royalty and country wear – giving them a new lease of life. Ten years after the Sex Pistols' single 'God save the Queen', she said: 'I'm really inspired by the Queen at the moment, and all that pomp and circumstance and Norman Hartnell that you associate with her.'[77] One hunting-pink barathea Harris Tweed suit with black velvet trim and brass buttons was memorably photographed by Snowdon for British *Vogue* (which by now was becoming seriously interested in Westwood) amongst the Horse Guards at Buckingham Palace (see p.85).

The collection was accessorized with Rocking Horse platform shoes, as Mini-Crini had been, pearly queen hats and tweed crowns. Of the crown, Westwood said: 'It's comic but it's terribly chic. I like to keep it on when I'm having dinner – like ladies who keep their coats on to take tea. It's so English, yet terribly attractive.'[78] Westwood's heroes had changed from punks and ragamuffins to cheeky 'Tatler' girls wearing clothes that parodied the upper-class English – as epitomized by Westwood's muse and model, Sarah Stockbridge, with her blonde pin-up looks (see p.81).

Many of the clothes first seen in the Harris Tweed collection became Vivienne Westwood classics, such as the traditional twinsets made by the long-established firm Smedley. These she customized, making them more shapely and adding to them her embroidered logo and trademark amber buttons. The collection also included the important Stature [*sic*] of Liberty corset, based on the eighteenth-century corset, which Westwood reclaimed and reinvented. As Valerie Steele wrote in *The Corset, A Cultural History*: 'Once women no longer felt that they had to wear corsets – when the corset, in fact, was stigmatized – some women consciously chose to wear them. Now, however, the corset was worn openly – as fashionable outerwear, rather than underwear. Long disparaged as a symbol of female oppression, the corset began to be reconceived as a symbol of female sexual empowerment.'[79]

Westwood's methodology – research, observation, an 'archivist's exactitude'[80] – had been established early in her career, and unlike many designers she was willing to explain her creative processes, confident that although she would be copied, she would always be ahead. 'Fashion design is almost like mathematics. You have to have a vocabulary of ideas, which you have to add to and subtract from in order to come up with an equation that is right for the times. Here I've taken the vocabulary of royalty – the traditional British symbols, and used it to my own advantage. I've utilized the conventional to make something unorthodox.'[81]

Westwood was later to reflect: 'I'm not really trying to be English – you can't avoid it, it's what you've absorbed. I do have fun knowing that I am doing it. I very much enjoy parody and this English sort of lifestyle as well, but I really am in love with the fabrics anyway.' Her work with the Harris mill Kenneth Mackenzie made the hard-wearing rough cloth fashionable again, and her collaboration with Smedley drew other designers such as Paul Smith to this source. Because she has drawn attention to the great qualities inherent in indigenous British manufacture throughout her career she has undoubtedly contributed to the change in the export climate, which has resulted in the success of other British institutions such as Burberry. For this she was awarded the Queen's Award for Export Achievement in 1998.

As she explained to fashion broadcaster and journalist Caryn Franklin, in 1987, 'I'm not interested in nationalism. I'm concerned with the way people look and the influence they have on other people. Dressed like this you are a vibrant force – you look like you've got power and culture. It's a move away from middle-class bourgeois dressing, but it's also a move away from the underground. I have an aversion to the underground … there's no status in it. I'm obsessed with the quality of life, and you have a much better life if you wear impressive clothes. I strongly believe that.'[82]

1988–90

'I am never more happy than when I parody the British in the context of a classical perspective.'[83]

In the next five collections, later known as 'Britain Must Go Pagan' because of the combination of English and ancient Greek

influences, Westwood continued to feature Smedley fine-gauge twin-sets, in unfashionably feminine colours, but she now picked up a theme that she had first touched upon in Clint Eastwood when she used prints of classical Greek pornographic images. By this time Westwood was ever more consciously incorporating the material she had been absorbing through her studies of literature and art. Britain Must Go Pagan reflected the inherent contradiction in her work between respect for tradition, culture and dignity, and a love of parody and sexual liberty. This opposition was epitomized by the pairing of classical drapery with Prince of Wales check in Pagan I (S/S 1988). (See pp.88–93).

In Time Machine (A/W 1988–9), named after H.G. Wells' novel, Westwood introduced Fair Isle sweaters with computer game patterns, articulated check jackets and silver and gold corsets with removable sleeves, inspired by medieval armour (see pp.94–7). Attracted to the unfashionable once again, she made precise 'Miss Marple' suits (after Agatha Christie) for men and women in check, thorn-proof Harris Tweed, which were worn with wigs and fur hats. The knee-length skirts were fitted with 'Knock Outs', removable flounces of gathered tulle that knocked the skirts' two front pleats upwards and outwards. Civilizade (S/S 1989) featured heraldic sweatshirts and track suits quartered into different colours like public school rugby and hockey shirts.

Voyage to Cythera (A/W 1989–90), its title inspired by a painting by Watteau (Cythera was the birthplace of Venus), teamed Savile Row-style tailored jackets and shirts with brightly coloured knitted tights and leggings, which recalled the theatrical costume of the masked Harlequin and Columbine (see pp.98–101). 'I just thought I would show the jacket without a skirt and it would be like a man half-dressed, as if he hadn't put his trousers on. I showed it with knitted tights and I brought in the whole story of the commedia dell'arte.' This 'principal boy' look was picked up by the press and soon became a popular mainstream fashion. 'There was a picture of the harlequin tights and black velvet jacket in Marie Claire. I only had 12 pairs of these tights and they just went in the morning, everyone wanted them. I could have sold another hundred pairs if I'd had them.'

Westwood's interest in neo-classical dress was informed by the writing of fashion historian Anne Hollander (who contributed to Painted Ladies, a series of three films Westwood made with her brother for Channel Four, shown in 1996). Early nineteenth-century men's dress, with its cut-away jackets and tight, buff-coloured breeches, Hollander observed, echoed the classical proportions and nudity of ancient statuary, and had contributed to Westwood's concept of the 'trouserless' man (see p.101).[84] Westwood took this fashion idea further, and created something that shocked even herself. 'When I first did the fig leaf, in 1989, I just kept screaming. It was porno and so hilariously mad. Then I got used to it, and I think it looks so elegant and ironic. In the eighteenth century, men wore pale chamois leather breeches and short jackets. The look was of a man with no trousers on.'[85] Westwood famously wore this outrageous ensemble – tailored jacket, half-undone shirt, tie with her logo and 'Nude' footless tights with green mirror fig leaf to lend support for a strike over the loss of museum staff outside the Natural History Museum in 1990. Her message was that culture must be saved.

Westwood found the inspiration for Pagan V (S/S 1990), the last of the Britain Must Go Pagan collections, in the patterns and decorative elements from some of her favourite eighteenth-century objects, including pieces of Sèvres porcelain, printing these onto chiffon togas and layered skirts (see pp.104–5), combining classical and eighteenth-century influences in a collection that, she said, 'telescoped time'.

1990–1

'Fashion is very important. It is life-enhancing and, like everything that gives pleasure, it is worth doing well.'[86]

In Portrait (A/W 1990–1) Westwood created one of her richest and most elaborate collections. Using mature models dressed in sumptuous costumes and placed in 10-inch platform shoes, as if on a pedestal, Westwood's intention was to suggest that they had just stepped out of a painting. As a Japanese fan commented, 'When everyone was heading towards minimalism, Vivienne Westwood's clothes were the complete opposite.'[87] Many of her designs at this time were influenced by a love for the Wallace Collection of French paintings, ceramics and furniture assembled by the Marquis of Hertford in the nineteenth century. In the

epilogue to Marie Simon's book, *The Second Empire and Impressionism*, Westwood wrote, 'Picture galleries are essential to my work, and not merely paintings containing costumes but also landscape and still-life, in which harmonies of colour, design and movement can germinate so many fashion ideas.'[88] Westwood explained in the book accompanying the V&A's exhibition *The Cutting Edge, 50 years of British fashion 1947–1997* (March – July 1997): 'Fashion as we know it is the result of the exchange of ideas between France and England,'[89] and by this time, having shown in Paris and become increasingly familiar with the depiction of aristocratic dress in French art, Westwood could draw on this cultural marriage. 'On the English side we have tailoring and an easy charm, on the French side that solidity of design and proportion that comes from never being satisfied because something can always be done to make it better, more refined – hence an elaboration that always stops short of vulgarity – and then that "je ne sais quoi", the touch that pulls it all together.'

In Portrait, the opulent fabrics – fake fur, lace, velvet, knits, tweed, city-stripe cotton, tartan, linen and satin – were complemented by costume jewellery. 'I thought the idea of one pearl earring or … three strands of pearls with a pearl drop in the middle was typical of all jewellery. You could fit it with practically any period and it would look all right. So I sort of chose things in that way, I wanted them to be complete, as archetypal as they could be.'

From the Wallace Collection Westwood used a rococo design derived from a brass inlay pattern on the back of an eighteenth-century mirror by furniture designer André-Charles Boulle (see pp.106–7). Taking advantage of the latest technology she printed the design in gold ink on to stretch black velvet, intentionally letting it crackle, like the glaze on an old master. As a final touch, she used a photographic print of Boucher's *Shepherd Watching a Sleeping Shepherdess* on shawls and corsets, in order to incorporate a sense of an Arcadian landscape (see p.108).

'In recent years it is perhaps the British designer Vivienne Westwood who has succeeded in interpreting the pictorial tradition most audaciously, in collections sparkling with idiosyncrasy,' wrote Marie Simon. 'Ambassadress of Boucher, Ingres and Tissot in turn, she resurrects the corset, the crinoline and the bustle. Encumbering and feminine symbols of a life of idleness, they had been assumed to be tucked away forever in the catalogues of the history of costume and only displayed in the showcases of museums. Yet here they are again, freshly dusted down, flaunting themselves on the catwalks of the Cour Carrée. "Mini-crinis" and bustles steady the tottering walk of tall, slim girls perched on platform soles and crowned with unruly ringlets. They parade themselves before our astounded eyes, defying logic, time and rationality. For fashion, frivolous and changeable, blithely spins its threads between periods and people. And to gather up and stitch together the scattered pieces, as it saunters on its way, it leaves behind, in Cocteau's words: "History, sitting and plying the needle." '[90]

Following the success of Portrait, Westwood began to attract clients such as Romilly McAlpine, who lent her personal collection to the Museum of London for 'Vivienne Westwood, the Collection of Romilly McAlpine', in 2000. The wife of Lord McAlpine (Treasurer of the Conservative Party, 1975–90), she wore Westwood's clothes to many political and state occasions, to the approval of Margaret Thatcher. Romilly became a great champion of Westwood's clothes. Remarking on the English character, she said: 'We're supposed to be eccentric, but I think what we do is enable eccentric people to live and operate here without really appreciating them. We tolerate and, in some ways, enable them, but we don't go out of our way to participate. People used to say, "That looks lovely on you, but I couldn't wear it." Thank goodness this attitude is finally changing and Vivienne's talents are being properly acknowledged.'[91]

The critical acclaim that Portrait received was a turning point. It was followed by two successful collections based on the seventeenth-century technique of decoratively cutting textiles to create a pattern, revealing the bright silk underlining of the garment, which Westwood had studied in Tudor portraiture and in the V&A's important collection of slashed garments. Cut and Slash (S/S 1991) was Westwood's first show specifically for men and it was shown in Florence at the Villa de Gamberaia at the Pitti Palace and then in Tokyo, at the invitation of Hanae Mori's Fashion Foundation. This was followed by Cut and Slash (womenswear, S/S 1991) which was shown in London. Both

collections utilized denim, partly because Westwood realized that it was the most commercial application of the technique; the deep, hand-cut gashes and fraying edges animated the jackets and jeans, emulating the passionate, masculine vitality that Westwood admired so much in Tudor portraits (see pp.118–21). Ever practical, Westwood also devised a method of fine machine slashing for shirts and accessories using a broderie anglaise programme – omitting the embroidery, but retaining the fine regular cuts. These dynamic outfits were completed with chunky knitwear, with 'slashes' knitted in. On seeing the menswear Cut and Slash collection when it was brought back from the Pitti Palace, fashion historian Juliet Ash described its richness:

> 'The racks of sumptuous garments stand like idle courtiers lining the corridors. Pink, blue and bluer, pale green, white, red and yellow satin men's frock coats with printed, eighteenth-century furnishing fabric as lapels, and photographic roses; raffia jackets, bolero tops and denim slashed – small machine cuts – in ritualistic patterns; large frayed slashes across the leg; to feel the slash and the fray is to feel the exposed skin beneath. The satin is smooth. Pyjama suits in stripes hang loose and move their silky texture in the slight breeze. Immaculately tailored suits in cotton-cool white, yellow – gold, blue and rust hang limp with diagonally cut flies, waiting to be filled; rounded Dickensian bowler hats, neckties, and kipper-printed portrait ties lie in a period piece.'[92]

The V&A's recently acquired Costiff Collection contains many examples from Cut and Slash, including a red satin corset and pants set with detachable codpiece.

In Cut and Slash, Westwood explored clothing that was androgynous, as she had done intermittently since Punk. Incorporating references to eighteenth-century court dress and the nineteenth-century dandy, she created a more clinging and less angular profile for the torso, eschewing certain late twentieth-century masculine tailoring conventions, such as the padded shoulder, for a natural sloping shoulder line, which some male customers found difficult. 'There are certain polarities operating in whatever I do, very strong ones – between masculine and feminine (how much femininity goes into men's clothes, how much masculinity can go into women's clothes).'[93]

The men's show was carefully choreographed and included a single female model. 'First of all I showed the tailoring and you didn't see any cuts in it; then I wanted to bring the "cuts" on and mix them in with it … I had Susie [Bick] come on with just a little pair of knickers with all these cuts in them and a plain white shirt over the top and some red satin high-heeled shoes, and a cut-throat razor. And then this bloke comes on with cuts in a vest and a pair of trousers all covered in cuts, and his face covered in shaving lather, and she started to shave him.'[94] The show culminated with a sword fight and Scottish reel, with Susie Bick wearing a voluminous, diagonally slashed cotton 'circle' dress, belted high on the waist and constructed from a vast circle of fabric. The V&A acquired a similar, bright red example for its costume collection shortly after (T.157–1991). Going against the grain of current fashion once more, Westwood showed skirts at an elegant lower calf-length in anticipation of her exploration of 1950s tailoring in subsequent collections.

1991–6
'It's just a question of adjusting the eyes. It is only perverse because it is unexpected.'[95]

In 1991 the Parisian-based designer Azzedine Alaïa invited Westwood to use his atelier to show her A/W collection, and this marked her return to that city after a break of some seasons. Dressing Up (A/W 1991–2) reflected Westwood's eclecticism and, as she had often done, it elaborated on certain earlier themes. It included tailored 'love jackets' with large lapels that formed a heart when fastened up (as seen in Harris Tweed, see p.84), slashed black leather and codpieces for women, the gold 'Boulle' print from Portrait (on satin this time), tartan busbies, silk 'DL' jackets (named after the Stephen Frears film *Dangerous Liaisons*, 1988, and based on the eighteenth-century frock-coat. Westwood introduced these jackets in Portrait, see p.109) with hand-painted floral borders, and rubber mackintoshes printed with putti from a Fragonard painting (see pp.122–5). The show opened with a model carrying

a candelabra, wearing a mac over a nighty; the theme was the last days of the British Empire, and featured ironic interpretations of tweeds, and clothes embellished with gem stones, evoking the British Raj. Westwood's sketch on the invitation depicts two girls rummaging through a trunk that Westwood imagined had belonged to a retired ex-patriate.

Since the mid-1980s Westwood's collections had been the antithesis of casual wear. Hers were complex, formal, indoor clothes; by modern standards, the models were overdressed, and the fabrics high-maintenance, but this merely served to emphasize Westwood's singularity. In the introductory scene to *Painted Ladies*, a series of 'dressed up' characters flit through a gallery in the Wallace Collection, admiring the old masters. Westwood's preoccupation with the past is expressed using clothes as a cultural carapace; each ensemble is laden with historical references, imbuing the wearer with a self-awareness, a pleasure in being observed and 'read'. As Anne Hollander wrote in *Seeing Through Clothes*, 'It is pictorial art that dress most resembles, and to which it is inescapably bound, in its changing vision of what looks natural. In order that the look of the body might always be beautiful, significant, and comprehensible to the eye, ways developed of reshaping and presenting it anew by means of clothing.'[96]

Dressing Up was followed by Salon (S/S 1992), also shown at Alaïa's atelier. Westwood's clothes had always been identifiably British, and appreciated as such by customers outside Britain – Japan remains a major customer base for the company. Westwood continued to favour indigenous textiles, often having fabrics specially made up for her by silk suppliers Andy Stutz of Fabric Frontline and Locharron in Scotland. However, her work was aesthetically most comfortable in Paris, the home of couture and dressing 'up' rather than 'down', where there were appropriately grand venues for fashion collections. A francophile, she continued to study French art and literature and the development of dress. In her conversations with Gary Ness, Westwood had long nurtured the idea of creating a literary salon, based on eighteenth-century precedents – intellectual and social gatherings hosted by influential society women as 'places where ideas can flourish', saying 'nothing is more needed today than the salon, for we stagnate in our deep

conservatism because of the isolation of intellectuals'. She included prints of a gilded French salon on the clothes, to add a literal touch, as well as artists' smocks spattered with paint (see p.128). Westwood's shows had begun to be characterized by a maturity and handsomeness, and Salon ended with two strapless tulle ball gowns in black and white, confirming the designer's authority. In October 1991 she was named British Designer of the Year for the second time. Snowdon took a memorable photograph of Westwood in the white gown for British *Vogue* (see p.131). Unbelievably, the shredded tulle dress was mistaken for rubbish and thrown away after the shoot.

Always on Camera (A/W 1992–3) characteristically reflected the paradoxes in Westwood's work – a combination of tribute and parody, focusing on certain periods, genres or individual women in history. It was inspired by Hollywood film stars and the way that they were dressed by the leading French couturiers in the 1930s and '40s, in particular Marlene Dietrich whose mannered, mannish style of dressing was admired by Andreas Kronthaler, Westwood's ex-student and second husband, who was now co-designing her collections. The clothes featured photographic prints of Dietrich on denim, while the models had finely drawn 'Marlene' eyebrows. To her oeuvre of French art Westwood added the work of Northern painter Frans Hals; a low-cut, tightly fitting corset with a large print of a baby's face framed with heavy lace was particularly disconcerting (see p.133).

In Always on Camera Westwood continued to investigate ways of communicating her love of painting through her clothes. Instead of simply reproducing an image on fabric, Westwood began to create clothes inspired by portraits that emulated the very quality of the artist's brushwork. As usual, she was open about her influences, confident that no one else could achieve what she could – for even if the clothes were copied, the original ideas that gave them such resonance would be absent. Writing of Westwood's 'Gainsborough' blouse from Always on Camera Rebecca Arnold explains, 'the sheer fabric was bunched in heavy layers around the neckline, with deep flounces falling across the shoulders and down the front of the blouse into a deep point. The edges of the frills were left un-hemmed, stray, wispy threads mimicked the hazy outlines produced by Gainsborough's light brush-strokes in his

double portrait, *Mr and Mrs Hallett (The Morning Walk)*, of 1785. The blouse pays homage to the fashions of the 1780s, and also to the vision of Englishness that Gainsborough idealized in his paintings. It is a world of tranquillity, where elegant aristocrats promenade in the dappled light of summer landscapes, where nature has been tamed to create pastoral vistas of rolling fields and swaying trees. This portrait, while informal in style, retains the impact of a society painting, the artist's restraint tempering the swagger of the overall effect. Once again, Westwood is inspired by the idealized glamour of portraiture, seeking to imbue her blouse with the history of art, of dress and of social class.'[97]

Grand Hotel (S/S 1993), shown in the Grand Hôtel, Paris, followed. With its Latin feel, the collection played on the idea of a South American hotel in the 1950s with assorted, well-dressed people passing through. The collection was notable for the continued development of the 1950s cut, denim printed with eighteenth-century prints inspired by fabrics in the V&A collection, and precarious 10-inch heels.

The collection also reflected Westwood's increasing interest in twentieth-century couture, especially the work of the French couturier Christian Dior (1905–57). She studied Dior's tailoring carefully, particularly the way that the Parisian couturier had subverted traditional men's cut for women. She said of his suits, 'It's beautiful how those buttons are there just for show, how he adapts the masculine look so wonderfully to the feminine body.' The late Richard Martin of the Costume Institute at the Metropolitan Museum of Art commented on the influence on Dior's ubiquitous grey suit: 'The designer of the utmost feminine silhouette used the defining materials of masculinity in a Diorism of masculine-feminine that abides in his work and is perpetuated and extended in the work of designers today.'[98] Dior's padding and restructuring of traditional tailoring to exaggerate the feminine figure had a resonance with Westwood's own interest in body shape. In 1947 Dior had launched the New Look, and the V&A has in its collection 'Bar' (T.376&A–1960), the outfit that proved the sensation of the New Look collection. A two-piece of fitted natural shantung hourglass jacket with padded hips and long, full black pleated wool skirt, it was in complete opposition to the masculine, square-shouldered and short-skirted post-war look that

was a legacy of military styles and rationing. Dior remarked: 'I created flower women with gentle shoulders and generous bosoms, with tiny waists like stems and skirts belling out like petals.'[99] Much of Westwood's own extravagant, couture-like work was made during a recession in the early 1990s when many designers were reducing their vision to more economic lines. She emulated Dior's silhouette in a series of tailored jackets at first called the '1950s jacket', and then the 'Bettina jacket' (after the 1950s Dior model who still attends Westwood's shows), which reappeared in different versions in many subsequent collections (see p.134). She explained that, while the jacket was not cut in exactly the same way as Dior's, it had a similar 1950s feel, which was more important. 'My clothes have a scent, a feeling of "I know it but I don't know what it is." They have a certain type of nostalgia which, for me, is how I would define glamour. They are part of the story of human culture. Even though it's all references to the past, they are synthesized to a point where they couldn't have been done at any other time.'[100] Westwood was elevated to the rank of 'Grade I' designer in Paris and in the same year was awarded the OBE by the Queen. She attended the ceremony in a Dior-esque grey suit from Grand Hotel with Bettina jacket and long, full circle skirt, recalling the silhouette of the glamorous woman whom Westwood and her mother had seen in Tintwistle many years before.

The title of Anglomania (A/W 1993–4) referred to the French passion for all things English – literature, language, clothing and even food – that prevailed during the 1780s, when pre-revolutionary, foppish styles were replaced by the plainer English aristocratic look. Westwood's fascination with English and Scottish traditions – as source of inspiration and subject of parody – was reiterated in Anglomania with mini-kilt tartan ensembles, and for the same collection the Locharron Textile Mill created a special tartan for Westwood called the 'McAndreas', after her husband. 'Locharron to me is the most wonderful company in the world, really, because of the choice of wool. It's possible to weave anything at that place from traditional right through to messing about and doing more innovative things, from the most wonderful tartans to thorn-proof tweeds, and they are very versatile. They have wonderful machinery and they still do everything in a traditional way.' Rebecca Arnold wrote of the bravado of

Westwood's approach to tartan, which she has utilized more successfully than almost any other designer: 'Her designs demand a present that is as dramatic and purposeful as that inhabited by, for example, MacDonnell of Glengarry, painted by Raeburn in the late eighteenth century, in what was itself a wistful mythology of Scottish identity. For Westwood, women can cut just such a dashing and heroic figure as men, in clothes that are just as much about constructing an idealized, theatricalized femininity as they are about representing national identity.'[101]

Since returning to show in Paris Westwood increasingly used supermodels, and it was in Anglomania that Naomi Campbell, wearing a royal blue velvet jacket, tartan kilt, tam o'shanter and slippery cream rubber stockings, famously fell from her 10-inch, super-elevated, blue 'mock croc' platforms. These were subsequently acquired by the V&A and remain one of the most popular exhibits in the Costume Gallery today (see p.140). Westwood said: 'Fashion to me is like walking a tightrope, where you risk falling off into the ridiculous, but if you can stay on that tightrope you can achieve a triumph.'[102] This inherent precariousness and willingness to take risks attracted devoted collectors. The platform shoes began to be acquired by various enthusiasts, not always to wear, but as sculptural objects in their own right – Romilly McAlpine's shoes were displayed on her mantelpiece rather than remaining in obscurity at the bottom of her wardrobe.

Westwood had always designed for 'extreme' women, and in the next two collections, Café Society (S/S 1994) and On Liberty (A/W 1994–5), supermodels provided the perfect vehicle for her exaggerated silhouette, achieved with precise tailoring and padding. Already exceptionally tall, wearing her platforms they took on the persona of cyber-women. Westwood remarked on Café Society: 'The models looked incredible because they had all this hair and lots of white make-up, and incredibly high shoes. I remember saying I didn't know whether they were monsters or goddesses, knowing that that's a statement that the press kind of like. But you really thought, they are freaks, definitely. They look so freaky, so different, but so beautiful.'

In 1994 and 1995 Westwood styled two highly successful advertisement campaigns for Brintons, the long-established British carpet manufacturer, featuring clothes made of carpet – a challenging brief since the carpet was exceedingly heavy and difficult to manipulate. Photographed by David Bailey, the first advertisement featured interpretations of Westwood's designs, such as the corset and fabric crown. It was followed by designs based on the date 1783, when Brintons was established. This collaboration raised both Brintons' and Westwood's profile and the company made a special leopard-print carpet intended to grace the catwalk at subsequent shows.

Café Society focused on French styles from the 1890s to 1910s, and was inspired by Toulouse Lautrec and the work of the English-born couturier, Charles Frederick Worth, who established his fashion house in Paris in the late nineteenth century. It was imbued with the spirit of the *belle époque*, with an S-shape silhouette standing out in a chocolate-box collection full of Redouté roses printed in different colourways on many different fabrics and garments: lace, ticking, a wedding dress, dresses made from a complete circle of fabric and even bathing costumes. There were 'Worthmore' jackets and a number of grand evening dresses, too large to be shown on a normal catwalk (see pp.144–5). The collection made reference to the past in two ways, through reconstruction of cut, and through echoing the assemblages and composition of clothing and fabric seen in old master paintings. Arnold draws a comparison between Westwood's clothes and the 'swagger' portraits of Van Dyck and other seventeenth-century painters, where the subjects are swathed in fabric. Describing a particularly extravagant, rustling yellow silk gown from Café Society, she wrote: 'Westwood, like them, creates heroic images, bodies are displayed in the grand manner, ennobled and made into stars by the sheer power of their visual impact.'[103] Westwood and Andreas Kronthaler were memorably photographed in the Wallace Collection in 1994, as if themselves in a painting, Vivienne wearing a grand rustic dress in orange and yellow shot taffeta with a tulle gypsy blouse and raffia straw petticoat.

On Liberty was named after the economist and philosopher John Stuart Mill's 1859 essay, which argued that democratic, middle-class society suppressed bold and adventurous individuals and cared nothing for individual liberty. The collection also featured a new collaboration with Liberty & Co. of Regent Street, London, utilizing prints from their archives on pile, needlecord

and quilted georgette. Westwood created the knitting pattern for a woollen dress based on a scaled-up version of one of these patterns. Richly graduated in colour and with a curving pattern and three-dimensional flowers, Westwood still wears it today, saying that it is her favourite dress (see p.152). A large tailoring section continued to explore the new S-shaped silhouette, using a cushioned bum-pad that had the effect of making the waist look tiny, just as its intention had been in the late nineteenth century. The silhouette was accentuated with upward-sloping shoulders (in a take on power dressing) and exceptionally high concealed platform shoes (see pp.146–53). Although other designers such as Georgina Godley and Rei Kawakubo of Comme des Garçons have explored distortion and exaggeration almost as an art form, Westwood's intention was a critique of the modern ideal of slenderness. She said, 'I don't like the idea of treating women as a sort of art object. The impact should be from the woman herself. The clothes have to be real clothes.'

Erotic Zones (S/S 1995) followed, featuring tailored trouser suits, inspired by the portraits of Otto Dix, with fitted jackets and high-waisted trousers. The collection also included more Liberty prints, cotton and raffia handknits with flowers and elegant fishtail evening gowns (see pp.154–5).

Taking delight in 'baiting the feminists' Westwood named the next two collections Vive la Cocotte (A/W 1995–6) and Les Femmes ne Connaissent pas toute leur Coquetterie ('Women do not understand the full extent of their coquettishness', from La Rochefoucault, the seventeenth-century French essayist and pessimist, S/S 1996). The inspiration for Vive la Cocotte was the seventeenth-century courtesan, Ninon de l'Enclos. Westwood's interest in exaggerating the figure was now taken to the extreme, using both a padded bust and, replacing the bustle cushion, a metal cage which was tied with small bows to a pull-on elastic foundation with suspenders (see p.157). The padded bust and bustle proved particularly challenging to sell: 'We were going mad trying to get this wonderful hourglass thing going, and in fact we had to do two collections, a selling collection as well as the catwalk one, but without the foundation garments. I always take pride in the fact that people can buy anything that's on the catwalk, so of course they could have bought this, but I don't believe anyone did,

except perhaps a Japanese customer who bought the false cage and wore it on top.' Westwood herself wore the cage under a wool suit on the streets of New York.

Westwood recalled, 'The press and the public really loved this look and I remember somebody saying "You're not really thinking that women are going to wear it, are you?" Somehow I had hit the way women want to be even though it's so exaggerated. They said I'd managed to define this idea of the new feminine power. Well, it's powerful and really quite aggressive as well with all this padding. It's very confrontational somehow. It's for someone who's a very strong character.' The collection also included another reworking of Dior's suit (see pp.158–9). Of her own version, which was exaggerated to accommodate the foundation garments, she said: 'I just love this suit. I don't mind at all telling people that I copied it because I believe in copying if you can, there is nothing better.'

One of the star garments of the collection was the 'Queen of Sheba' dress (see p.165). Inspired by pagan themes in Tiepolo's paintings and embroidered with beads and ostrich feathers by the corsetier Mr Pearl, it was worn by the actress Demi Moore. Vive la Cocotte also included a tailoring detail which was to become part of Westwood's vocabulary for some time. Several garments, including a navy cashmere suit and an evening dress, were based on the cut of an early fourteenth-century *pourpoint* jacket in the Musée Historique des Tissus, Lyon. Westwood was intrigued by the fact that the *pourpoint* (originally a long-sleeved, padded garment worn under armour) was a transitional garment in the evolution of tailoring. The development of plate armour made it necessary to create a protective undergarment that fitted the body closely, but also allowed free movement. The solution was the *grande assiette* ('large plate') armhole which allowed the arm to rotate freely. Westwood herself had started in her first collections using simple squares and rectangles with triangular gussets and then gone on to learn the principles of tailoring – assembling and fitting different shaped components together to form a shell-like garment moulded to the body. It was the detail of the *grande assiette* in particular that Westwood picked up, yet so modern was the effect that the clothes looked anything but historical.

Les Femmes ne Connaissent pas toute leur Coquetterie

featured exquisite silk ball gowns, one of which was acquired by the V&A (T.438–1996). The 'Watteau' evening dress in green silk shot with lilac taffeta with a burgundy bow had been worn by Linda Evangelista and formed a compelling publicity image for the V&A exhibition *The Cutting Edge* (see p.8). Lou Taylor, Professor in Dress and Textile History at the University of Brighton, wrote of the dress: 'She dramatically subverted the sack-back style of Watteau, making it sexily strapless and exaggerating the tightness of the bodice and the flamboyance of the *échelles* bows that trim the corset-bodice.'[104] The dress was displayed in the V&A's Costume Gallery with an eighteenth-century mirror reflecting the complex, tumbling silk back.

1996–9

'We must defend every inch of our own personal luxury … Our civilization is a luxury, and we are defending it.' Christian Dior [105]

Storm in a Teacup (A/W 1996–7) featured asymmetric cuts, chalk-striped single-breasted jackets and trousers in taupe pinstripe, brocade waistcoats and shirts and ties in the same striped poplin, in an innovative interpretation of traditional English menswear. Westwood explained, 'I just loved those windows in Jermyn Street, with all that shirting fabric. Menswear is so brilliant, with all those different stripes. I love it together, so I made a tie in matching fabric – it had three or four buttons that you could undo, then you could wash and iron the whole thing and button it all back. That took rather a long time for people to start copying, but eventually they did' (see p.106 and p.168). The collection also featured jackets with pleated or flaring backs which draped from the shoulder in another modification of the sack-back (see p.167). More ball gowns followed in Vive la Bagatelle (S/S 1997), stunning confections in gold shot cream duchesse satin. Having established her silhouette Westwood described the narrow waists and curvy profile without using foundation garments, simply through cut and proportion of detail. The invitation card explained: 'It's about flirting … a trifle, a nothing, a ribbon; a bow tied prettily and easily undone'. Flirtatious, half-cup bras in striped cotton to match the shirts, puff-sleeved blouses, tight pencil skirts, shirtwaisters, rough silk tweed wasp-waisted jackets, drape jersey dresses, gold brocade evening

coats, corsets and high heels confirmed Westwood's preoccupation with femininity and decoration. Suzy Menkes described the collection as 'a sexy romp.'[106]

Five Centuries Ago (A/W 1997–8) was shown at the Lido, Paris, in a seedy strip joint and looked further back in history, to Tudor portraiture. The invitation described the various elements that had inspired Westwood: 'skirts of heavy fabrics laid over cone-shaped wooden frames, a carapace of a bodice, hats of architectural geometry which hid the hair and sleeves so long and full that the lady joined her hands in front so as to carry the weight.'[107] However, in Westwood's versions, these heavy fabrics were transposed into lightweight ones and volume was achieved without underpinning – a farthingale effect, for example, was achieved with pleats. Westwood even posed as Elizabeth I for a striking advertising campaign shot by Gian Paolo Barbieri, accessorized with fictional instruments of torture. Jerry Hall, in a photograph entitled 'The Queen and her Punk', wore the same cream duchesse satin dress, its design of exotic animals copied by Fabric Frontline from a detail of Elizabethan fabric.

With characteristic openness, Westwood explained her process of research and her revelation that Christian Dior, who had inspired her for so many collections, was also inspired by sixteenth-century dress. 'What I have discovered is here for you to see, in its translation to modern times. The difficulty was to avoid Dior. This period is the source for so much of his work. When I began to develop the themes, every beginning led back to him. Colours are restricted to the serious palette of the Tudor era – black, browns, reds – from Bordeaux to carnation, touching on violet – white, gold and silver. The only modern colour I have added is grey because it suits wool and talks of black.'

For Tied to the Mast (S/S 1998), with its striking publicity image based on Théodore Géricault's *The Raft of the 'Medusa'*, 1819 (see pp.174–7), Westwood created a second 'pirate' collection, complete with ripped and tattered clothing, suggestive of a shipwreck. She explained: 'I took into account something I have long been promising myself – to include in every summer season a range of sea-faring fashions as I have sometimes done in earlier collections.' Typically merging two apparently disparate influences she also cites the tailored outfits of British designer John Redfern

(whose ladies' tailoring business opened in London in 1878), designed in an era when frequent changes of costume were mandatory and specific events, such as a trip to the seaside, demanded specific outfits. The link between Redfern and Tudor dress lay in a small detail – the way that sections of a garment were edged in braid, providing a distinct frame for the primary sections of clothing such as the bodice. This, in Westwood's mind, was echoed by the snappy tailoring of Redfern. 'The most striking detail from sixteenth-century clothes is the way sections of a garment are edged with a contrasting frame. I have used mitering instead of appliqué to make stripes turn corners and frame edges … The waist is slightly higher and the torso is small, helped by a subtle paring away of the ratio between sleeves and bodice and the juxtaposition of bell or (fluid, yet essentially) cone-shaped skirts.'

Both Tied to the Mast and Five Centuries Ago explored the way that revealing glimpses of the undergarment – such as the chemise – suggested a state of *déshabillé*. 'When I did the collection – "Five Centuries Ago", I called it – it was about Elizabethan times. I styled it with underwear and suspenders because they were always showing the dress on top and these beautiful chemises with embroidery underneath.' As Westwood had investigated in *Painted Ladies*, the idea of being depicted in one's chemise was permitted as an erotic device in painting because it was endorsed by pagan or classical references. Anne Hollander noted particularly how 'the tense consciousness of rough or rich outergarments worn over intimate soft undergarments was set up simultaneously in wearer and observer.'[108] In Westwood's clothes, sexuality is determined by sensation. As with most designers, she is concerned with the tactile qualities of fabric, but she focuses on how the clothes feel to wear, as well as how they look, from the smooth firm tailoring that holds the torso like a glove, to the constriction of corsets and alteration of posture by high heels and bustles, crinolines or bondage suits; even Punk had a physicality and femininity through its powerful and challenging sartorial codes. Westwood's intention is arousal, both physical and mental, and to instil the wearer with the confidence that clothes bring not only private and public pleasure but also an increased awareness through dressing up. It is not surprising that she has always been attracted to the eighteenth century, that most materially sensual of centuries, saying 'there has never been a more fantastic costume than the *pannier* or *juste-au-corps* as a vehicle for expression, gallantry.'

Exaggeration, reduction and enlargement have always played a significant role in Westwood's extremism. Dressed to Scale (A/W 1998–9) explored these issues as she discovered through her experience of tailoring that the slightest adjustment to a toile had great implications for the finished garment and, consequently, for the possibilities of distorting body shape. 'I have become ever more obsessed with finding ways to reduce the ribcage area of a woman's anatomy … why not take away the body space by making all the detail in relation to the total design as large as possible? Collar, cuffs, pockets, plaquet, our oval buttons enlarged to six centimetres in diameter.' (See pp.178–9.)

La Belle Hélène (S/S 1999) was inspired by Rubens' portrait of his second wife Hélène Fourment (*Hélène Fourment with a carriage, c.*1639). The movement, tension and elasticity of materials in the painting were explored in stretch wool and cotton and silk suiting that moulded the body. Evening fabrics consisted of lace mounted on wool or organza and garments made of plaited ribbons, while prints inspired by Matisse formed blocks of hand-painted colour, to resemble a canvas, especially in a painterly ultramarine. The clothes were accessorized with ballerina shoes and flat sandals, as Westwood's sense of the body returned to an appreciation of its lithe animation.

2000–3

'Her clothes are an intervention in fashion, not simply a development of it – which is why they are always so distinctive, and often so distanced from what's going on elsewhere in the industry.' Murray Healey [109]

In her twenty-first century collections, Westwood has, for the time being, put historicism to one side. Having taken the feminine power of clothing to its limits (in both men's and women's wear) with extreme exaggeration, emphasized with painterly surface decoration, she has returned in recent collections to her preoccupations at the time of the early 1980s Pirate collection – asexual, 'ethnic' cutting, using predominantly rectangles and triangular gussets, and some semi-circles and curved seams, in an

exploration of the natural dynamic of fabric. She describes this as a 'classical' preoccupation and, seeing one of Westwood's students in *Painted Ladies* sponge down a simple garment with water in order to create the effect of classical stone carved drapery, it is evident that recent collections emulate this sensual effect. Treating fabric like a living mass Westwood uses folding and pleating to create spaces between body and cloth, exploring different ways to create volume and allow it to stay, like air pockets. In a recent conversation Westwood held the two edges of a sheet of A4 paper together, but not quite aligned, demonstrating how this immediately gave a twisting dynamic to the inert paper, almost as if she was trying to find another dimension. She has described herself as having 'spatial intelligence. I've got a real sense of three-dimensional geometry. I can look at a flat piece of fabric and know that if I put a slit in it and make some fabric travel around a square, then when you lift it up it will drape in a certain way, and I can feel how that will happen.'[110]

Starting with Summertime (S/S 2000) and continuing in the collections Winter (A/W 2000–1), Exploration (S/S 2001), Wild Beauty (A/W 2001–2), Nymphs (S/S 2002), Anglophilia (A/W 2002–3) and Street Theatre (S/S 2003) (see pp.180–203), Westwood continued to explore the myriad of ways fabric can fold over the body. She described the process: 'It's just getting form by putting fabrics together that do not have the same angle. The fabrics are all at slightly different angles so that they create a form, and the nice thing about it is that it's the sort of look that we are after – tailored/non-tailored, spontaneous and arty-looking, if you like, and a bit futuristic in the way that the clothes are shaped not necessarily with the purpose of fitting the prominent point. It's to do with the fact that you do not care about the bust or waist anymore, yet you do have to be aware of them to make sure there is room in the fabric for them. But to give this lively look to the clothes – because it's incredibly lively-looking and nervous-looking – you are purposely not hitting the crucial body points. The thing about them is that you can wear them without caring at all, and they are just working for you all the time, showing your body – it's very dynamic. It's amazing, even off it looks dynamic. It's augmenting body movements in some way, carrying them on after they have finished.'

Westwood's most recent collection, Le Flou Taillé (A/W 2003–4), while by no means a finale to her career nevertheless embraces the essential paradox of constriction and freedom in her work. 'You have two ways of making clothes, and in the couture in France you would have the two different ateliers, one for the *flou* (fluid fabrics) and one for the *taillé* (tailoring), and so the people who make the *taillé* don't make the *flou*. The collection is to do with the fact that I've been cutting into the *flou* in certain ways. It is more uncompromising than any of my work up till now.' (See frontispiece, endpapers and back jacket.)

Self-taught, but mistress of her craft, Westwood's fashions are often sparked off by historical styles but have a timeless appeal of their own. Steeped in references and allusions, they are at the same time exercises in discipline and control. As she said, 'I work from a simple principle that a geometric fabric piece will have its own terrific dynamic. The technique comes first. That's why I never dry up for ideas, because when you master a technique, self-expression is automatic.'[111]

VIVIENNE WESTWOOD TODAY

Vivienne Westwood learnt her profession in the public eye. Although she says of Punk, 'I'm proud to have been part of it. It was heroic at the time,'[112] she has long since moved on, and her distinctive voice has introduced a startling and highly influential new vocabulary to fashion, characterized by a Utopian vision about its potential: 'I would describe it really as a nostalgia for the future.' A heterodox figure, she has been difficult to categorize because she has never conformed to contemporary trends. One of the achievements of which she is most proud is that through her innovative cutting she has imbued the production of ready-to-wear tailoring with a couture quality, saying that through her patterns, 'I'm trying to put intelligence and humanity back into the technological process.' Westwood's motivation has clearly never been about commercial success – despite the fact that many of her ideas, such as the customized T-shirt, the tube skirt and printed and slashed denim were very marketable, she did not capitalize on them. 'I've never cared one way or the other about failure, having to fold the business. I don't even think about it.'

Success has been on her own terms and she has remained defiantly independent. 'I own my own company. For 30 years I've been the judge, it's me that has to like it. First you have to have aptitude, talent. I have that. That incredible need to just question everything. I have to do it another way. I'm making something new all the time – the technical, physical fact of doing it introduces me to other possibilities all the time.'

From the early 1990s, the business side of Westwood's company began to expand with various licensing arrangements and her production shifted to Italy. Comparing her career with that of Gianni Versace – who started at the same time – she argued that there were not the structures to support a creative fashion designer in the UK. 'For years I struggled to manufacture in England, and the breakthrough came for me when I finally started to produce in Italy, because before that I could never really overcome the problem of production quantities … The gap between cottage industry, which is where I started and where a lot of other people started in England, and the kind of people who produce for Marks & Spencer, is an unbridgeable chasm. There still isn't the infrastructure or the mentality to help anybody manufacture from a creative point in England.'[113]

Gradually, Westwood has increased her international profile through accessories and licences, designing a wide range of products, including shoes, eyewear, scarves and ties, knitwear and, recently, cosmetics (by Shu Uemura) and a homeware collection with Wedgwood, all of which help to keep her independent. Her collaborations with Austrian hosiery company Wolford, the Sock Shop, and the French mail order catalogue Trois Suisses have resulted in affordable fashion in the Westwood spirit. She created the 'orb' watch for Swatch in 1992, and launched her perfumes Boudoir in 1998 and Libertine in 2000. The company has numerous shops in England, including a flagship store in Conduit Street, and many more worldwide. Japan (with partner Itochu) and Korea remain both strong fan bases and valuable markets.

Diffusion collections include the more affordable prêt-à-porter line, Red Label, 'created for the studious yet reckless young lady. After reading the length of the day she lets loose in the evenings.' Red Label is produced and distributed in Italy, as is the biannual menswear collection, Man, launched in 1996 and shown in Milan.

Anglomania, also produced in Italy, is based on past designs for both men and women and was launched in 1998. The demi-couture collection, Gold Label, which is shown biannually in Paris, is personally overseen by Westwood and hand-finished in the UK.

'Chanel probably designed for the same reasons that I do, really: a certain perversity and irritation with orthodox ways of thinking.' [114]

Vivienne Westwood's influence on other designers is indisputable. She is constantly being rediscovered – a recent article in *Elle* magazine observed that the majority of the catwalk shows for A/W 2003–4 appeared to have felt her touch.[115] Westwood predicted the impact of sportswear on fashion with her lycra body suits in Hypnos (S/S 1984) and she was the first to feature trainers on the catwalk. Punk continues to permeate fashion – British *Vogue* (September 2003) devoted many pages to 'posh punk', while tartan has become a fixture in the high street. Sir Paul Smith said: 'Vivienne constantly comes out with new uninhibited ideas, which she turns into reality. Her collections are always adventurous, thought-provoking – and she definitely makes a statement.'[116] Valerie Mendes has described Westwood's work as 'refreshing – she can always be relied upon for something quite different and puzzling which then drifts into mainstream.'[117]

The most characteristic aspect of Westwood's design has been, until recently, its historicism. 'I take something from the past which has a sort of vitality that has never been exploited – like the crinoline – and get very intense … you get so involved with it that in the end you do something original because you overlay your own ideas. So there's your own individuality, your own particular way of looking, and what you see cements it all together. Things are never quite as they were, so even if you tried to copy a traditional garment exactly you couldn't because you'd have to use a modern way of making it. The idea is something that comes with the form, and it grows as you do.'[118] The importance of Westwood's revival of the corset is clear. Karl Lagerfeld claimed that the corset was one of the most significant fashion ideas of the late twentieth century. 'Her relationship with historical dress is on an entirely different level from any other designer,'[119] commented

Susan North, V&A Curator of eighteenth-century dress, who was particularly struck by the accuracy of Westwood's corsets. However, far from being 'costume', they are a perfect example of historicism transformed into a modern garment. For, despite her romanticism, Westwood is also practical, designing corsets with removable sleeves for evening, and utilizing stretch fabrics that look constricting but in fact move with the body. Michal Costiff revealed that his late wife Gerlinde wore Westwood's corsets every day, like underwear, and Westwood has described how comfortably the boned and elasticated garment supports the torso. Costume historian and eighteenth-century specialist Aileen Ribeiro observed: 'She has a quintessentially English way of looking at the past – slightly offbeat, informed by practical knowledge and intuition about the way that historical garments work.'[120] In the recent exhibition, *Patterns*, at the fashion museum MOMU in Antwerp, an eighteenth-century sack-back dress was displayed, unpicked, in a giant circle. Beside it, appropriately, was an image of Westwood's 'Watteau' dress.

Westwood's technique can also be compared to that of Madeleine Vionnet (1876–1975); both share the same way of working in the round on a dressmaker's dummy rather than from sketches, and of employing geometric principles in their cutting. Westwood said, 'Art must be anchored in technique; this means the manipulation of materials – in my case my materials are essentially the human and cloth. It is my job to make the cloth give expression to the body of a human being. One must constantly judge and manage the detail in terms of the general effect one is trying to create so that the form is the idea: a beautiful form is a beautiful idea – this is design.'[121]

Westwood's use of materials has always been creative. She has developed a technique of pre-washing georgette to make it more crepe-like, equating its crumpled charm with a particularly British nonchalance. She thinks of silk taffeta as the most modern of fabrics; rarely bothering to hang her silk dresses up when travelling, she explains that they look marvellous worn straight from the suitcase. Westwood's knitwear demands serious study in its own right. From the first mohair sweaters to the chunky hand knits in the Buffalo collection (1982), the *mélange* underwear by John Smedley in Witches (1983) and the fine-gauge harlequin leggings and twin-sets of Harris Tweed (1987) she has subverted traditional forms of knitwear in almost every collection. In her recent designs for Wolford, the trademark Scottish Argyle pattern is reversed to expose snagged and tangled floating threads.

Like the late Jean Muir (1928–95), Westwood values craftsmanship and has appreciated and employed craftspeople throughout her career. She is similarly hard-working, and never takes the easy route – literally. A familiar figure in south London as she cycles past with her wire-haired fox terrier, Alexandria, in the basket. She said: 'I always try to go a different way home. It's a kind of curiosity, not to want to do the same thing – "Why do we have to do it this way? I'm going to try it that way." '

Westwood's overriding gift to fashion is her conviction that clothing can change the way people think. 'I think that the real link that connects all my clothes is this idea of the heroic.' She has great faith in fashion as personal propaganda, as mental and physical stimulation, saying 'clothes can give you a better life'. It is this vitality that is unique, rather than her cut and construction, original as they are. As Alix Sharkey wrote in *The Observer Magazine*, 'For her, clothes should intensify and refine the wearer's sense of physical presence; provoke a reaction, charge the atmosphere with sexual and political tension; they should directly alter the physical reality of the world around them. Clearly, this kind of clothing poses questions, and challenges us to explore, to consider the unknown. It can make us uncomfortable, this fashion that works like a drug, that alters our state of consciousness.'[122]

Vivienne Westwood has said 'I think my clothes allow someone to be truly an individual'[123] and wears her own clothes with panache – usually with a silk handkerchief from Tie Rack round her neck and often an antique spider brooch. Her clothes are characterized by an apparent complexity but, complimented recently on a green gingham blouse which lay in folds and drapes across the torso, she unfastened it to show that it was simply made of squares. Her use of familiar, often modest materials married with dynamic structure allows us to see the potential of fabric and form as if for the first time. Her historicism will never evaporate but at the moment she is concentrating on a new direction. Like the green gingham blouse, Vivienne Westwood's clothes seem fresh and surprising; they offer an alternative; they do seem heroic.

430 KING'S ROAD

1967 HUNG ON YOU

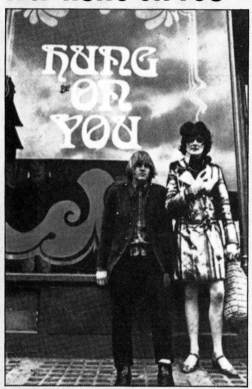

A greengrocers, a restaurant, then in the Summer of Love, Michael Rainey (above, with Jane Ormsby-Gore) opened his hippie boutique for upper-class bucks.

1969 MR FREEDOM

The pop art of dressing: Tommy Roberts of Mr Freedom outside the shop with Chelsea dolly-birds.

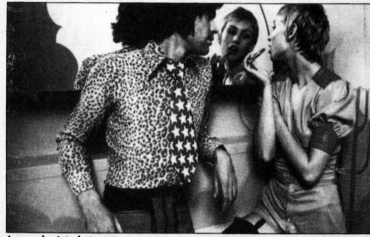

Leopard-print hot-pants, star-spangled kipper ties, unisex butcher-boy caps, T-shirts with clashing satin appliqués of sundaes and rockets and Mickey and Minnie and Donald and Goofy and catch-phrases of the period like 'Slip it to me' and 'Pow'. Mr Freedom was halfway between Bash Street and Disneyland: no comic-strip image was too kitsch or too childish, no colour combination was too garish. Customers, at one time, were greeted by a giant stuffed gorilla dyed fun-fur blue. Confident Cockney Tommy Roberts claimed he'd inspired Saint Laurent's tarty 1970 look. He moved to even flashier premises in Kensington, went bust like Biba and has now gone back to antique dealing.

1970 PARADISE GARAGE

When Mr Freedom moved on, Trevor Myles (right, with his flocked tiger-striped Mustang) stayed and opened Paradise Garage. Behind a South-Sea fascia of bamboo, corrugated iron and petrol pump were tropical birds and £5,000 worth of new and used Americana bought in downtown Manhattan — Hawaiian shirts, baseball jackets, denim dungarees by cornpone labels like Osh Kosh b'Gosh. Though copied a lot since, the Garage ran out of gas in a year.

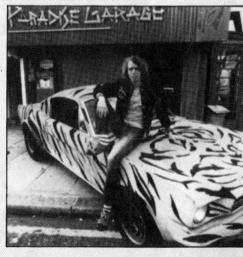

From the Swinging Sixties to the Extreme Eighties every dedicated follower of fashion has made monthly visits to check out what's happening at this extraordinary shop site. One by one it has housed the leaders of the avant-garde pack. *Miles Chapman* pots a style history

1971 LET IT ROCK

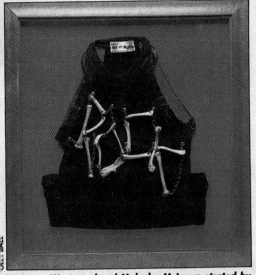

Vivienne Westwood and Malcolm McLaren started by selling Fifties Rock'n'Roll records in the back room of Paradise Garage done up as a suburban Teddy Boy's dream front room with ornamental jars of Brylcreme. Vivienne made Ted clothes for Malcolm, they started to sell those too and soon took over the entire shop. Teds loved it. So did milliner Stephen Jones, then aged 13, whom they fitted out in orange and black — drape jacket, drainpipe jeans, day-glo socks, ruffled shirt, bootlace tie — and lime-green suede brothel creepers.

1972 TOO FAST TO LIVE TOO YOUNG TO DIE

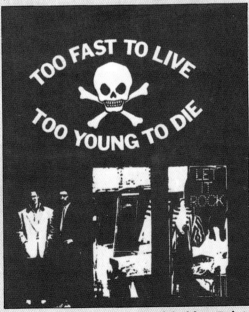

Malcolm and Vivienne's interest shifted from Teds to Rockers. The new name was a slogan from a biker's jacket. They got deeper into leather, studs and zips.

1974 SEX

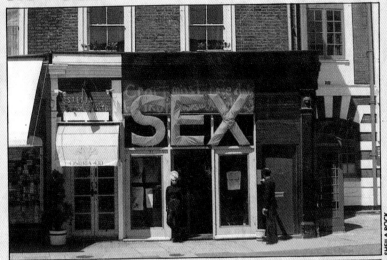

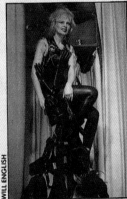

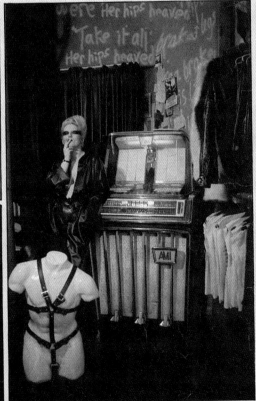

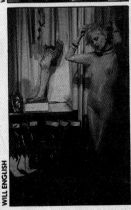

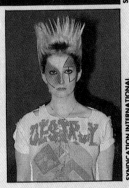

The huge padded plastic letters of the new name were shocking pink. Malcolm and Vivienne had gone all the way — making public display of the leather and rubber stuff that fetishists succumbed to in private. The two little pictures above show Vivienne sporting a strappy ensemble and the all-in-one 'rubber johnny' suit. Jordan (shopgirl of the year, above and right) wowed fellow commuters from Sussex by boarding the train in such apparel. The shop's walls were thick with gobs of latex and sprayed with lines from things like the S.C.U.M. Manifesto. Malcolm formed the Sex Pistols. A boy was arrested in Piccadilly Circus for wearing a Sex T-shirt of two semi-nude cowboys. The Police swooped. Jordan starred in Jarman's Jubilee.

1977 SEDITIONARIES

1980 WORLDS END

The white windows were so often smashed by soccer fans the front was boarded up, then sprayed by punks. Inside was an upside-down pic of Piccadilly Circus. Vivienne's Jubilee outfit, worn above by Debby, echoed Johnny Rotten's God Save The Queen. The baggy and bondage-strapped look was copied by the youth of the world.

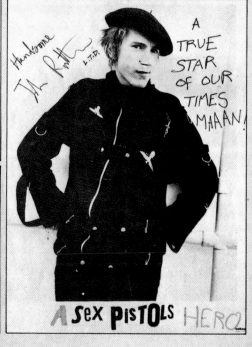

A TRUE STAR OF OUR TIMES MAAAN!

A SeX PISTOLS HERO

The front is a mixture of a cuckoo clock and the back of a galleon. The clock's hands whizz round backwards. The steps lead up to a rickety old door. Inside, the floor slopes alarmingly. David Connor and Malcolm designed it. The clothes (see page 72) are piratical. Vivienne's gold-foil teeth are pirated from a pack of Benson and Hedges.

PICTURE RESEARCH: SONYA TAYLOR

70

36

Vivienne Westwood collections

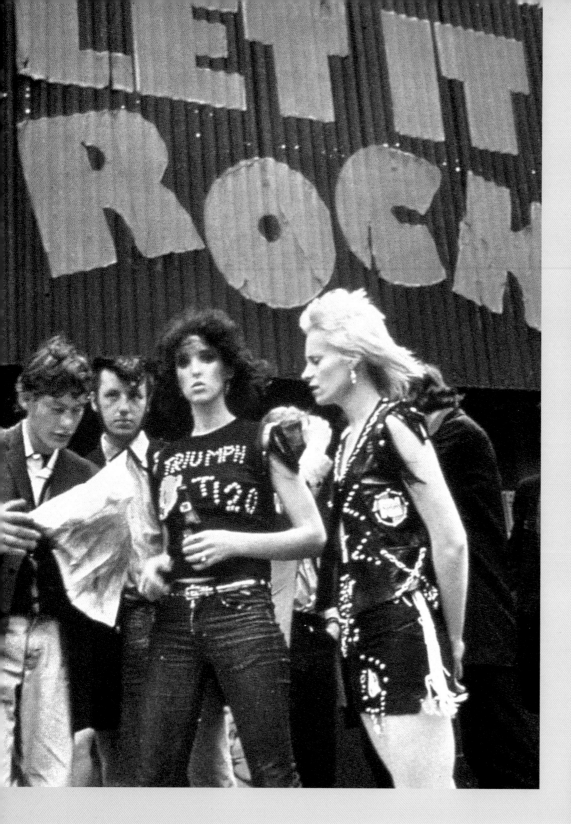

LET IT ROCK 1971

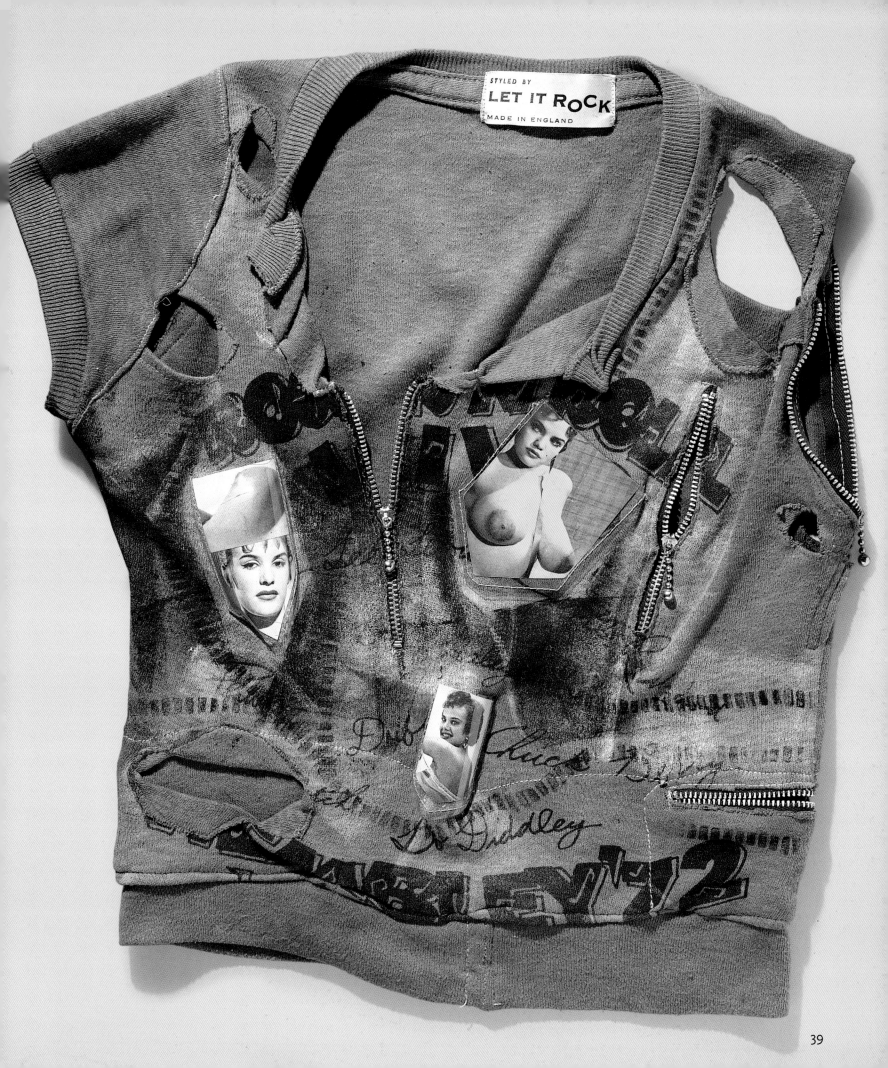

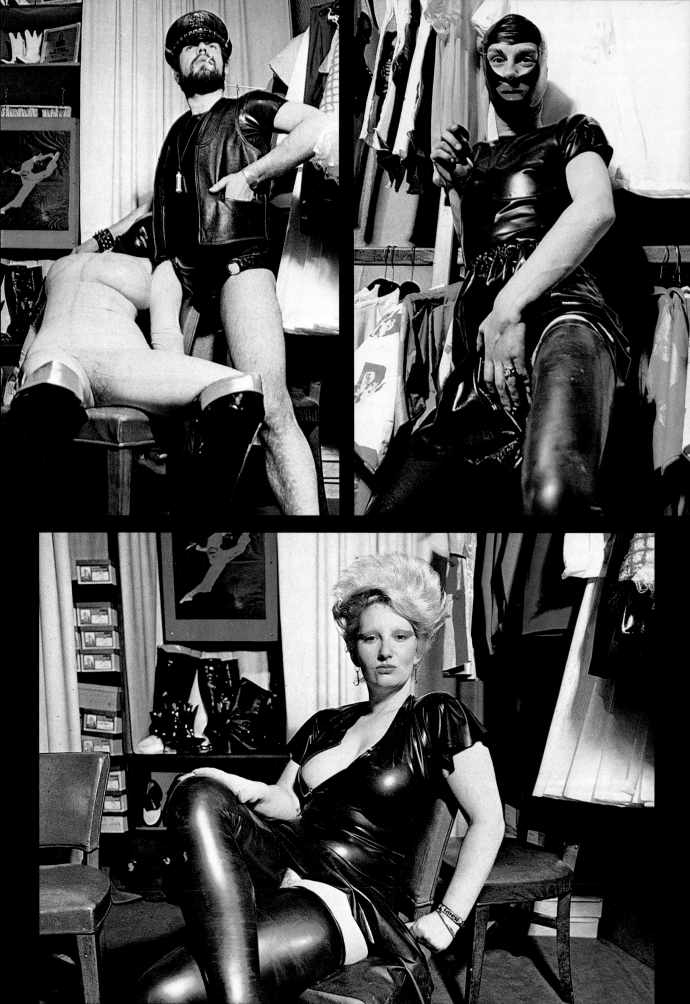

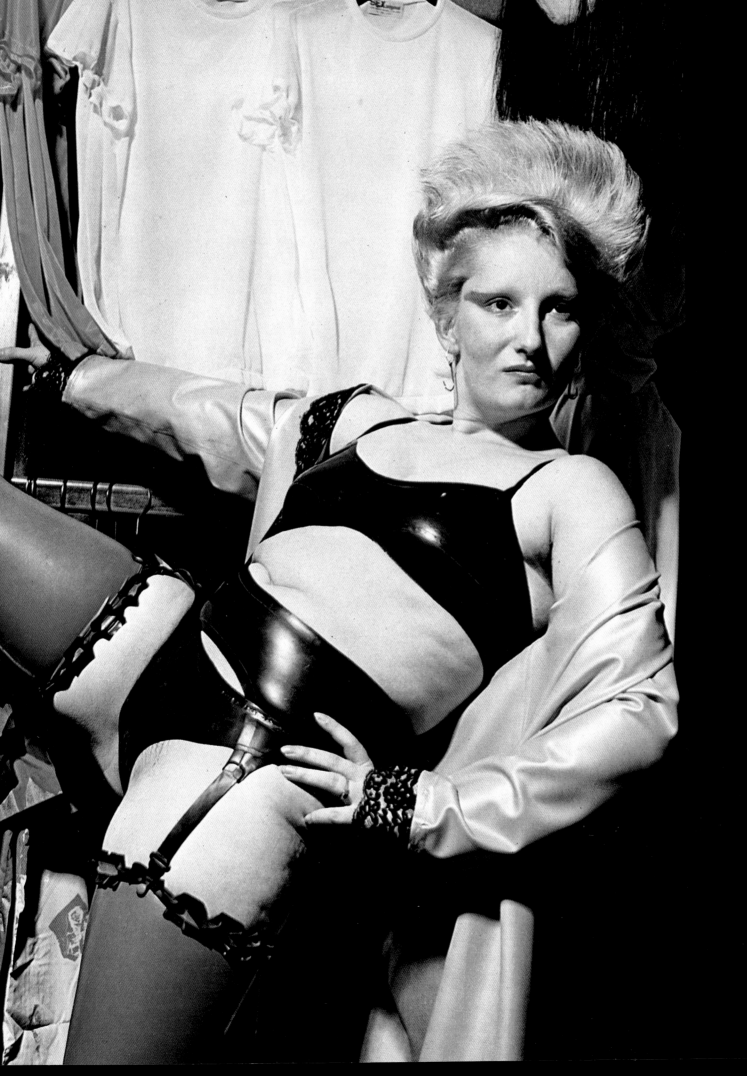

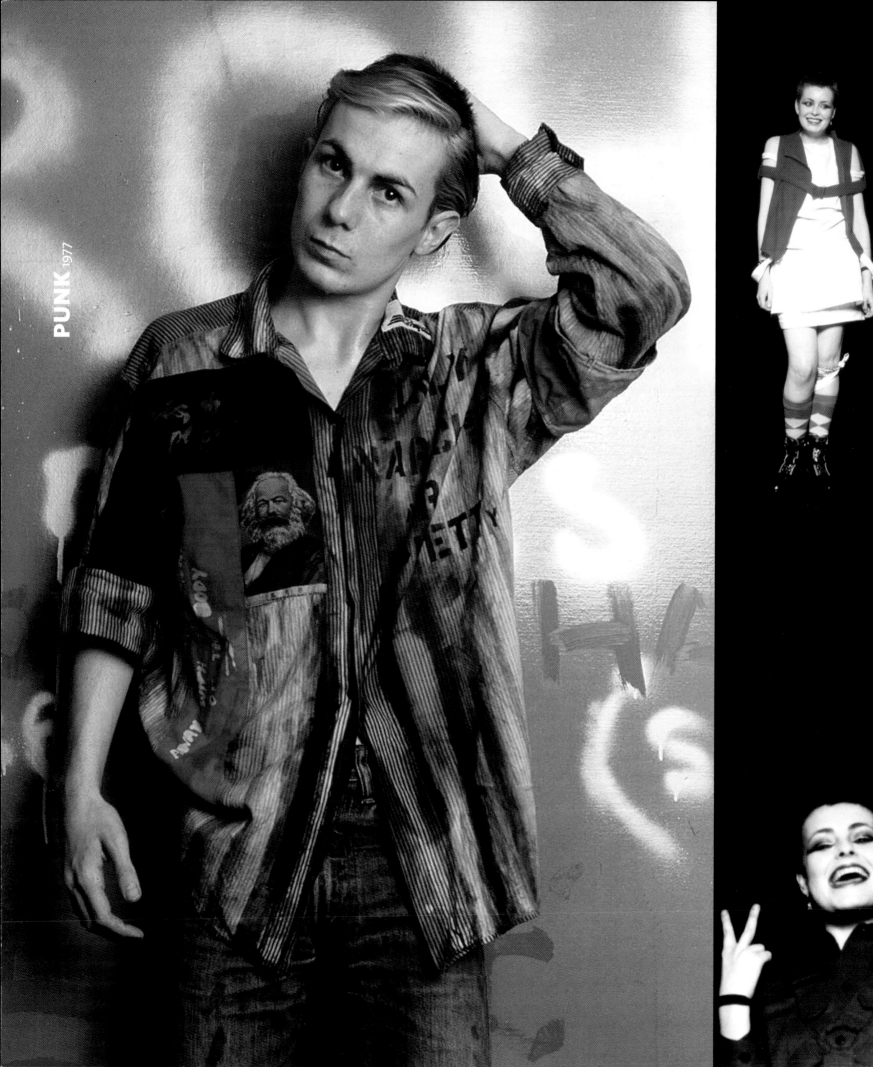

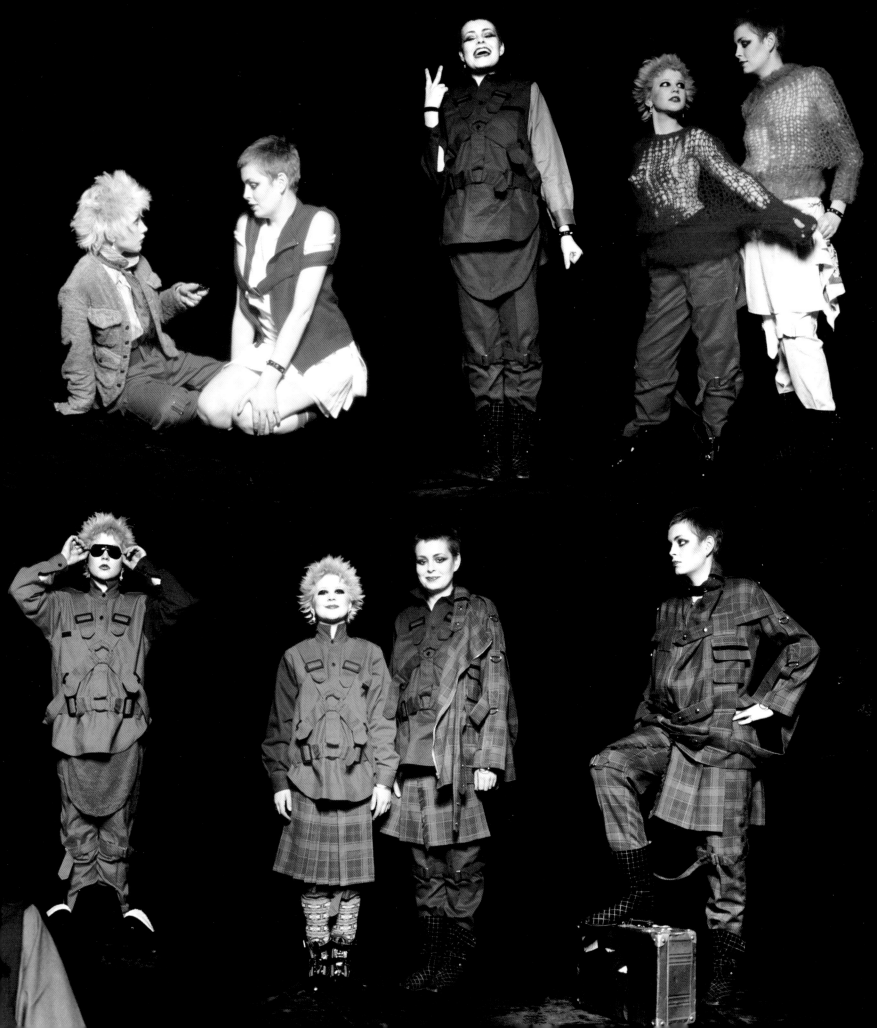

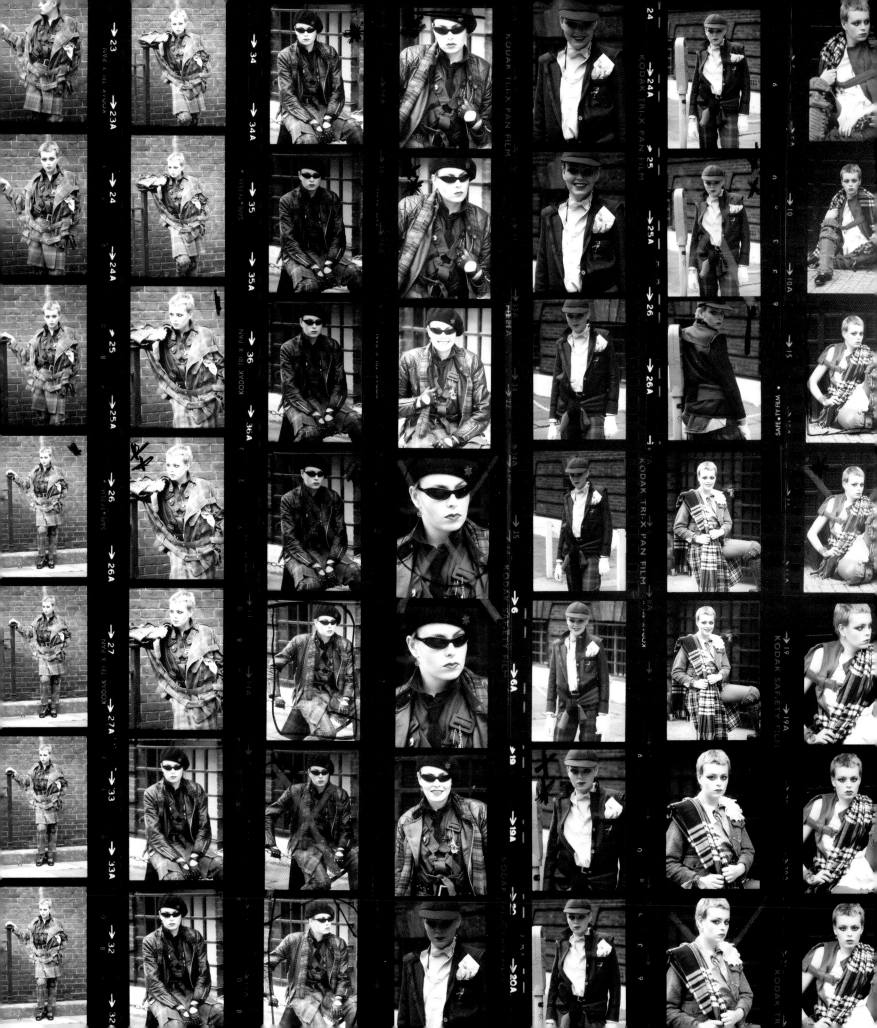

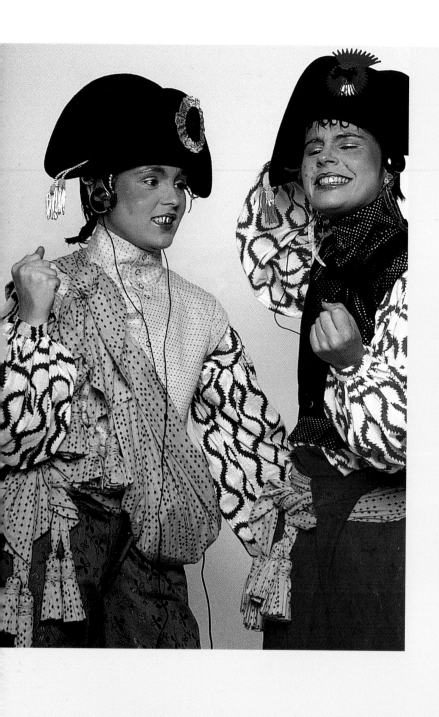

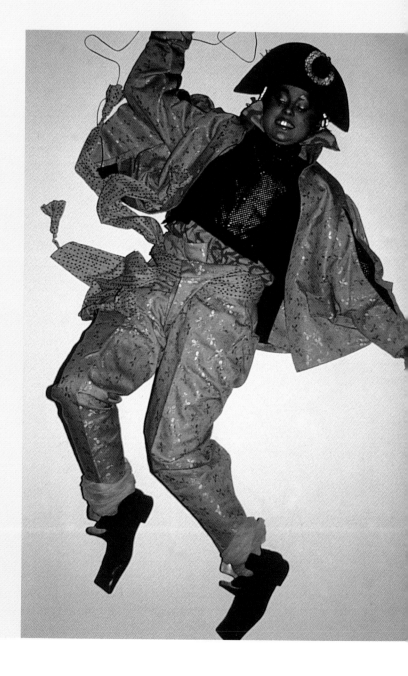

PIRATE

AUTUMN/WINTER 1981–2

With Pirate, Westwood began an exploration of historical cut and tailoring that would inform her life's work. The loose-cut trousers and romantic, billowing shirts, with their vermicular 'squiggle' print, were based faithfully on 18th-century men's clothing. Westwood blended the idea of the pirate with the North American Indian and the early 19th-century French *Merveilleuses*. This heady mix created a collection that burst onto the London fashion scene in a riot of gold, orange and yellow.

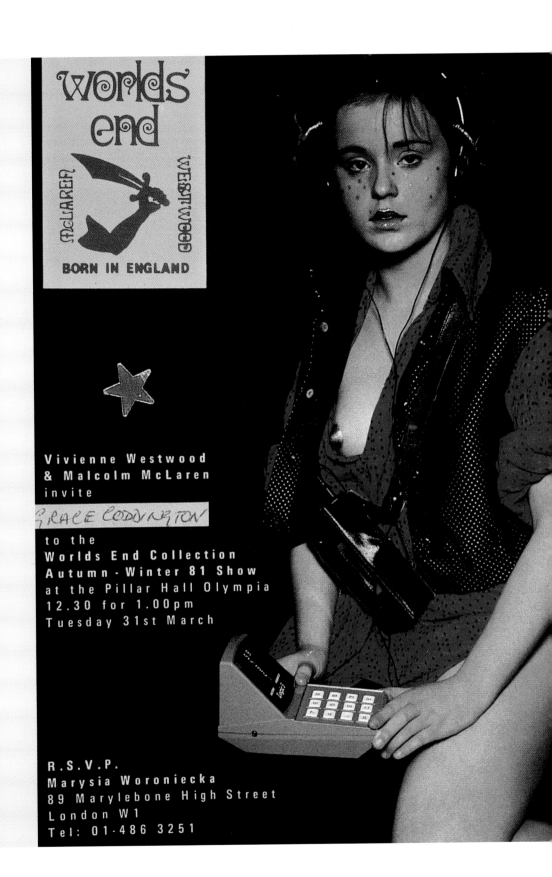

worlds end

McLAREN WESTWOOD

BORN IN ENGLAND

Vivienne Westwood
& Malcolm McLaren
invite

GRACE CODDINGTON

to the
Worlds End Collection
Autumn - Winter 81 Show
at the Pillar Hall Olympia
12.30 for 1.00pm
Tuesday 31st March

R.S.V.P.
Marysia Woroniecka
89 Marylebone High Street
London W1
Tel: 01-486 3251

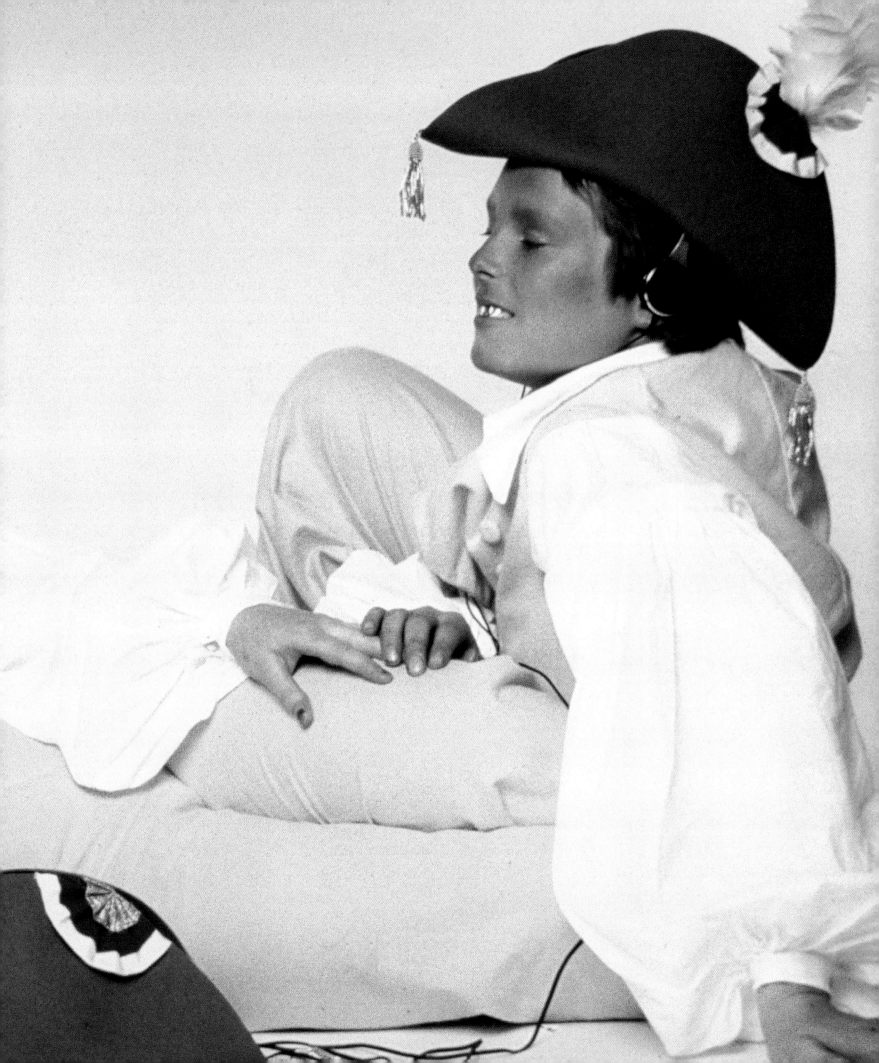

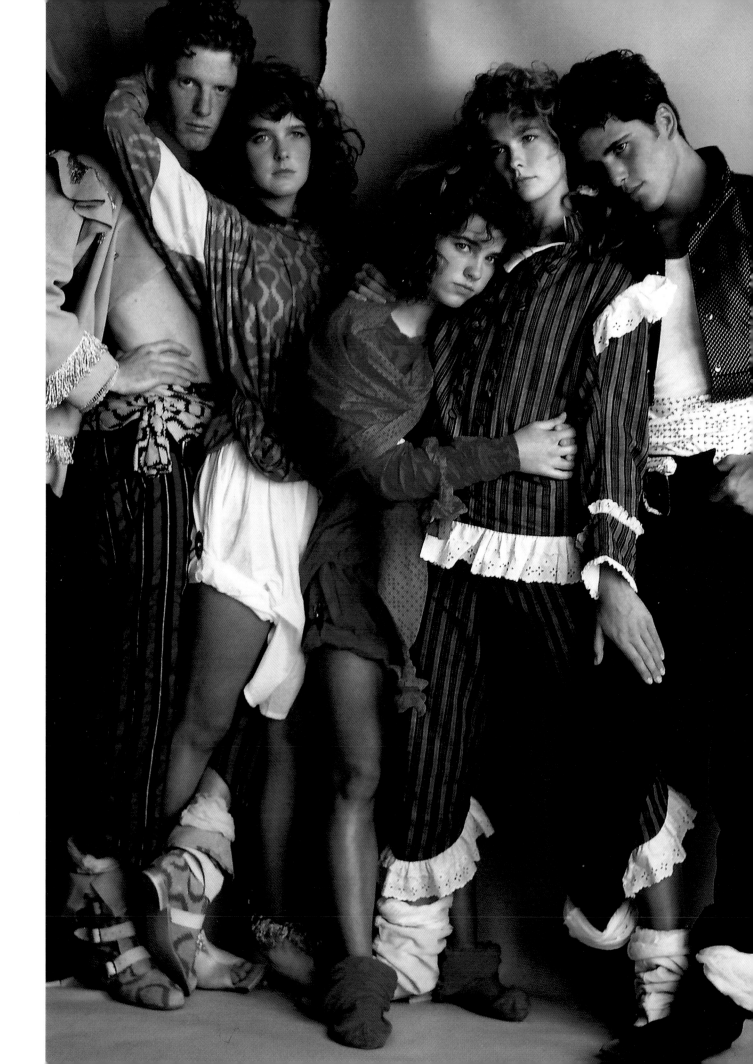

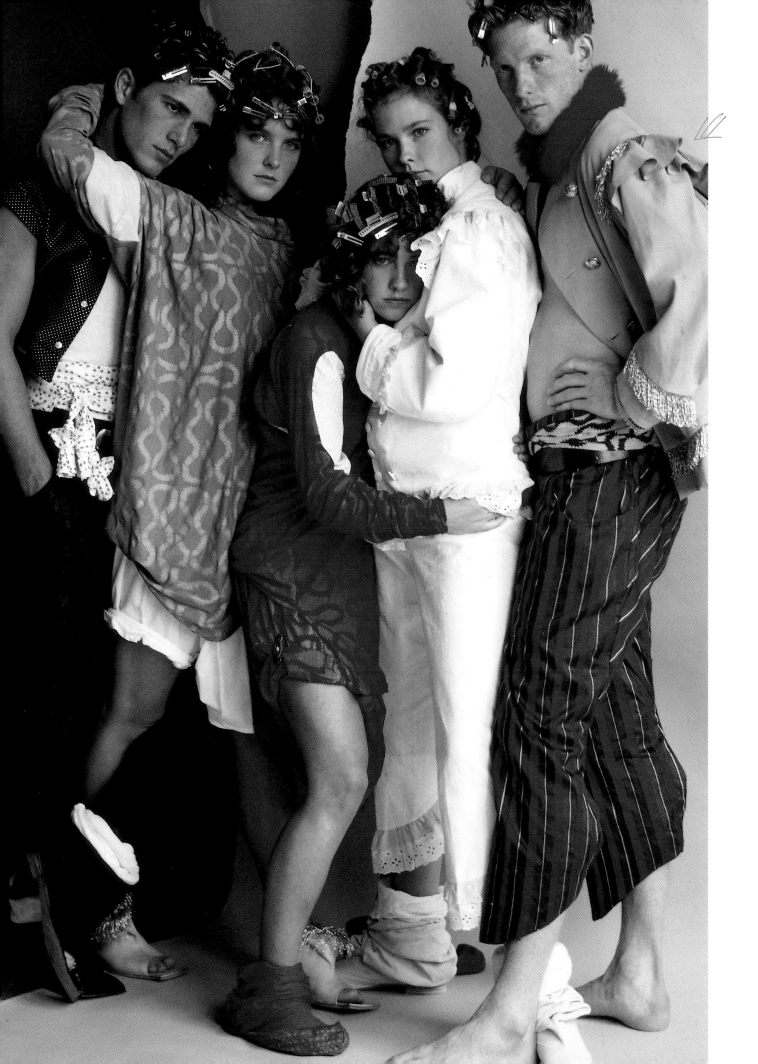

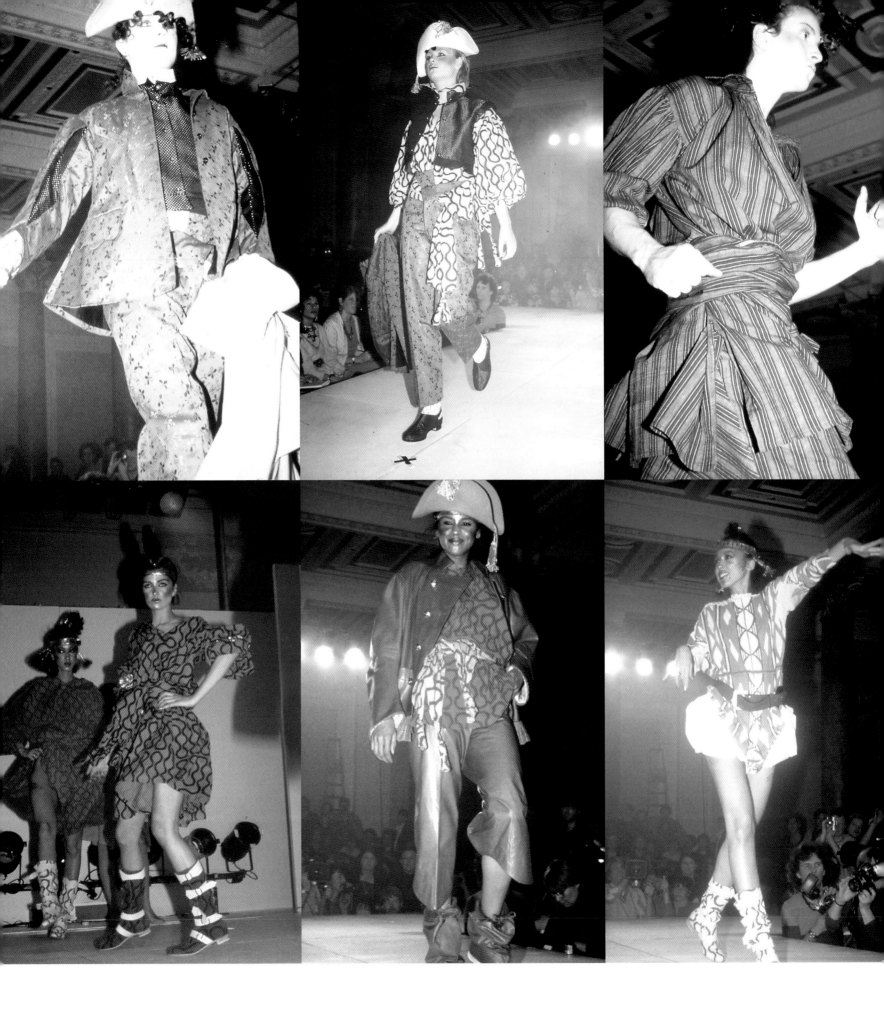

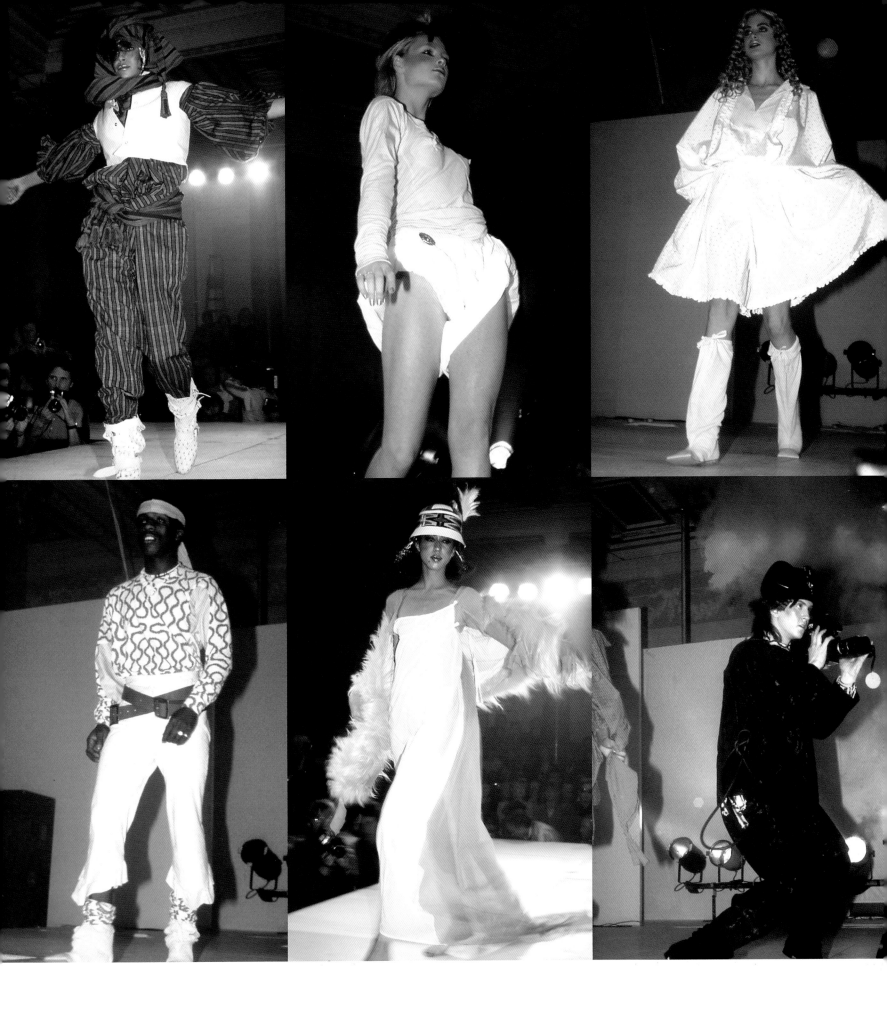

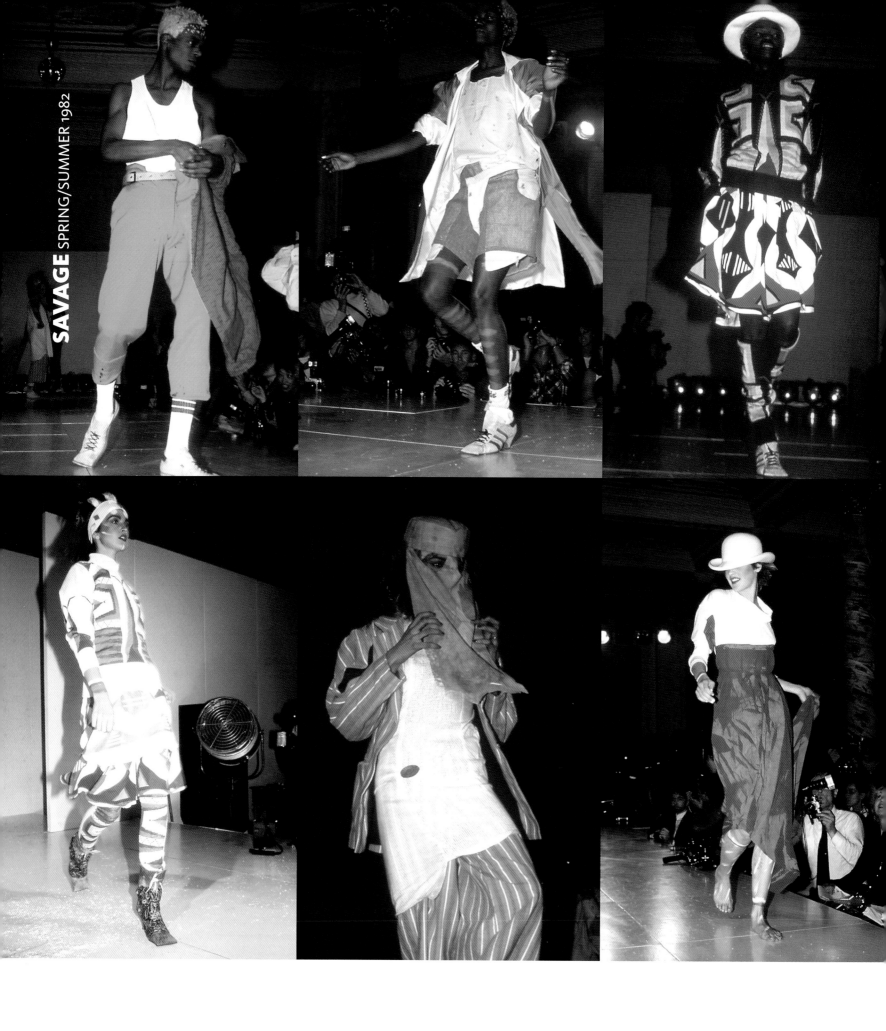

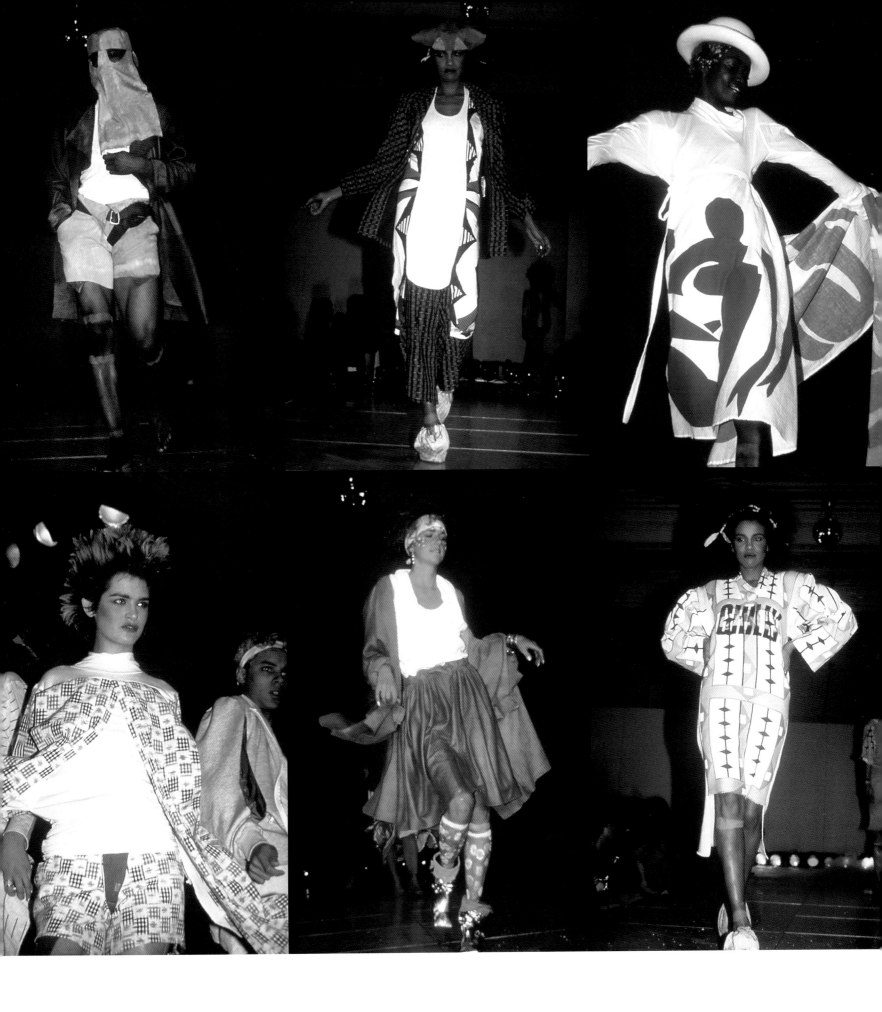

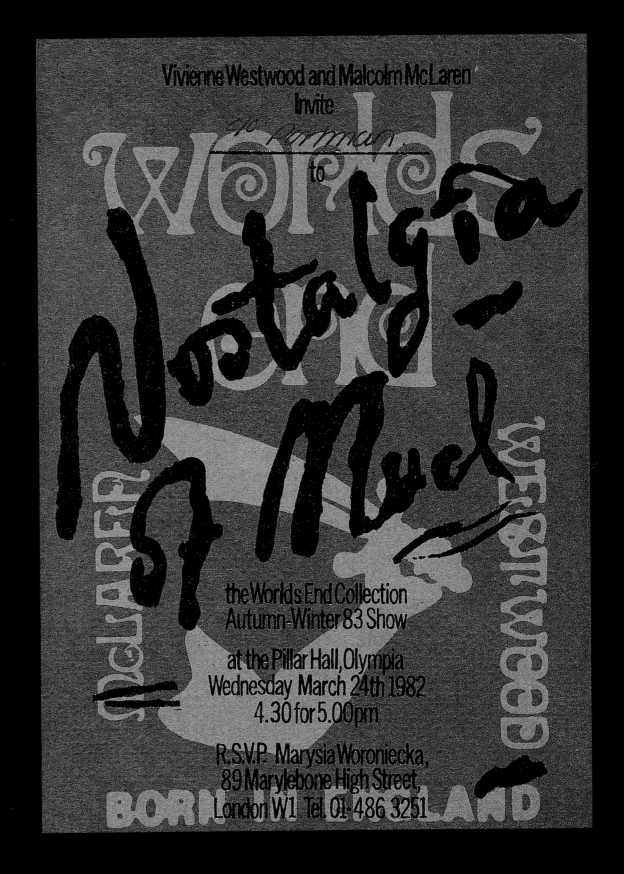

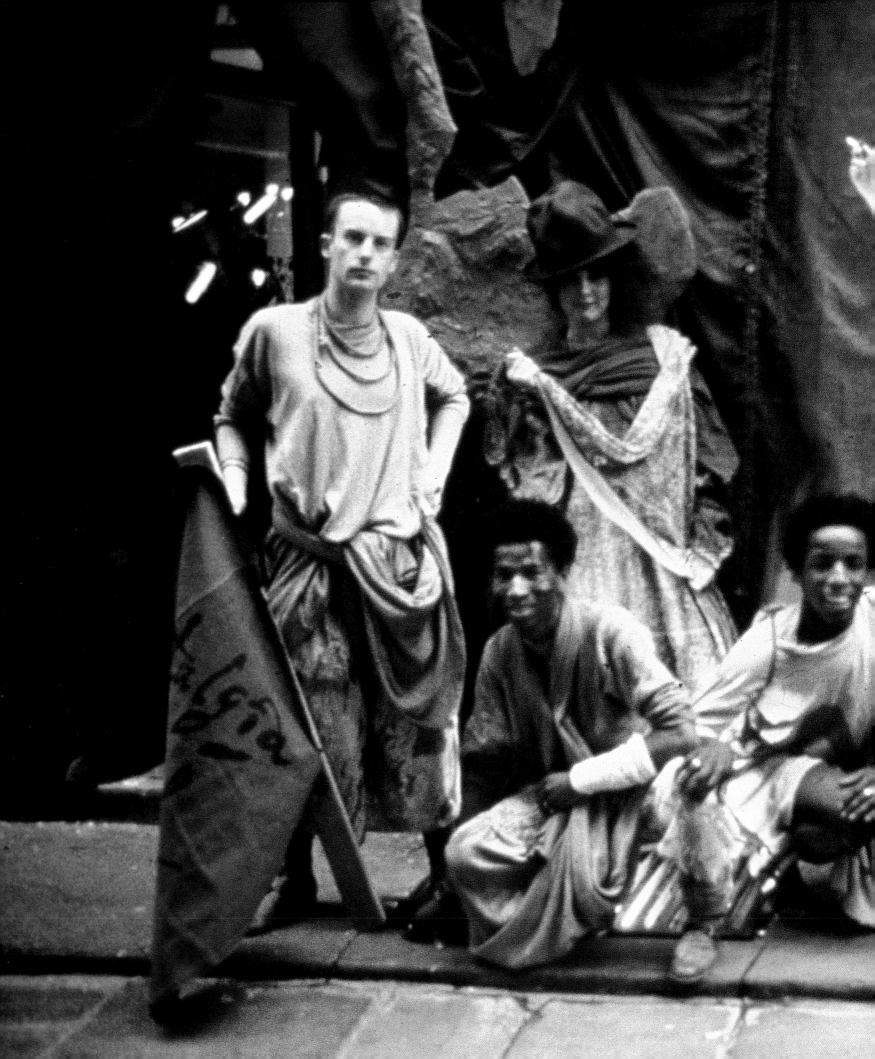

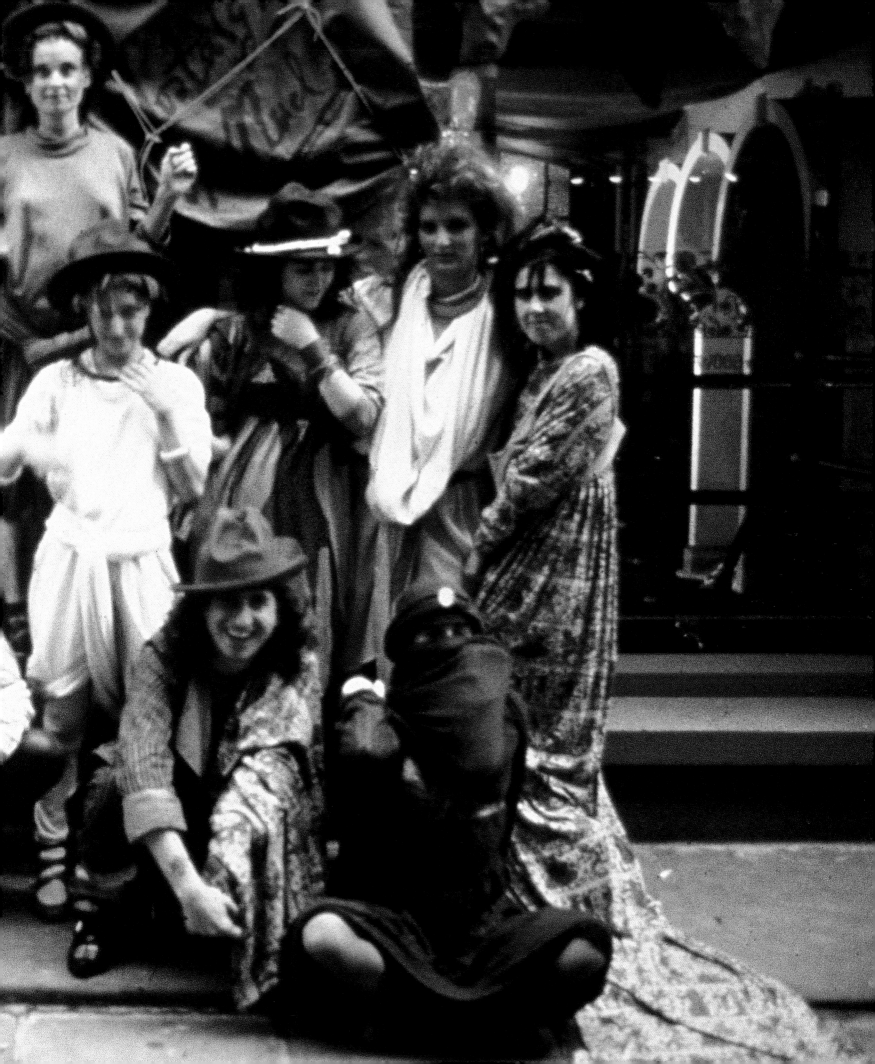

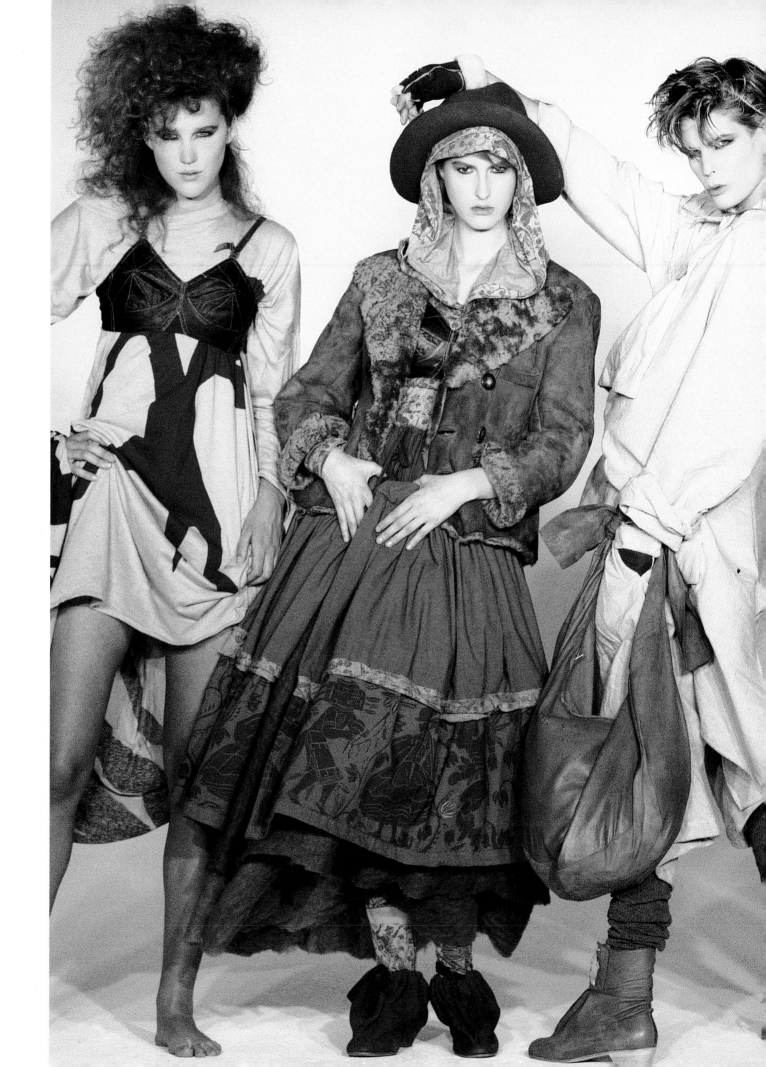

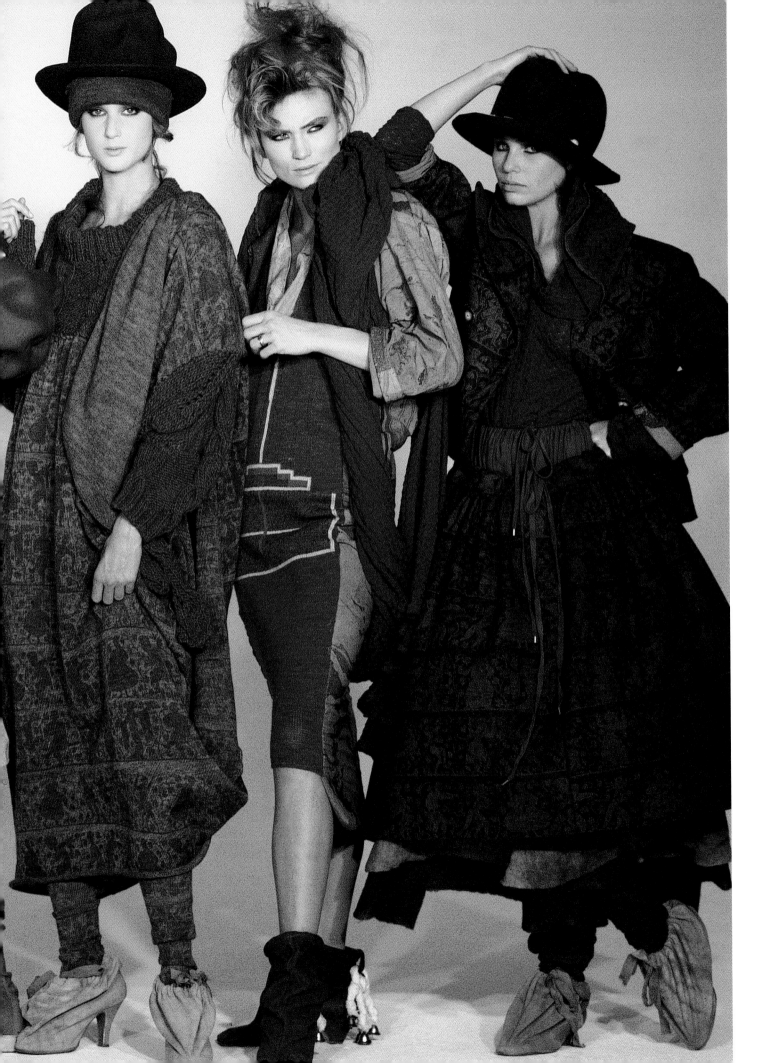

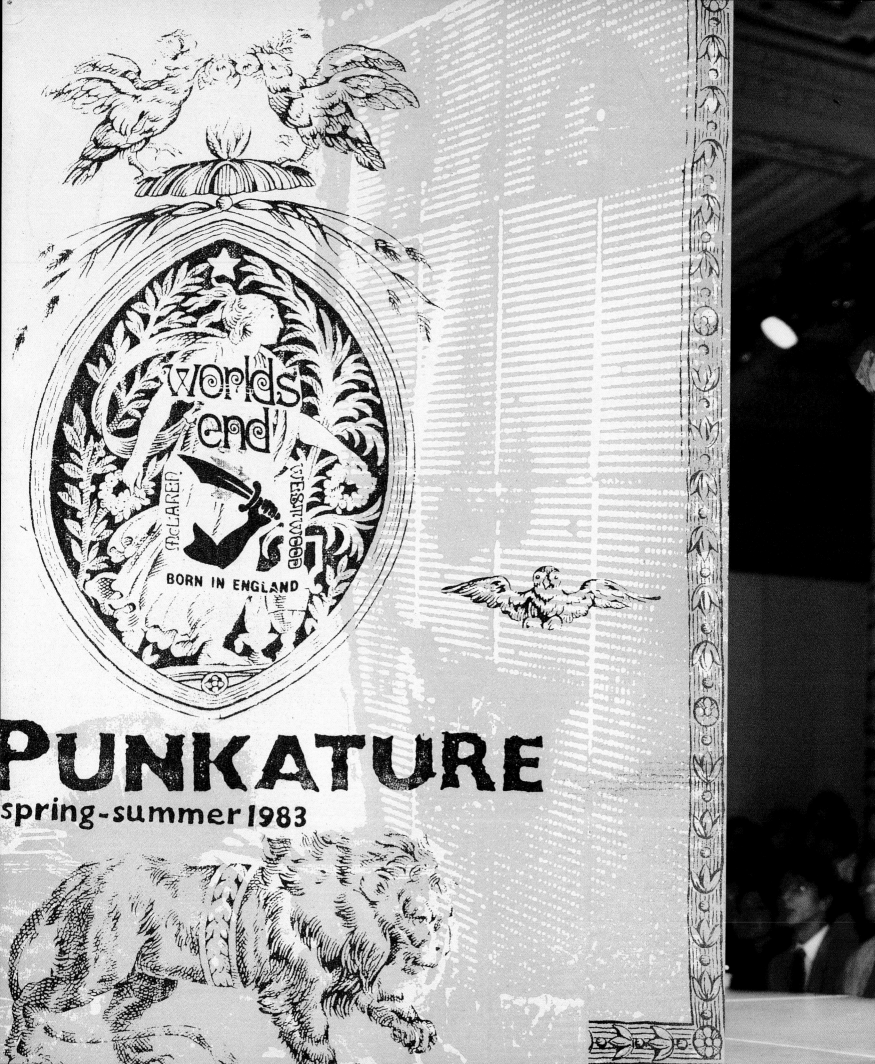

worlds end

McLAREN · WESTWOOD

BORN IN ENGLAND

PUNKATURE

spring-summer 1983

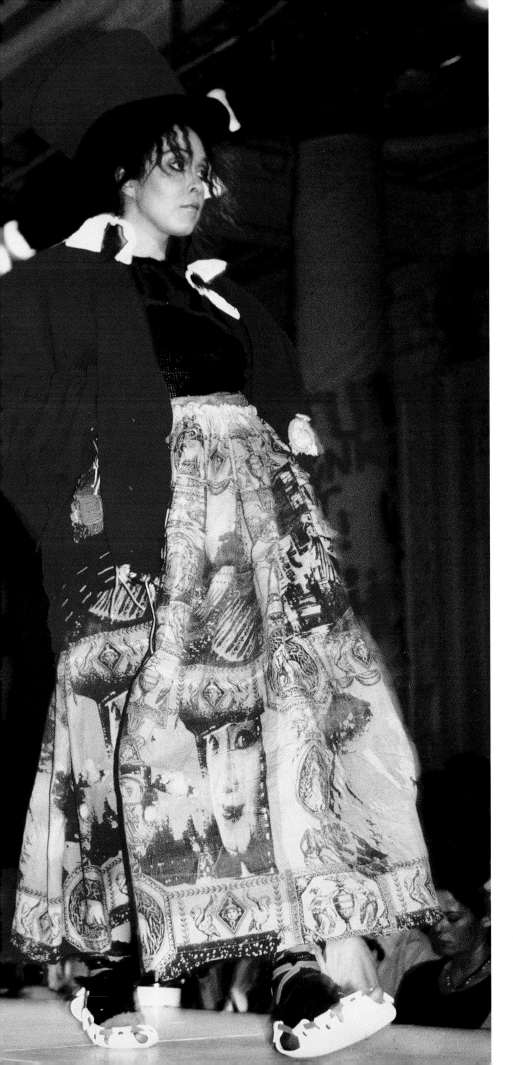

PUNKATURE

SPRING/SUMMER 1983

Left: Westwood took a conventional toile de Jouy and overprinted it with images from Ridley Scott's film *Blade Runner* (1982).

Overleaf: Westwood's tube skirt began life as a roll of cheap cotton stockinette. She recalled: 'No one had made one before, the idea of a sweatshirt or jersey tube. You could wear it around your body, however you wanted it, but I liked it really low, ankle-length. I liked this falling-down look, with a bare tummy and a little cropped top.'

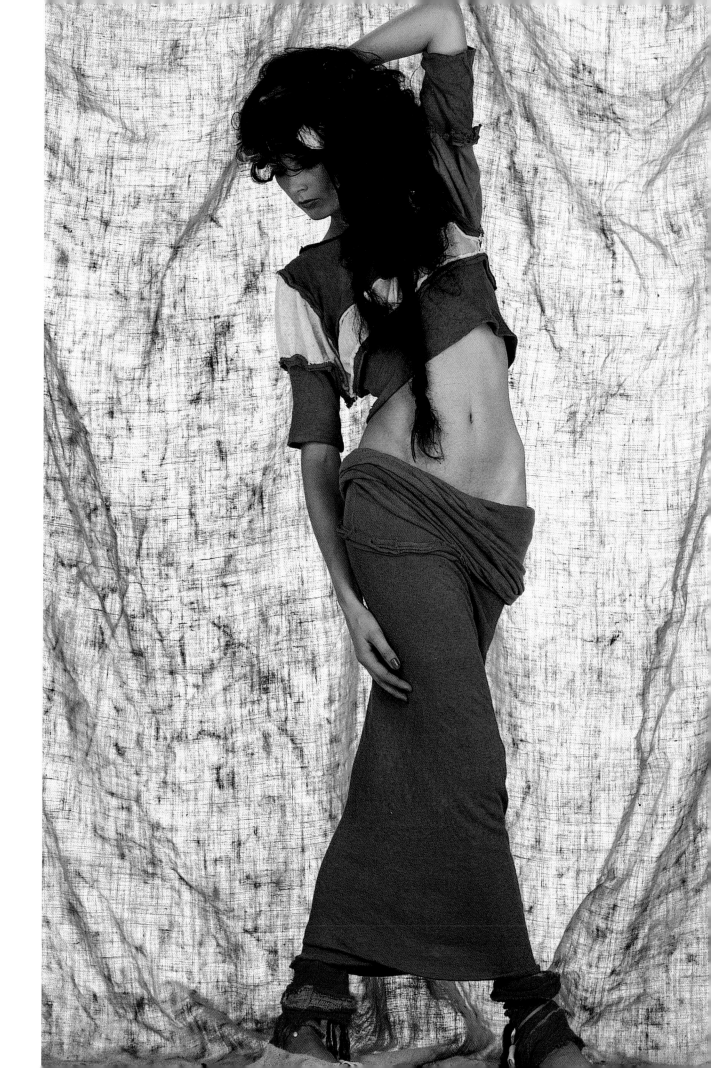

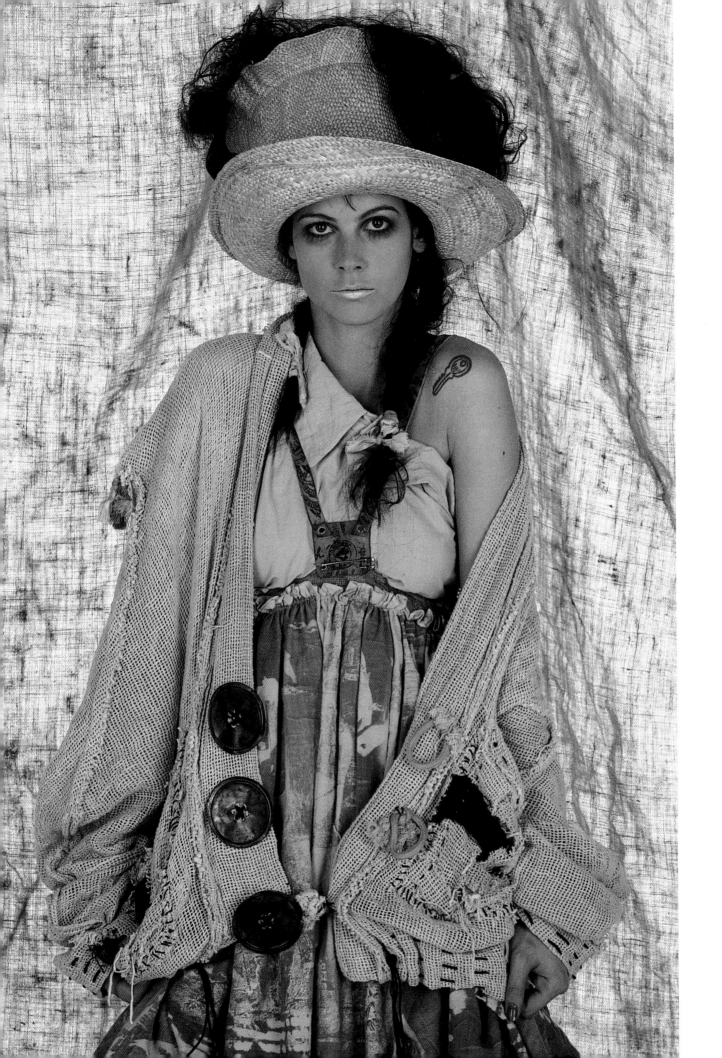

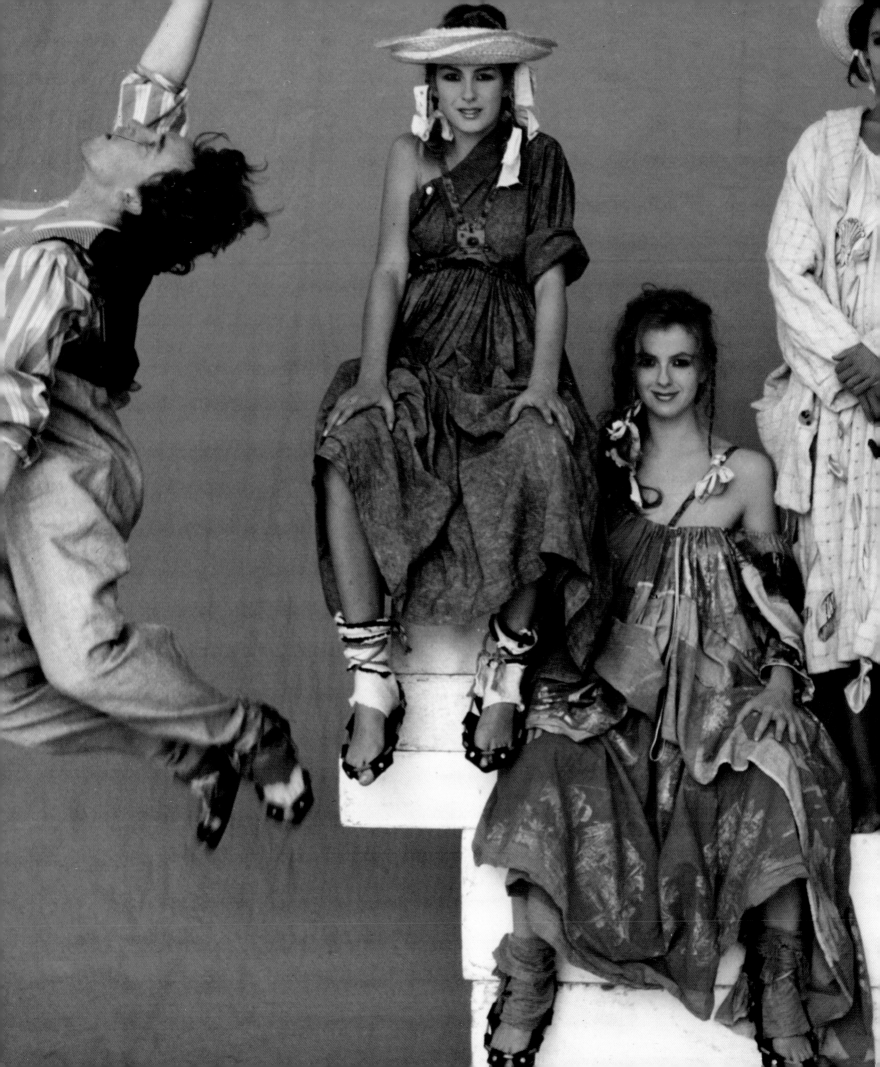

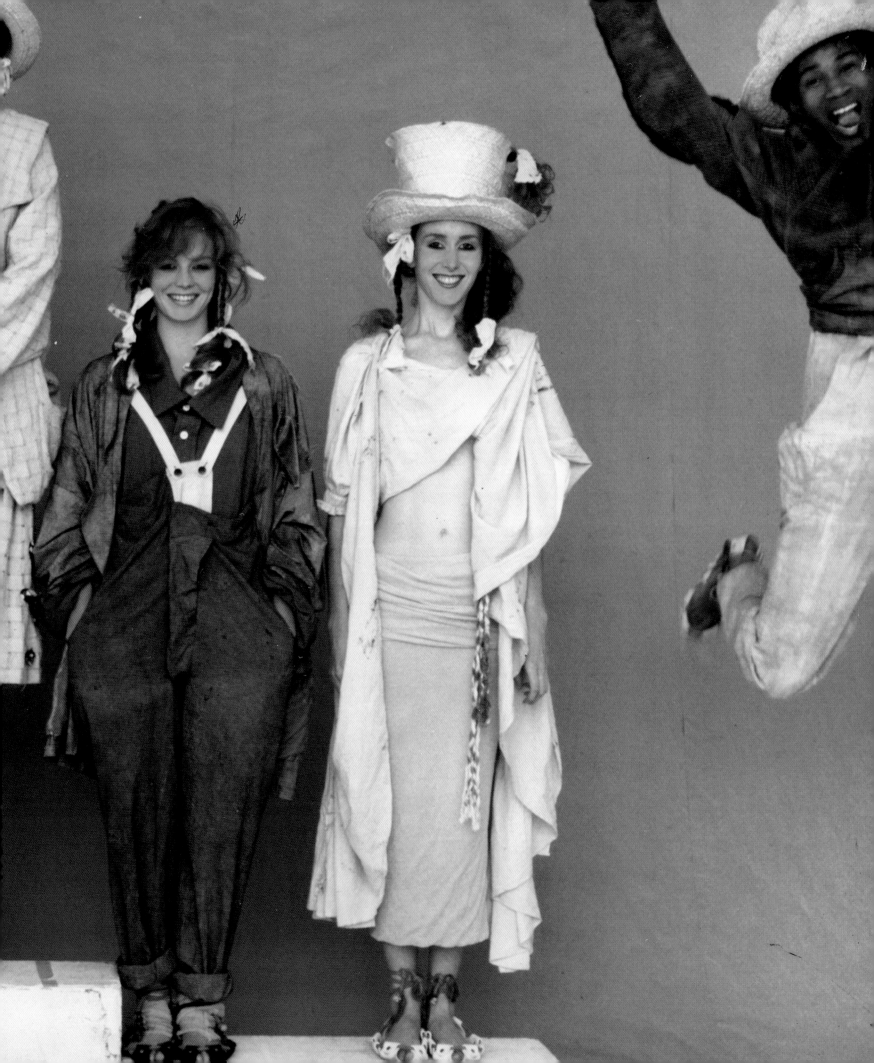

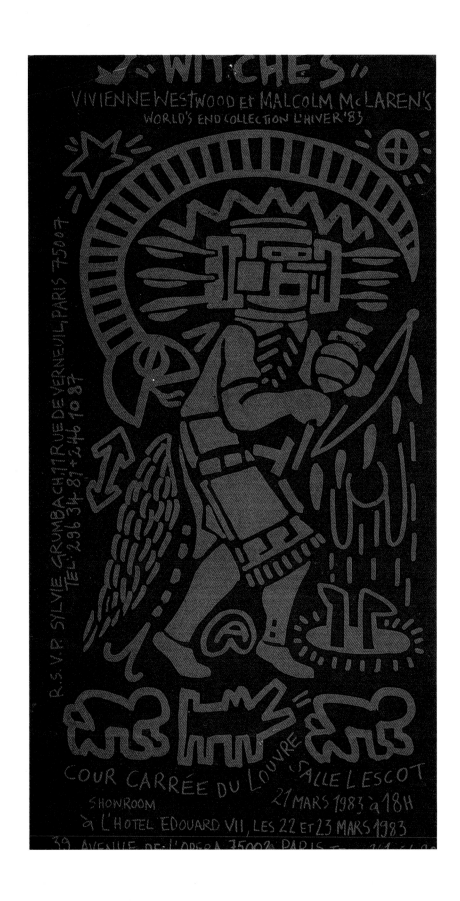

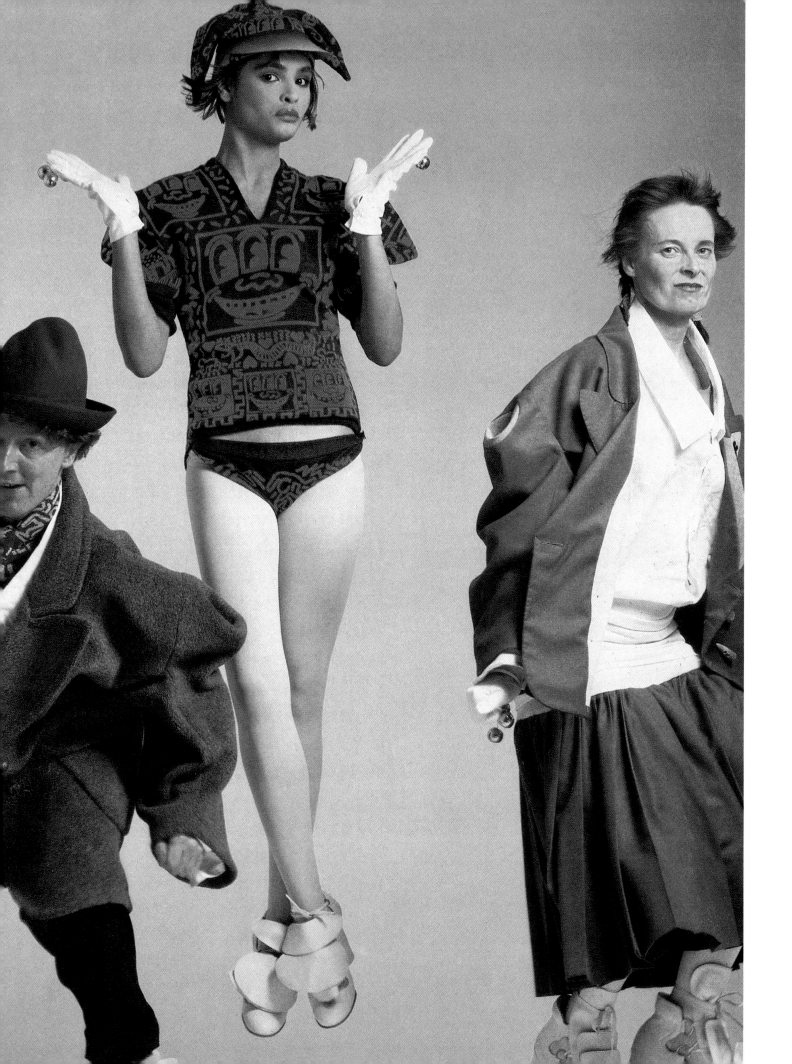

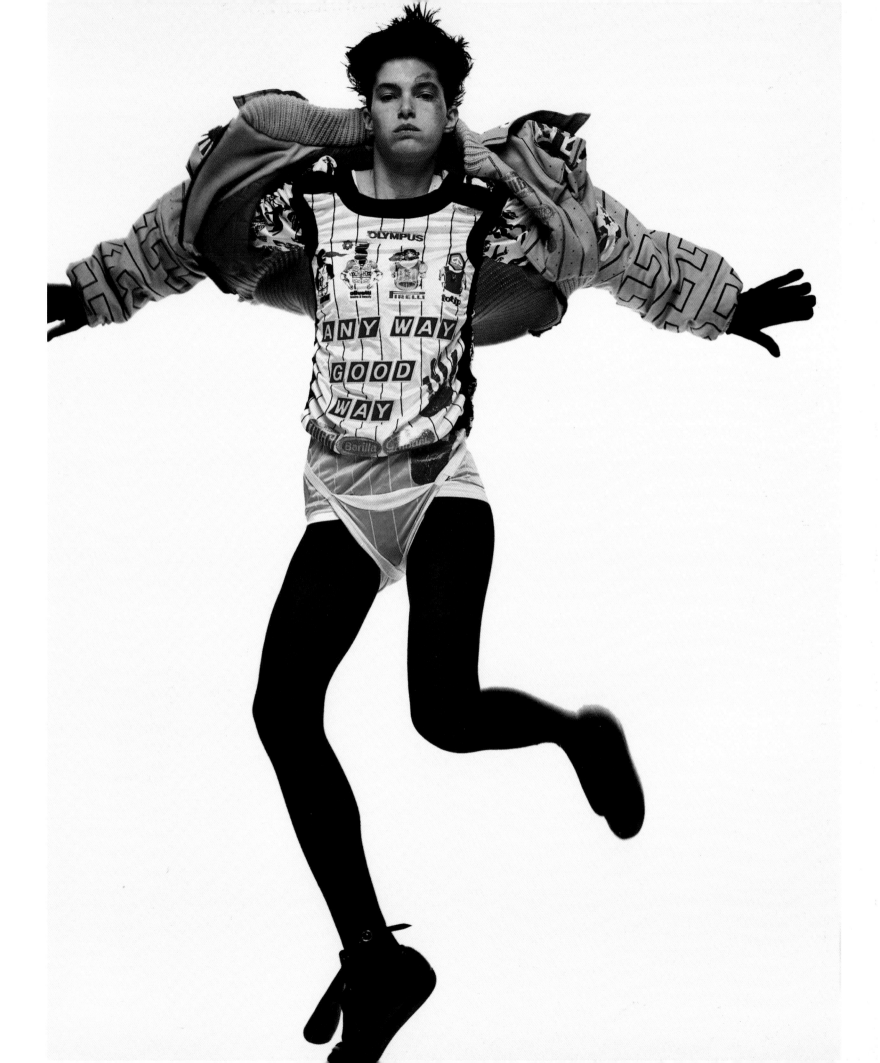

MINI-CRINI

SPRING/SUMMER 1985

Above:
NEW OMNIBUS REGULATION
"Werry sorry'm, but yer'l 'av to leave yer Krinerline
outside." *Punch*, 1858

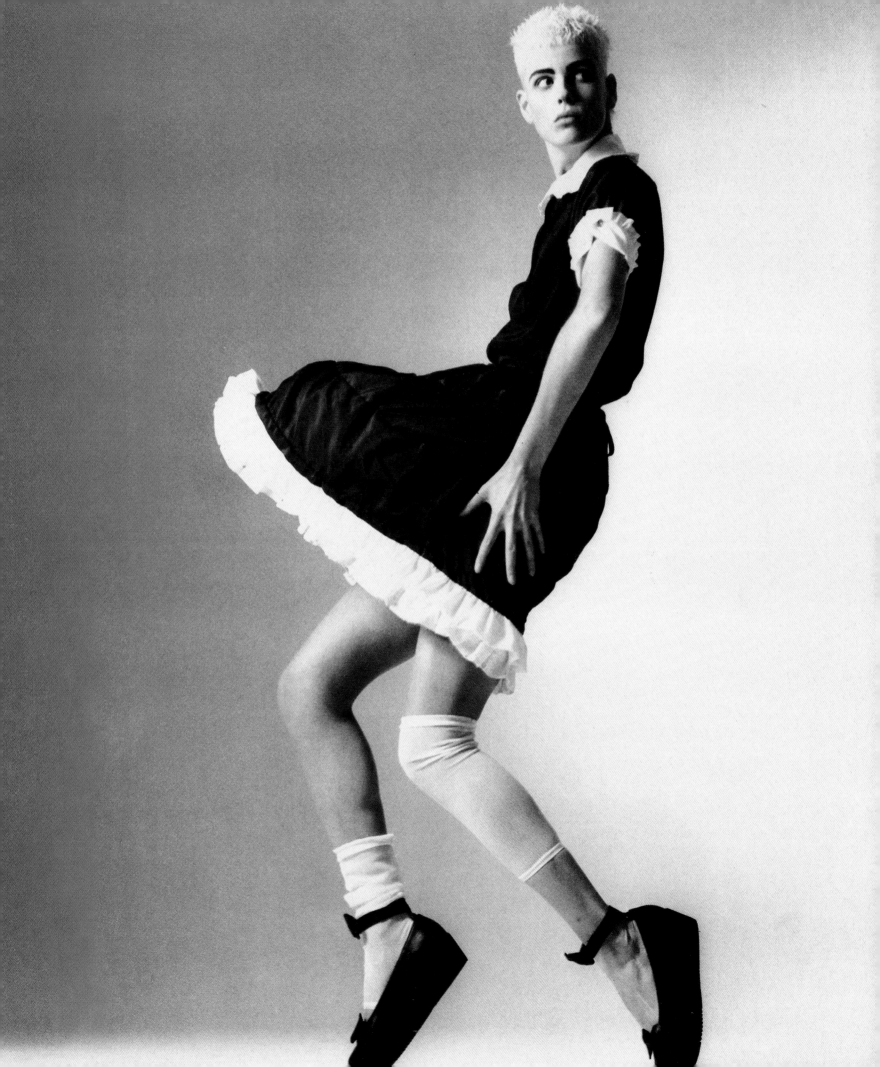

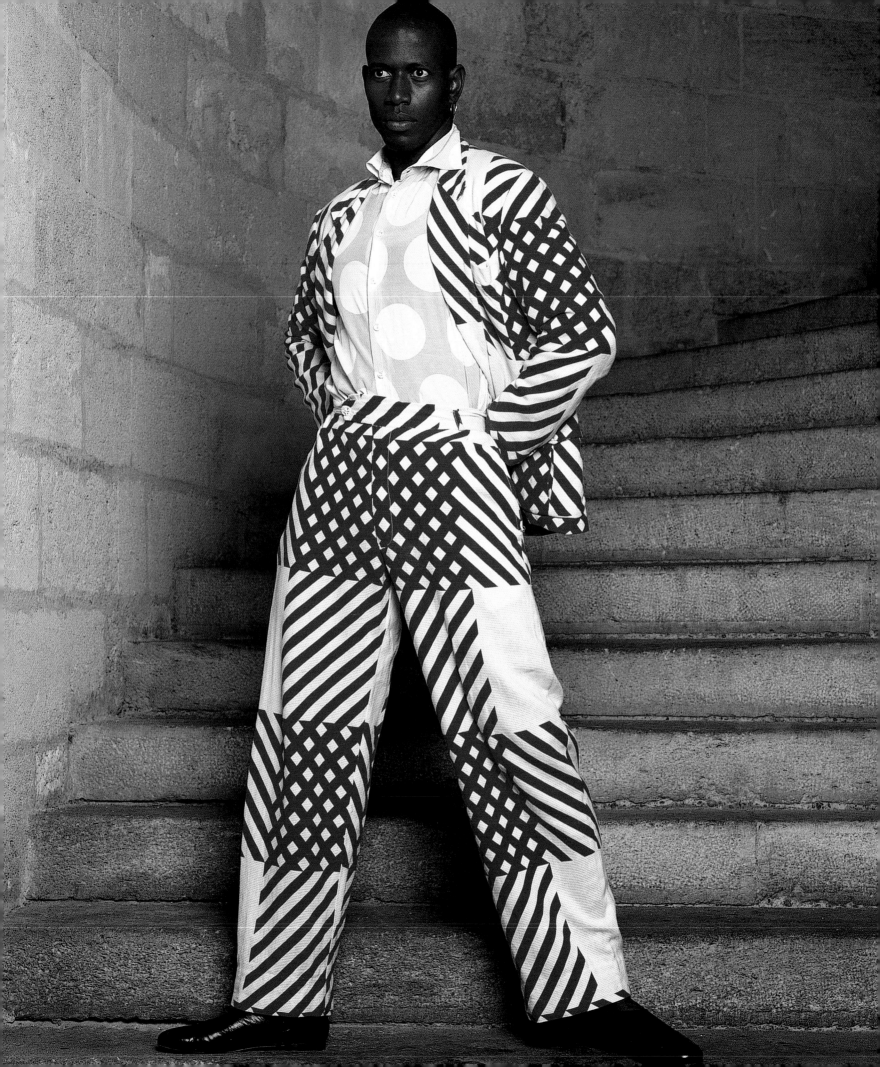

HARRIS TWEED

AUTUMN/WINTER 1987–8

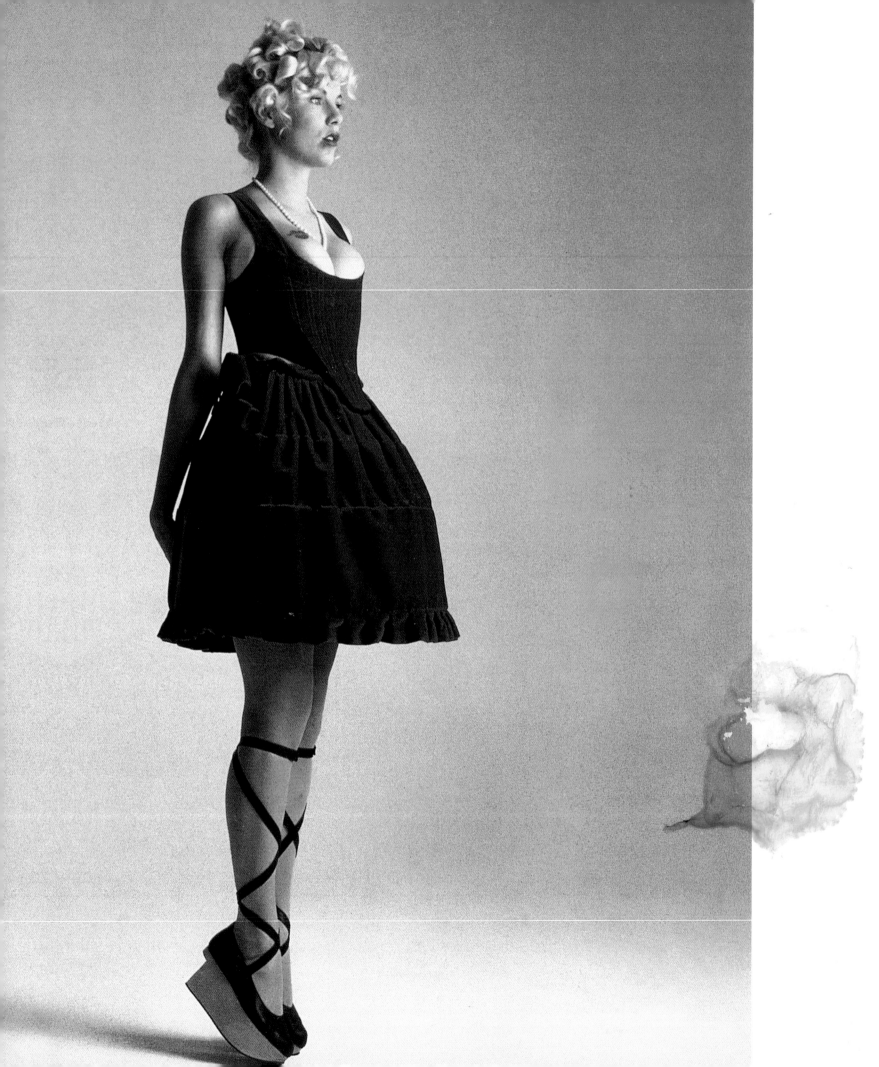

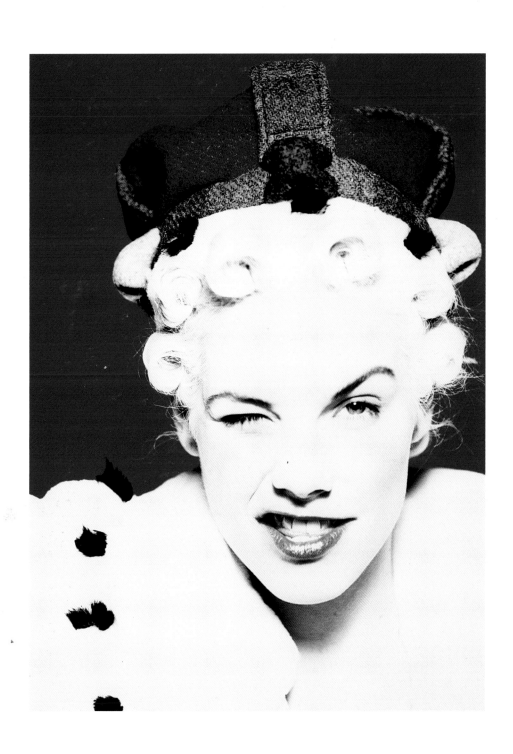

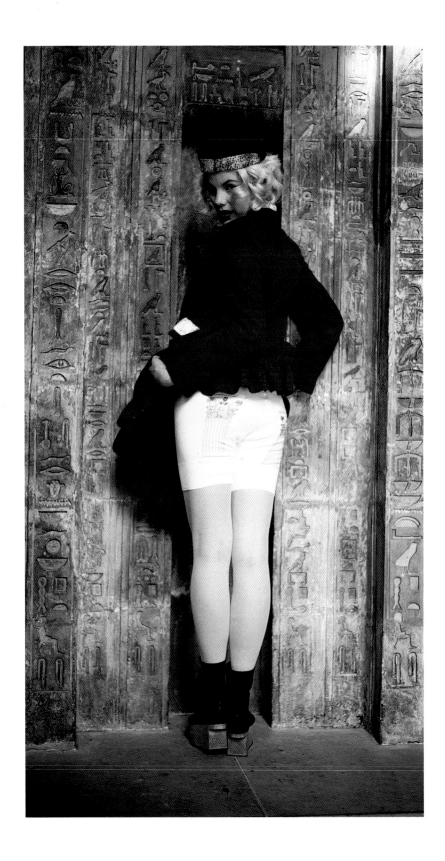

With Harris Tweed Westwood returned to traditional English cutting. She said, 'This was one of those cardinal points when you stop doing one thing and start doing something else. It was a change of direction – I wanted to make things that fitted.' This winter version of the Mini-Crini in red barathea imbues the fabric with flirtatious weightlessness. The short, double-breasted jacket was inspired by the princess coats worn by the Queen as a girl. The curved collar and pocket flaps are trimmed with a dress velvet that resembles ermine; it was so expensive that it could only be used sparingly. Curving in at the waist and then smoothly outlining the hips, the 'Princess' jacket sits poised on top of the bell-shape skirt, counterbalancing the flirtatious, swaying crini.

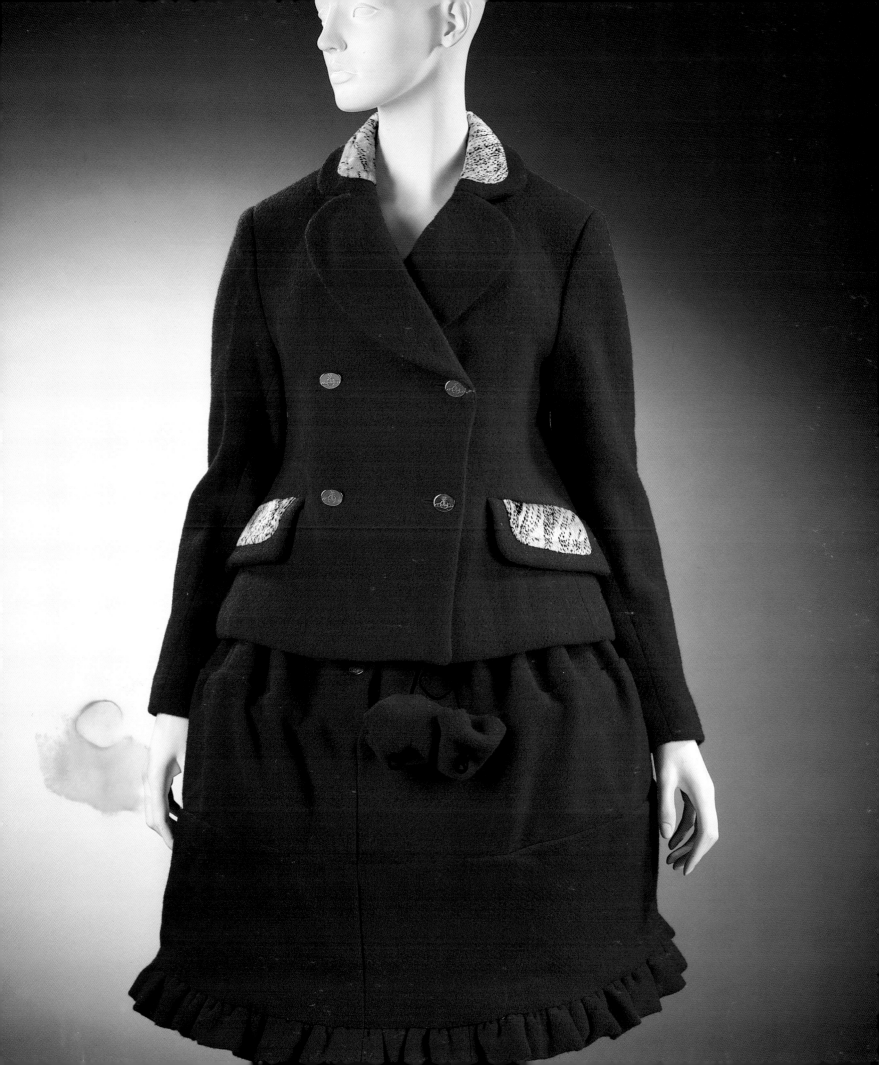

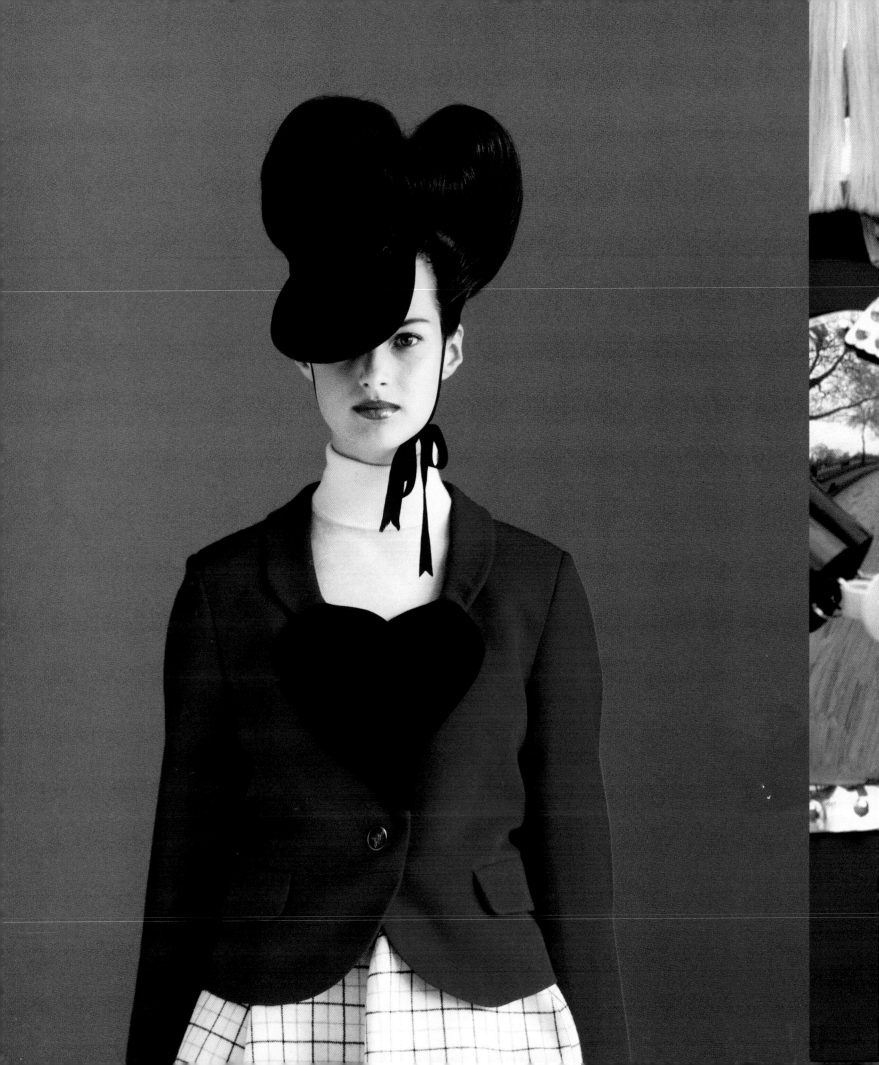

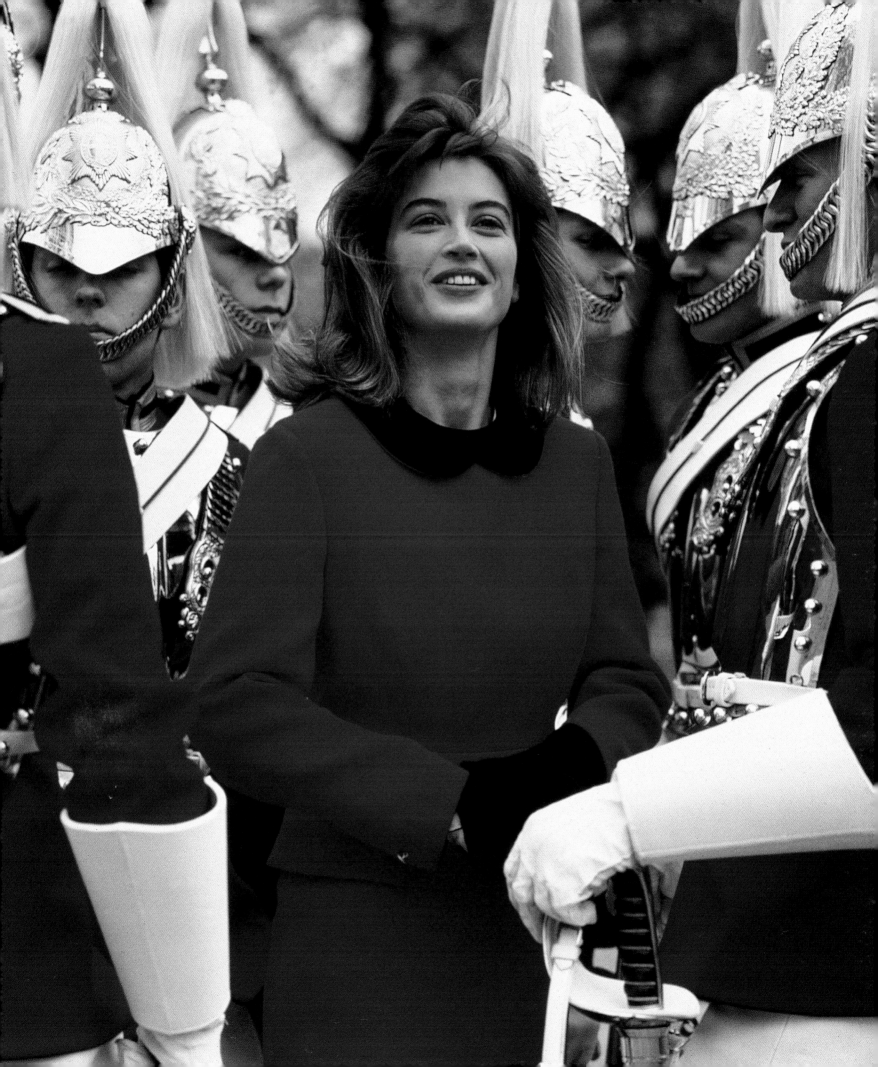

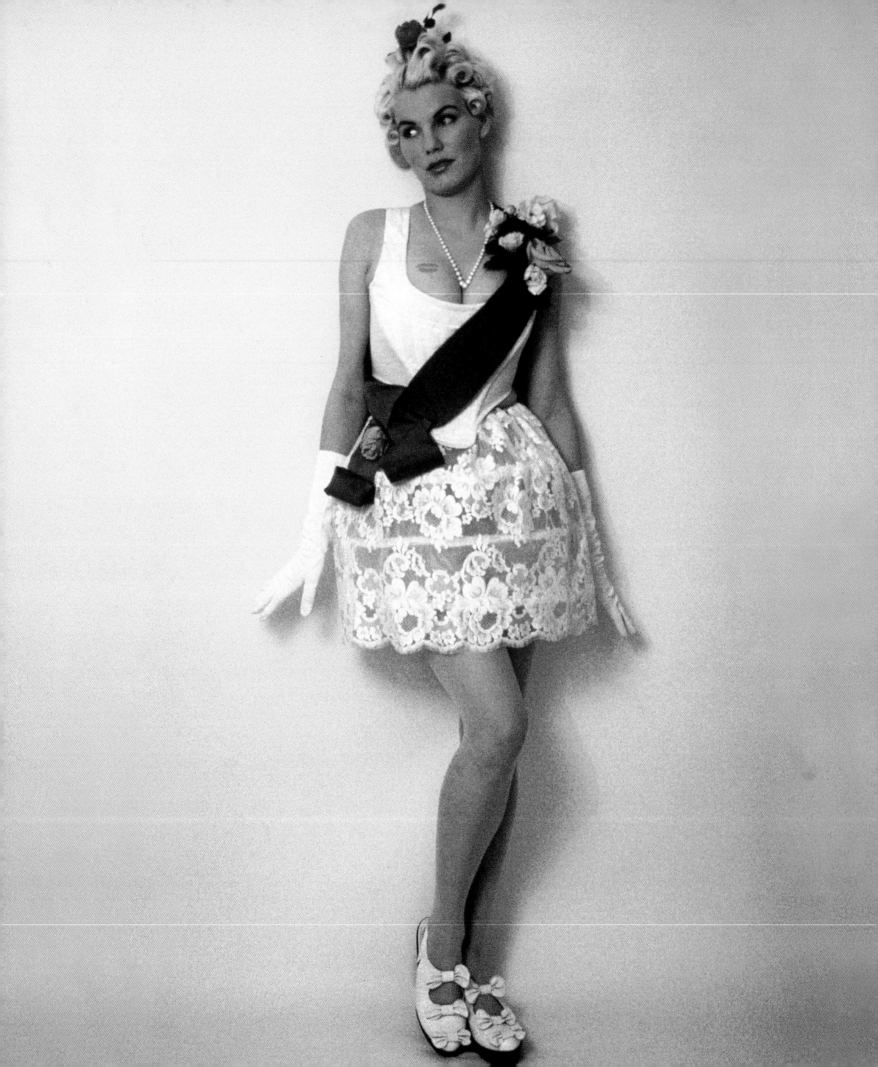

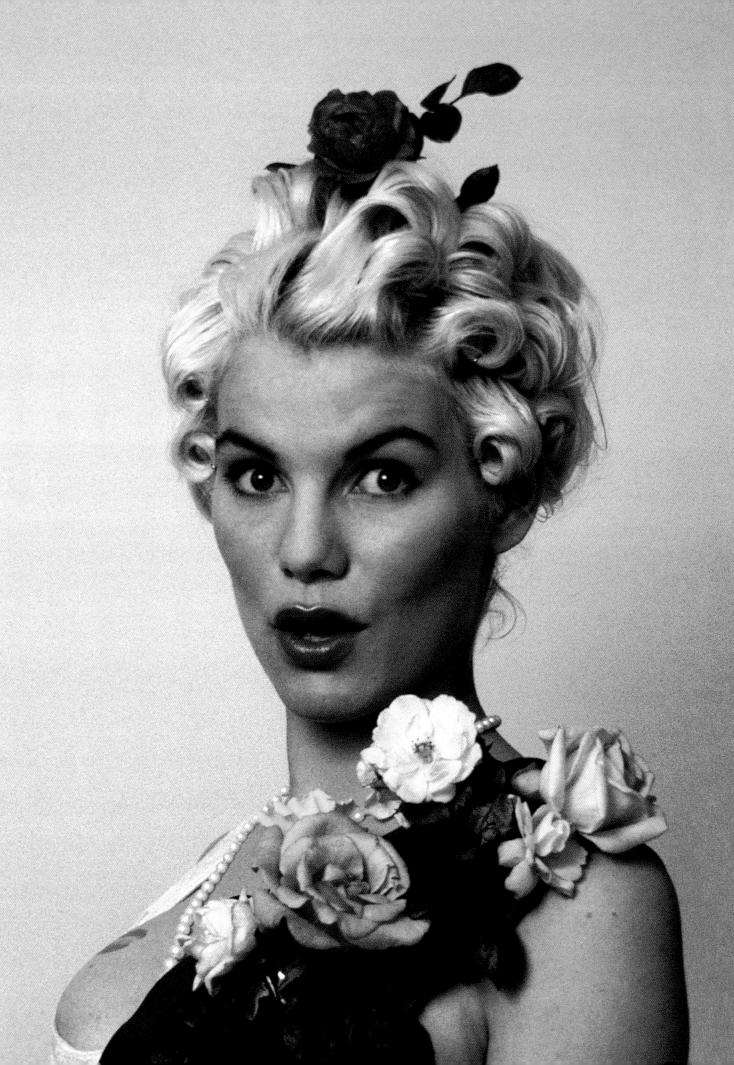

PAGAN I

SPRING/SUMMER 1988

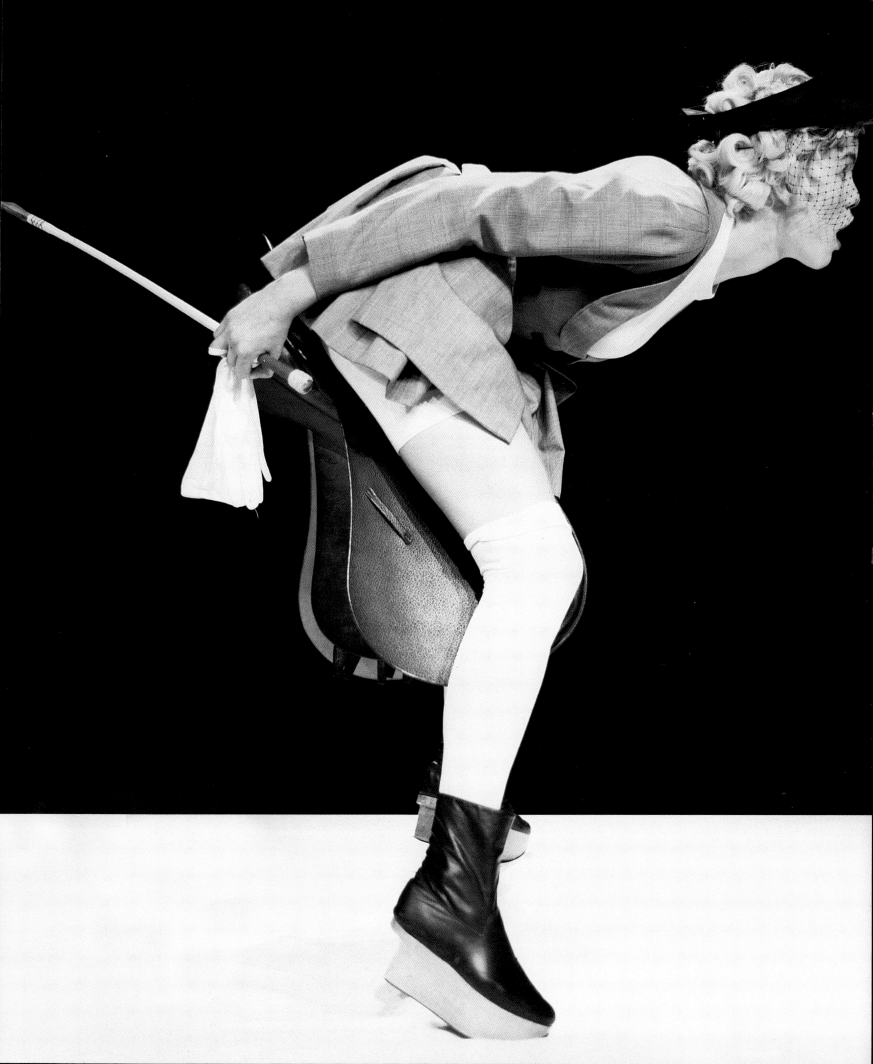

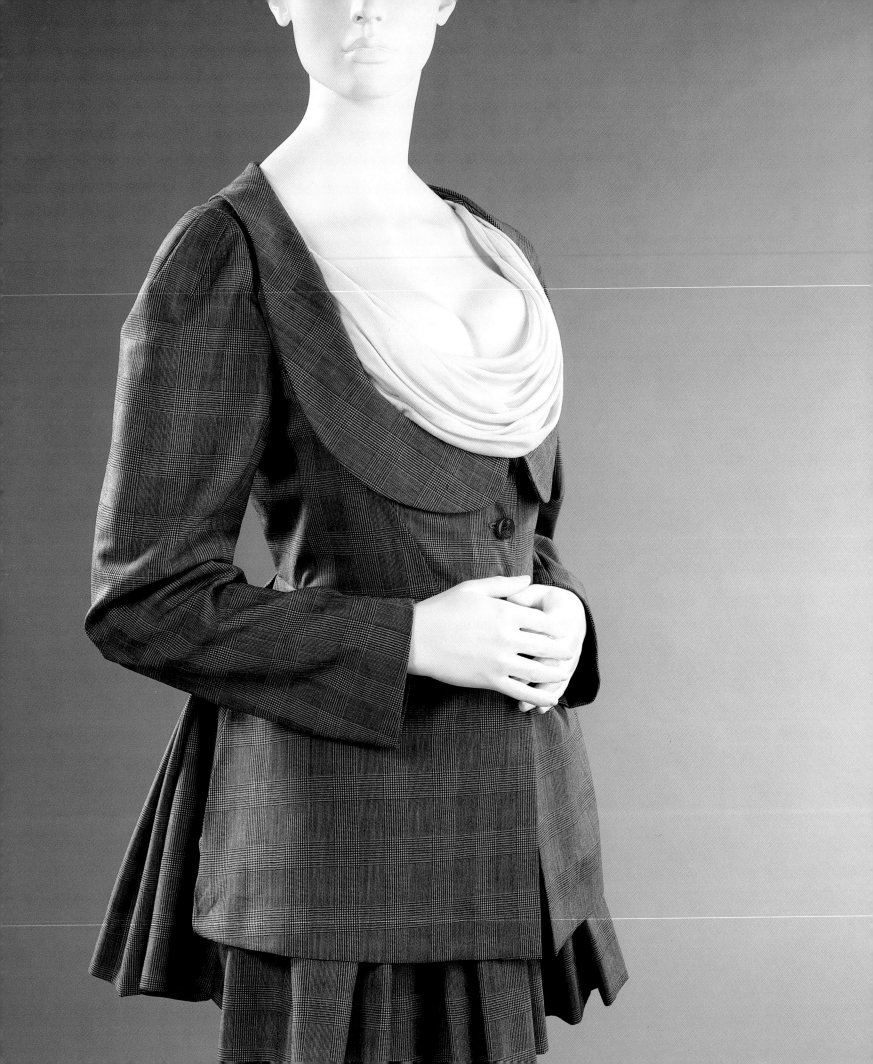

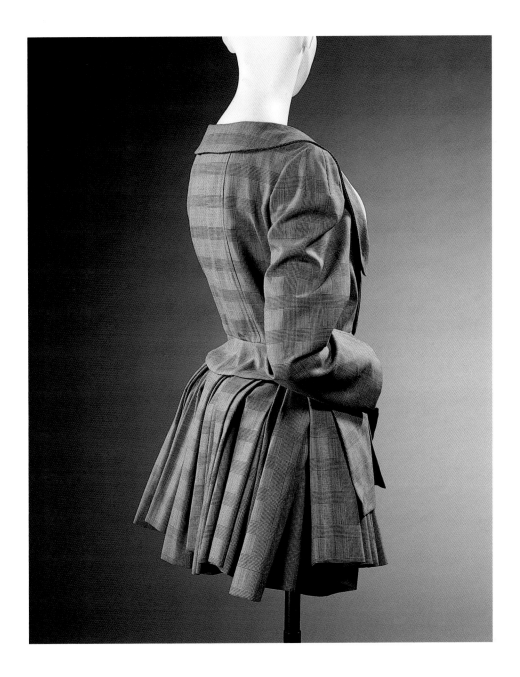

In Pagan I, Westwood paired structured tailoring and drapery. The lightly boned, fine wool check jacket has a curved neckline cut to below the bust to reveal the boned draped white silk corset. It is cut shorter at the back to accommodate the matching 'Centaurella' bustle skirt. Westwood combined a style of pleating used in the 18th-century sack-back with a 19th-century technique of holding fabric away from the body with padding: 'I had noticed in the back of an Empire line dress four little silk balls which I assumed were there to hold the dress away from the body. I realized I could insert them into the pleats to make them more column-like. This skirt is full of movement – it's held there but it's really away from you. It can swish around, it really moves a lot when you walk. It's very lively.' Because it was so short, the skirt was worn with silk shorts.

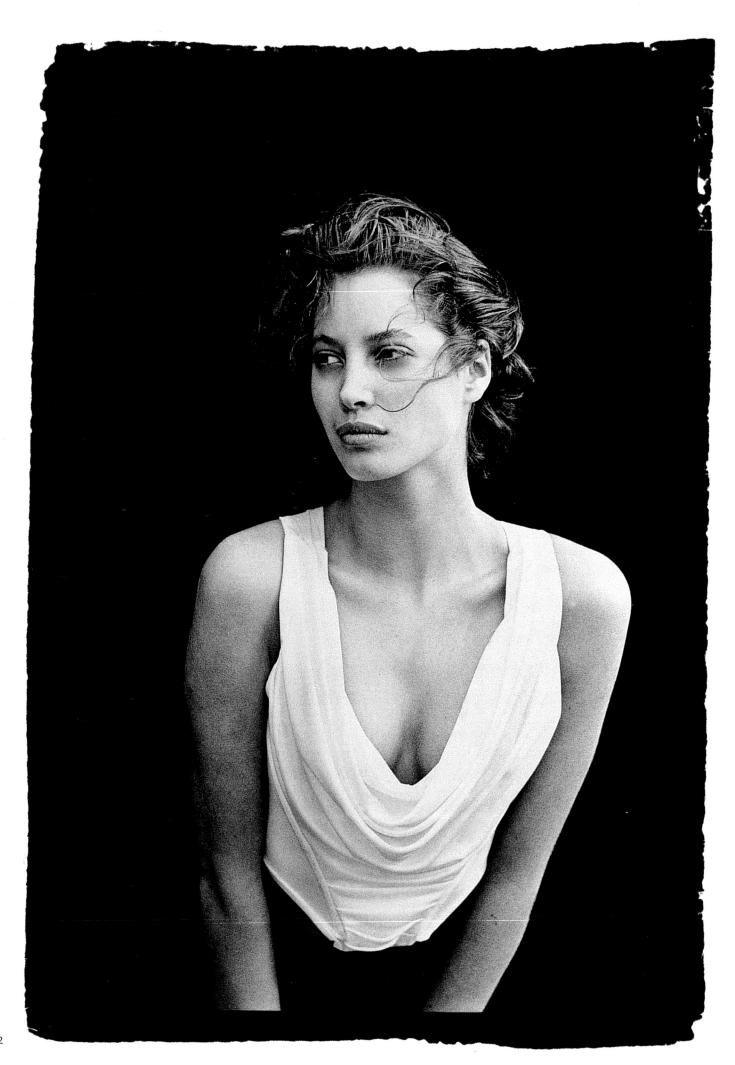

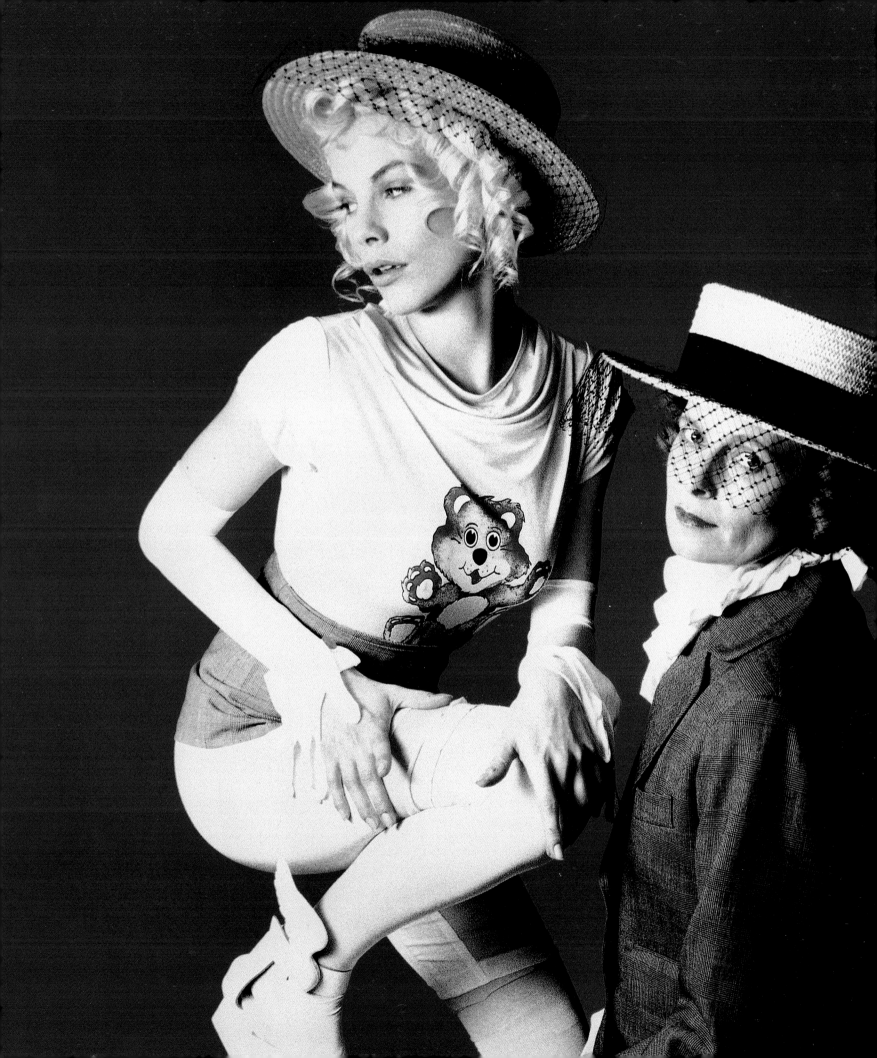

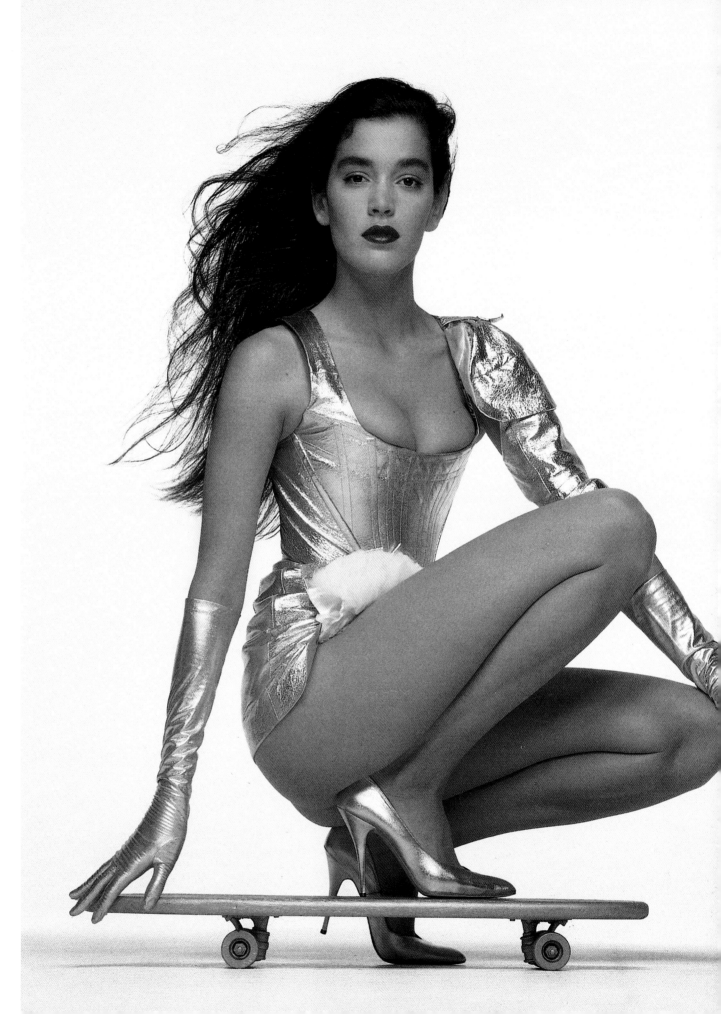

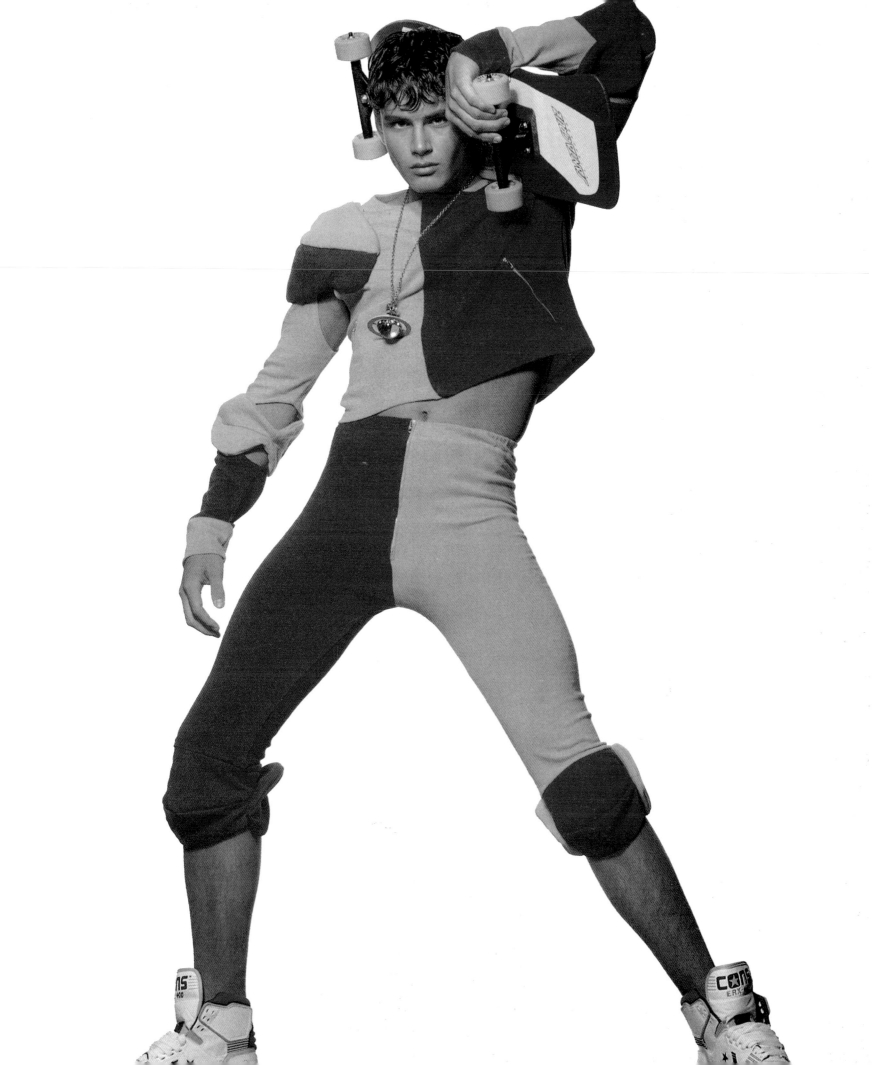

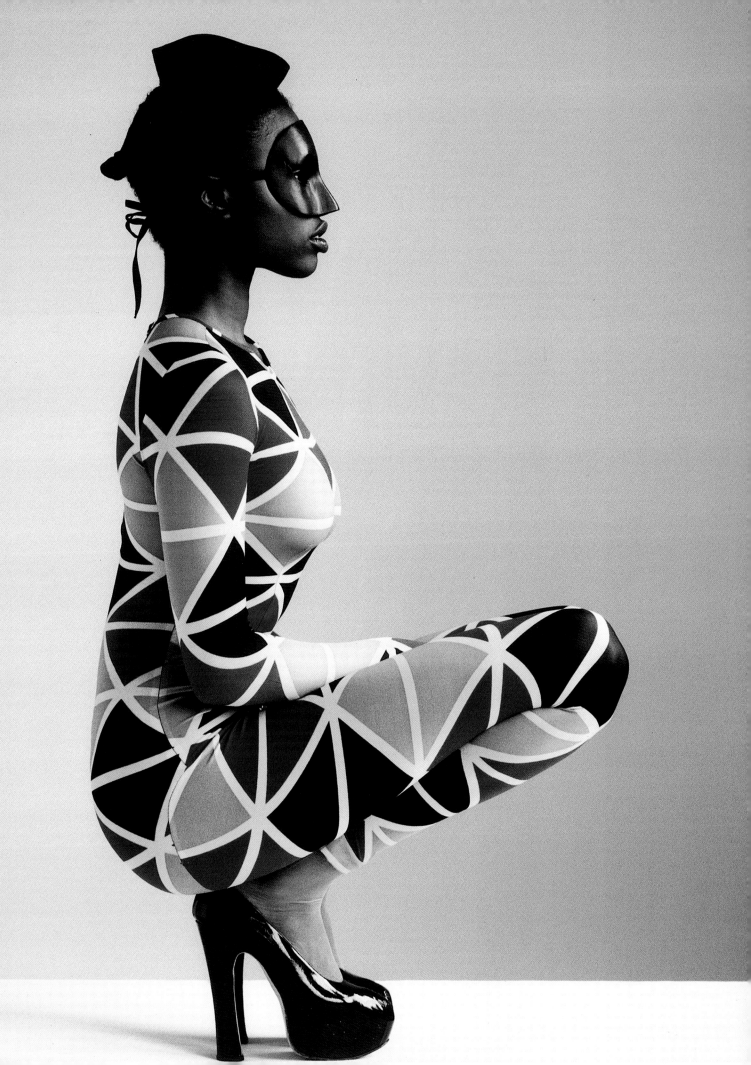

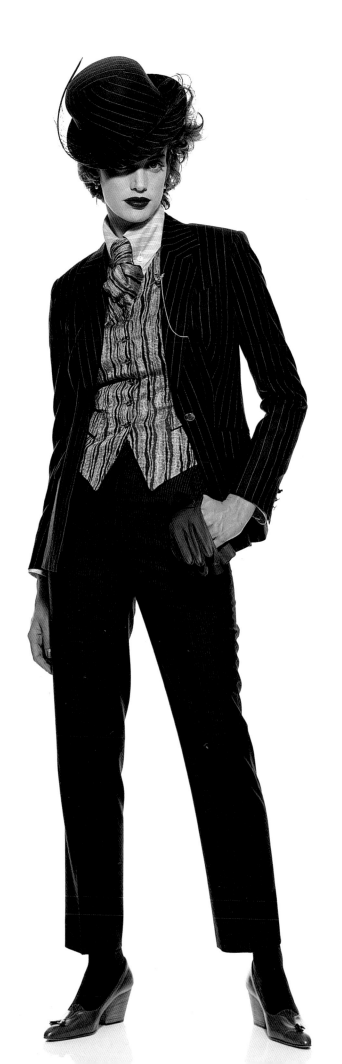

Left: Westwood has been continually fascinated by the sexuality of women dressed in men's clothes. In this ensemble (Storm in a Teacup, A/W 1996–7), she appropriated an aristocratic, tailored style, mixing and matching different fabrics. The hat, by Prudence, who has created hats for Westwood for many years, is made in the same striped fabric as the jacket.

Above: Incroyable, no. 9. Engraving from *Incroyables et Merveilleuses* by Horace Vernet, published by Pierre La Mésangère. French, *c.*1815. V&A: E.127–1947

Right: This ensemble of mustard-coloured, single-breasted Harris Tweed 'Savile' jacket with black velvet collar, lycra tights with a green mirrored fig leaf, white shirt and unfastened tie was inspired by the cropped jacket and smooth, buff-coloured pantaloons of early 19th-century tailoring. Westwood explained: 'I wanted my outfit to look like a girl dressed like a man with no trousers on.'

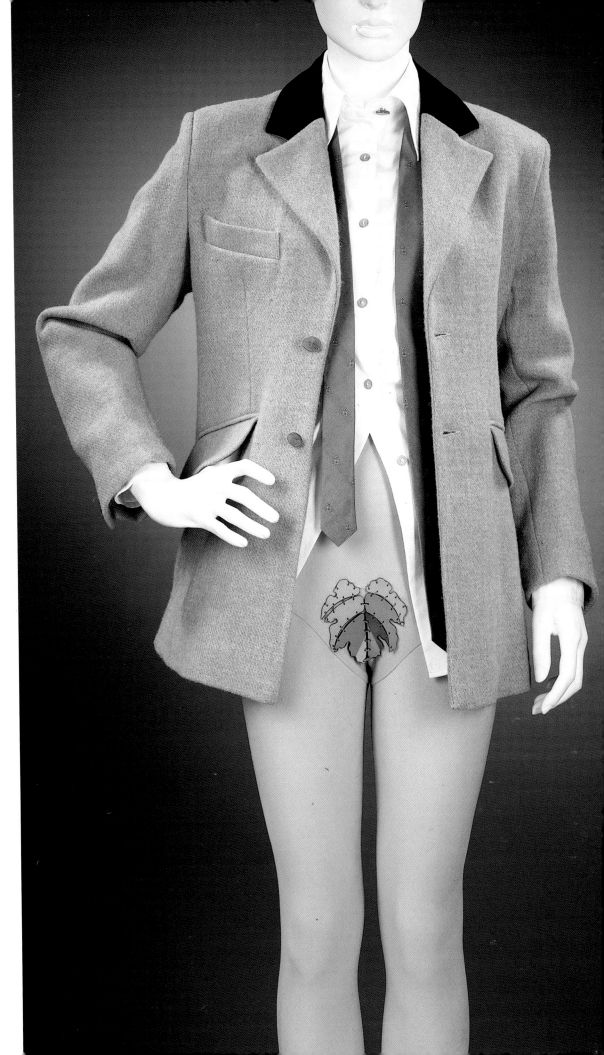

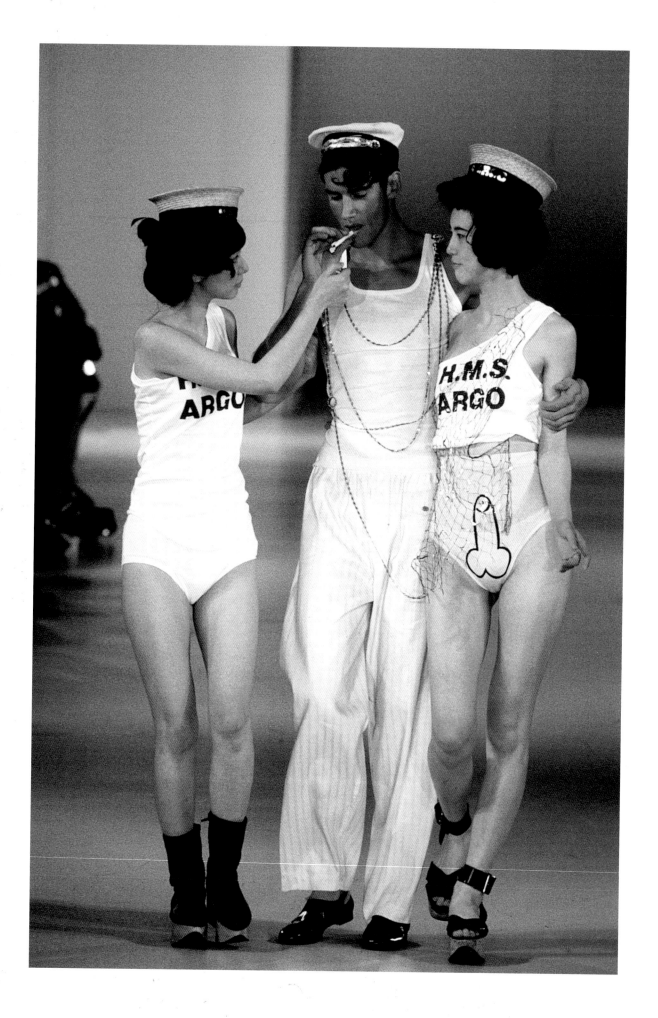

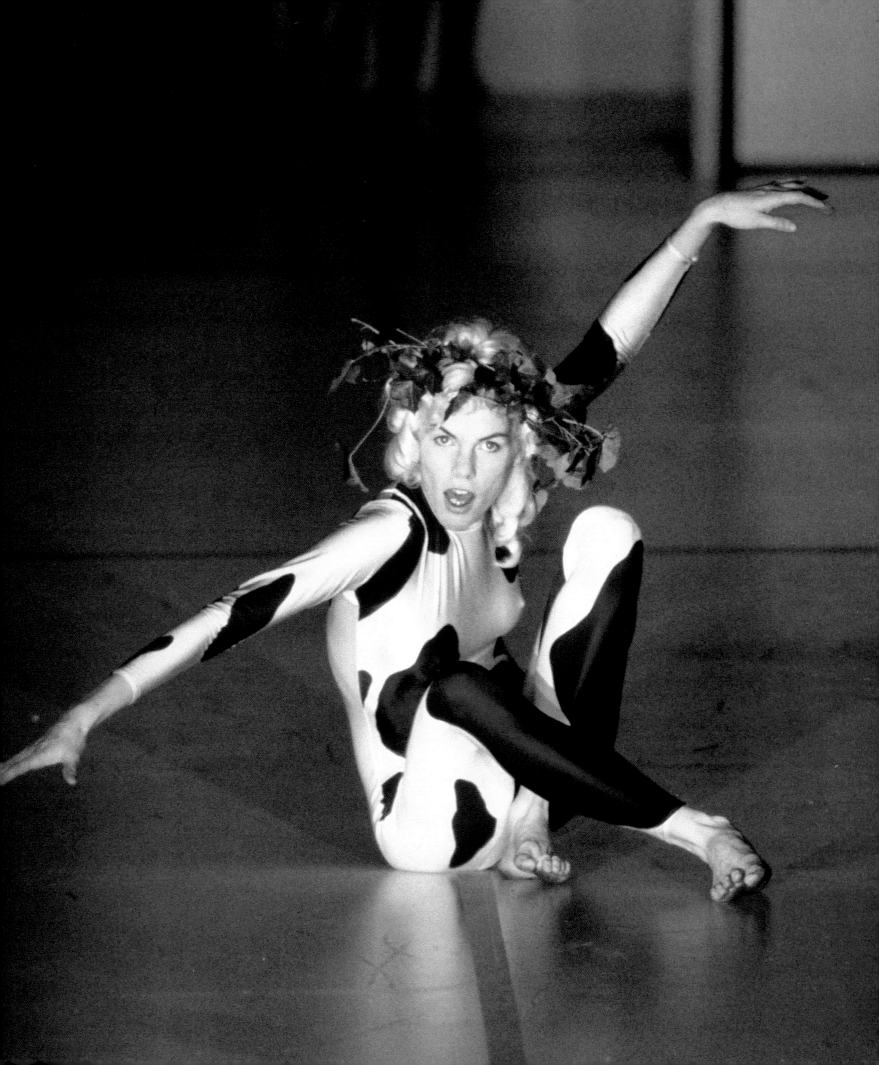

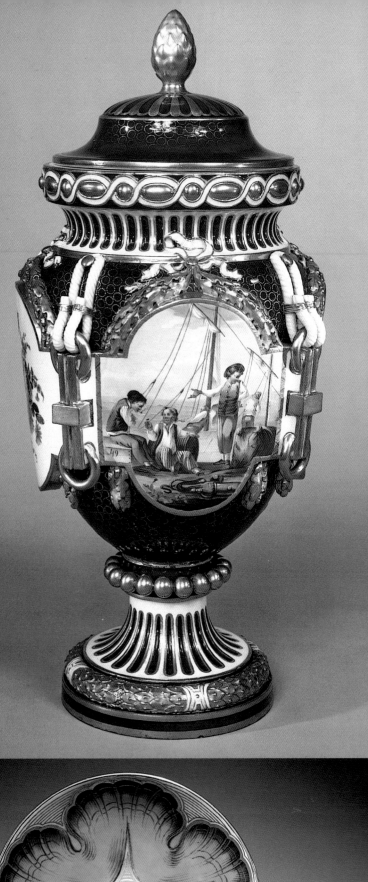

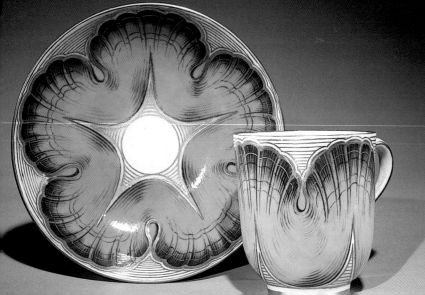

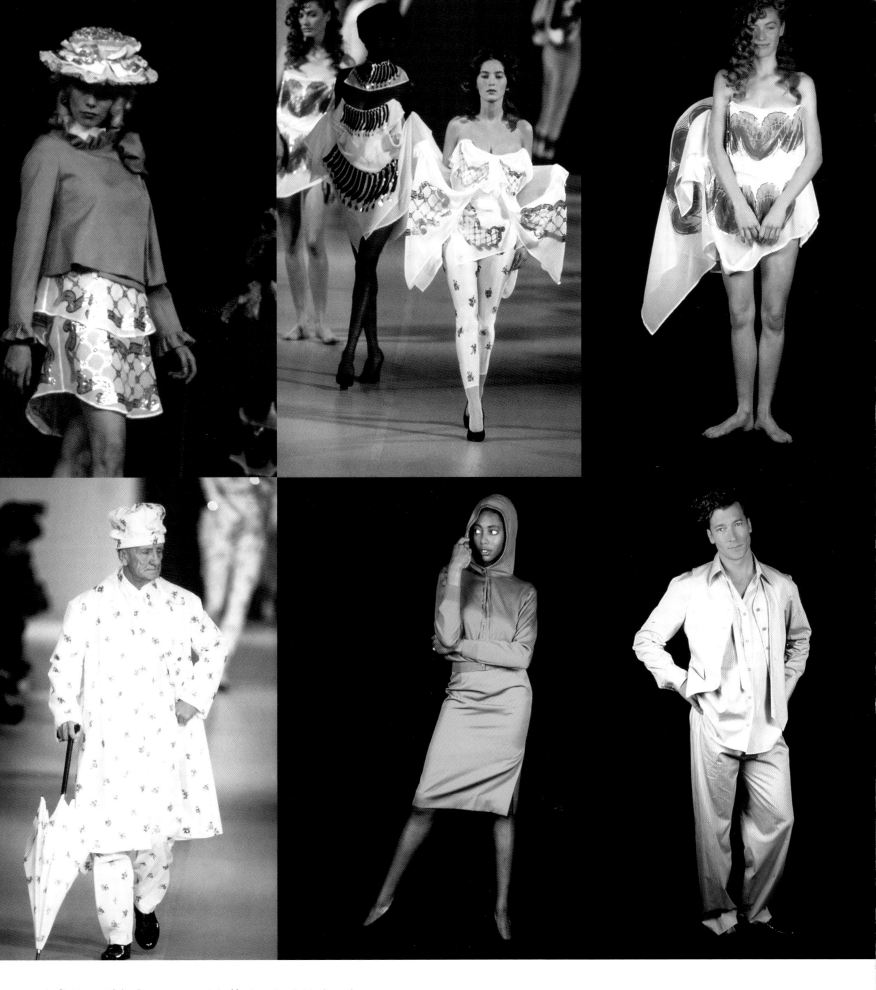

Left: Vase with harbour scene, painted by Jean-Louis Morin, 1769.
Table tray, 1757. Cup and saucer, 1765. Wallace Collection.

Above: Back of mirror with marquetry by André-Charles Boulle. French, 1713. Wallace Collection.

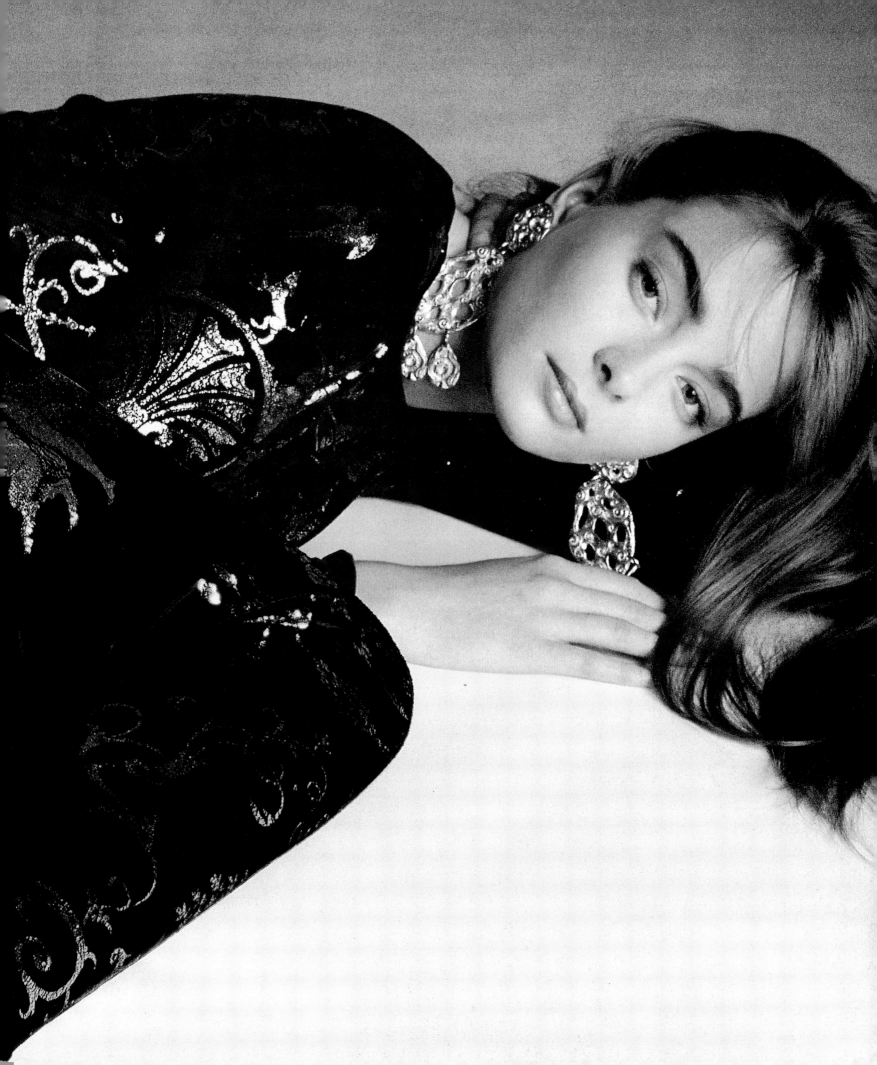

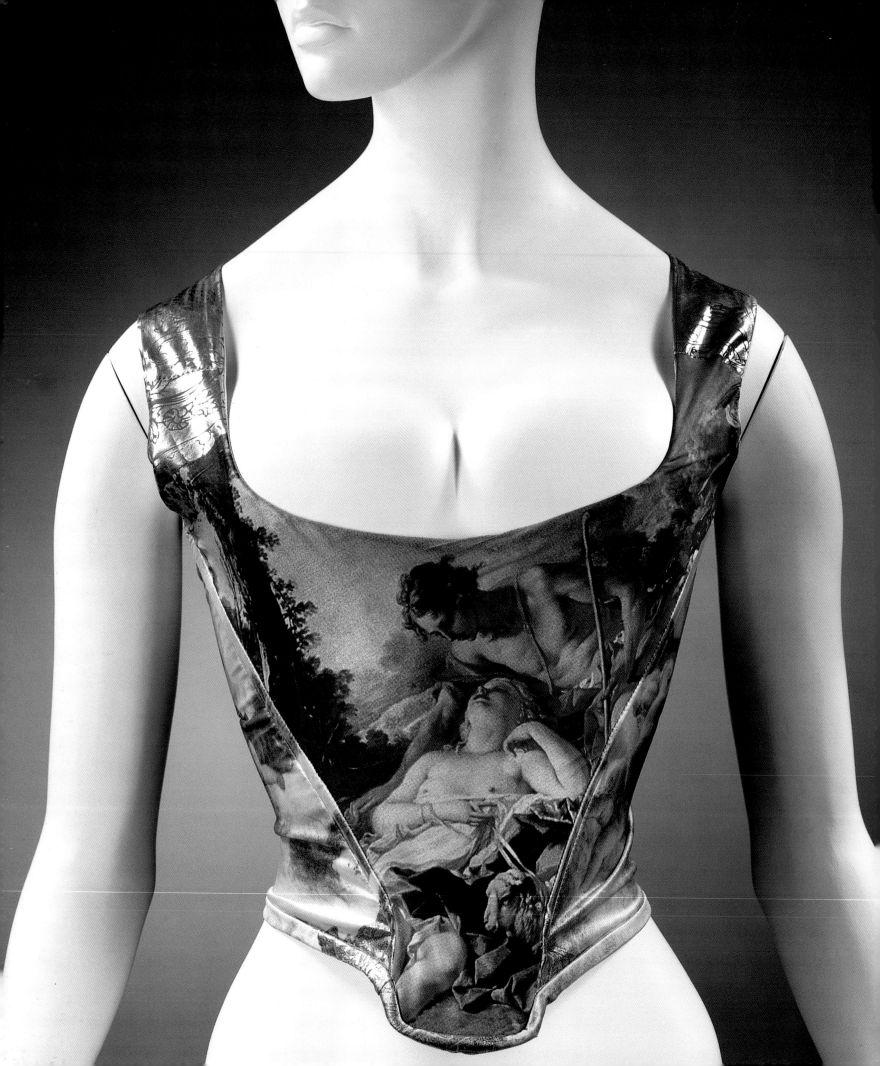

Left: Westwood's revival of the corset was one of her most important fashion ideas of the 1990s. Her corsets were modelled on the 18th-century style, flattening and raising the bosom. This corset is photographically printed with a detail from Boucher's *Daphnis and Chloë (Shepherd Watching a Sleeping Shepherdess*, 1743–5) in the Wallace Collection, London.

Above: *The Boy with a bat: Walter Hawkesworth Fawkes*. English school, 18th century. Private collection.

Right: This long, red barathea open jacket with black velvet collar and pockets (called the 'DL' after the film *Dangerous Liaisons*, directed by Stephen Frears, 1988) was copied from the 18th-century portrait, *The Boy with a bat*, shown above. The collection was named 'Portrait' because Westwood wanted to suggest that her models had stepped out of a portrait, and because much of the collection was inspired by 18th- and 19th-century portraiture. The jacket is teamed with a high-waisted pencil skirt and a silk 'Boucher' scarf.

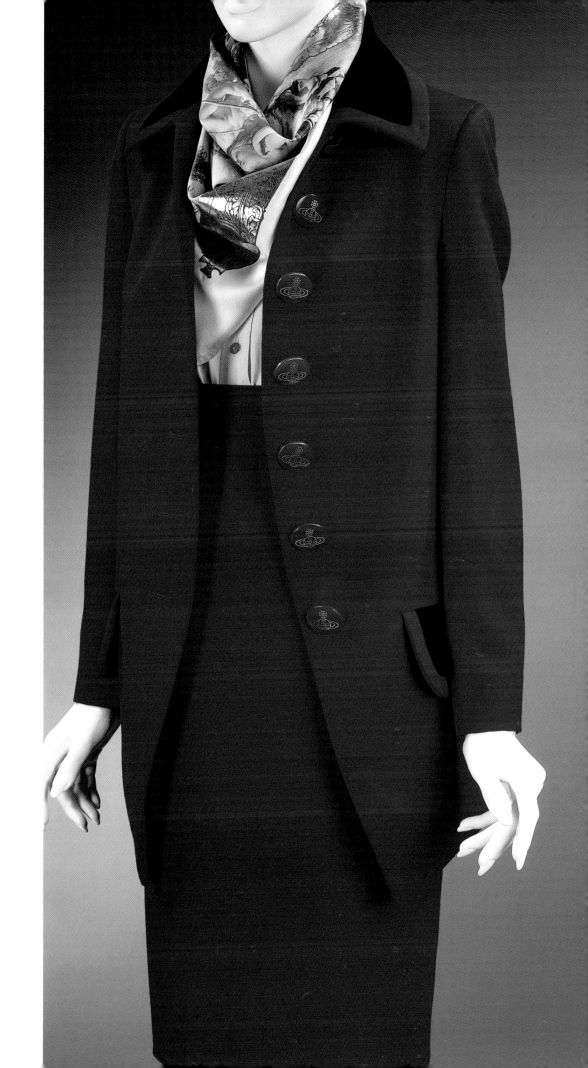

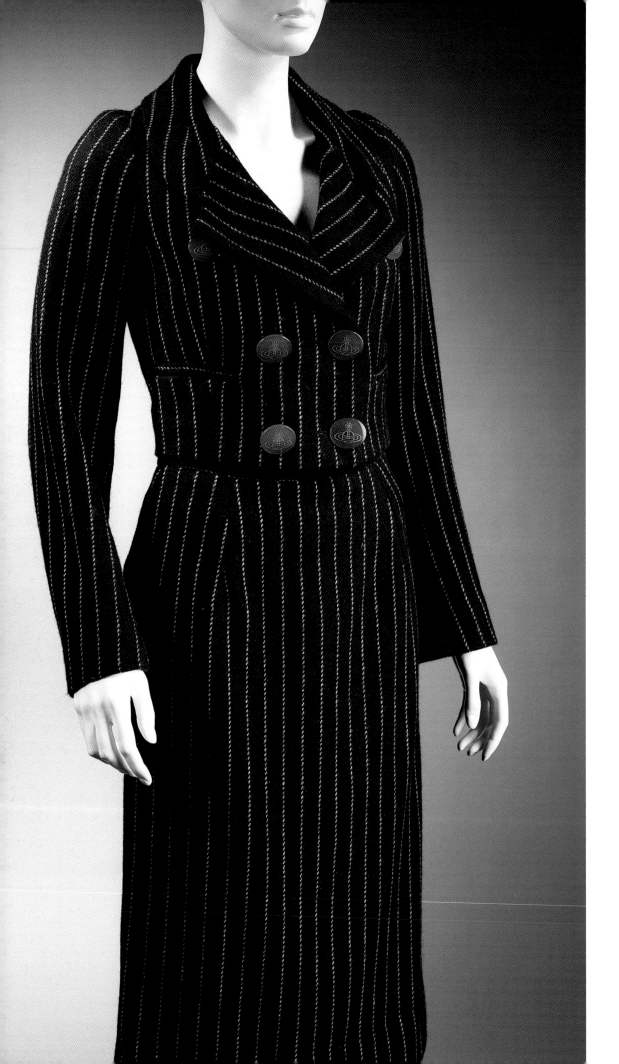

This close-fitting suit in Breenish Tweed fastens with large amber lozenges (Westwood's trademark buttons). The short, double-breasted jacket has broad revers and collar, padded shoulders and puff sleeves, and the cut was inspired by the high-fronted jackets of the 1810s. Westwood utilizes the vertical chalk stripes of the tweed to emphasize the fitted, elongated verticality of the suit. The jacket on the right is cut in the same style, in blue Harris Tweed.

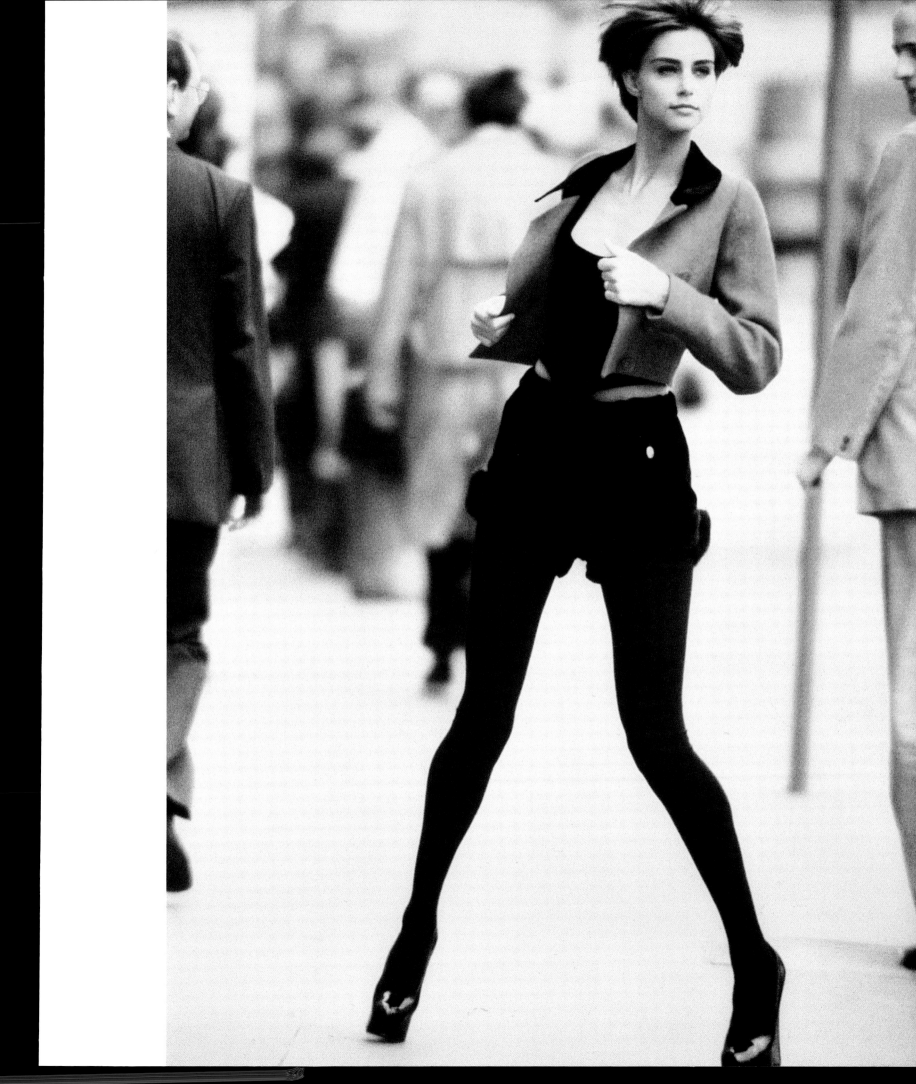

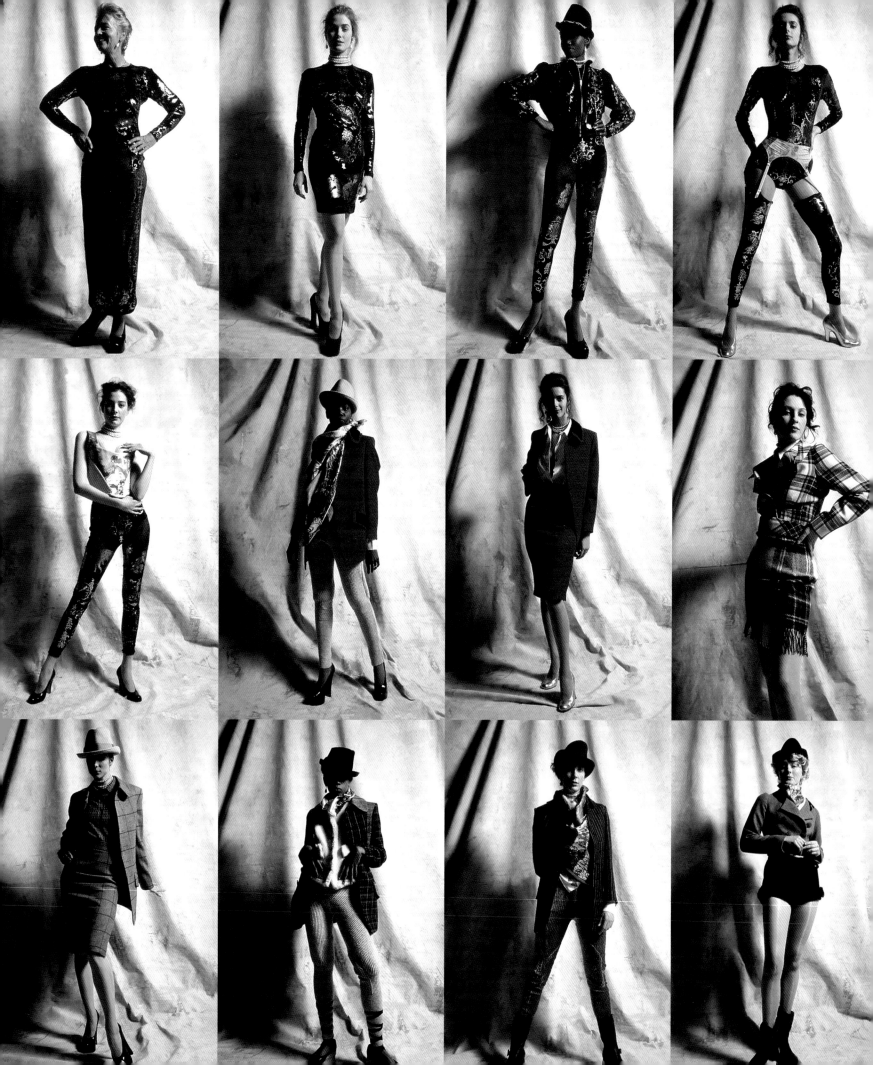

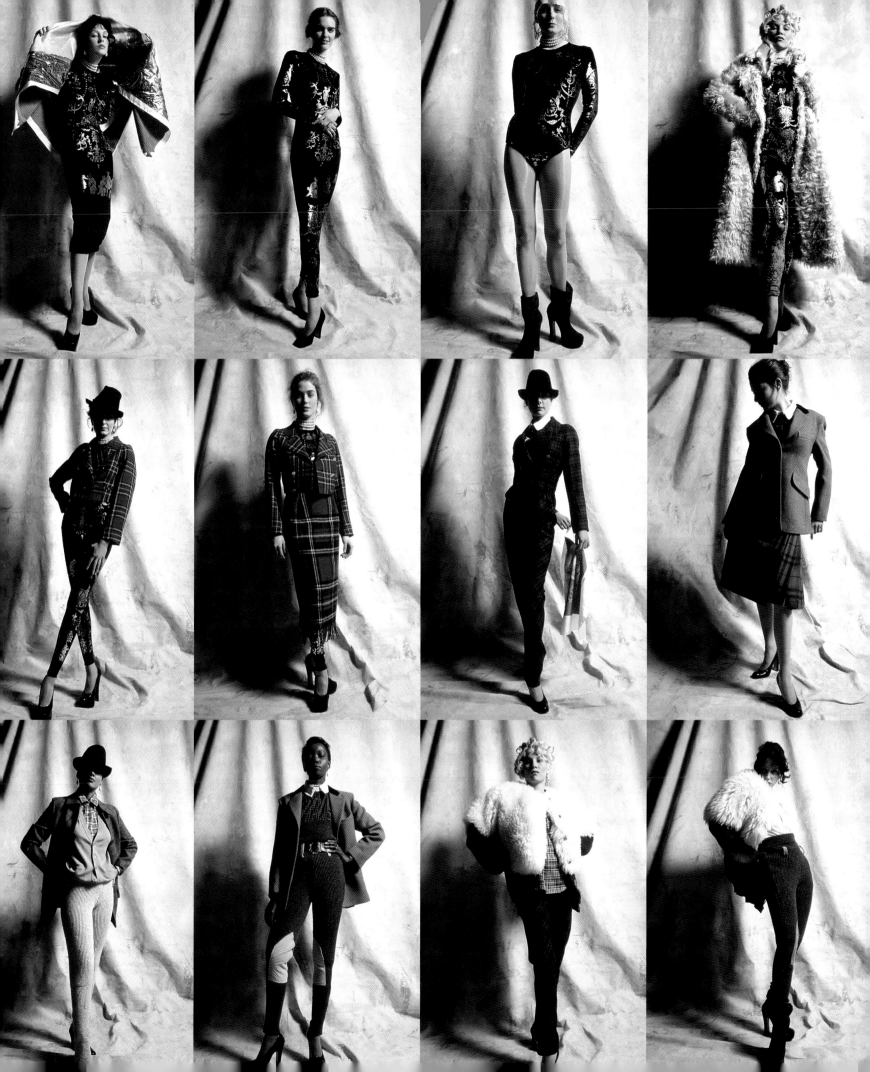

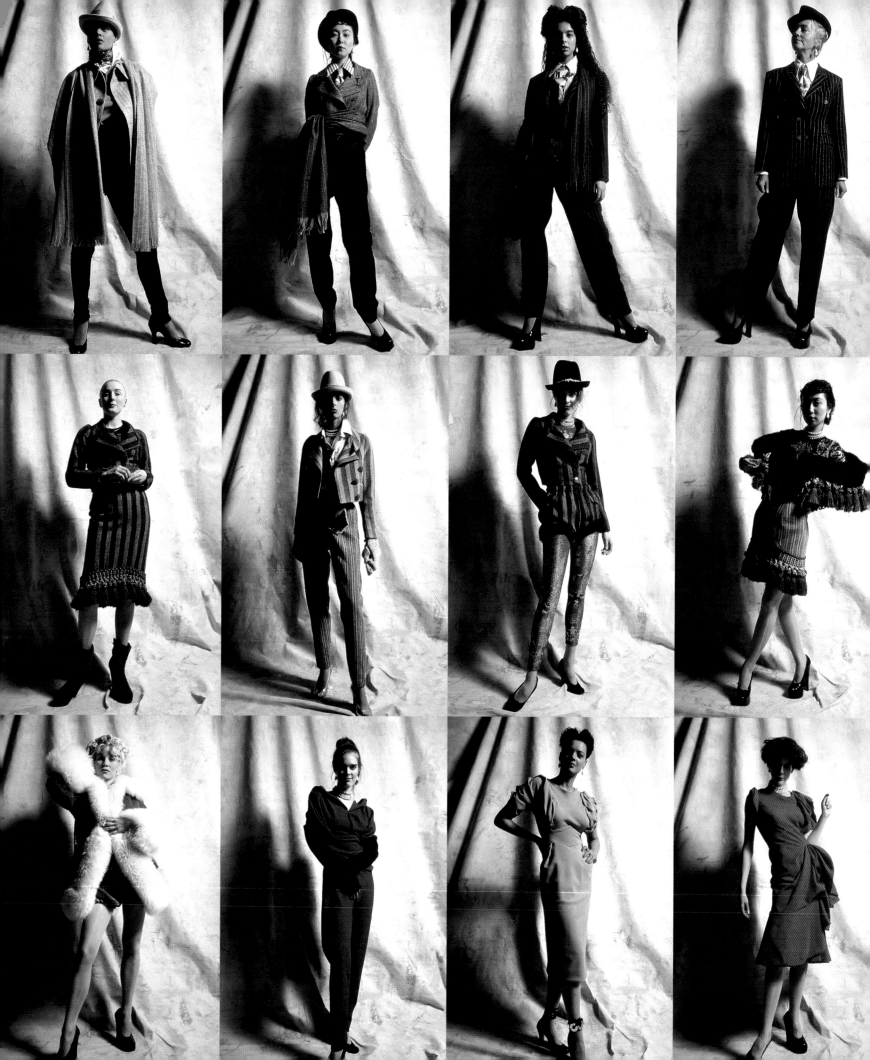

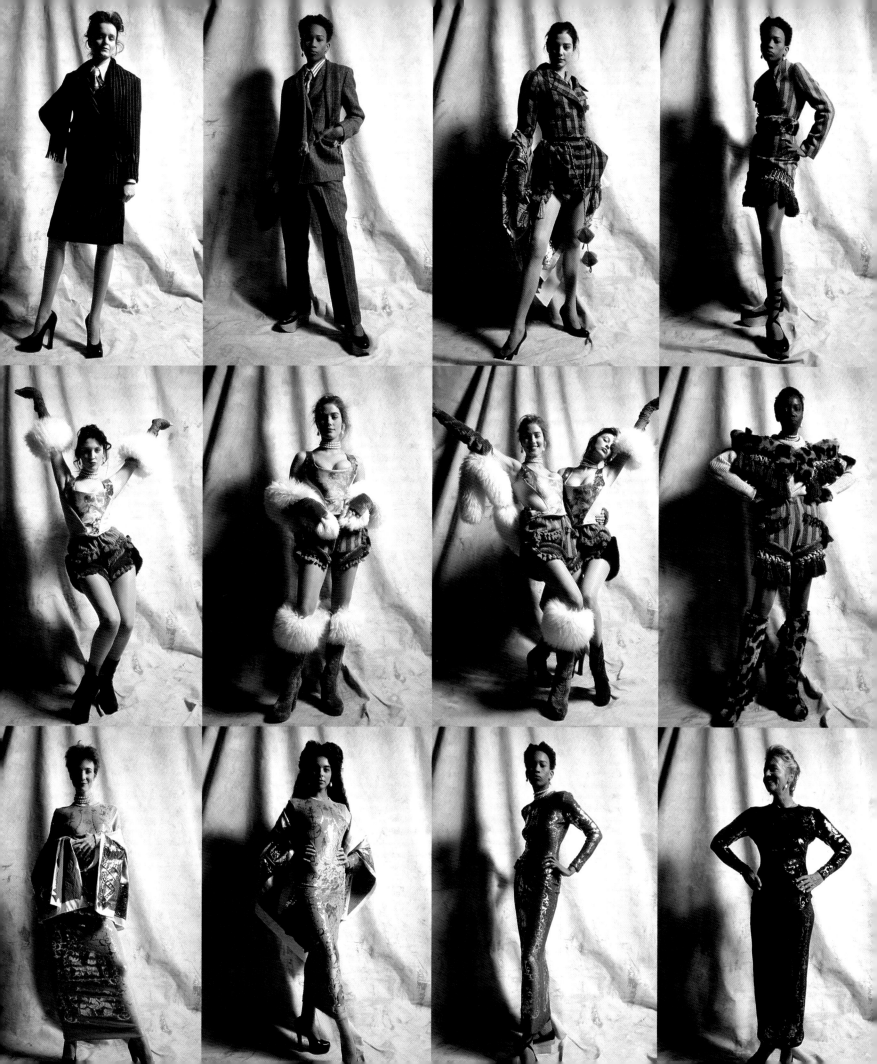

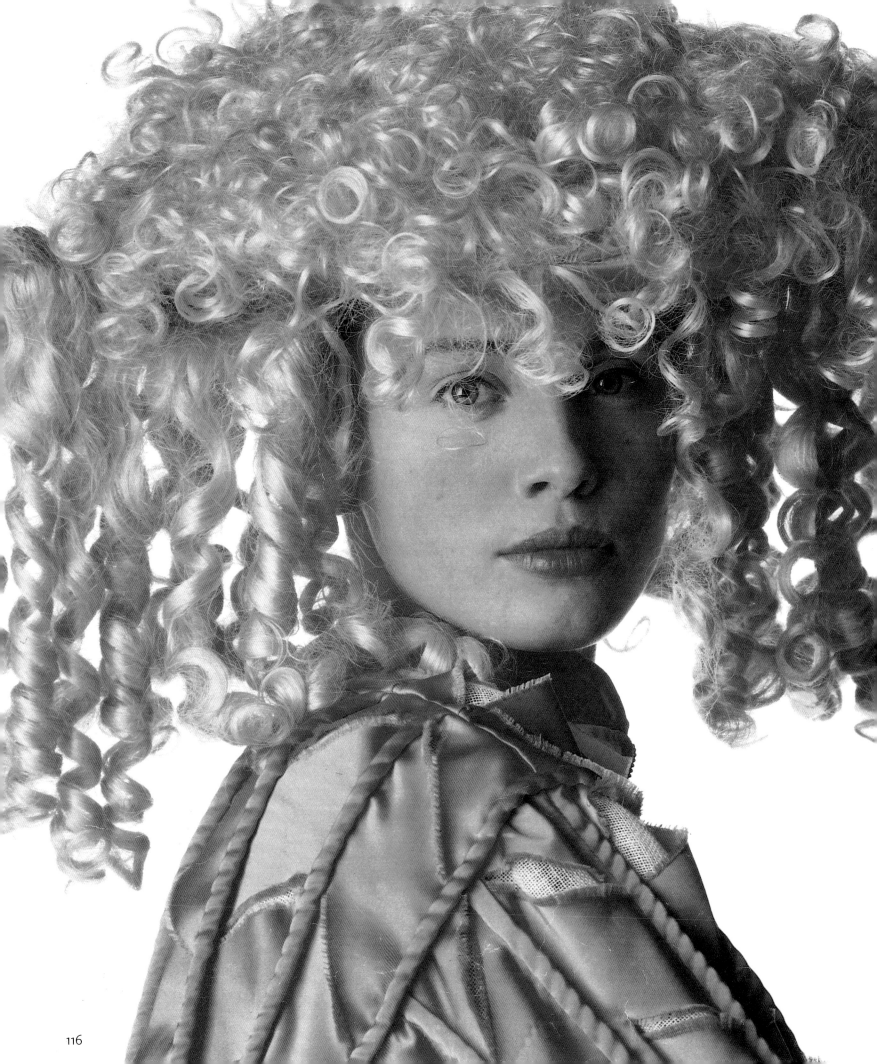

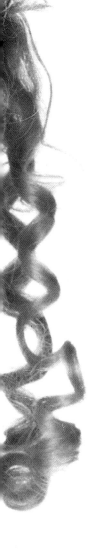

CUT AND SLASH

SPRING/SUMMER 1991

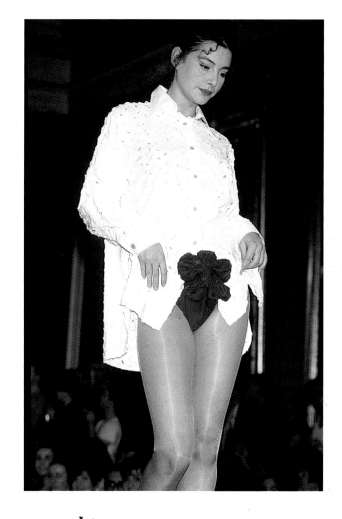

This collection employed the 17th-century technique of slashing, studied by Westwood at the V&A. Westwood's slashing animates and gives depth to the fabric – satin, silk, cotton and denim all received the same confident treatment. The effect was achieved in a variety of ways: the large slashes were hand-cut while the smaller, regular cuts were made using a broderie anglaise programme in which embroidered sections were cut, but the embroidery itself omitted. The technique was further emulated in chunky hand-knits.

Right: Woodcut by Jost Amman, c.1570. V&A Museum. Westwood incorporated similar large leather codpieces into the collection, for both men and women.

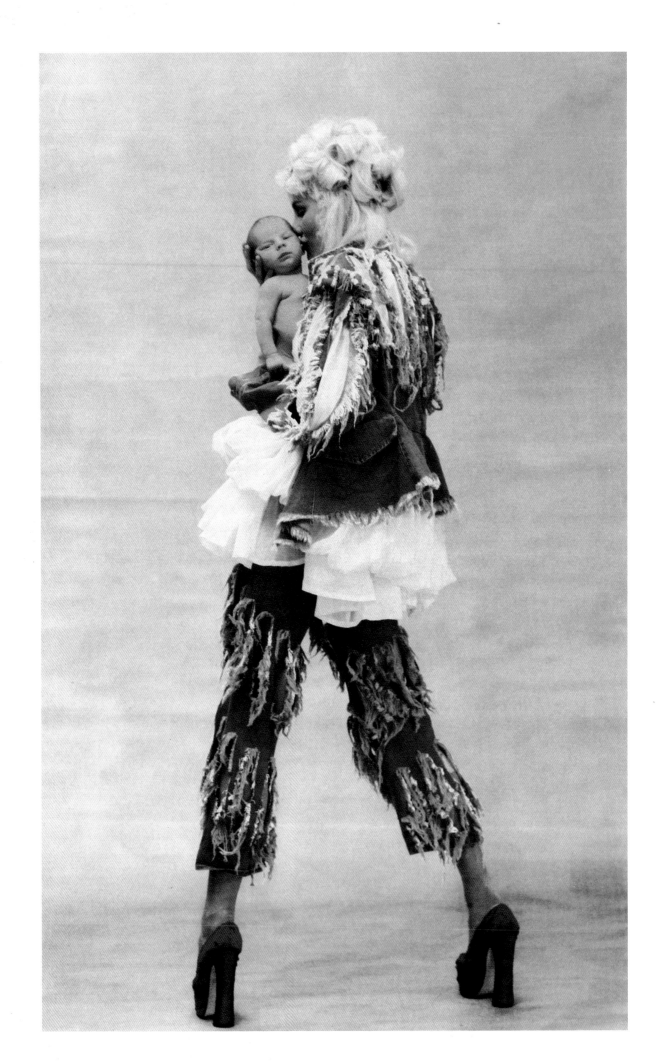

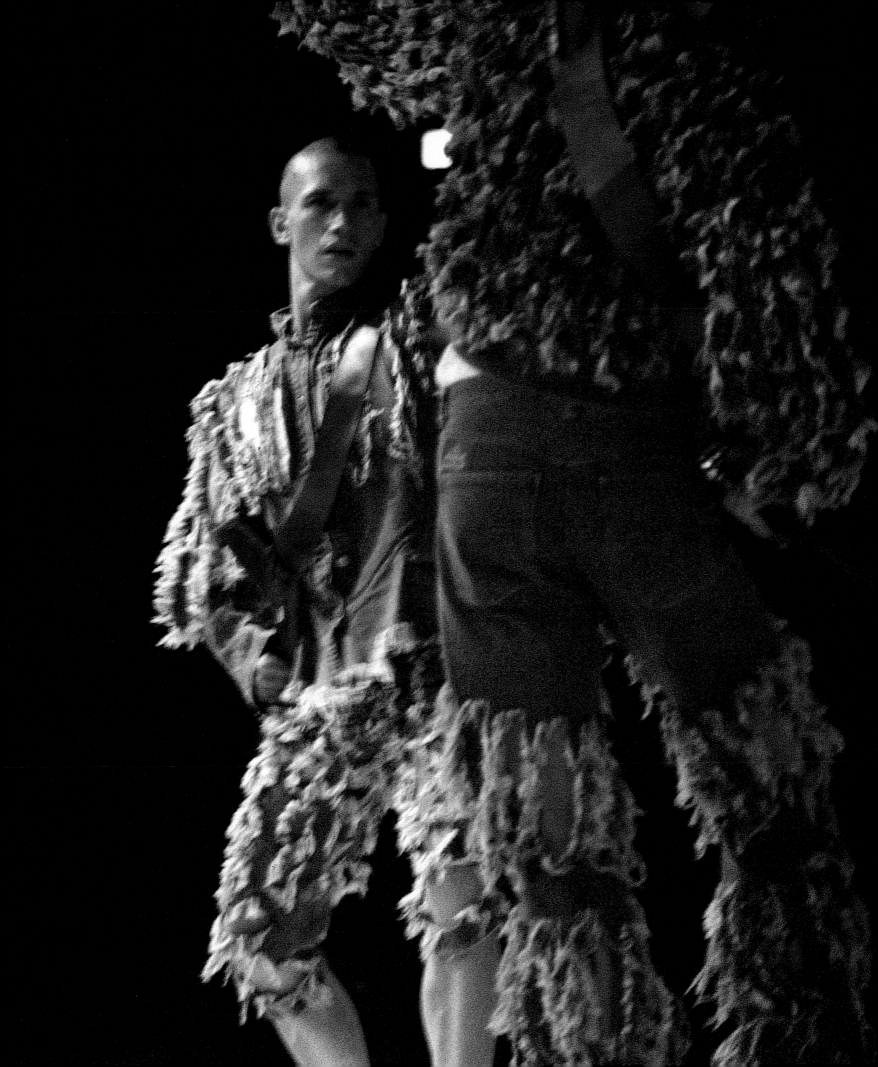

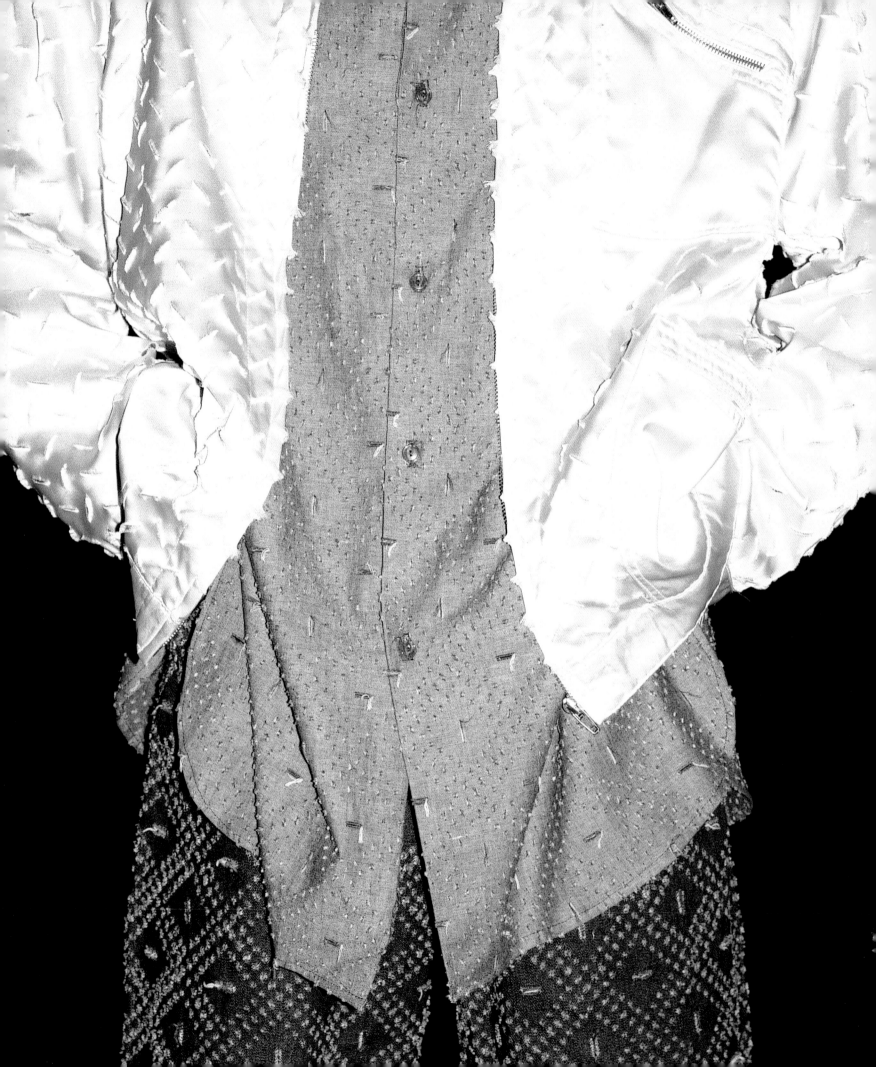

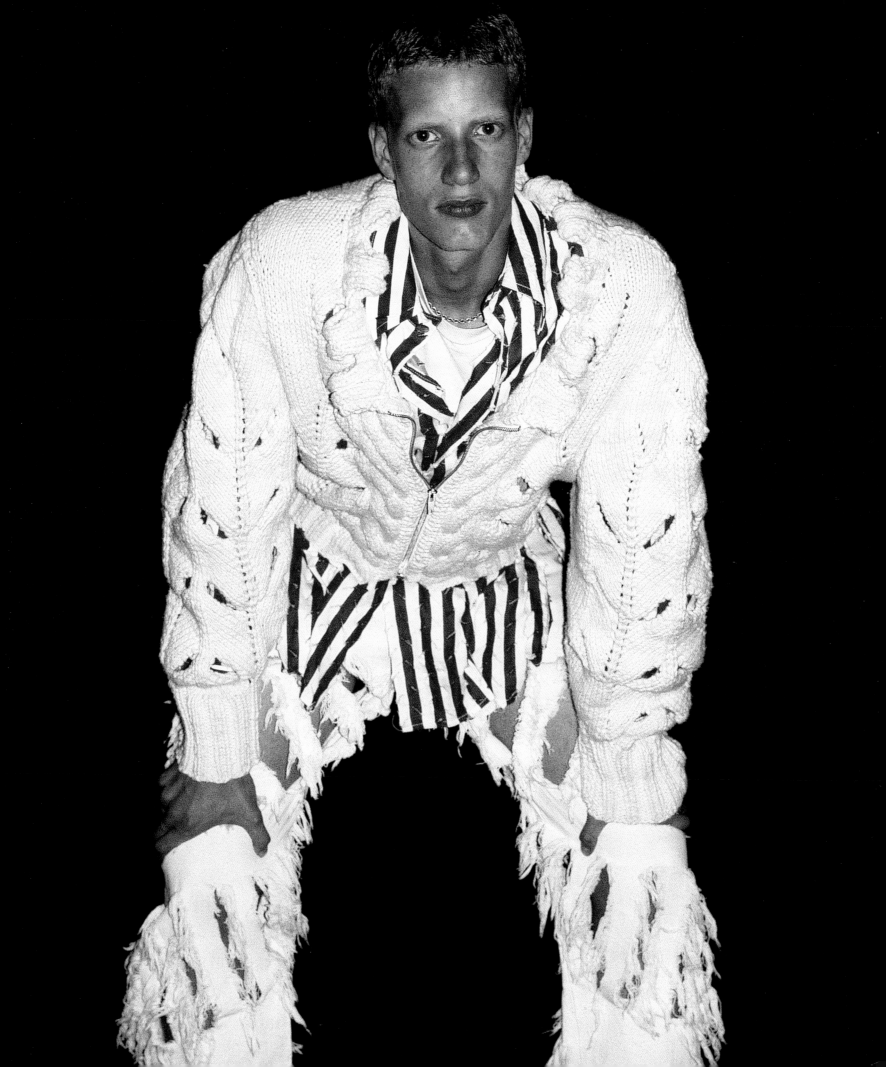

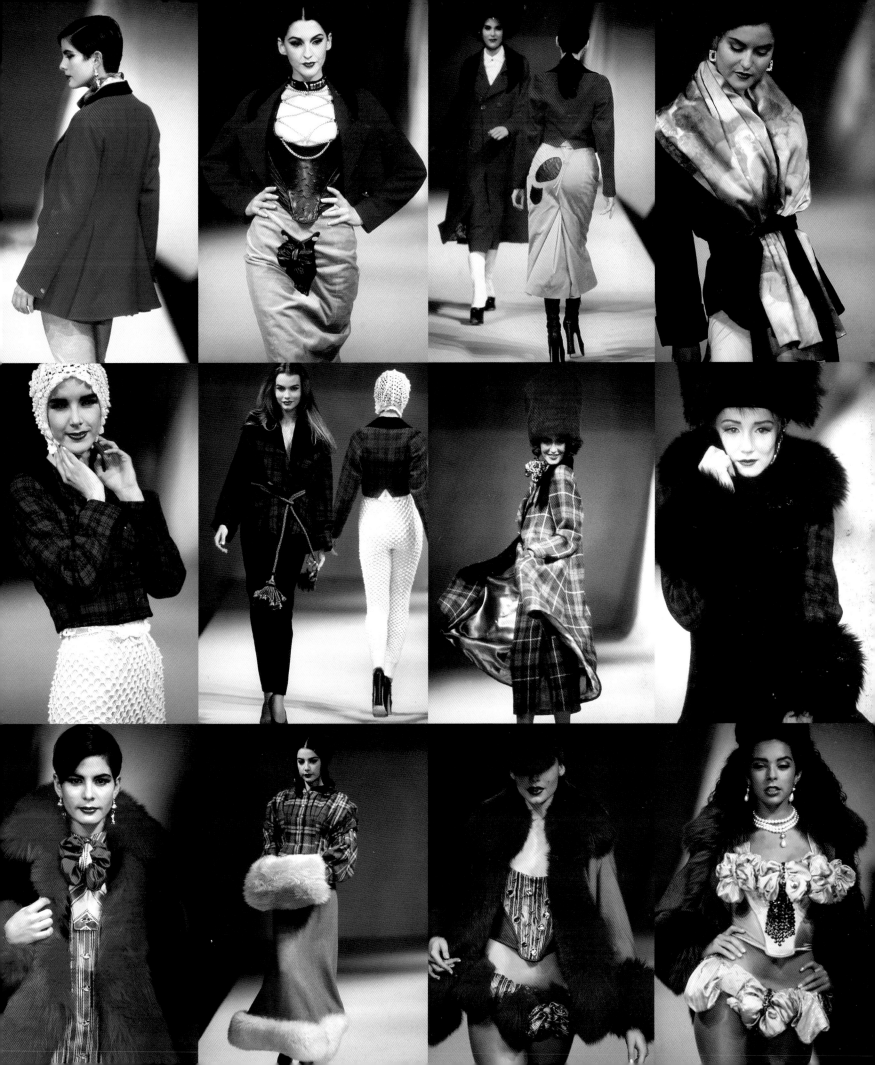

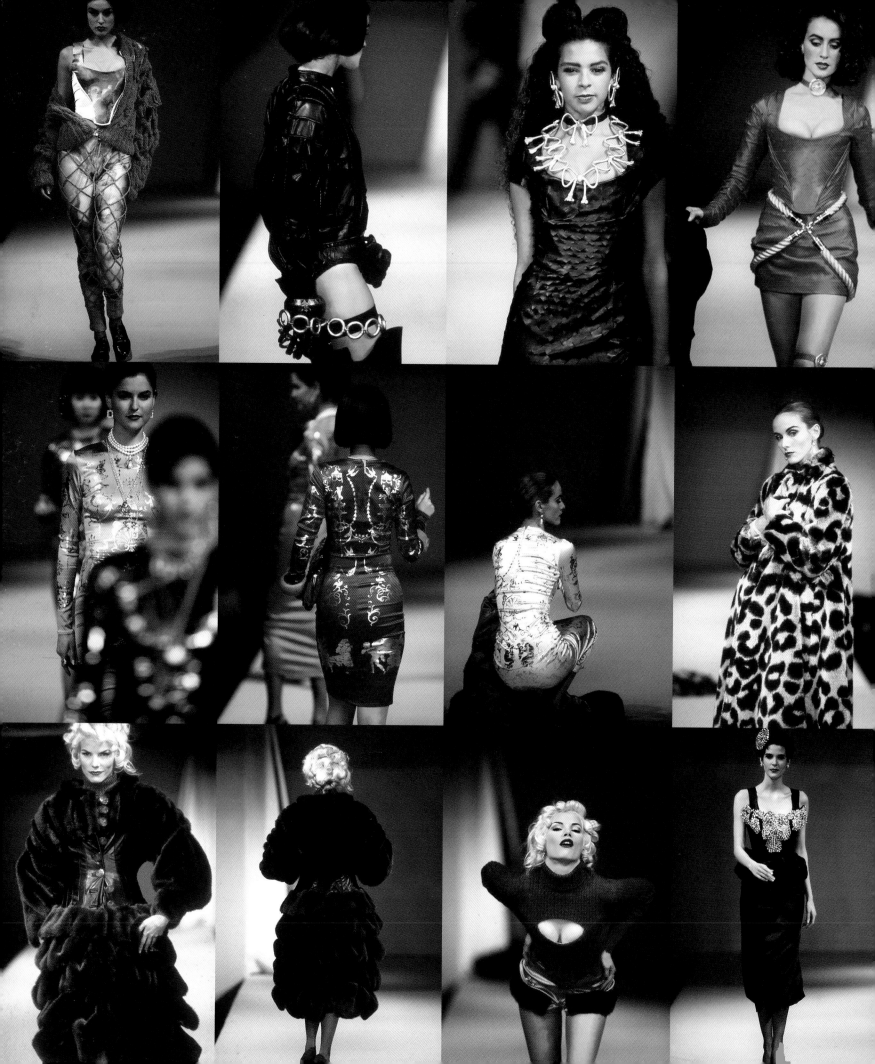

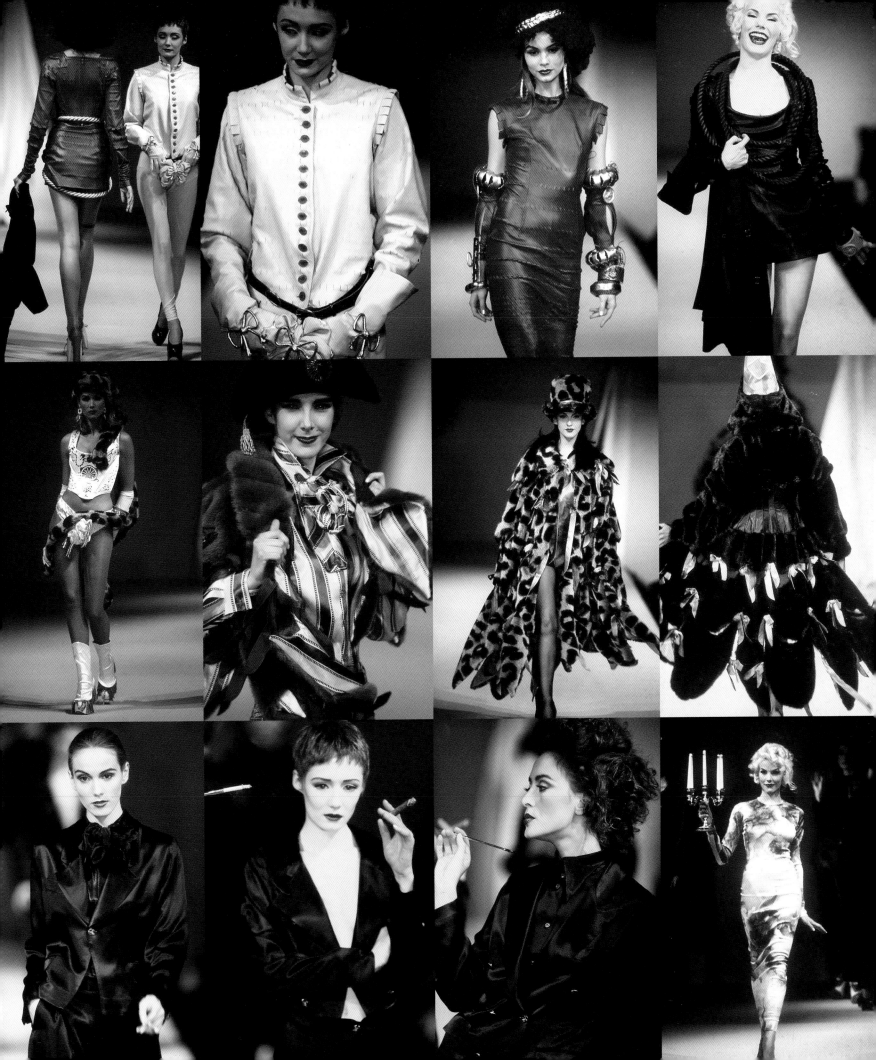

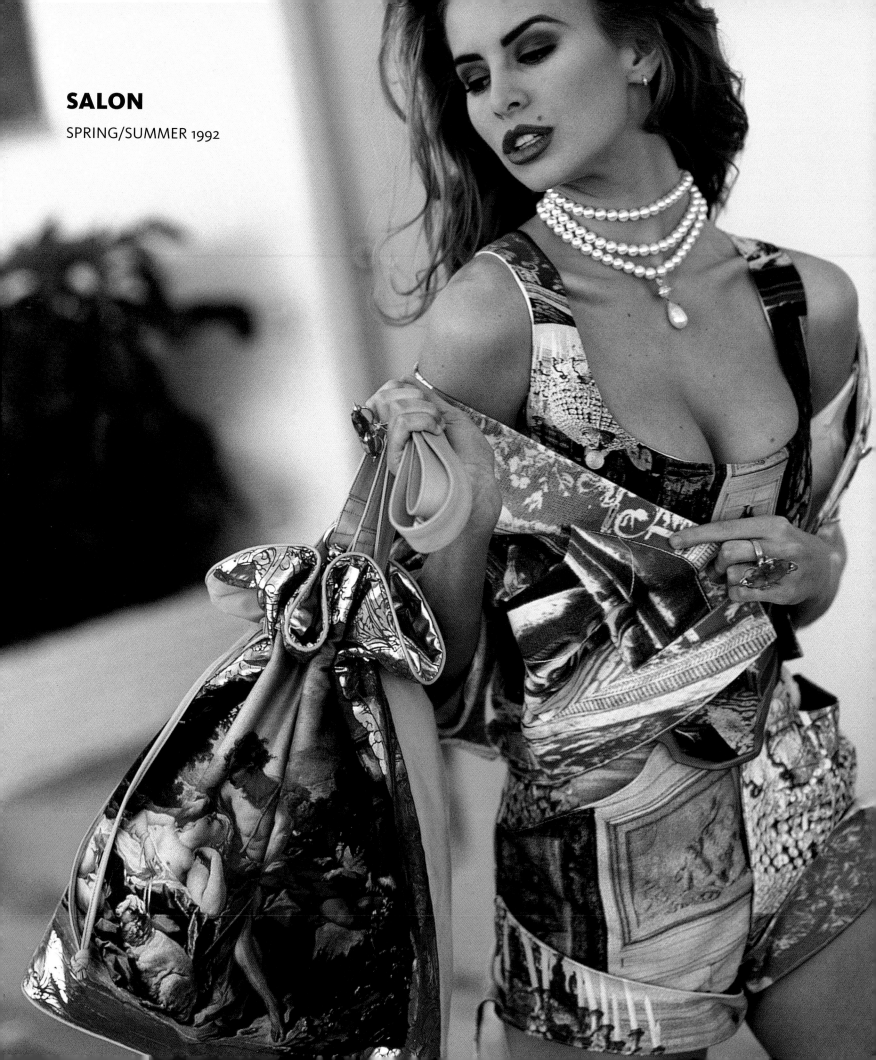

SALON

SPRING/SUMMER 1992

SALON

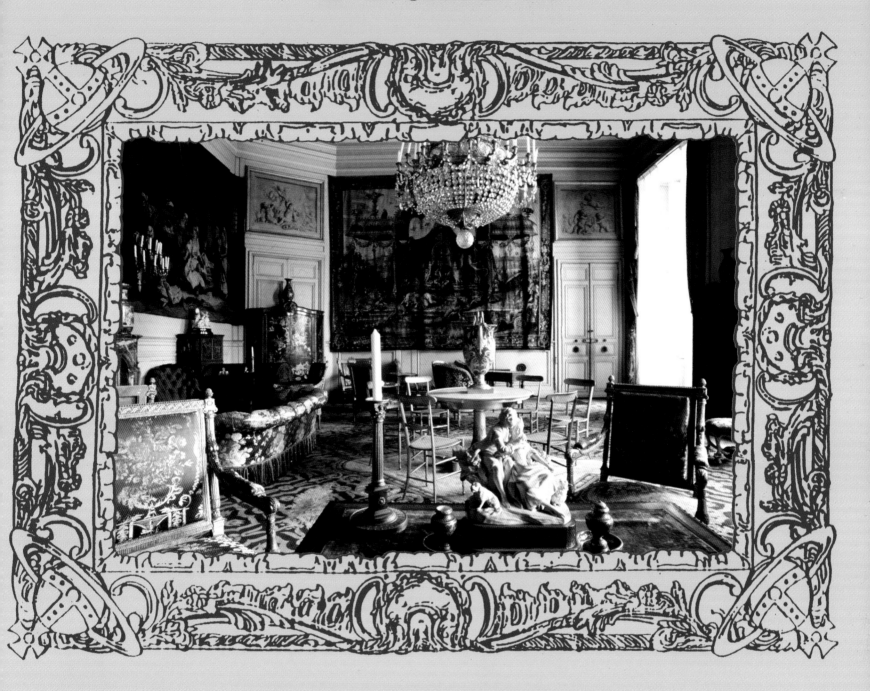

Oscar Wilde said that he knew of a lady in
England who tried to open a salon but found that
she had opened a saloon.

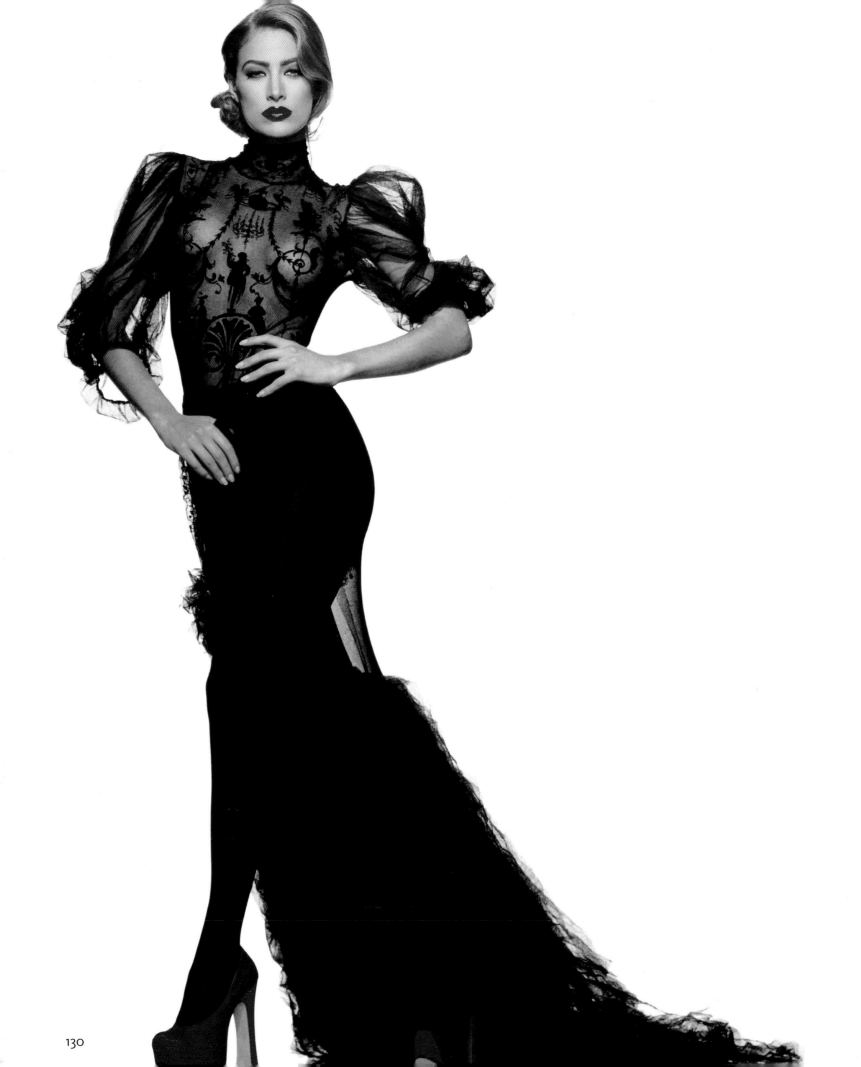

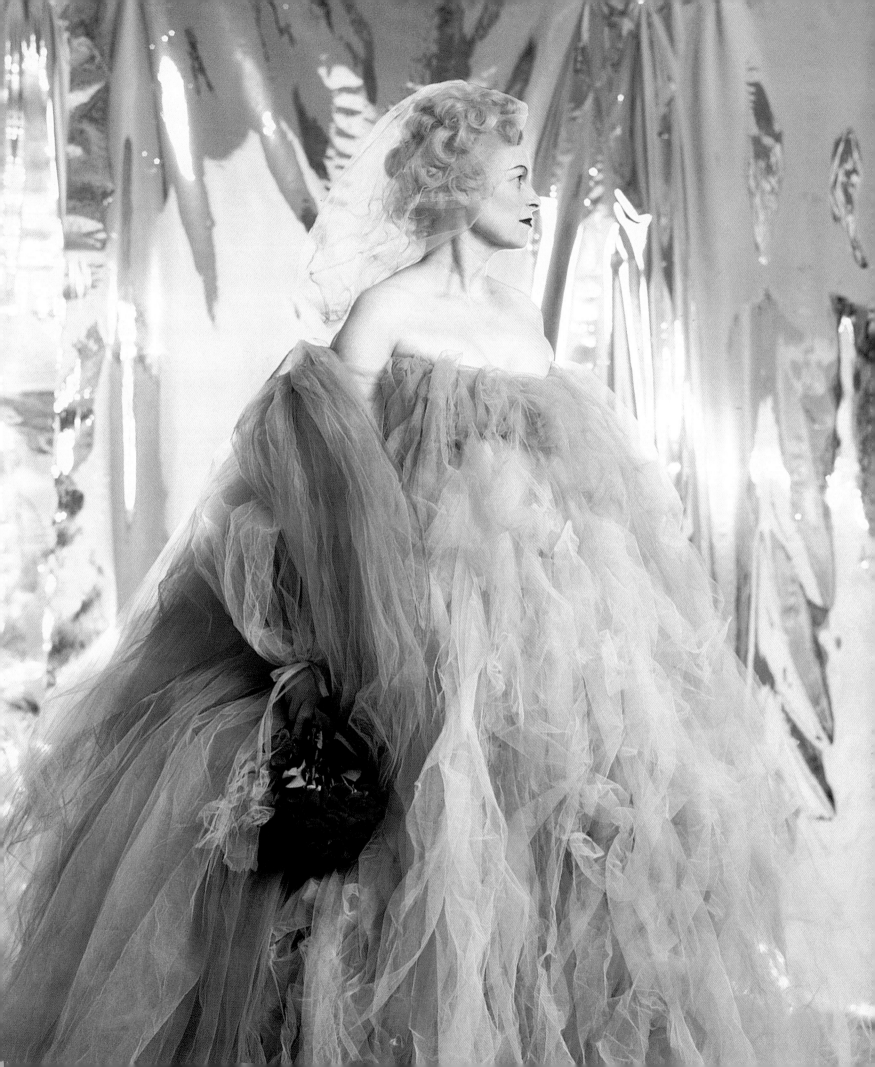

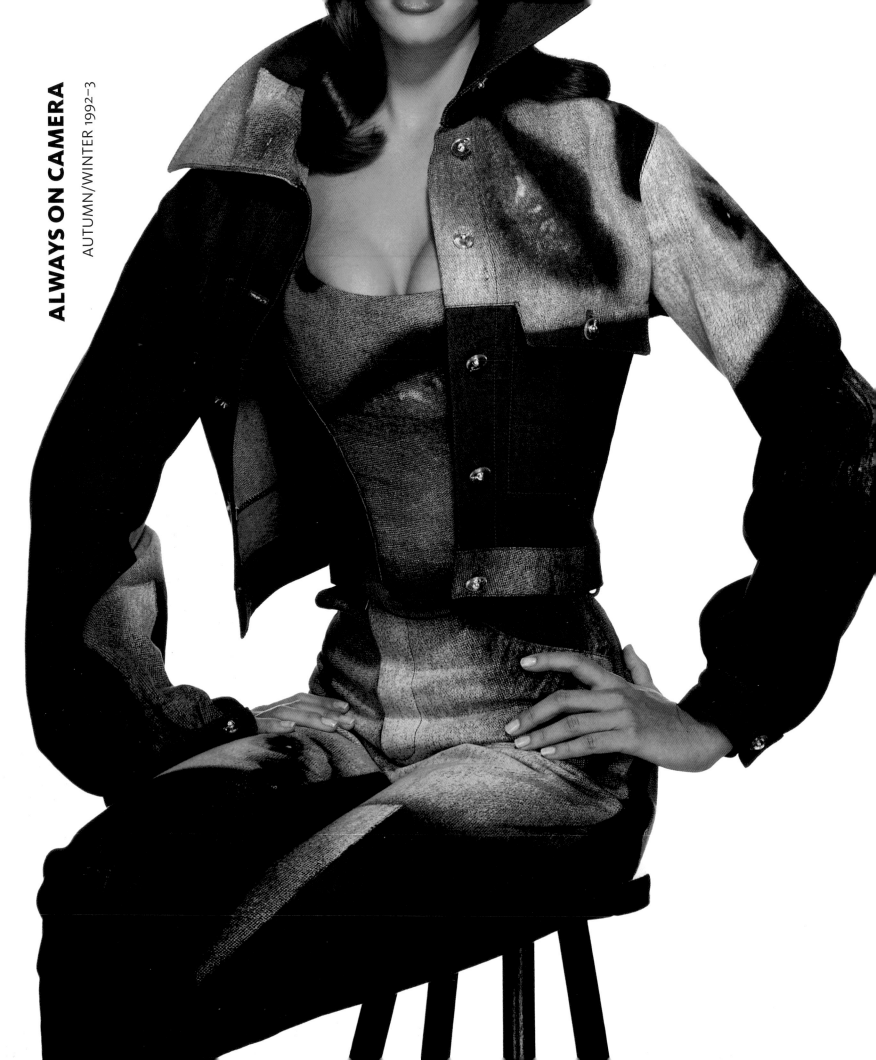

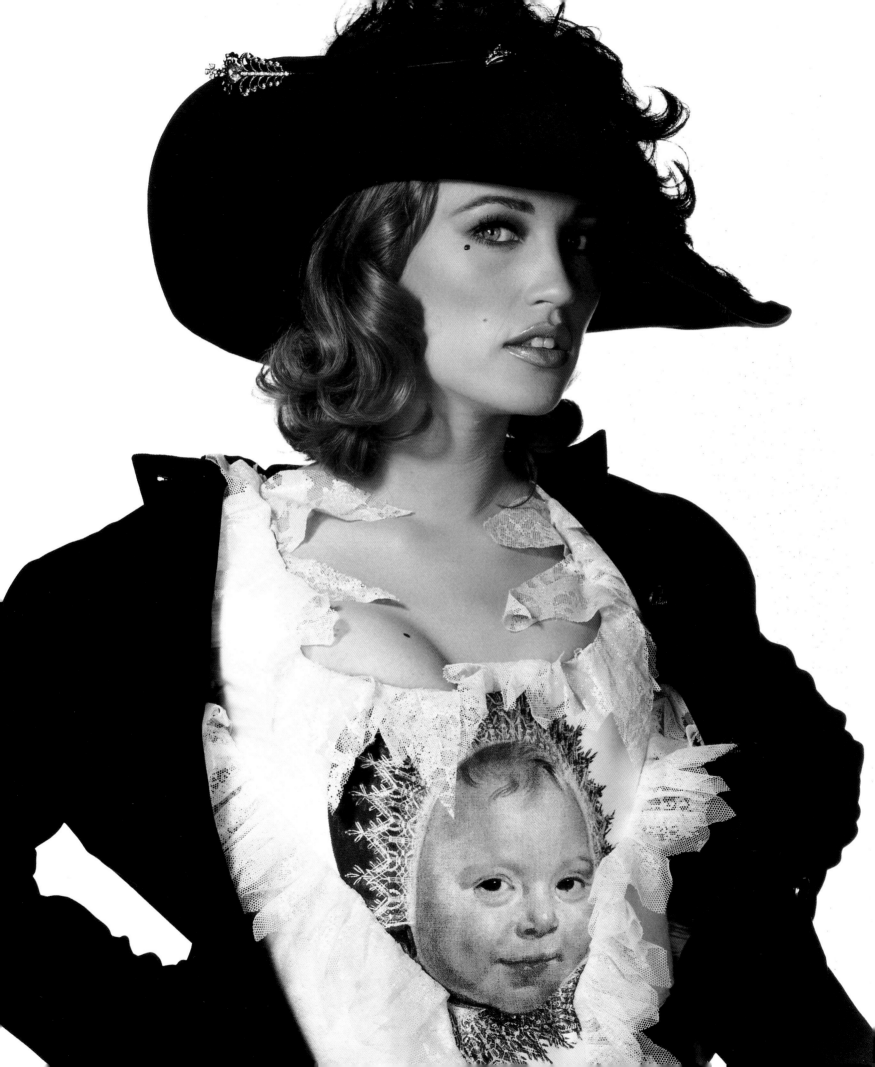

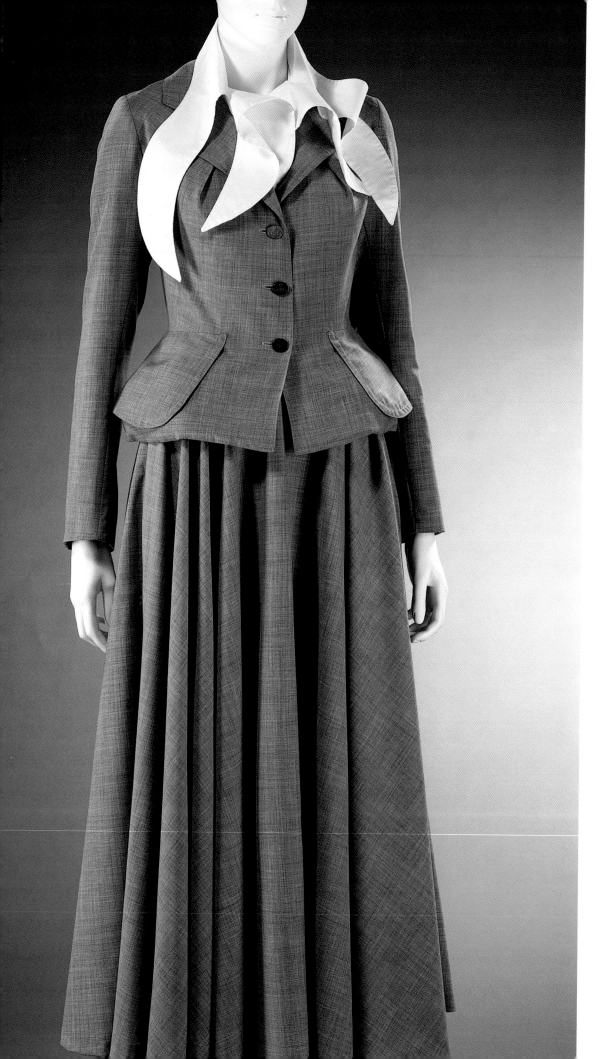

GRAND HOTEL

SPRING/SUMMER 1993–4

Left: This fine grey wool single-breasted jacket was named 'Bettina', after the Christian Dior fashion model of the 1950s who still attends Westwood's fashion shows. Westwood pays tribute to Dior's silhouette with a jacket with large pocket flaps which emphasize the hips. The collar is formed from a single diagonal tuck while another tuck lies concealed by the pocket. It is teamed with a matching long, full 'Circle' skirt. The white cotton poplin shirt has an elongated collar and revers which can be tied in a bow or left loose.

Right: The same jacket was created in tartan for Anglomania (A/W 1993–4), teamed with a pencil skirt that used a different tartan, cut on the diagonal. A blue and pink tartan shirt and a pheasant feather hat by Prudence complete the stylish ensemble.

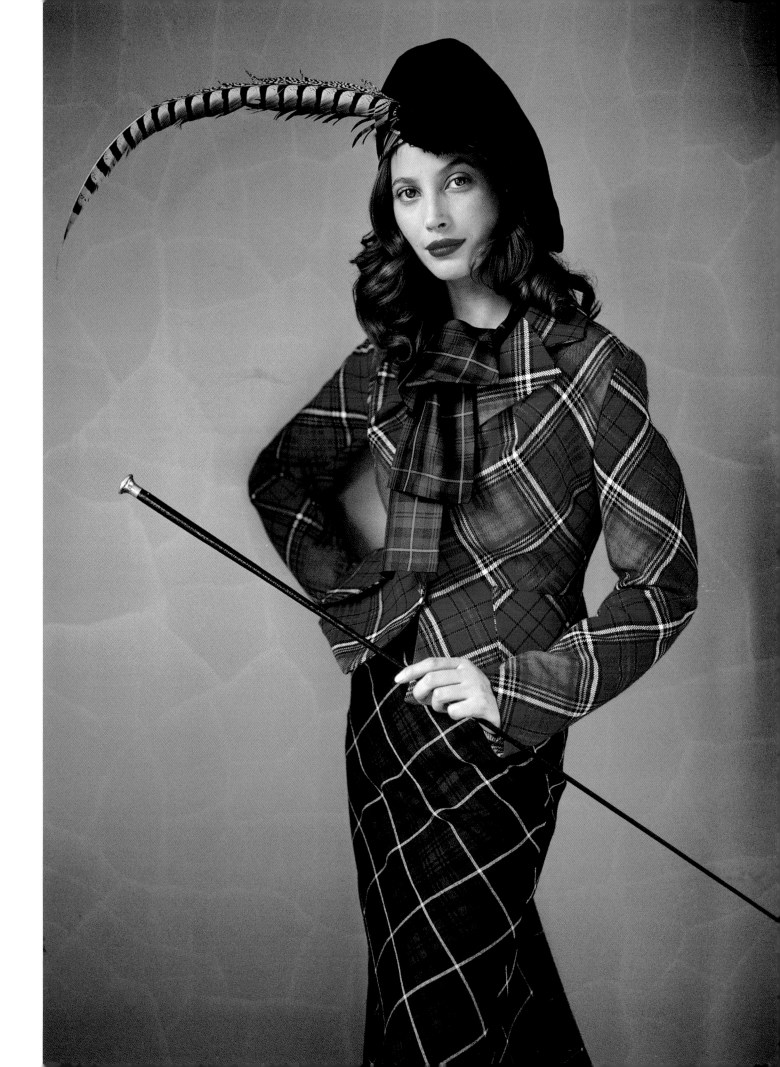

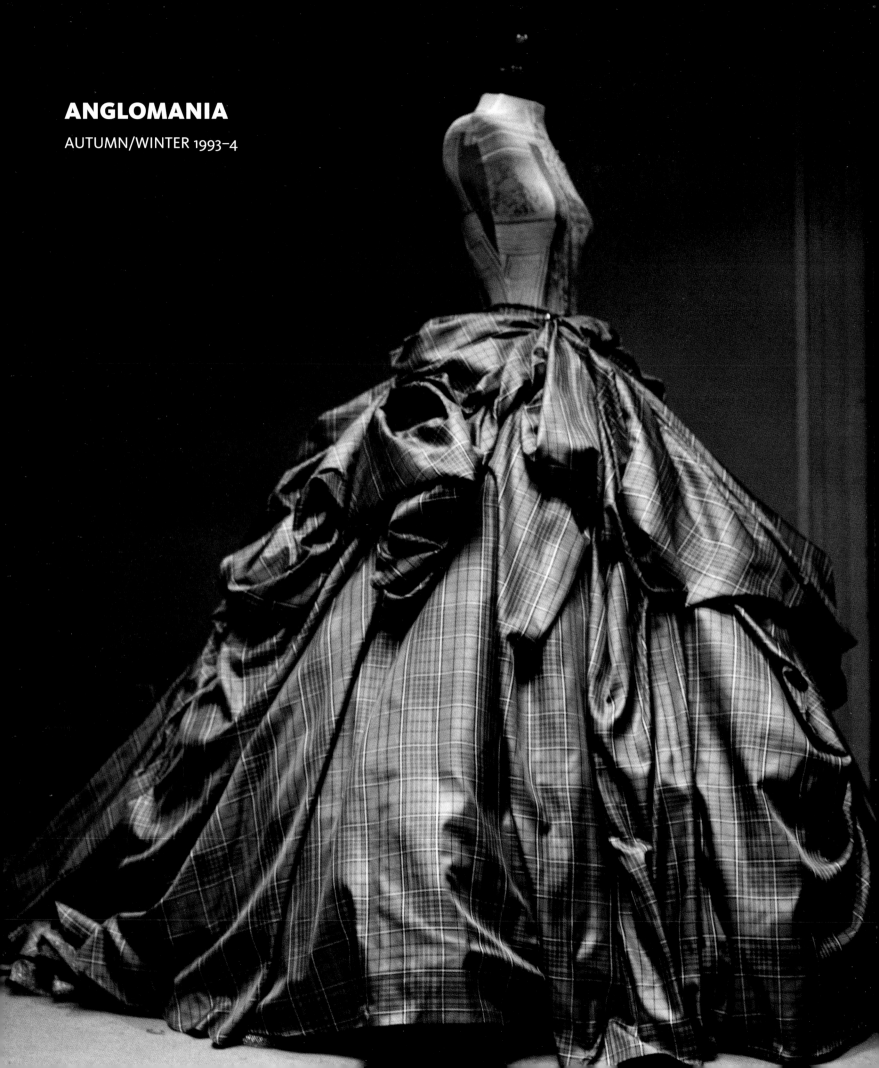

ANGLOMANIA

AUTUMN/WINTER 1993–4

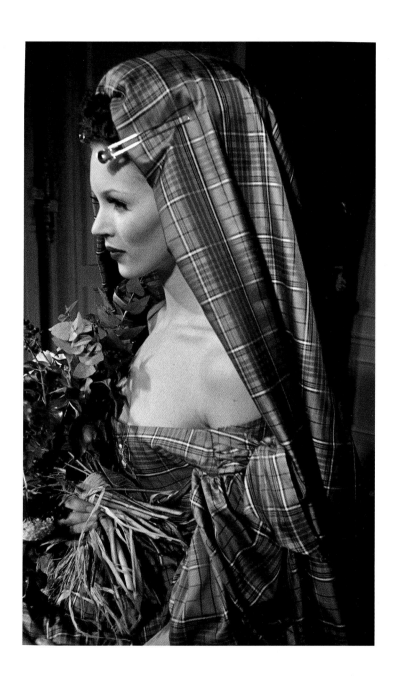

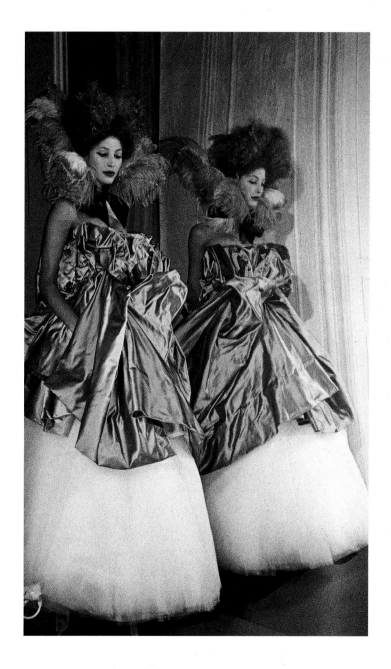

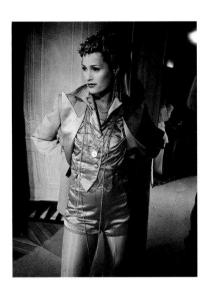

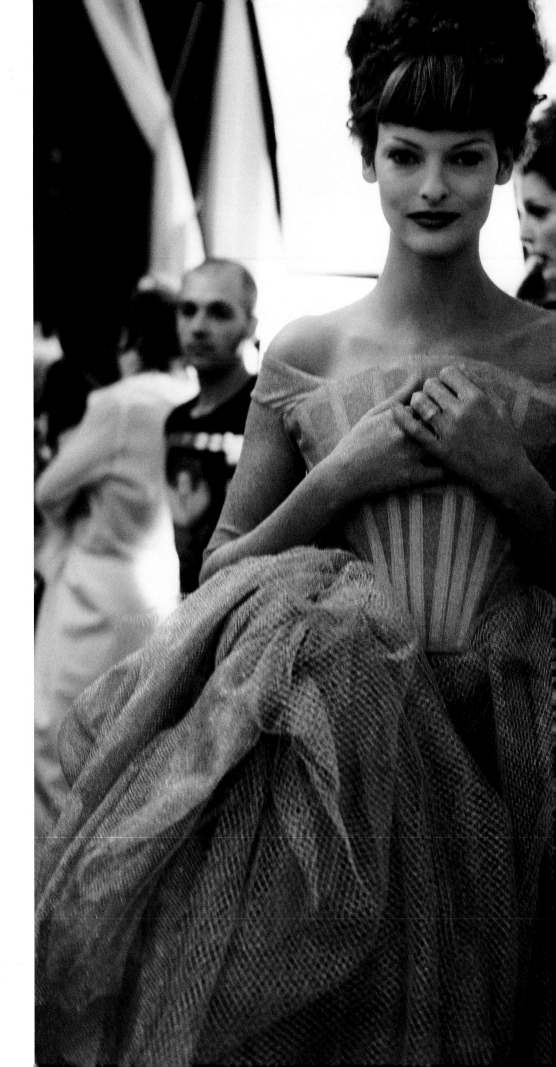

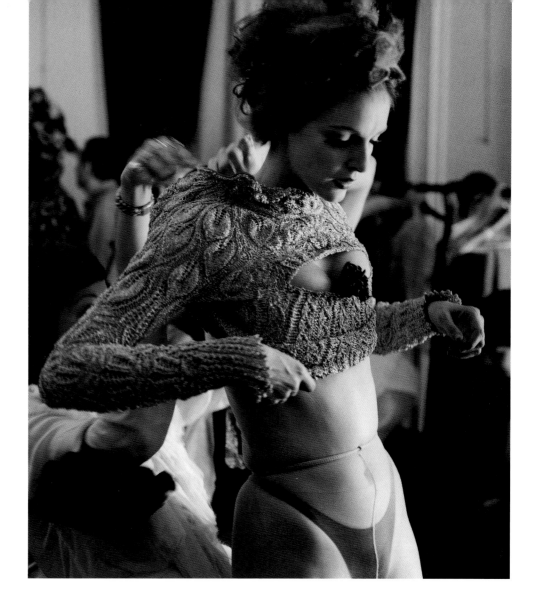

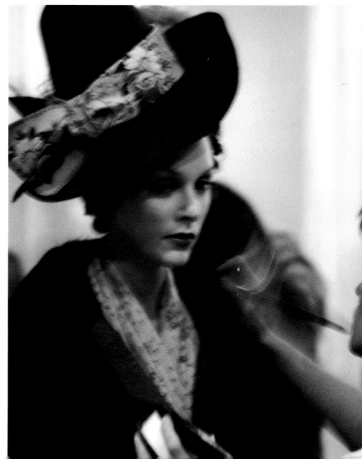

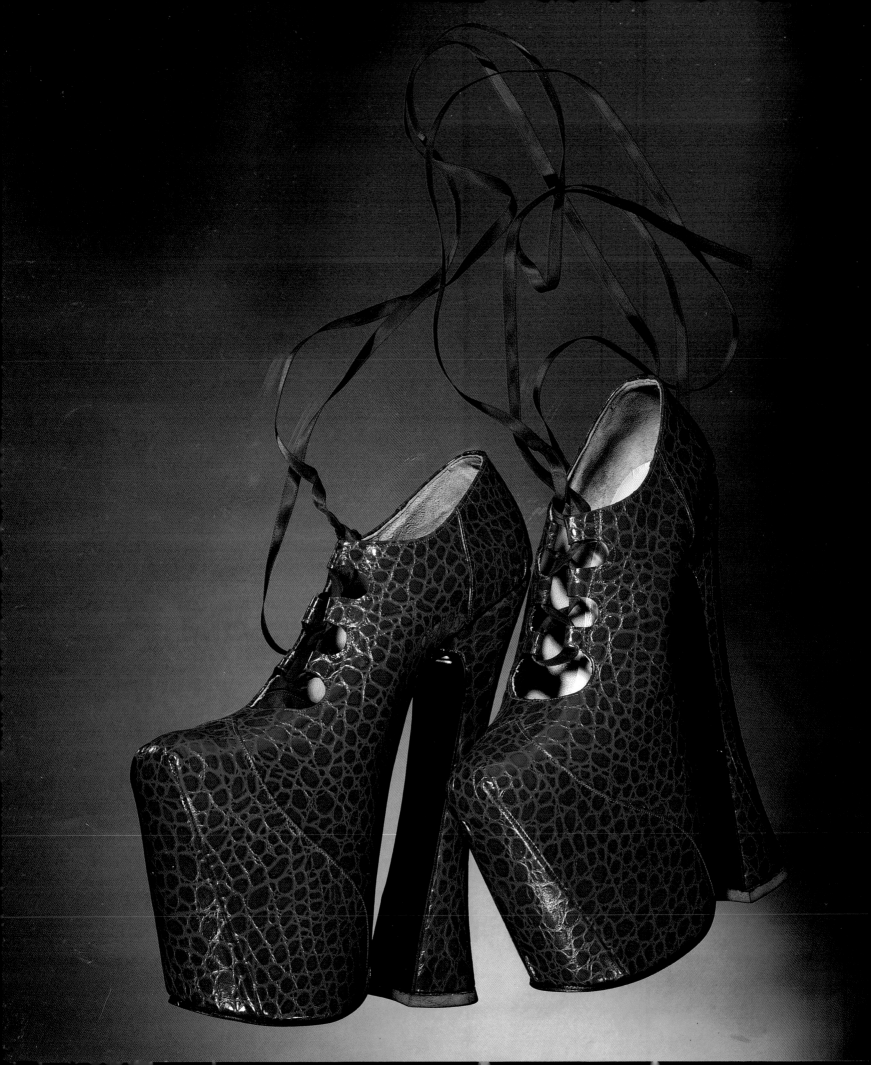

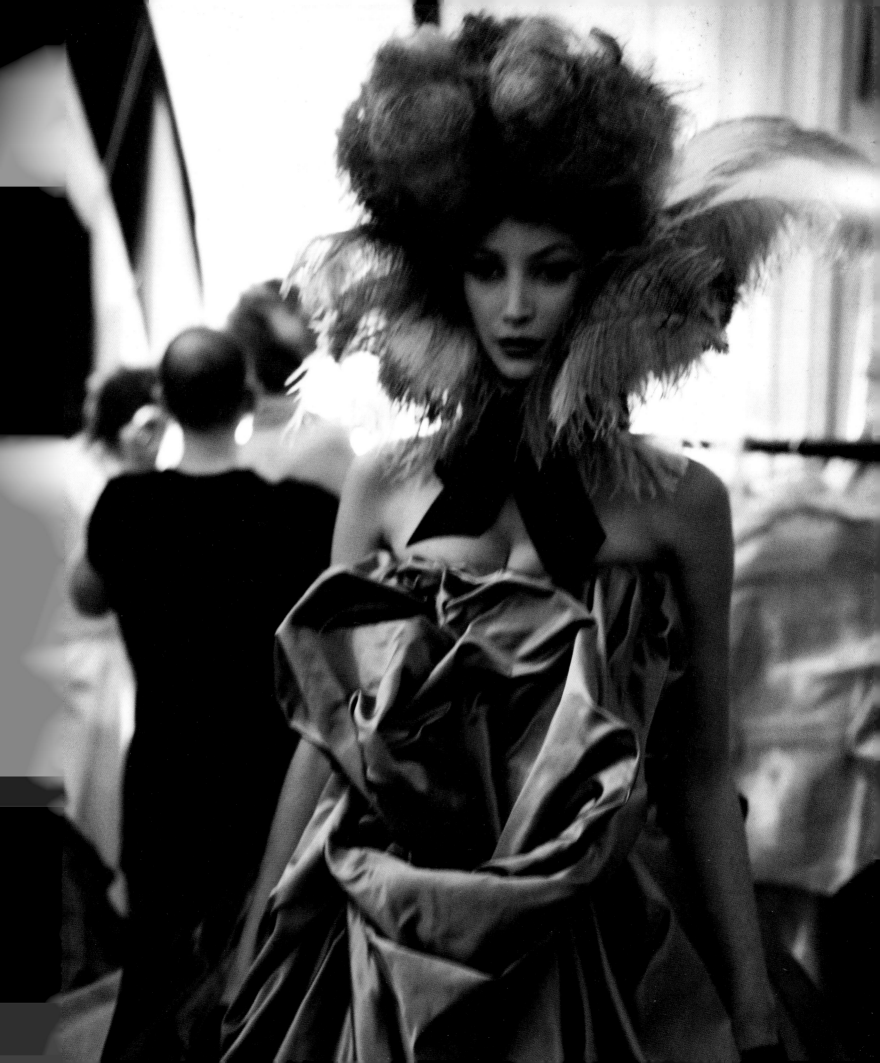

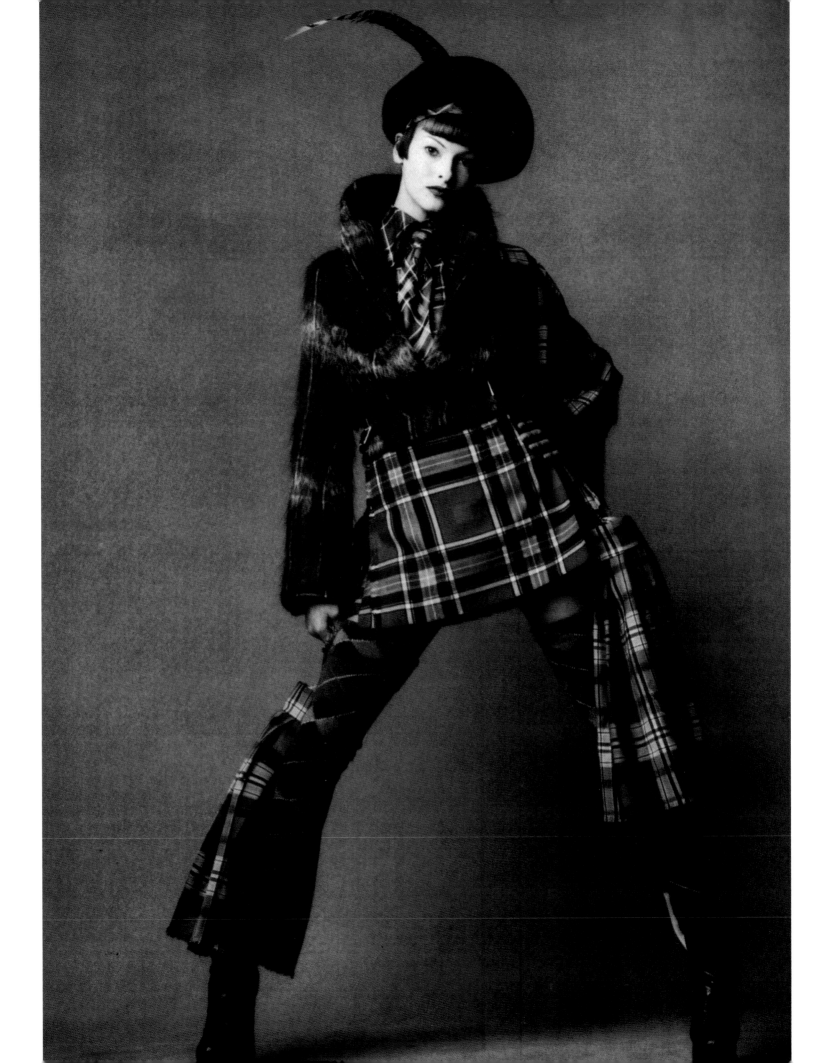

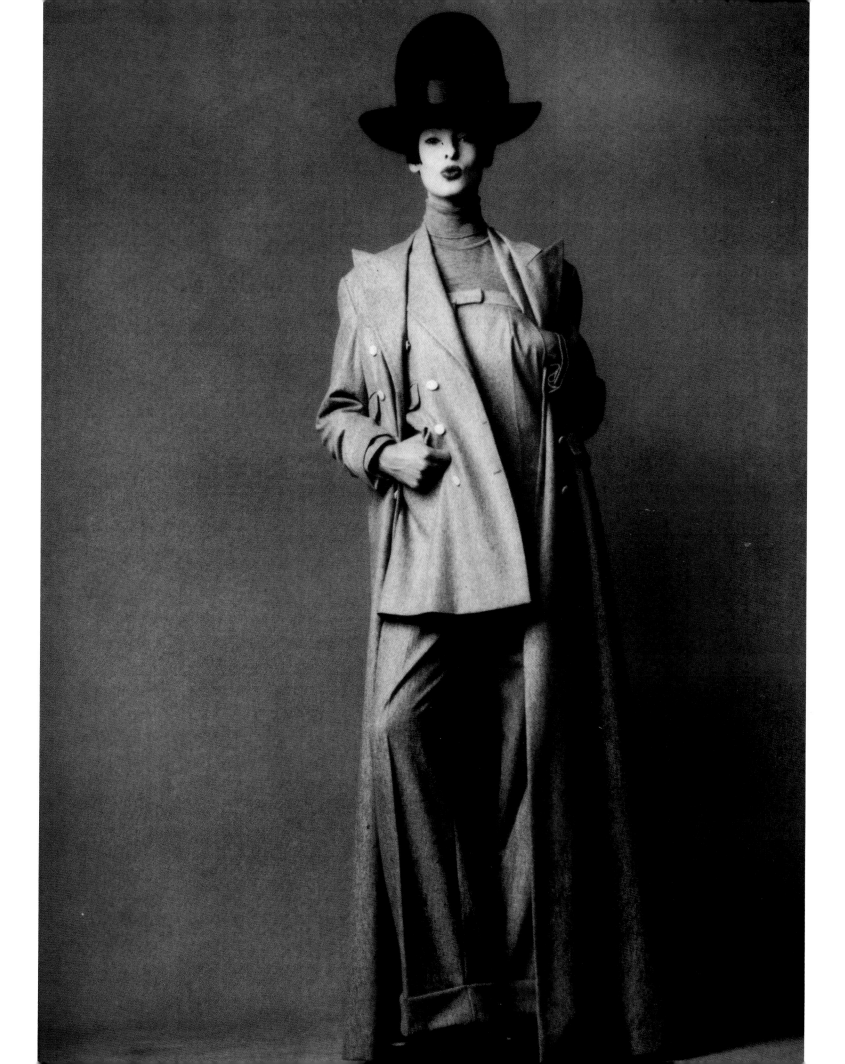

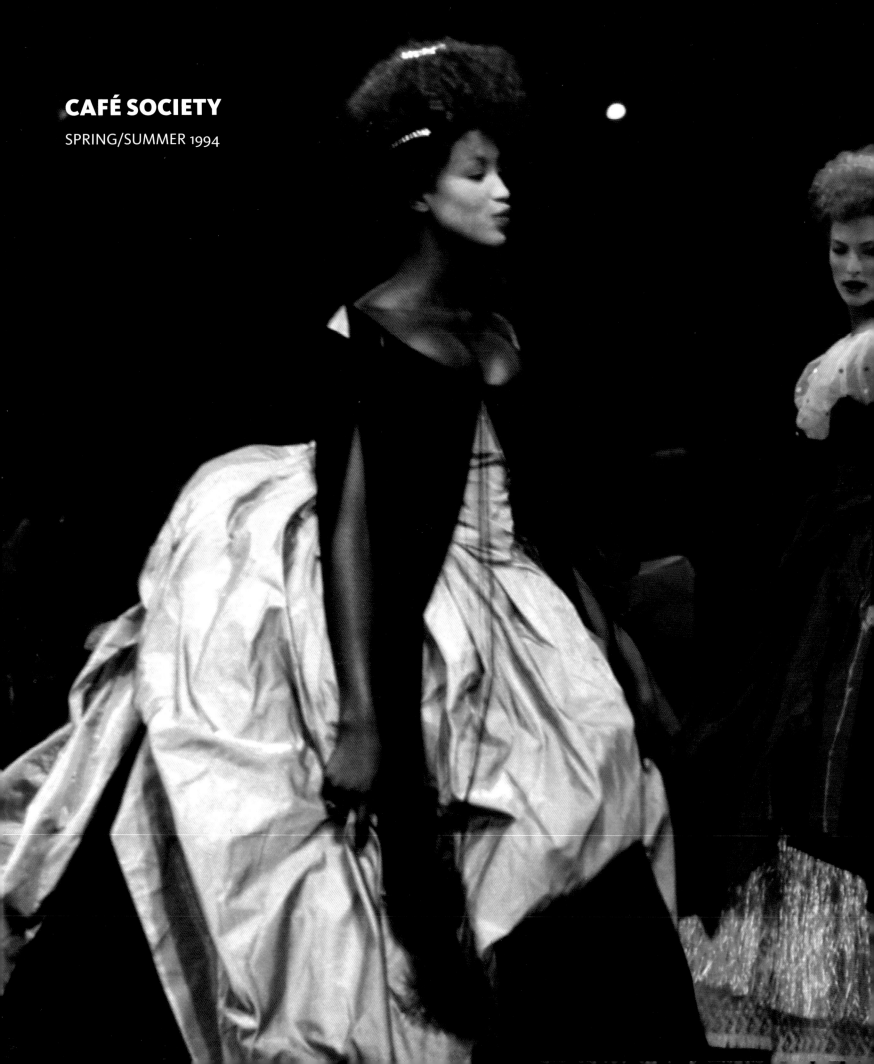

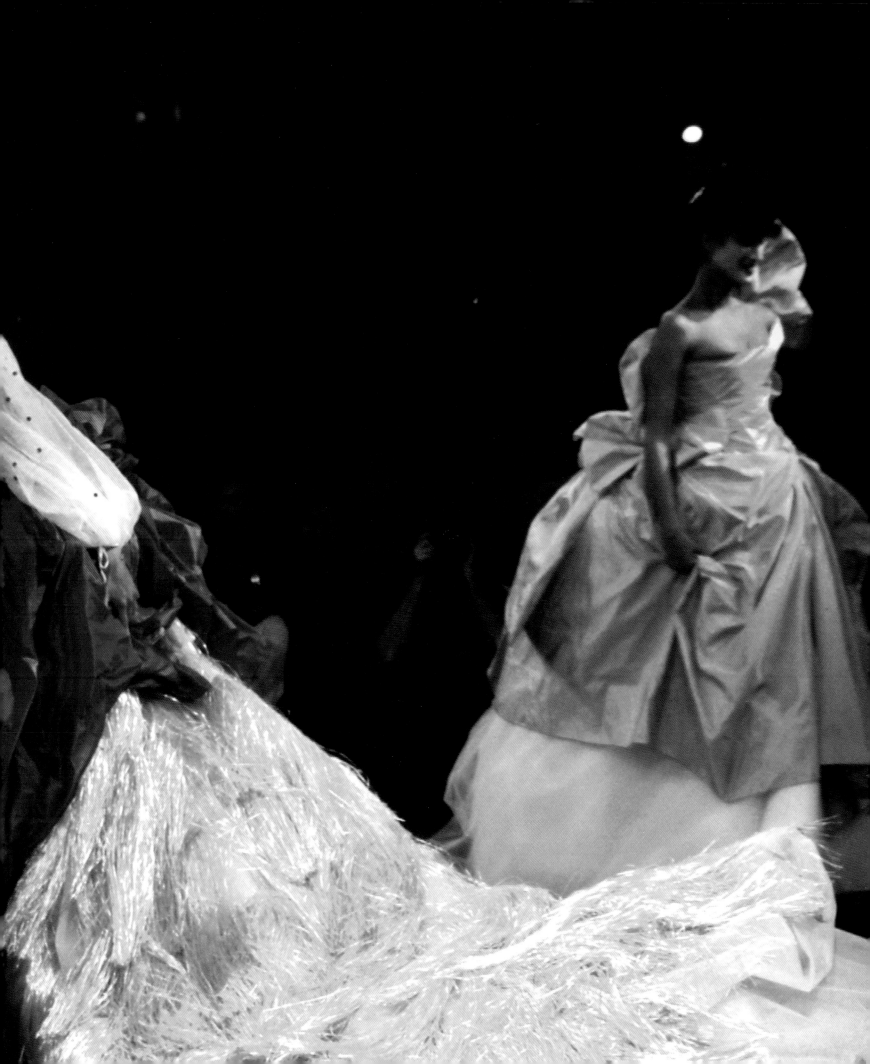

WOMEN'S WEAR DAILY, TUESDAY, MARCH 8, 1994

Queen

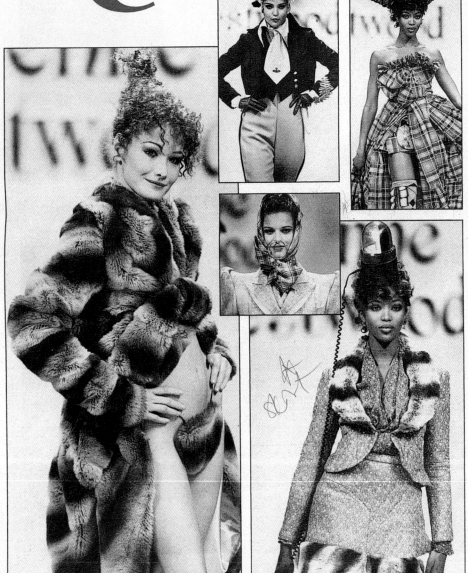

PARIS — The British press went ballistic. "Vivienne Westwood dragged haute couture to a new low in Paris yesterday," proclaimed the Daily Mail in a front-page story. The newspaper charged that Westwood made Kate Moss look like a "child prostitute" and Carla Bruni "a cheap tart."

The truth of the matter — the pompous British press notwithstanding — is that it was a clever, outrageous romp that was equal parts ridiculous and sublime — but always fun. Westwood, as usual, sent out dozens of new ideas that will be sure to be copied from here to Timbuktu — and other places the sun never sets. Long live the Queen!

Viv

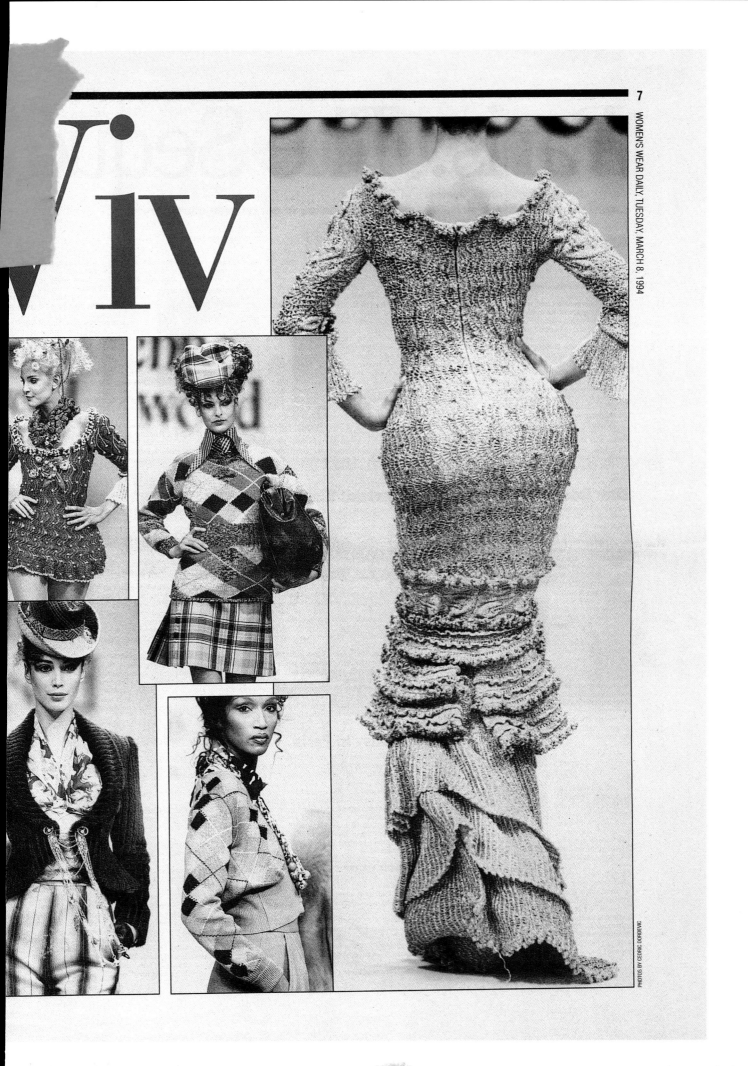

Left: Detail from a knitted dress and a Liberty print georgette dress from the On Liberty collection. The knitting pattern was devised by Westwood and scales up the pattern of the georgette. The knitted dress is her 'favourite dress of all time' and was originally designed to be worn with a bum cushion.

Right: The hourglass shape of this double-breasted 'Power' jacket, with its exaggerated shoulders and padded hips, plus matching skirt with cushion bustle, takes the late 19th-century silhouette into the modern age using a bold checked mustard-yellow and brown Harris Tweed.

Below: Bustle and underwear: white cotton under-dress with Bedfordshire Maltese lace trimming; corset, red sateen; bustle, steel wire. English, *c.*1883–95. V&A: T.15–1958. Westwood developed a wire cage on a similar principle to this 19th-century steel bustle. It was made in the Tyrol, Austria, by Andreas Kronthaler's father, a blacksmith.

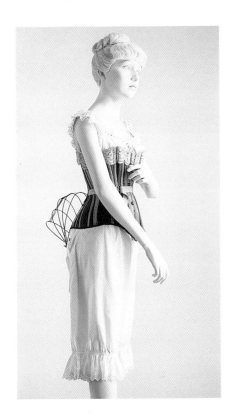

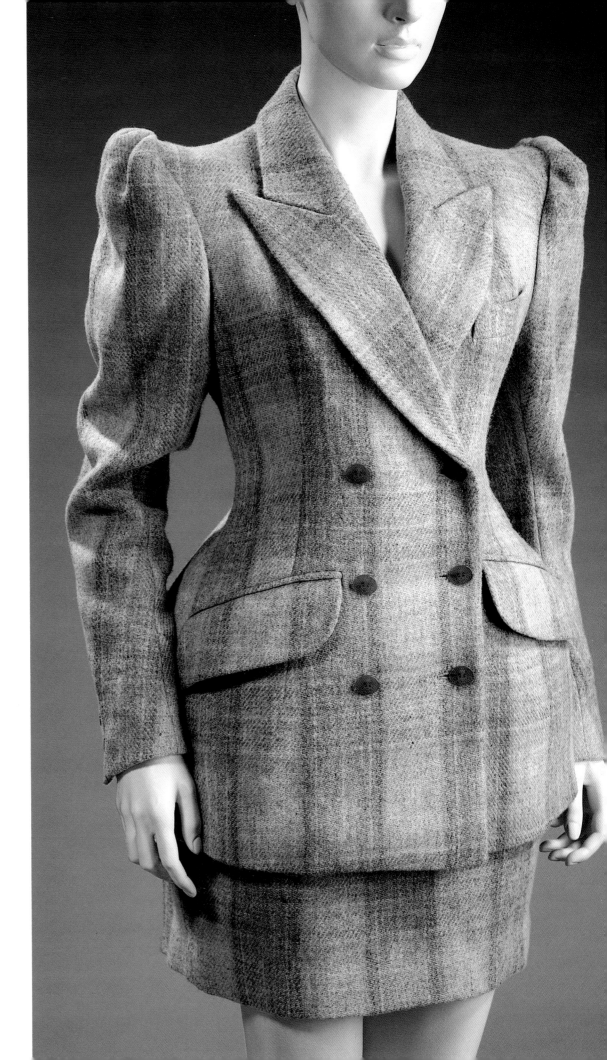

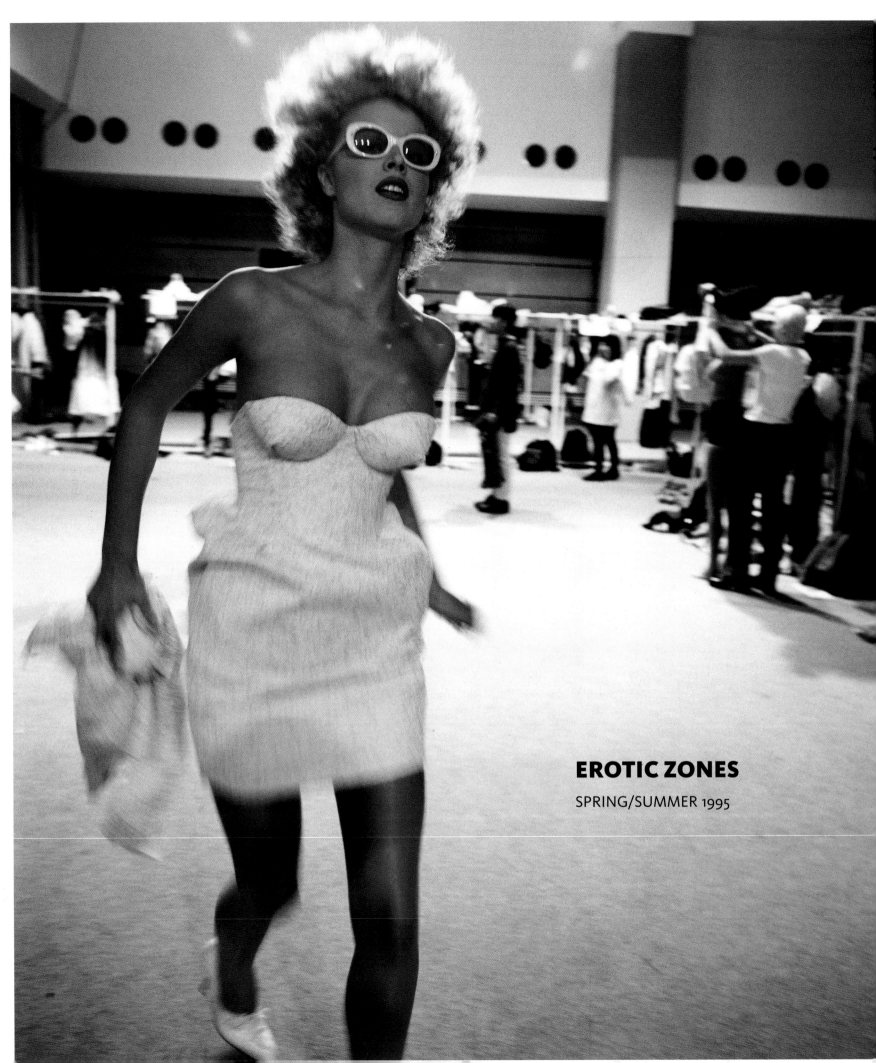

EROTIC ZONES

SPRING/SUMMER 1995

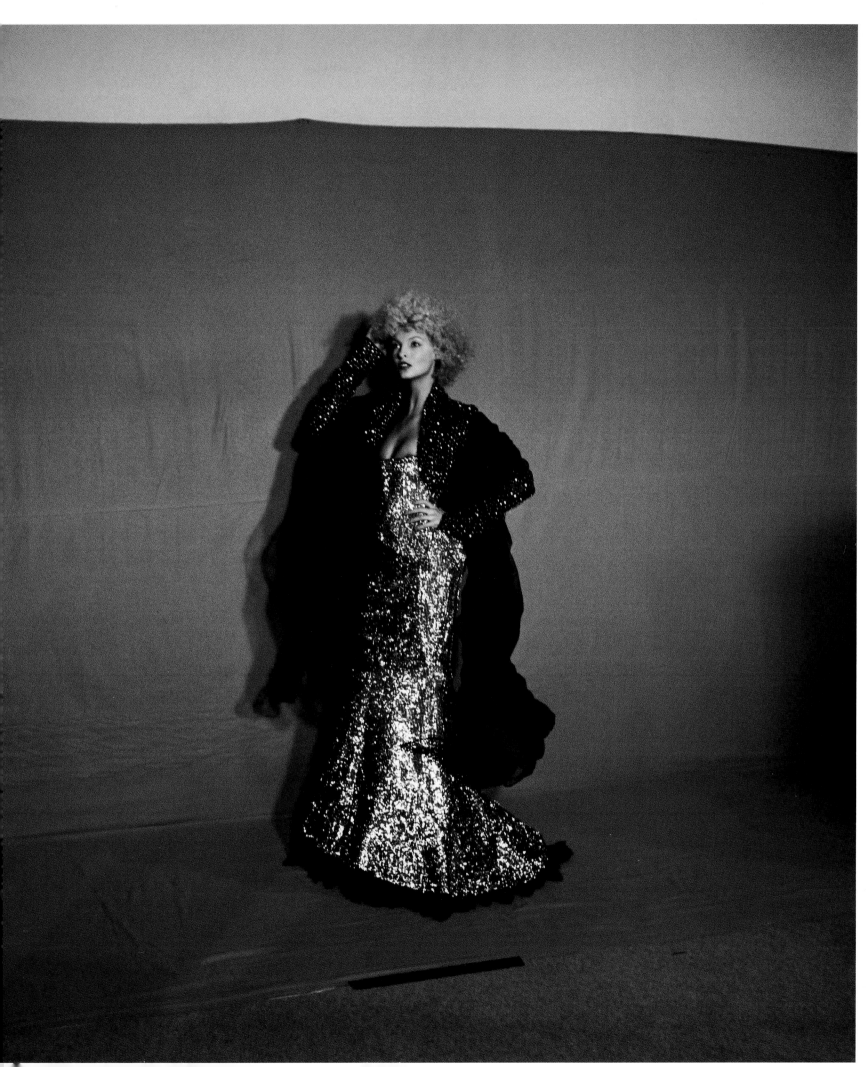

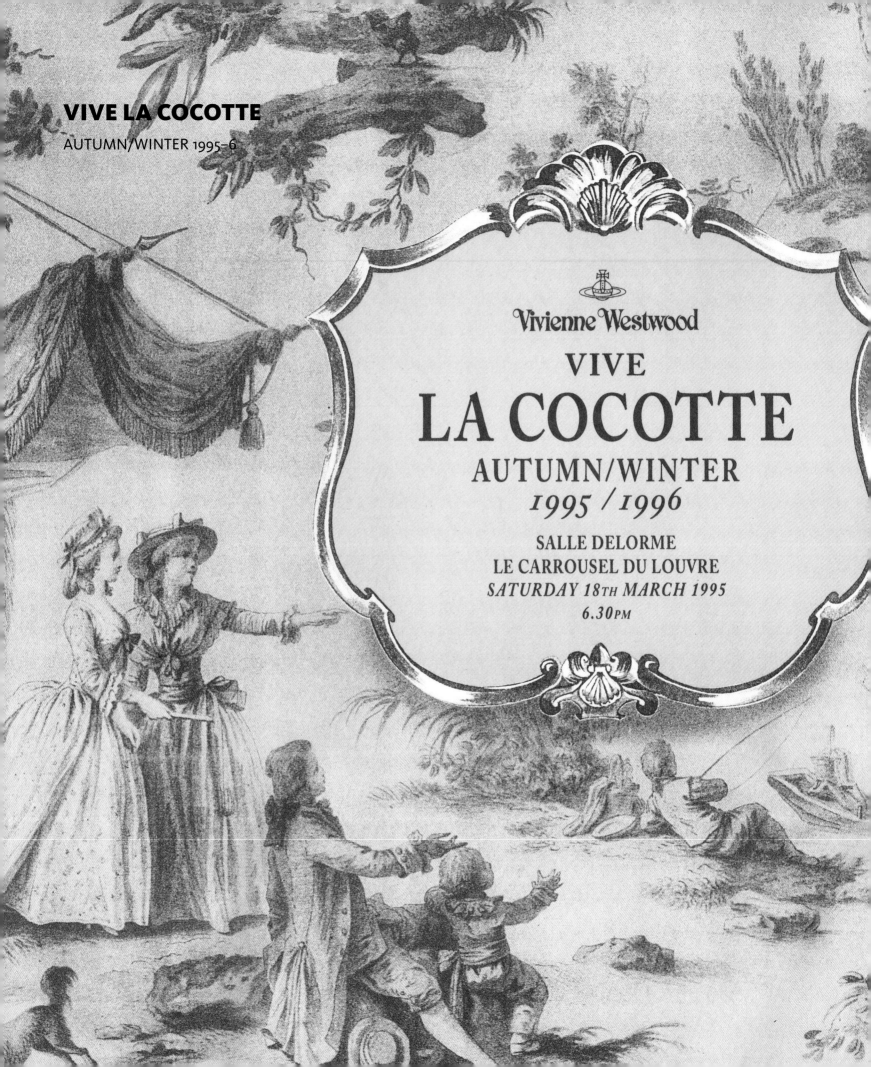

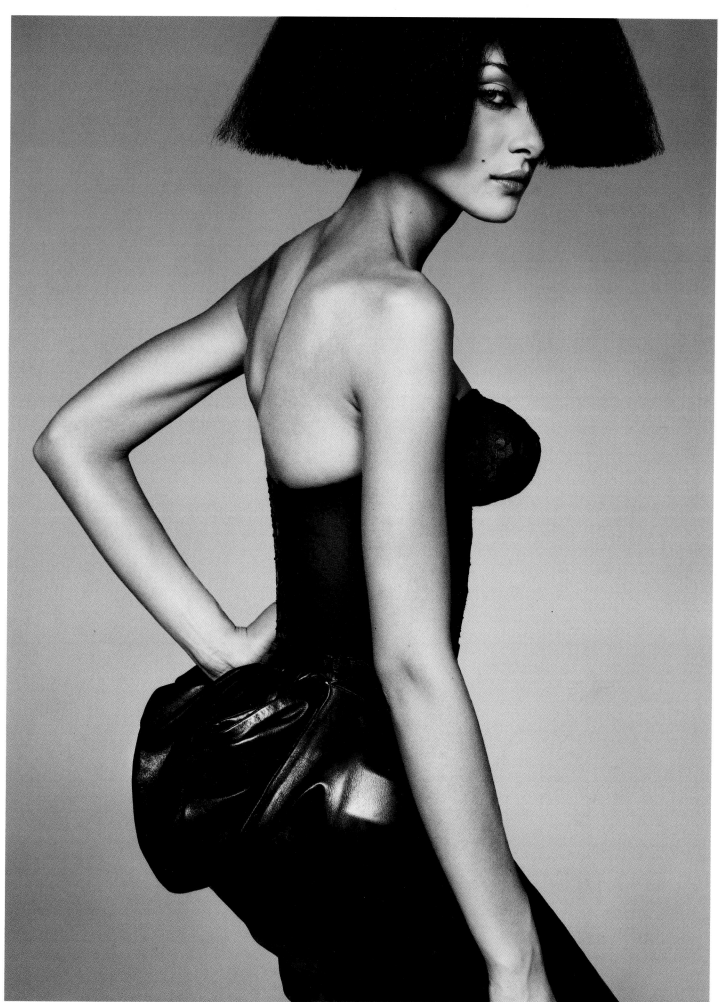

The dark grey wool 'Metropolitan' jacket and skirt was based on a Christian Dior suit that Westwood studied in the Metropolitan Museum of Art, New York. It is tailored to fit over the exaggerated form created by Westwood's cage bustle.

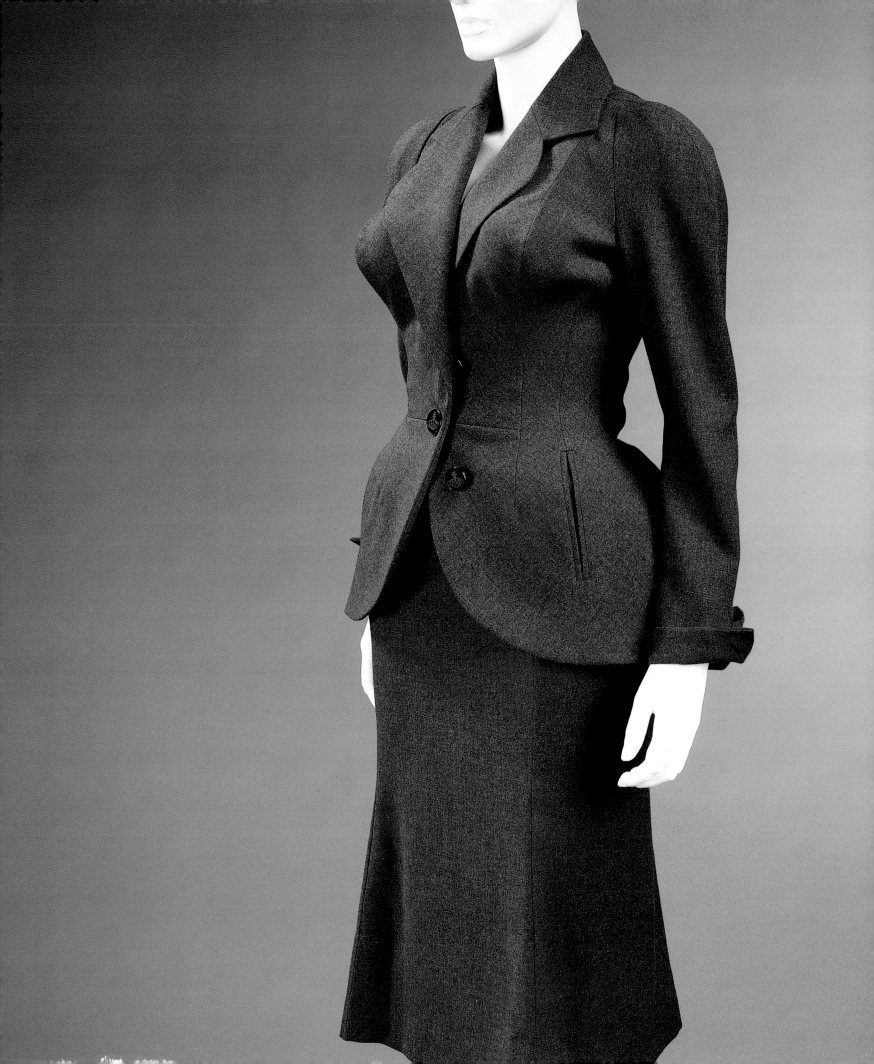

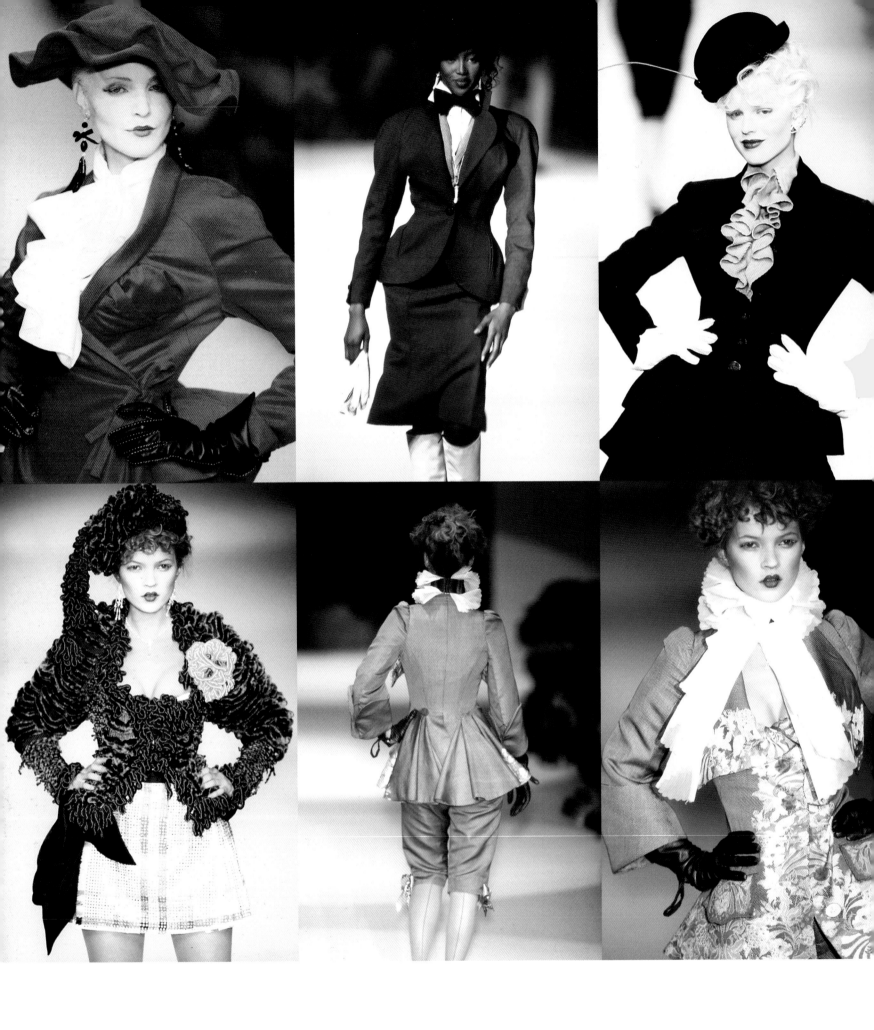

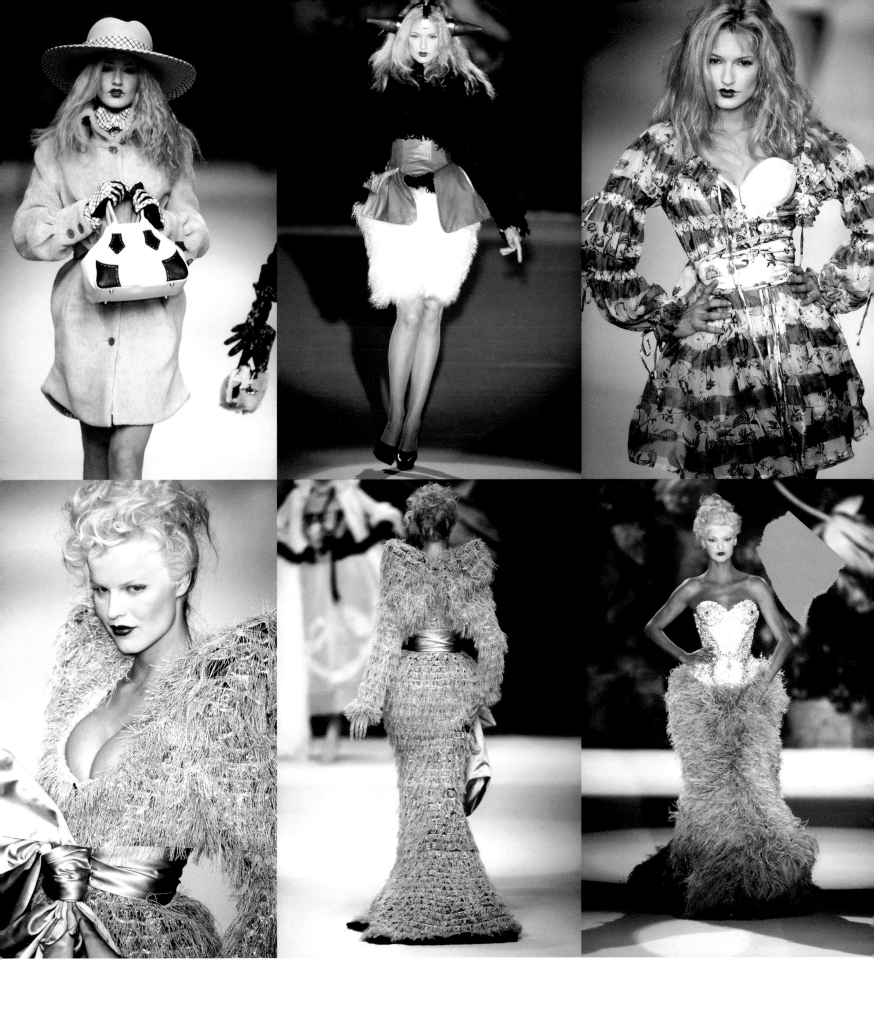

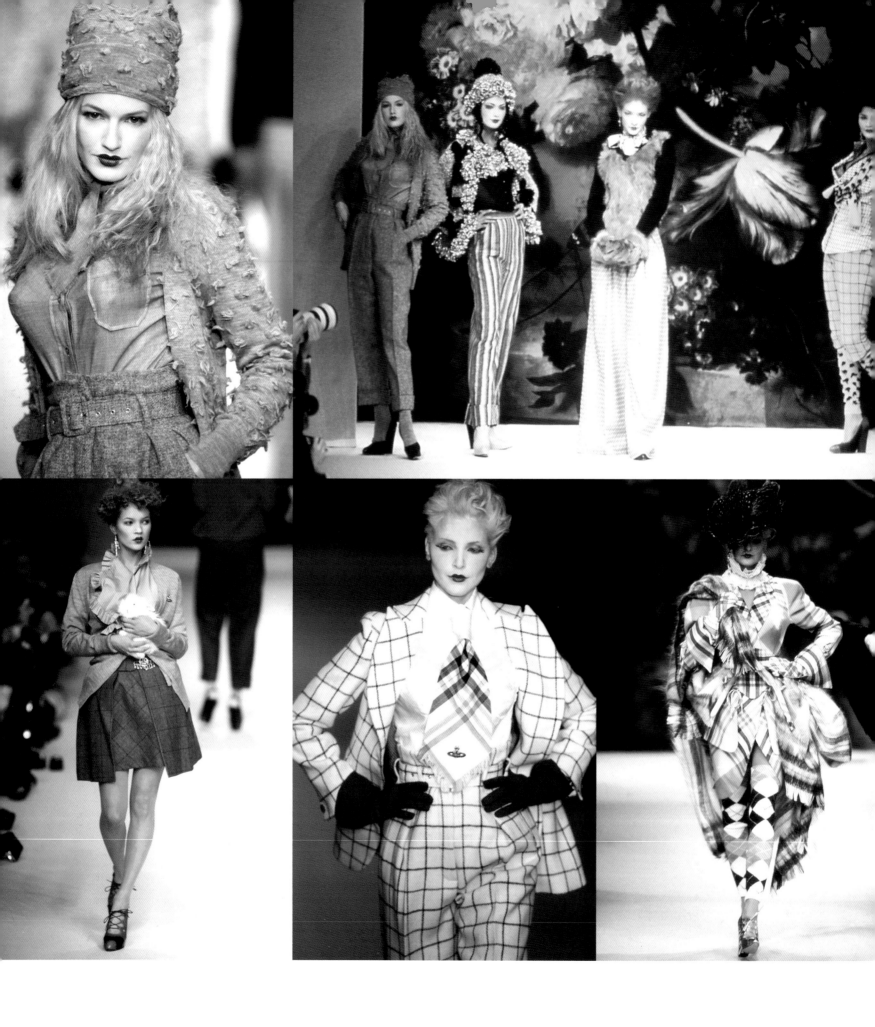

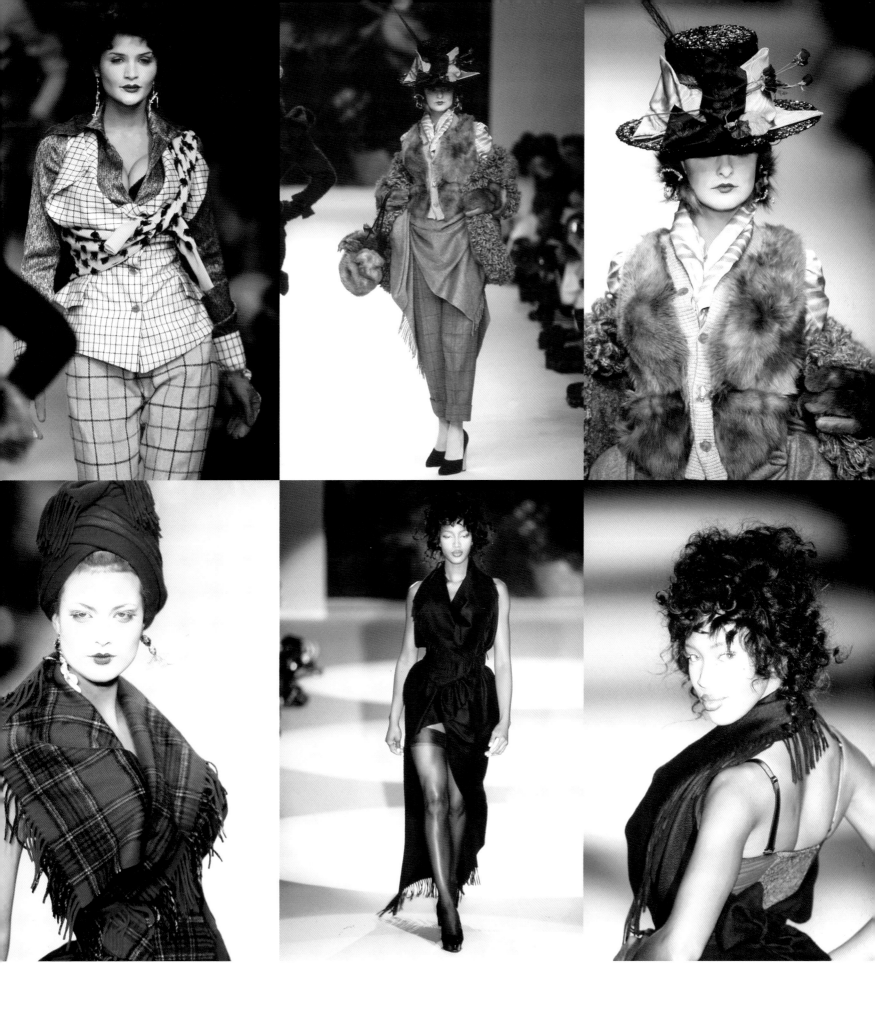

'Les femmes ne connaissent pas toute leur coquetterie'
(La Rochefoucault)
Spring/Summer '96

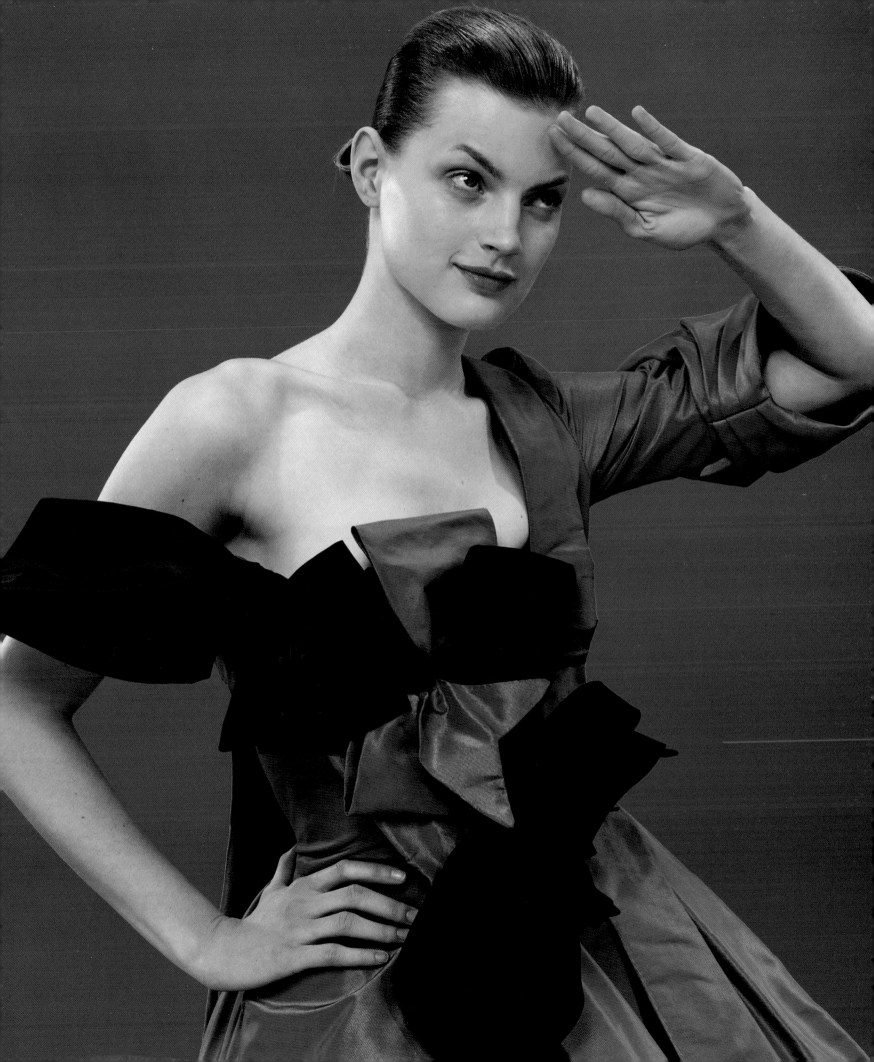

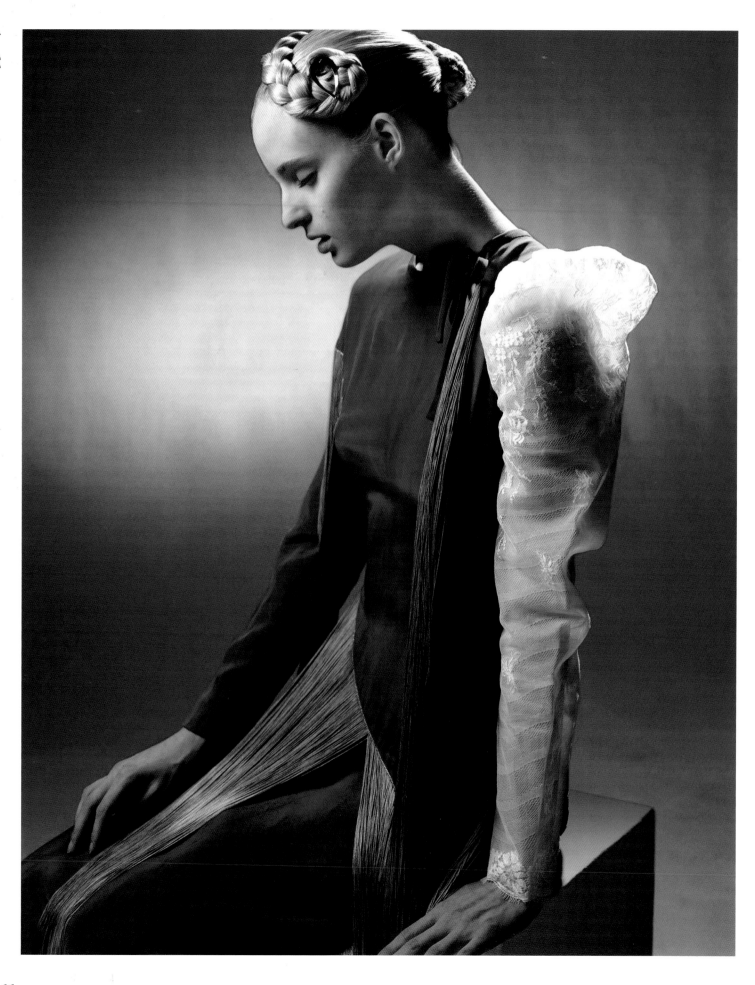

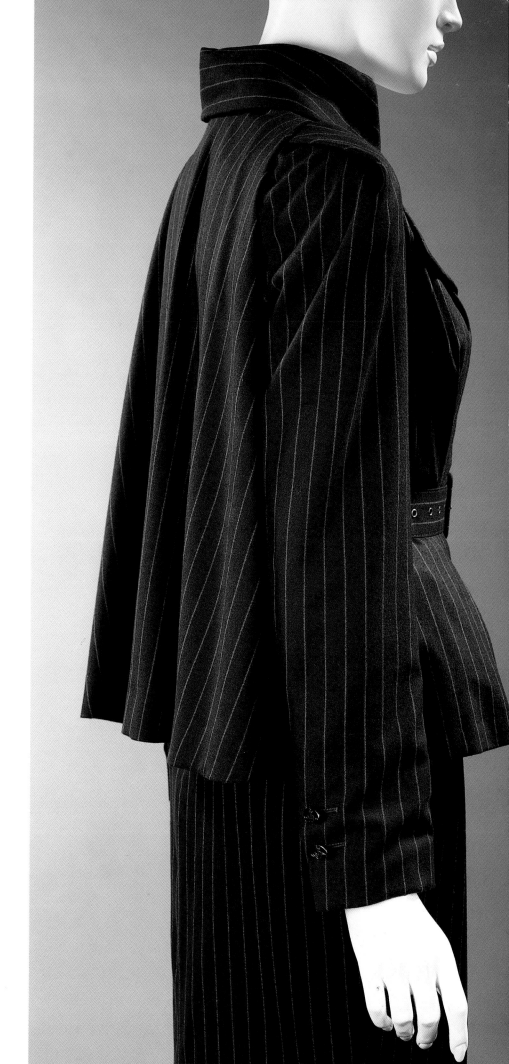

Right: In this brown chalk stripe 'Watteau' jacket with pencil skirt, Westwood employed the same system as she had with the 'Bettina' jacket, whereby the revers grows out of the dart and is joined to the high collar. From behind, all that is visible is the flaring swing back; from the front the jacket is crisply belted and fitted.

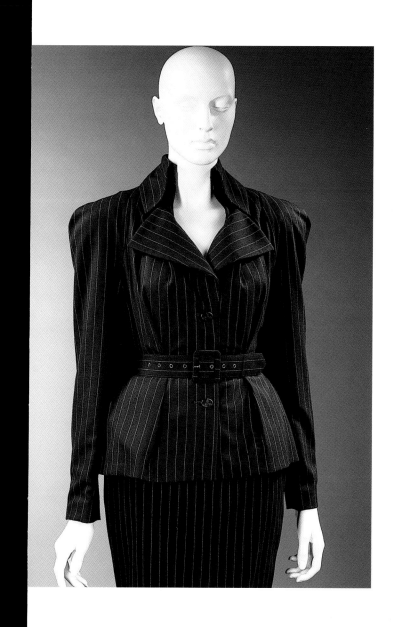

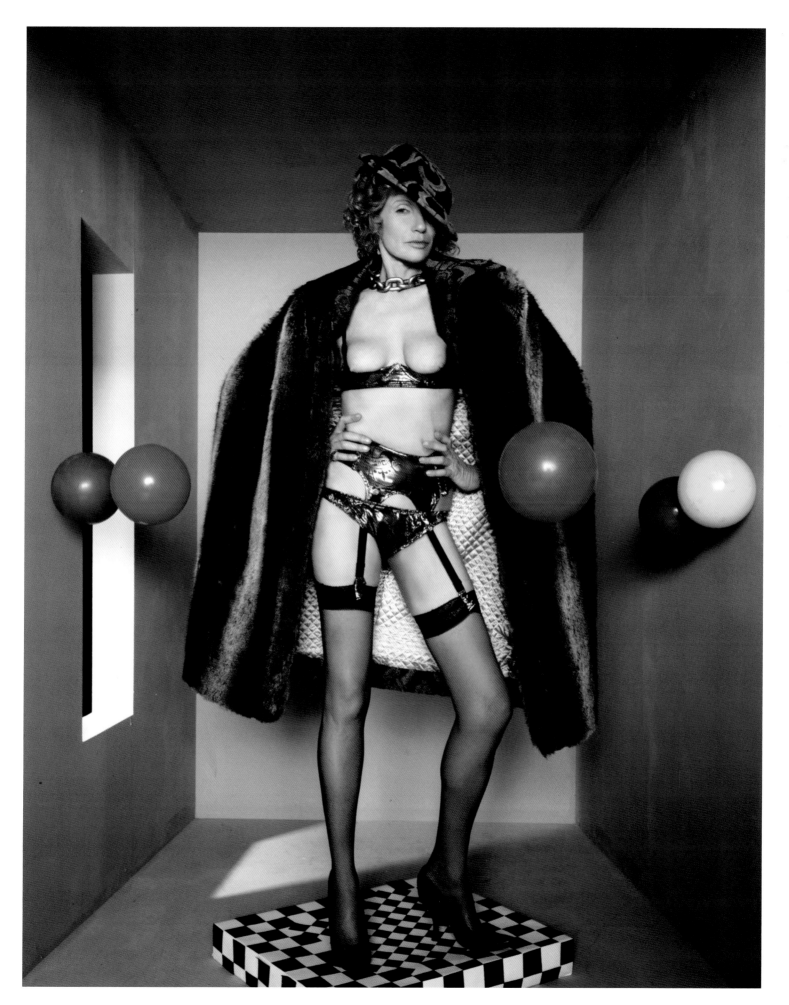

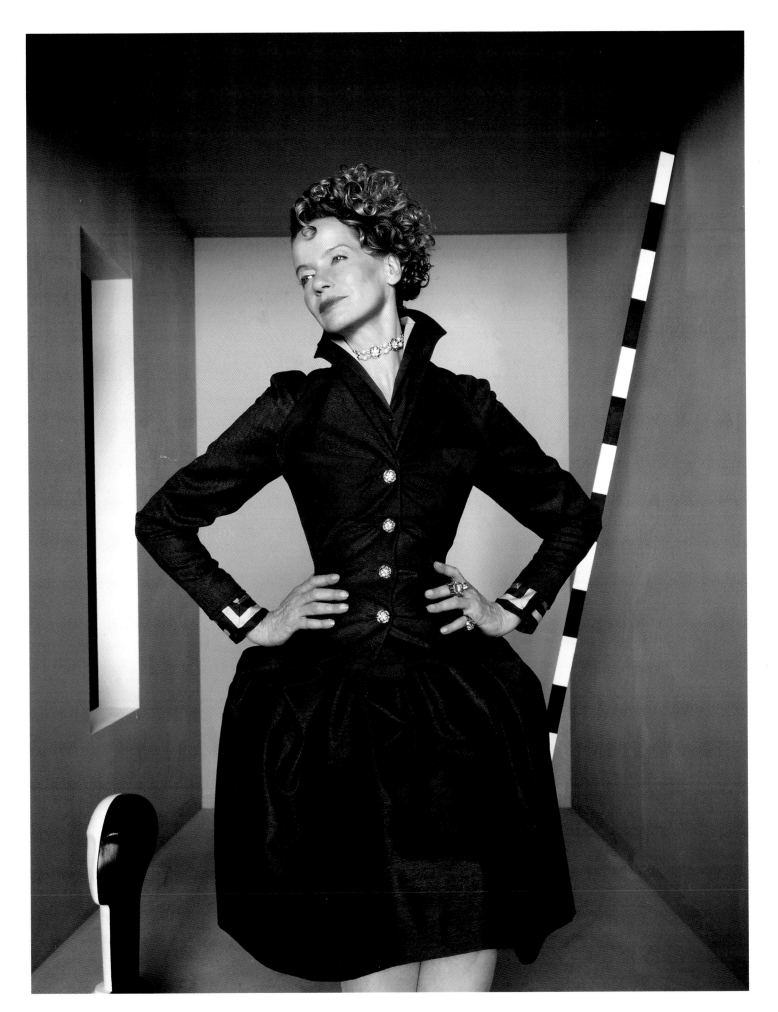

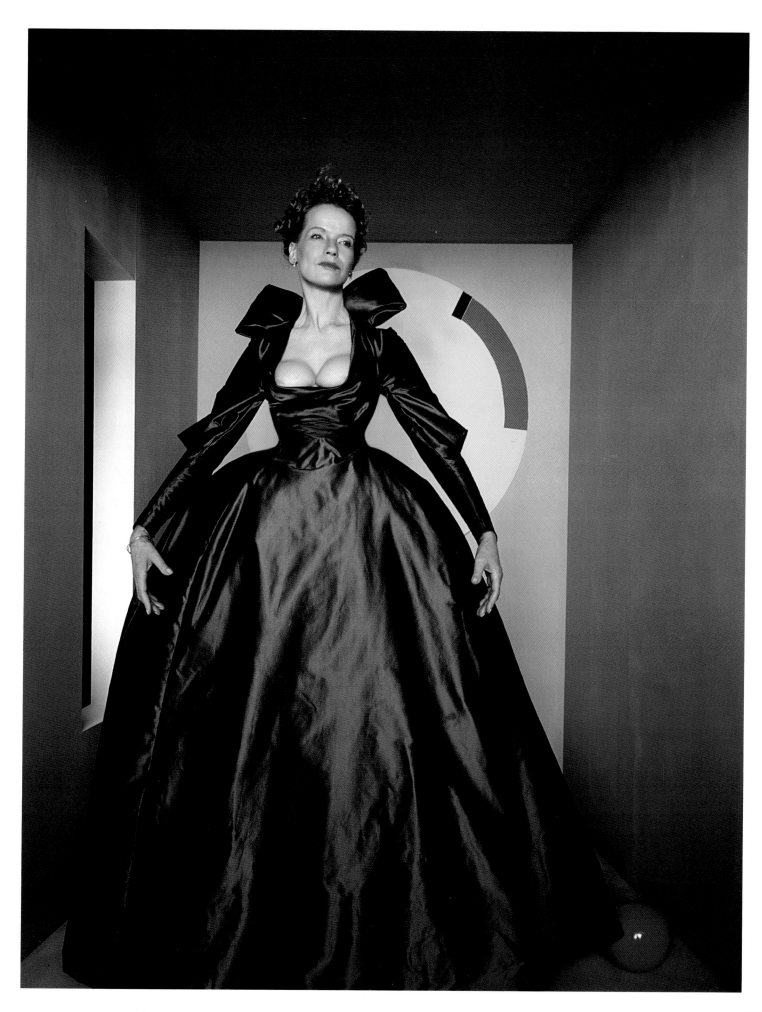

TIED TO THE MAST

SPRING/SUMMER 1998

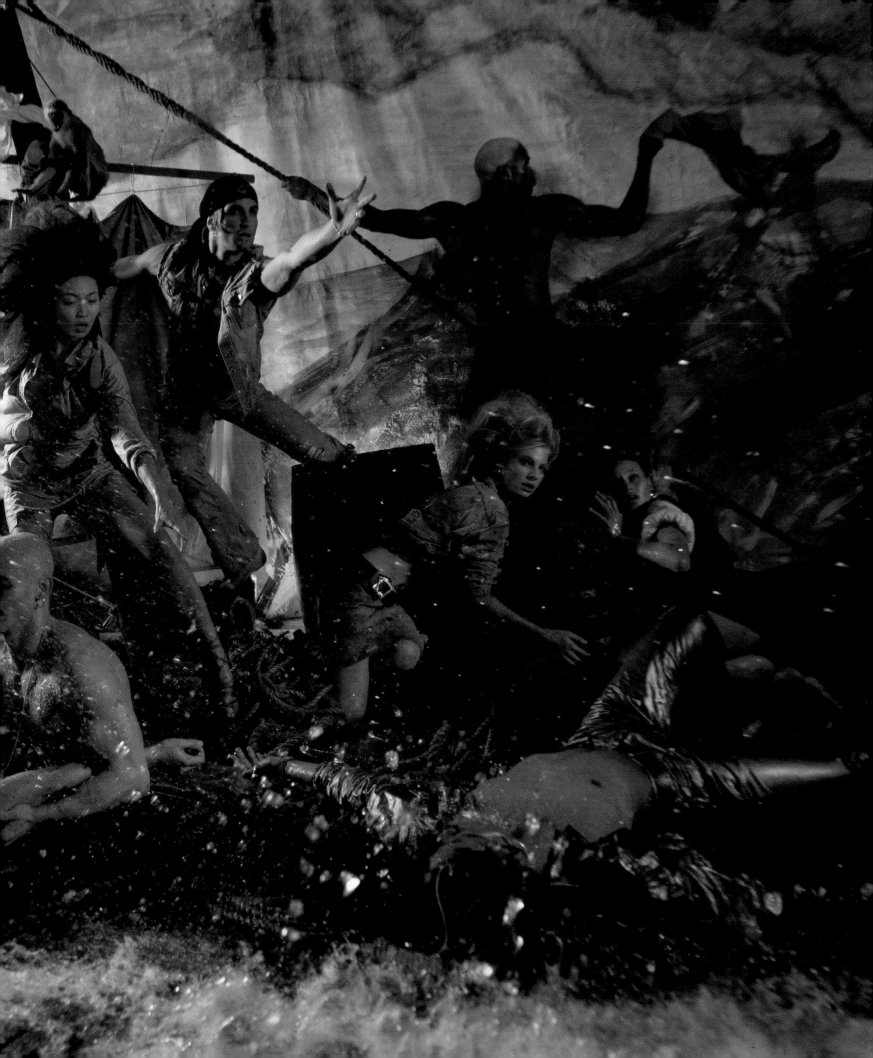

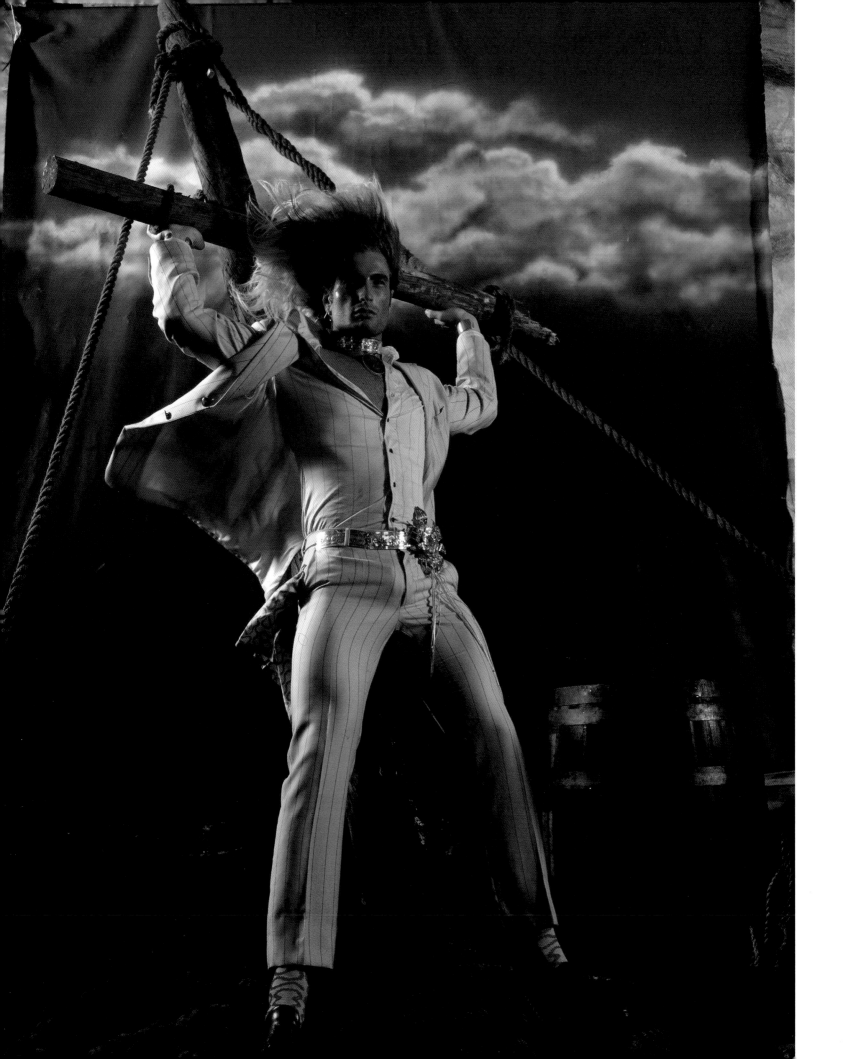

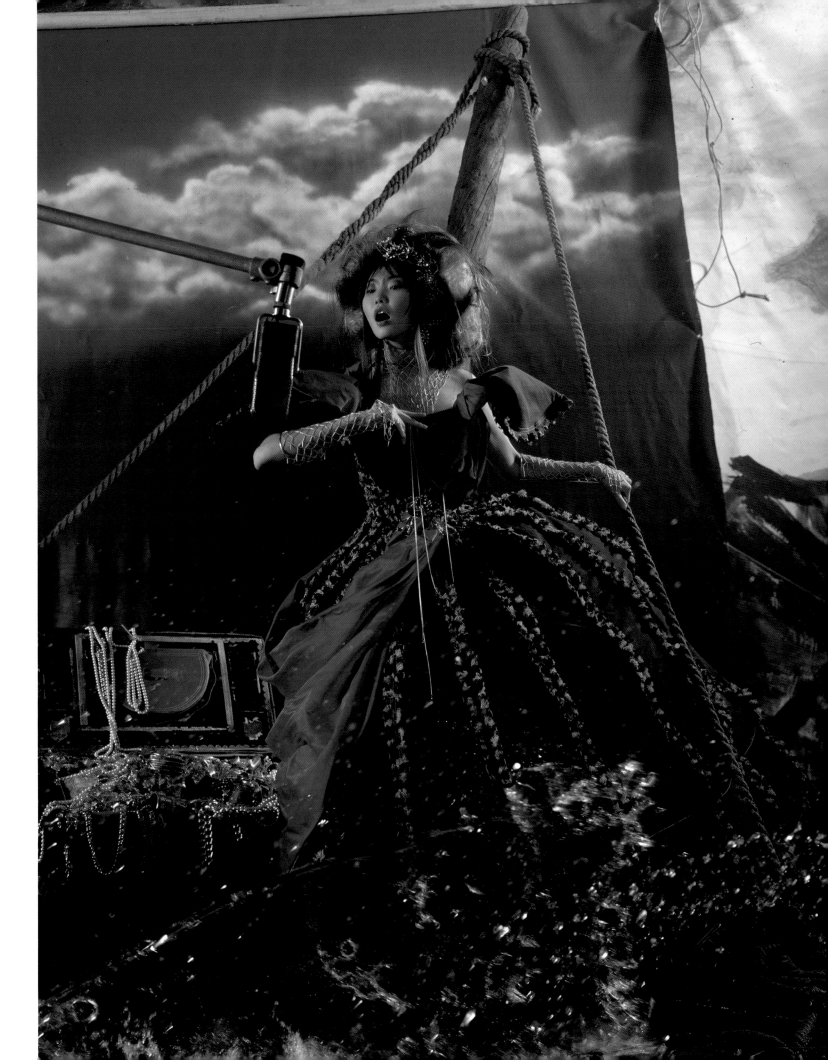

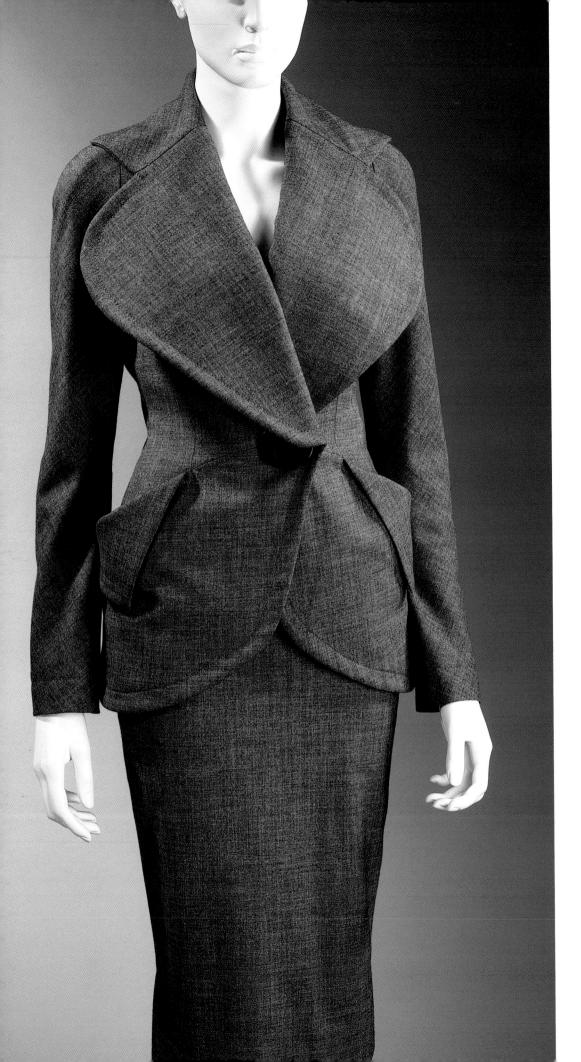

DRESSED TO SCALE

AUTUMN/WINTER 1998–9

This light grey stretch wool 'Amphora' jacket and pencil skirt achieved an hourglass look without padding in an exaggerated version of the 'Metropolitan' jacket. The enormous lapels which cover the torso and the huge button gave the collection its name. Westwood said: 'It was very popular. When we did that jacket, as soon as someone saw it, they wanted to try it on. As soon as they tried it they would buy it.'

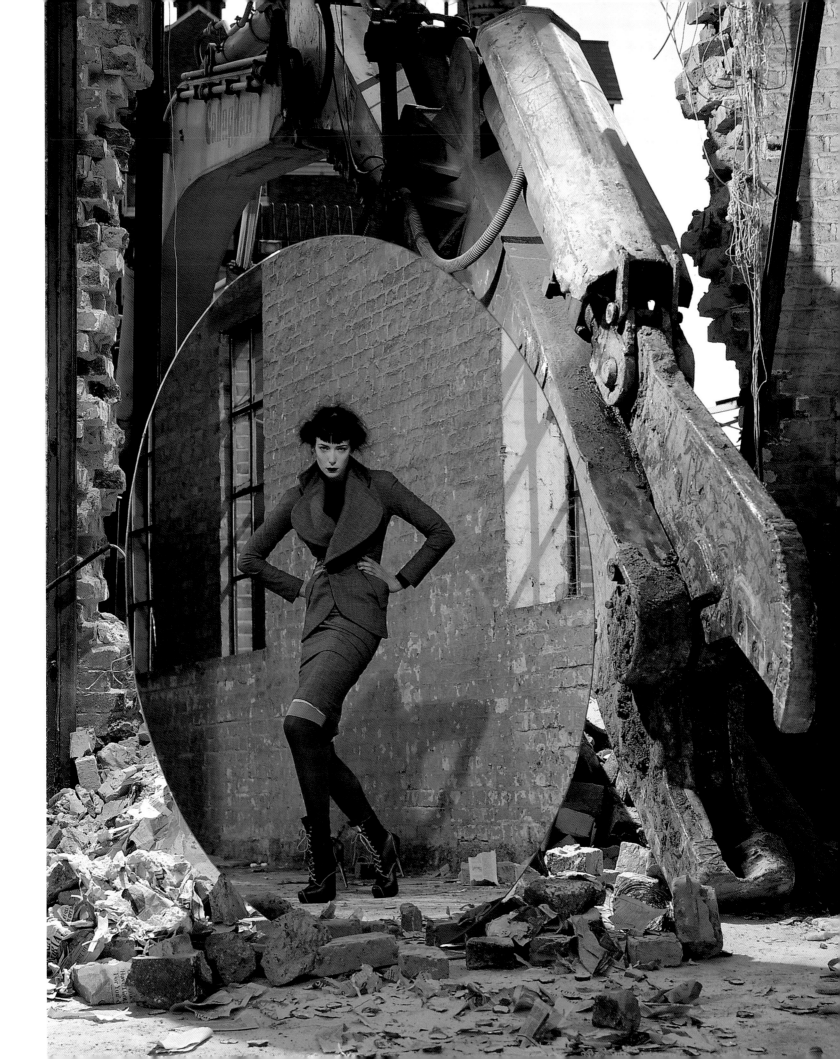

This jacket and skirt was designed by Andreas Kronthaler. Moving away from precision fitting to the body, the angular feel of the suit is achieved by piecing together geometric sections cut at different angles, utilizing both sides of the reversible, fine wool fabric.

SUMMERTIME

SPRING/SUMMER 2000

Right: Westwood started the 'Booze' jacket by working on the construction of the sleeve and the composition evolved in a complex series of folds emphasized by the subtle grain of the wool *mélange*.

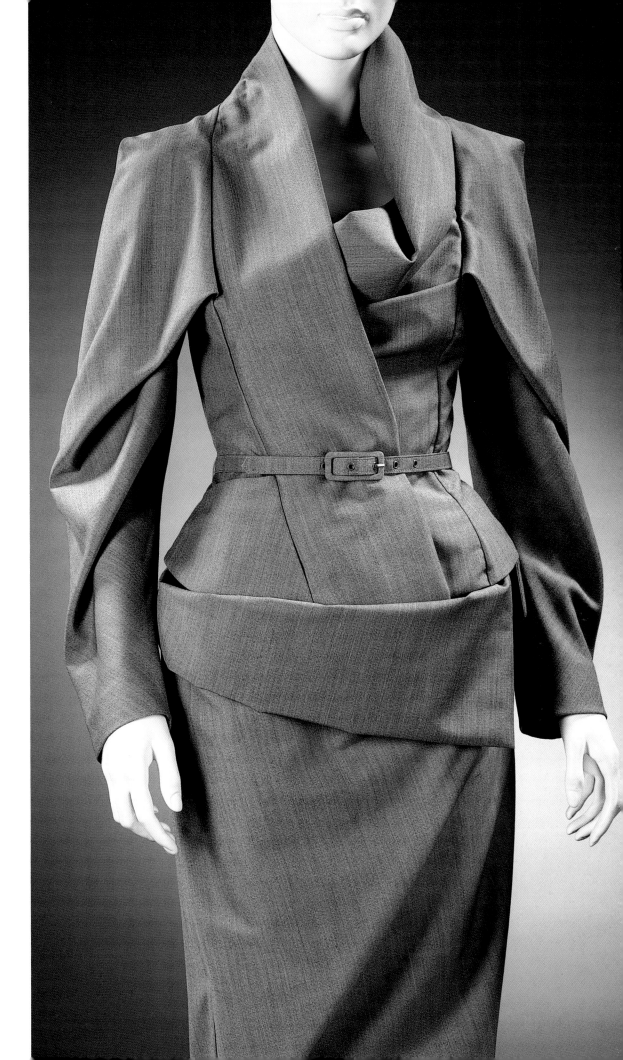

Vivienne
Westwood
LONDON

KRISTINA

Summertime backstage beauty shots

Gold Label Spring / Summer 2000
Paris, Jeu de Paume, 8 October 1999

183

EMIN FOR
WEST WOOD

EMIN FOR
VIVIENNE
WESTWOOD

TRACEY
EMIN
FOR
VIVEUNE
WESTWOOD

exploration

WILD BEAUTY

AUTUMN/WINTER 2001–2

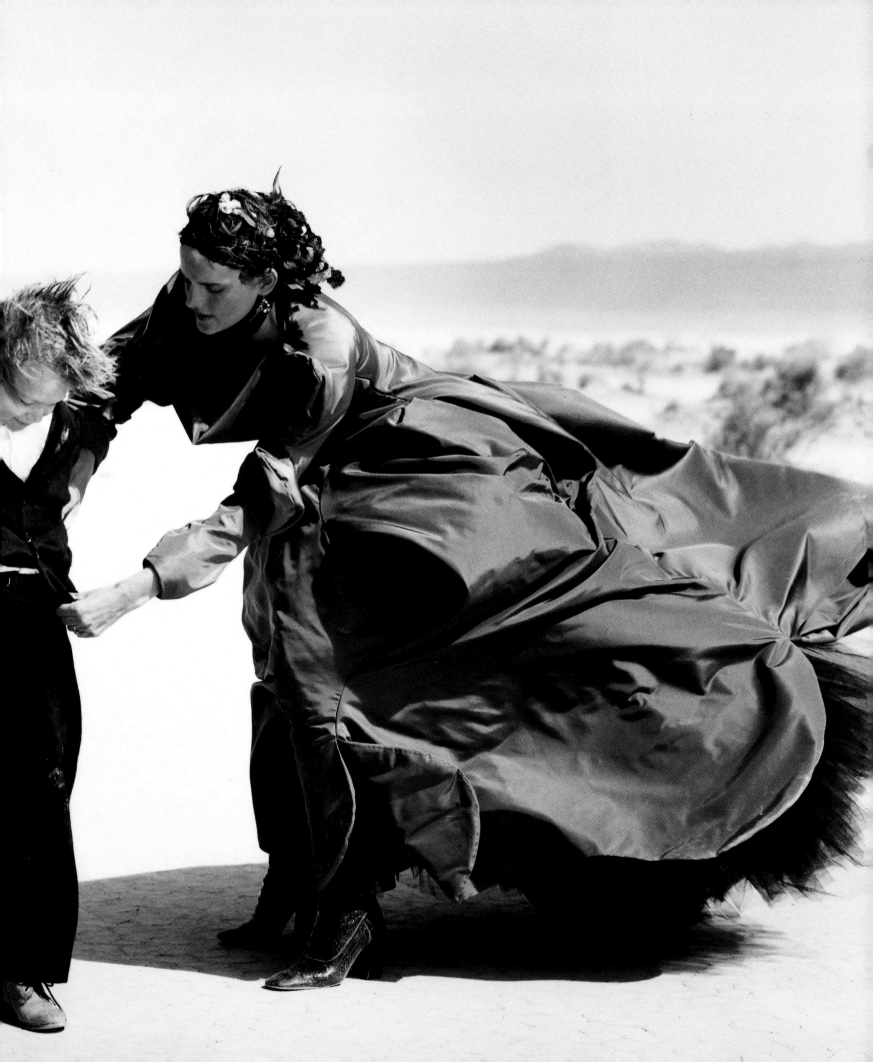

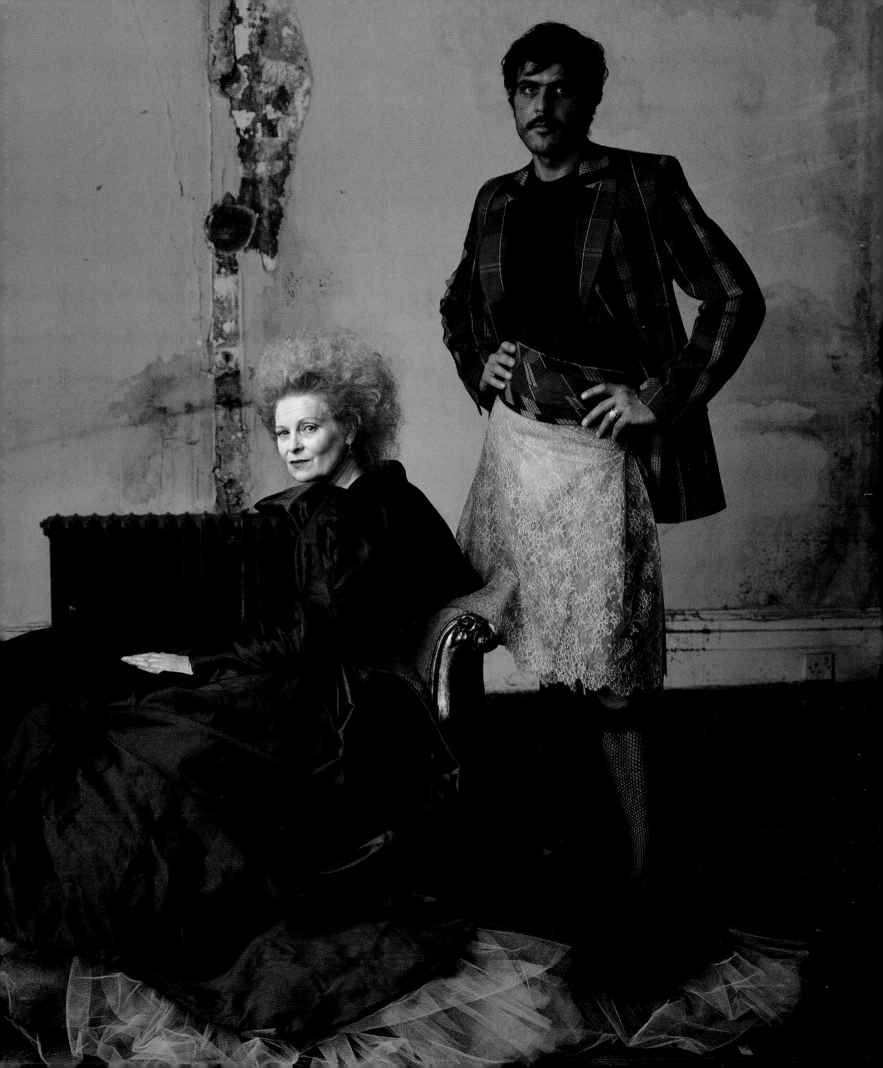

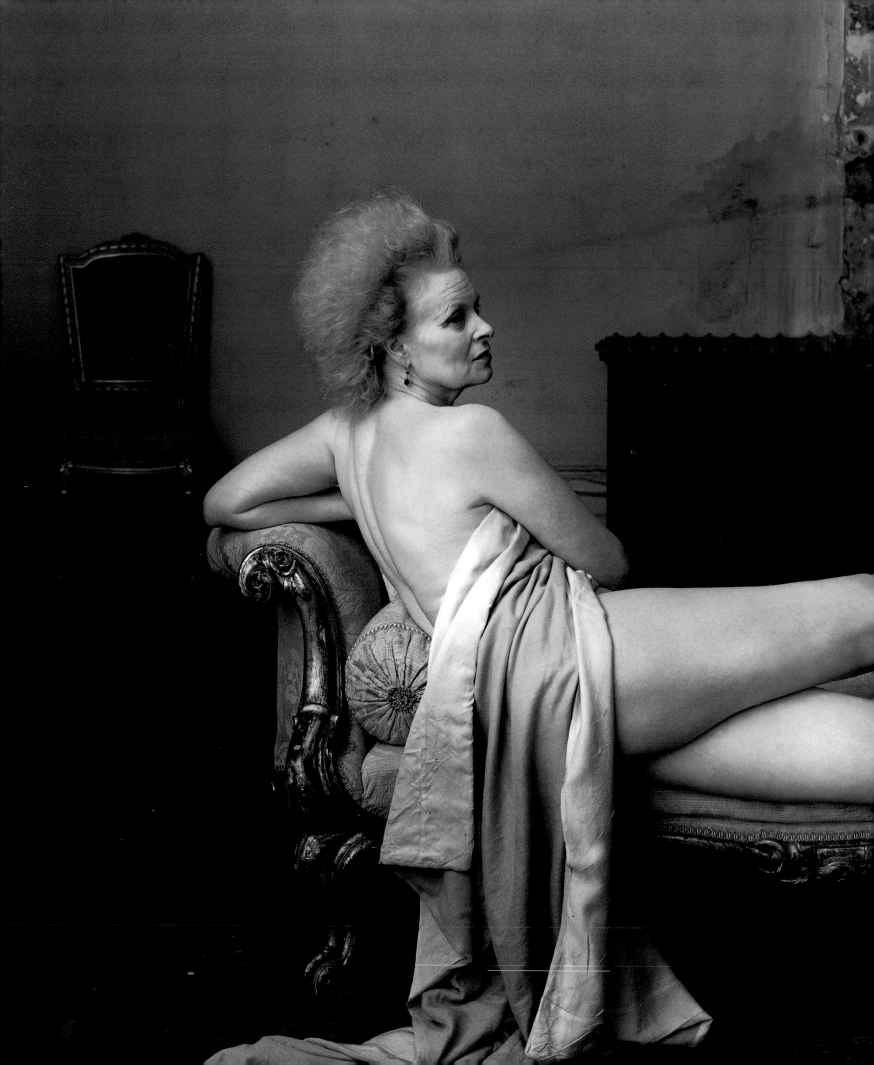

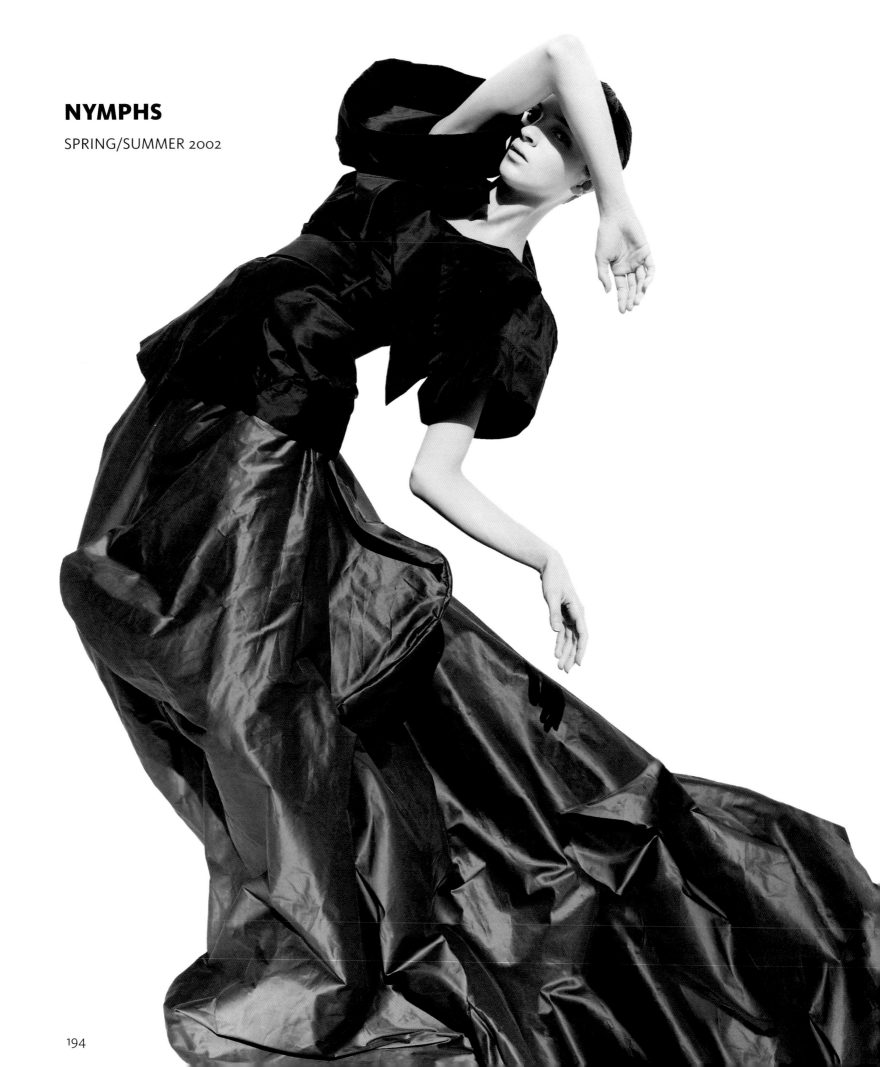

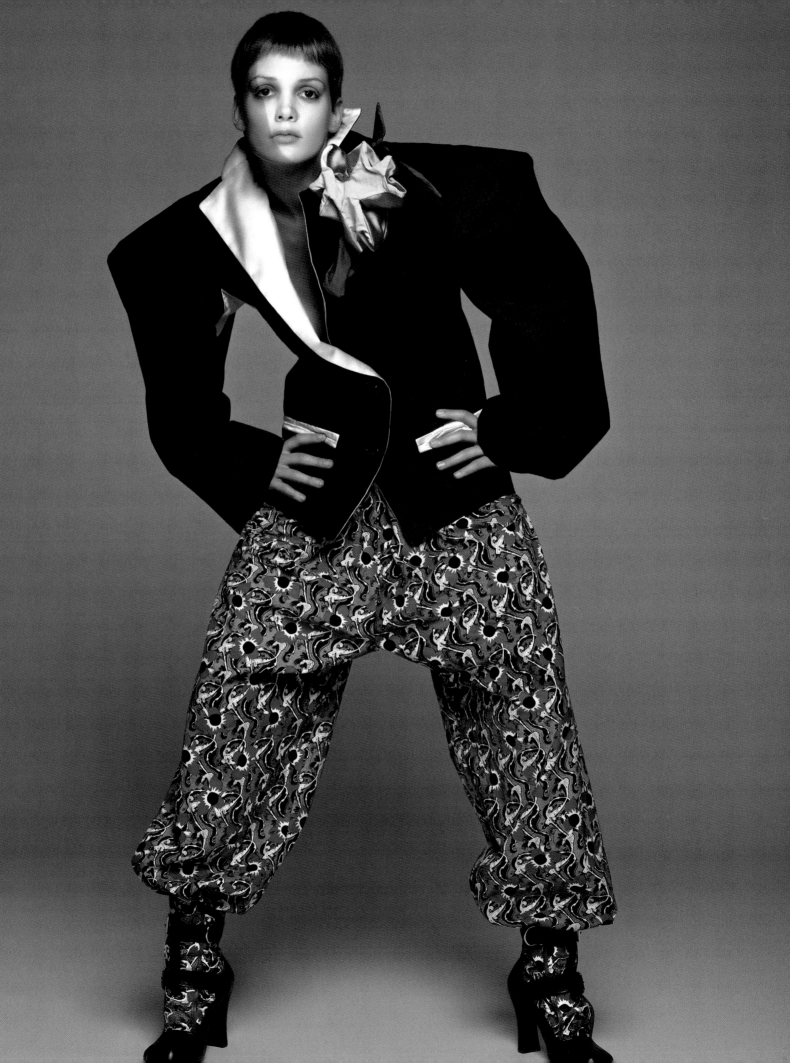

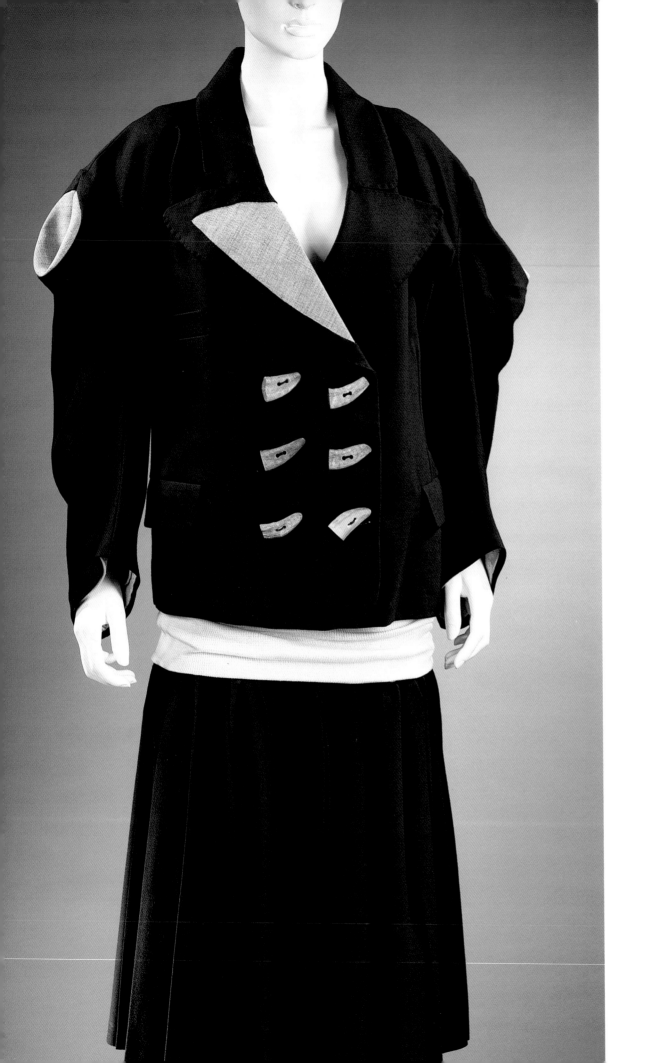

WITCHES
AUTUMN/WINTER 1983–4

Left: The double-breasted 'Chico' jacket (inspired by Chico Marx) first appeared in the Buffalo collection (A/W 1982–3) in sheepskin and corduroy. For Witches it was scaled up in navy wool, with square cut sleeves which hung off the shoulder. A single lapel and the shoulder points are constructed from stiff, undyed horsehair, pushed in to create a dimple. Westwood recalled: 'It was the first time I ever had this sleeve with this point in it. I thought the point was a bit too exaggerated and I made sure that you pushed it in.' The jacket fastens with horn buttons. The skirt is constructed from an adjustable length cotton jersey tube with navy wool pleats.

Right: Westwood has returned to various tailoring themes throughout her career. For Nymphs (S/S 2002) she designed the 'Box' jacket which incorporates the sleeve first used in Witches, with its wide square cut and collapsed shoulder point. The 'Round' wool skirt is pulled up to the side, creating an apron effect.

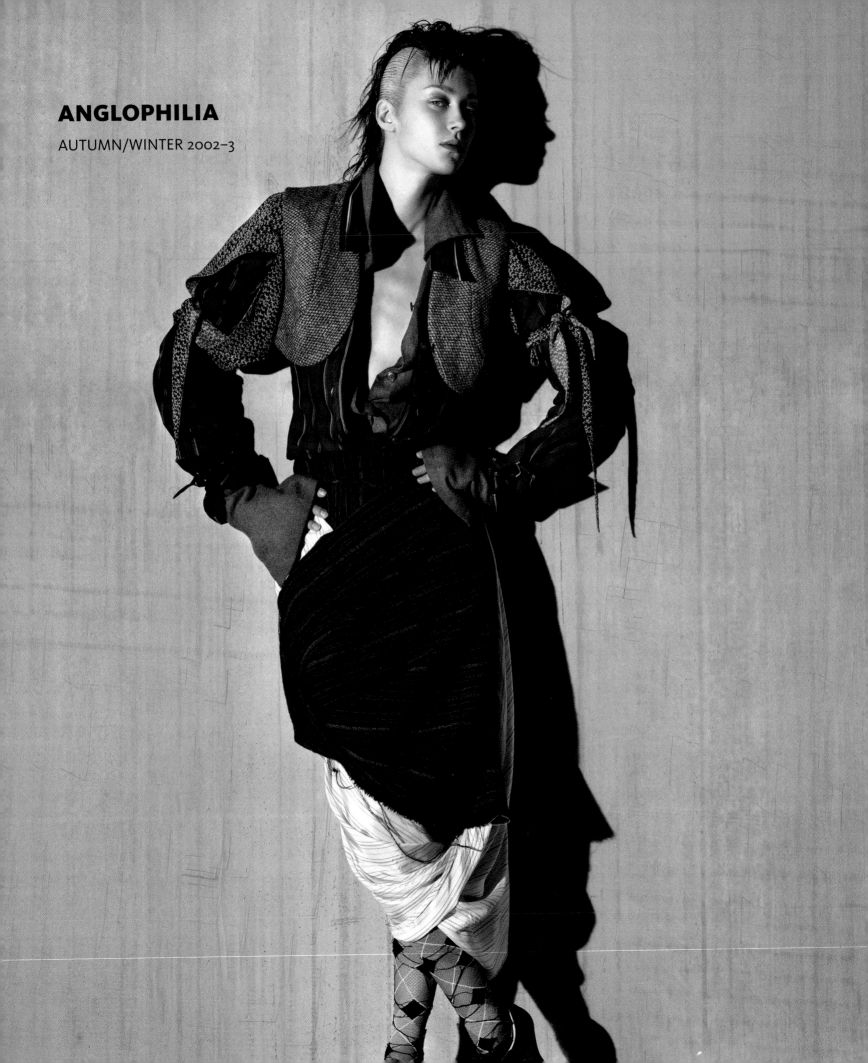

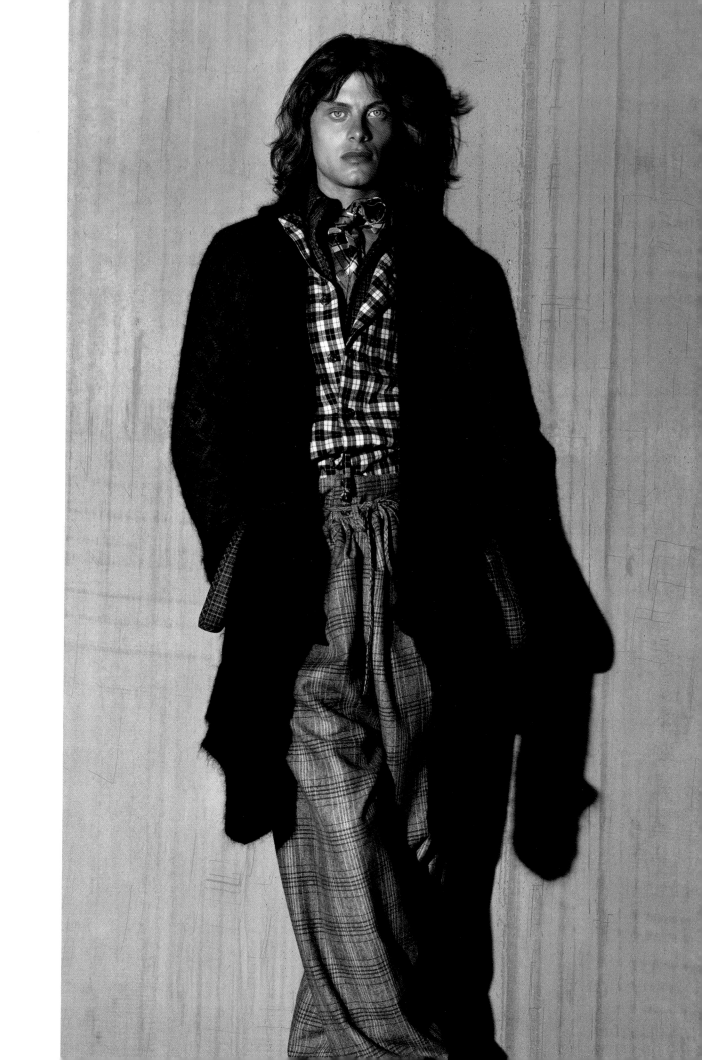

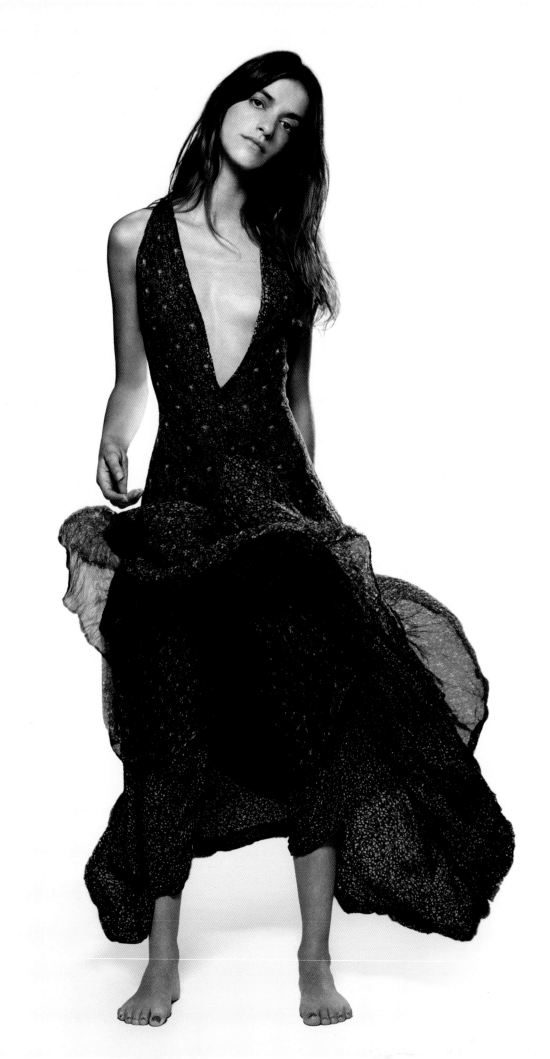

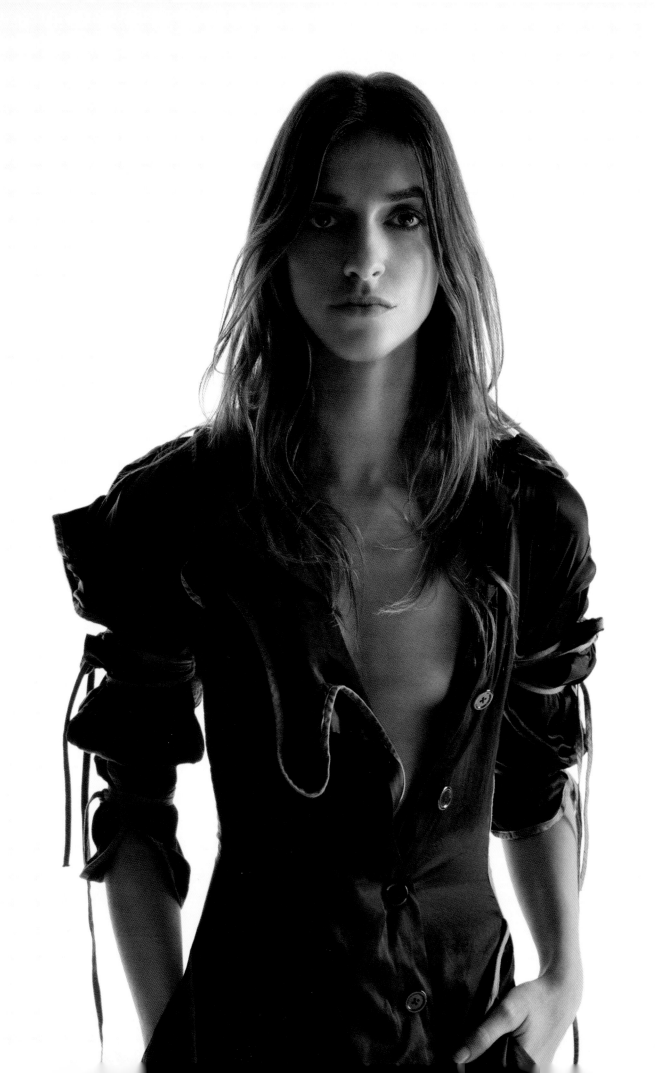

GLOSSARY

Argyle Originally hand-knitted and now usually machine-made knit with pattern of multicoloured diamonds based on the *tartan* of the Scottish clan Argyle. Commonly used on socks, scarves and sweaters.

Barathea Worsted or woollen fabric used for outer garments since the nineteenth century. Typically used in the twentieth century for making suits.

Bias Cut The fabric is cut diagonally across the warp and weft, imbuing it with stretch and cling. A popular style in the 1920s and '30s and a signature of French couturier Madeleine Vionnet.

Breeches Trousers worn to the knee, worn from the late sixteenth century to the early nineteenth century and continually as court dress.

Broderie Anglaise A form of embroidery originally created with a needle and thread but from the 1870s by machine. Characterized by white thread on a white background into a pattern of pierced round or oval holes and overcast.

Brothel Creepers Suede or leather shoes with a thick crêpe sole worn by *Teddy Boys*.

Busk A piece of stiffening material, usually whalebone, wood or steel, inserted into the front of stays from the sixteenth to the early nineteenth century.

Bustle A women's undergarment worn to support and extend the skirt to create fullness at the back or hips, made from a padded cushion which was either sewn into the back of the dress or attached to tapes which were then tied around the waist.

Cashmere Known since the fourteenth century and extensively used in Europe since the nineteenth century. An expensive fabric to produce, it is a rare natural fibre, combed from the fleece of the Kashmir goat found in Inner Mongolia, Turkey, Afghanistan, China, Iran and Iraq. It is often mixed with other fibres such as wool and made into luxury garments of coats, scarves and sweaters.

Chenille Yarn A tufted weft yarn, resembling a caterpillar, originating in France in the late seventeenth century, made of cotton, silk, rayon or wool. It is employed for both clothing and upholstery.

Circle Skirt Cut from one circular piece or two semi-circular pieces of fabric. Most popular in the 1950s when it was worn with layers of petticoat and associated with the rock 'n' roll era.

Corset A tight-fitting rigid undergarment relying on whalebone, stole or elastic to mould the female figure by maximizing or flattening the bust, waist and hips, according to the fashion of the time.

Crinoline A women's undergarment, originally a stiffened petticoat which extended the skirt. Introduced in the 1830s when the *bustle* was no longer sufficient to support the full skirts. They were made from *horsehair* fabric (known as 'crin', after the French for horsehair), cotton or linen with wood, metal or boned hoops.

Dart A pointed tuck sewn on the reverse of a garment to shape it into the lines of the body.

Dirndl Full skirt loosely gathered into the waistband to create soft pleats. Originally part of peasant costume originating in the Austrian Tyrol. It has been popular since the 1940s.

Dolman An outer garment worn by women in the late nineteenth century. A fusion between a jacket and a cape with the sleeves cut in one piece with the body of the garment.

Eyelet A lacing hole to take a cord or tape, to join parts of a garment or garments. Until the nineteenth century these were bound in silk thread, metal eyelets appeared after 1828.

Fetish/Bondage Wear Outfits usually made from rubber, leather or *PVC* including garments with a fetishistic or kinky appeal. Tightly-laced corsets, stockings and suspenders, *stiletto* heels, for example.

French Seam Narrow seam stitched first on right, then wrong side to conceal the raw edges, used chiefly on lingerie.

Frock Coat A men's single-breasted, knee-length coat worn from the eighteenth century to the present day, adapted from a working man's garment. Traditionally in wool but also cotton and linen for summer wear. It was adopted in the 1950s as part of the *Teddy Boy* sub-cultural dress.

Georgette A plain weave, lightweight, sheer fabric woven in highly twisted warp and weft yarns.

Gimp Wire or cord covered with silk.

Gingham A light or medium weight fabric originally made of *linen* and later cotton. It is woven from pre-dyed yarns into checks of various sizes. It was popular for dresses in the nineteenth century and became fashionable in the 1940s and '50s for dresses, blouses and skirts.

Grand Assiette (Large Plate) A sleeve construction dating back to the fourteenth century. Deep, round armholes are cut into the bodice of the garment into which the sleeves are set for ease of motion.

Gusset A small triangular- or diamond-shaped piece of fabric which is inserted in the seams of a garment to increase strength and facilitate movement.

H-line Introduced by Christian Dior in 1954, this dress style pushed the bust up as high as possible and dropped the waist to hip level.

Hacking Jacket A fitted, single-breasted jacket which is flared from the waist and has a single back vent. Worn since the nineteenth century, originally for riding, and adapted as a fashion garment during the latter half of the twentieth century.

Harris Tweed Originally hand-loomed from woollen yarns and dyed with vegetable dye by the inhabitants of the Scottish Outer Hebrides Islands of Barra, Harris, Lewis and Uist. A soft, thick tweed which was exported to the mainland during the 1840s and since then has been used to make coats, jackets, and suits for both men and women.

Haute Couture 'Chambre Syndicale de la Couture Parisienne' is the union under which couture designers show, and was established in 1910. Haute Couture is high quality, labour-intensive and costly fashion design and construction which is presented to the press for Spring/Summer and Autumn/Winter seasons. It utilizes specialists who make accessories and trimmings. The French word 'couture' means sewing or needlework.

Horsehair The hair of horse used as a fabric or fibre; usually a stiff woven, transparent fabric used for hats and stiffening.

Hunter's Pink Any of the various colours used for hunting coats; chiefly, bright red and dull scarlet.

Jacquard Created by a jacquard loom; a decorative weave used for brocades and damasks since the mid-nineteenth century.

Jersey Soft, stretchable knitted fabric made of cotton, nylon, rayon, wool or synthetic fibres. Used in the late nineteenth century for sportswear and outer garments. It was pioneered by Chanel in the 1920s for daywear.

Juste-au-corps/ Justaucorps A close-fitting, long skirted coat or doublet of the seventeenth and eighteenth centuries.

Liberty Bodice A child's undergarment for the upper body, designed and marketed by the Symington corset manufacturers from 1908 to 1974. Made of knitted cotton fabric and strengthened by cloth strapping and buttoning at the front.

Linen A name used for any fabric made from flax fibre obtained from the plant. It can vary in weight and texture. Commonly used throughout the nineteenth century for underwear and became popular during the twentieth century for women's and men's outerwear.

Manteau A cloak, cape, wrap or mantle; an obsolete word for a woman's gown.

Melton A popular fabric for men's and later women's coats in the nineteenth century. A thick, wool fabric in twill or satin weave which has a smooth surface.

Moleskin A fabric with a soft thick nap resembling the fur of a mole.

Paletot Loose-fitting, unwaisted outdoor garments worn by men and women in the second half of the nineteenth century.

Pantaloons A tight-fitting men's trouser, originating in the 1790s, displaying the musculature of the body, emulating classical statuary. Made of *jersey*, *bias-cut* cloth and soft supple leather and descending to mid-calf or ankle; usually tied or buttoned at the ends.

Pencil Skirt Popular in the 1940s when economical cloth measurements were in use, though not given its name until the 1950s. It is a skirt cut in one straight line from the hips to the hem, with a slit or pleat in the centre back.

Peplum A short skirt addition sewn onto the bodice of a dress or jacket, it is either pleated, *bias-cut* or gathered onto the hem of the bodice. Also known as a basque.

Platform A thick sole shoe introduced in the 1930s and fashionable in almost every decade since. Made of wood, cork and plastic.

Poplin From the fabric papalino, made in the papal town of Avignon in France. Originally made of silk warp and wool weft; now made from a combination of silk, cotton, wool and man-made fibres making a strong, plain-woven fabric with a corded effect. It is hard-wearing and is used mostly for summer outerwear.

Pourpoint A quilted garment. Worn with armour or civilian clothes from the thirteenth to seventeenth century.

PVC Polyvinylchloride, a fabric originally developed in 1844 during experiments with oilcloth. It is chemically related to linoleum and became fashionable in the 1960s when it was dyed in bright colours for outerwear.

Raglan Style of coat and sleeve named after Lord Raglan (1788–1855). The sleeve extends from the neckline to the wrist and is joined to the body of the garment by diagonal seams from the neck to under the arms and the body; originally a feature of the short woollen raglan coat, but since the late nineteenth century it has appeared on a range of garments.

Revers The turned-back edgings of a coat, waistcoat or bodice.

Rococo Extravagant and exaggerated style, usually consisting of an irregular assemblage of scrolls and conventional shellwork. Rococo embroidery is often worked with narrow ribbons.

Run and Fell Seam A method of joining two pieces of material. The two pieces of fabric are joined together with a running stitch and then one of the pieces is cut down to half length and the longer piece turned over it and hemmed.

Sack-Back An eighteenth-century gown characterized by its sinuous back pleats. Adopted from the French, the dress was well-suited to displaying fashionable, large-scale damasks and brocades. Also commonly known as a 'robe à la française'. Can also be spelt 'Sac Back' or 'Saqcue Back'.

Savile Row A London street at the heart of English bespoke tailoring since the 1800s.

Selvedge The lengthways edge of a woven fabric which is finished so that it will not ravel. Usually cut away in the making of a garment.

Slash To cut a slit in a garment, sometimes to show a contrasting colour beneath or simply to create patterns, used most effectively with closely-woven fabrics that do not fray easily.

Spandex Man-made fibre introduced in 1958 by Du Pont. The material has high stretch, strong yet lightweight characteristics and is used for swimwear and lingerie.

Stays The precursor of the corset, developed in the sixteenth century. Stays had their origin in the boned lining of the bodice and were intended to provide support and to mould the female torso. Constructed of layers of robust linen or cotton with built-in stiffeners of whalebone.

Stiletto Made of nylon and plastic covering a steel core which makes a high narrow heel, originating in Italy during the 1950s.

Suiting Fabric with enough body to be tailored successfully, usually sturdy, firm wool or cotton.

Tailored Having simple trim, fitted lines obtained by careful cutting, seaming and pressing. Characterized by masculine details and concealed seams.

Tartan Originating in Scotland with different patterns identifying individual clans. It is a closely woven woollen cloth which is cross-banded with coloured stripes which create checked widths, notably used for kilts. Fashionable in the 1840s when Queen Victoria established her estate at Balmoral in Scotland and in the late twentieth century.

Teddy A term for slim-fitting cami-knickers, in use in America since the 1920s and in Britain since the 1960s.

Teddy Boys A youth sub-culture centred around working class areas of London, notable for the adoption of Edwardian, upper-class tailoring with added features of American origin. Single-breasted, long fitted jackets often featuring velvet trim on the collar or cuffs were worn with narrow trousers and fancy brocaded waistcoats. Accessories included the cowboy's 'maverick' tie, *brothel creepers* or winklepickers, fluorescent socks and the quiff.

Toile A model or pattern of a garment, made up in a cheaper fabric, usually muslin or calico, for a fitting or for making copies from.

Top-Stitching A line or lines of stitching sewn from the right side, or top, of a fabric. Usually used decoratively or to prevent the lining from being seen.

Tweed A rough-textured fabric, woven from wool in a variety of coloured patterns. The name has associations with the River Tweed, a large centre for the weaving industry in the nineteenth century.

Twinset A matching jumper and cardigan worn by women since the 1940s. In the classic twinset both garments are usually plain and the jumper has short sleeves while the cardigan has long sleeves.

Yoke Fitted portion of a garment, usually over shoulders or hips, to which the rest of the garment is sewn.

Zoot Suit A wide-shouldered, knee-length jacket with a narrow waist and drape at the back. Worn with baggy trousers which were wide from the waist to the knee and tapered at the bottom. Commonly worn by Mexican-Americans and African-Americans in America in the 1940s and '50s and usually made of brightly coloured fabrics. The look formed a street style known as the 'Zooties'.

BIBLIOGRAPHY

Arnold, Janet, *Patterns of Fashion: English women's dresses and their construction, c.1660–1860* (London: Macmillan, 1964)

Arnold, Janet, *A Handbook of Costume* (London: Macmillan, 1973)

Arnold, Janet, *Patterns of Fashion: The cut and construction of clothes for men and women, c.1560–1620* (London: Macmillan, 1985)

Ash, Juliet and Elizabeth Wilson, eds, *Chic Thrills: A Fashion Reader* (London: Pandora, 1992)

Baines, Barbara, *Revivals in Fashion from the Elizabethan Age to the Present* (London: Batsford, 1981)

Barnes, Richard, *Mods!* (London: Plexus, 1994)

Barthes, Roland, *The Fashion System* (London: Jonathan Cape, 1985)

Boucher, François, *A History of Costume in the West* (London: Thames and Hudson, 1996)

Breward, Christopher, Becky Conekin and Caroline Cox, eds, *The Englishness of English Dress* (Oxford & New York: Berg, 2002)

Breward, Christopher, *The Culture of Fashion: a new history of fashionable dress* (Manchester: Manchester University Press, 1994)

Breward, Christopher, *Fashion* (Oxford: Oxford University Press, 2003)

Colegrave, Stephen and Chris Sullivan, eds, *Punk* (London: Cassell, 2001)

Coleman, Elizabeth A., *The Genius of Charles James* (Brooklyn: Brooklyn Museum, 1982)

Cunnington, C. Willett and Phillis Emily Cunnington, *Handbook of English Costume in the Nineteenth Century* (3rd ed.), with illustrations by Phillis Cunnington, Cecil Everitt and Catherine Lucas (London: Faber, 1970)

Cunnington, C. Willett and Phillis Emily Cunnington, *Handbook of English Costume in the Eighteenth Century*, with illustrations by Barbara Phillipson and Phillis Cunnington (London: Faber, 1972)

Davies, Stephanie, *Costume Language: A Dictionary of Dress Terms* (Malvern: Cressrelles, 1995)

De la Haye, Amy, ed., *The Cutting Edge: Fifty Years of British Fashion 1947–1997* (London: V&A Publications, 1996)

De la Haye, Amy and Shelly Tobin, *Chanel: The Couturière at Work* (London: V&A Publications, 1994)

De la Haye, Amy and Cathie Dingwall, eds, *Surfers, Soulies, Skinheads and Skaters: subcultural style from the forties to the nineties* (London: V&A Publications, 1996)

De la Haye, Amy and Elizabeth Wilson, eds, *Defining Dress: dress as object, meaning and identity* (Manchester: Manchester University Press, 1999)

Demornex, Jacqueline, *Fashion Memoir: Madeleine Vionnet* (London: Thames and Hudson, 1996)

Evans, Caroline and Minna Thornton, eds, *Women and Fashion: A New Look* (London: Quartet Books, 1989)

Ewing, Elizabeth, *History of Twentieth-Century Fashion* (London: Batsford, 1974)

Fairchild, John, *Chic Savages* (London: Simon and Schuster, 1989)

Frankel, Susannah, *Visionaries: interviews with fashion designers* (London: V&A Publications, 2001)

Gaines, Jane and Charlotte Herzog, eds, *Fabrications: Costume and the Female Body* (London: Routledge, 1991)

Glynn, Prudence, *Skin to Skin: Eroticism in Dress* (Oxford: Oxford University Press, 1983)

Gorman, Paul, *The Look: Adventures in Pop and Rock Fashion*, foreword by Malcolm McLaren (London: Sanctuary, 2001)

Hart, Avril and Susan North, *Historical Fashion in Detail: the 17th and 18th centuries* (London: V&A Publications, 1998)

Hennessy, Val, *In the Gutter* (London: Quartet Books, 1978)

Hollander, Anne, *Seeing Through Clothes* (Berkeley, Los Angeles & London: University of California Press, 1993)

Hollander, Anne, *Sex and Suits* (New York: Knopf: Distributed by Random House, 1994)

Jones, Terry, ed., *Smile I-D: Fashion and Style. The Best from 20 Years of I-D* (Cologne: Taschen, 2001)

Jones, Terry and Avril Mair, *Fashion Now* (Cologne: Taschen, 2003)

Koda, Harold, *Goddess: The Classical Mode* (New Haven & London: Yale University Press, 2003)

Krell, Gene, *Fashion Memoir: Vivienne Westwood* (London: Thames and Hudson, 1997)

Kyoto Fashion Institute, *Fashion: A History from the 18th to the 20th Century* (Cologne: Taschen, 2002)

Laver, James, Amy de la Haye and Andrew Tucker, *Costume and Fashion: A Concise History* (London: Thames and Hudson, 2002)

Mansfield, Alan and Phillis Cunnington, *Handbook of English Costume in the Twentieth Century, 1900–1950* with illustrations by Valerie Mansfield (London: Faber, 1973)

Martin, Richard and Harold Koda, *Christian Dior* (New York: The Metropolitan Museum of Art, 1996. Distributed by Harry N. Abrams, Inc.)

Martin, Richard et al, *The Fashion Book* (London: Phaidon, 1998)

McDermott, Catherine, *Streetstyle: British Design in the Eighties* (London: The Design Council, 1987)

McDermott, Catherine, *Vivienne Westwood* (London: Carlton, 1999)

McDowell, Colin, *Fashion Today* (London: Phaidon, 2003)

Mendes, Valerie and Amy de la Haye, *20th-Century Fashion* (London: Thames and Hudson, 1999)

Muggleton, David, *Inside Subculture: The Postmodern Meaning of Style* (Oxford & New York: Berg, 2000)

Mulvagh, Jane, *Vivienne Westwood* (London: Thames and Hudson, 1998)

Museum of London, *Vivienne Westwood: A London Fashion* (London: Museum of London in association with Philip Wilson Publishers, 2000)

Pochna, Marie France, *Fashion Memoir: Dior* (London: Thames and Hudson, 1996)

Polhemus, Ted, *Street Style: from sidewalk to catwalk* (London: Thames and Hudson, 1994)

Pratt, Lucy and Linda Woolley, *Shoes* (London: V&A Publications, 1999)

Reid, Jamie and Jon Savage, *Up They Rise* (London: Faber, 1987)

Ribeiro, Aileen, *The Eighteenth Century: a visual history of costume* (London: Batsford, 1983)

Ribeiro, Aileen, *Dress in Eighteenth-Century Europe 1715–1789* (London: Batsford, 1984)

Ribeiro, Aileen, *The Art of Dress: Fashion in England and France, 1750–1820* (New Haven & London: Yale University Press, 1995)

Ribeiro, Aileen, *The Gallery of Fashion* (London: The National Portrait Gallery, 2000)

Ribeiro, Aileen, *Dress and Morality* (New York: Berg, 2002)

Ribeiro, Aileen and Valerie Cumming, *The Visual History of Costume* (London: Batsford, 1989)

Rothstein, Natalie, ed., *Four Hundred Years of Fashion* (London: V&A Publications, 1984)

Savage, Jon, *England's Dreaming: The Sex Pistols and Punk Rock* (London: Faber and Faber, 1991)

Simon, Marie, *Fashion in Art: The Second Empire and Impressionism*, epilogue by Vivienne Westwood (London: Zwemmer, 1995)

Steele, Valerie, *Women of Fashion: twentieth-century designers* (New York: Rizzoli, 1994)

Steele, Valerie, *The Corset: A Cultural History* (New Haven & London: Yale University Press, 2001)

Townsend, Chris, *Rapture: Art's Seduction by Fashion* (London: Thames and Hudson, 2002)

Vermorel, Fred, *Fashion and Perversity: A life of Vivienne Westwood and the sixties laid bare* (London: Bloomsbury, 1996)

Watson, Linda, *Vogue: Twentieth-Century Fashion* (London: Carlton, 2000)

Waugh, Norah, *Corsets and Crinolines* (London: Routledge, 1981)

Waugh, Norah, *The Cut of Men's Clothes 1600–1900* (London: Routledge, 1994)

Wilcox, Claire, ed., *Radical Fashion* (London: V&A Publications, 2001)

Wilcox, Claire and Valerie Mendes, *Modern Fashion in Detail* (London: V&A Publications, 1991)

Wilson, Elizabeth, *Adorned in Dreams: Fashion and Modernity* (London: Virago, 1985)

York, Peter, *Style Wars* (London: Sidgwick and Jackson, 1980)

NOTES

Unless otherwise stated, quotations from Vivienne Westwood are from conversations with the author, 2003.

1. Fairchild, John, *Chic Savages* (London, 1989), p.34.
2. Steele, Valerie, *Women of Fashion: twentieth-century designers* (New York, 1991), p.158.
3. Jones, D., 'Royal Flush', *I-D* (August 1987), p.59.
4. Laver, James, *Style in Costume* (London and New York, 1949), p.6.
5. Savage, Jon, *England's Dreaming: Sex Pistols and Punk Rock* (London, 1991), p.20.
6. Cleave, Maureen, 'Queen of the King's Road', unidentified magazine, p.34.
7. Mulvagh, Jane, *Vivienne Westwood: an unfashionable life* (London, 1998), p.36.
8. Cleave, 'Queen of the King's Road', p.34.
9. Savage, *England's Dreaming: Sex Pistols and Punk Rock*, p.24.
10. *The Society of the Spectacle*, 1967: 221 numbered paragraphs of compacted prose described by Jon Savage in *England's Dreaming* as 'a brilliant collage of avant-garde art, Marxist theory and existential obnoxiousness' (p.31). The Situationist International movement was founded in France in the late 1950s.
11. Mulvagh, *Vivienne Westwood: an unfashionable life*, p.29
12. Savage, Jon, 'Rich pickings at the Worlds End...', *The Face* (9 January 1981), p.25.
13. And was one of the first shops to sell screen printed T-shirts. The designs included Disney motifs, and Disney later bought back the rights because the T-shirts were so successful.
14. Mulvagh, p.47.
15. Ibid., p.31.
16. William English, quoted by Mulvagh, p.53.
17. Bernardi, David, 'Vivienne Westwood' *Flash Art* (Jan/Feb 1992), p.160.
18. Cleave, p.34.
19. Savage, *The Face* (9 January 1981), p.25.
20. Savage, *England's Dreaming: Sex Pistols and Punk Rock*.
21. Watson, Shane, 'Designer of a Decade', *Elle* (November 1985), p. 58.
22. Savage, *The Face* (9 January 1981), p.25.
23. McDermott, Catherine, *Streetstyle: British Design in the Eighties* (London, 1987), p.26.
24. Stanfill, Sonnet, interview with Michael Costiff, 2003 (unpublished).
25. Evans, Caroline and Minna Thornton, eds, 'Women and Punk', *Women and Fashion: A New Look* (London, 1989), p.20.
26. York, Peter, 'The Post-Punk Mortem', *Harpers & Queen* (July 1977), p.106.
27. 'Malcolm McLaren: You ask the questions', *The Independent* (12 January 2000).
28. Savage, *The Face* (9 January 1981), p.25.
29. The type of fabric worn by railway guards.
30. Savage, *The Face* (9 January 1981), p.25.
31. Paul Cook, 'They wear her well', interviewed by Dee O'Connell in *Life, The Observer Magazine* (8 April 2001), p.16.
32. Savage, *The Face* (9 January 1981), p.25.
33. Breward, Christopher, *Fashion* (Oxford, 2003), pp.196-7.
34. McDermott, Catherine, 'Vivienne Westwood: ten years on', *I-D* (February 1986), p.12.

35. Gill, Alison, 'Deconstruction Fashion: the making of unfinished, decomposing and re-assembled clothes', *Fashion Theory* (March 1998), vol.1, p.33.
36. Steele, *Women of Fashion: twentieth-century designers*, p.157.
37. McDermott, *I-D* (February 1986), p.12.
38. Ibid.
39. Ibid.
40. Savage, *The Face* (9 January 1981), p.25.
41. McDermott, *I-D* (February 1986), p.12.
42. Ibid.
43. Sutton, Tara, 'A conversation with Vivienne Westwood', unidentified source.
44. Franklin, Caryn, 'Rule Britannia', *I-D* (March 1987), p.74.
45. Waugh, Norah, *The Cut of Men's Clothes 1600–1900* (London, 1964).
46. Webb, Iain R., 'First Lady', *Blitz* (May 1986), p.77.
47. Savage, *The Face* (9 January 1981), p.26.
48. Mulvagh, p.142.
49. Ibid., p.154.
50. Stanfill, interview with Michael Costiff.
51. Ibid.
52. Savage, *The Face* (9 January 1981), p.25.
53. Ash, Juliet, 'Sex is Fashion Fashion is Sex', *2G magazine* (1986).
54. Franklin, *I-D* (March 1987), p.74.
55. McDermott, *Streetstyle: British Design in the Eighties*, p.24.
56. Valerie Mendes in conversation with the author, 2003.
57. McDermott, *Streetstyle: British Design in the Eighties*, p.34.
58. Ibid., p.28.
59. Cleave, p.36.
60. Ibid., p.32.
61. See Coleman, Elizabeth A., *The Genius of Charles James* (Brooklyn: Brooklyn Museum, 1982).
62. Steele, Valerie, *Fifty years of Fashion, New Look to Now* (New Haven and London, 1979), p.128.
63. Valerie Mendes in conversation with the author, 2003.
64. Cleave, p.31.
65. Made by the jeweller Tom Binns.
66. McDermott, *I-D* (February 1986), p.12.
67. Ibid.
68. Webb, *Blitz* (May 1986), p.76.
69. Ibid.
70. Franklin, *I-D* (March 1987), p.74.
71. McDermott, *I-D* (February 1986), p.12.
72. Franklin, *I-D* (March 1987), p.74.
73. McDermott, *I-D* (February 1986), p.12.
74. Franklin, *I-D* (March1987), p.74.
75. De la Haye, Amy, ed., *The Cutting Edge: Fifty Years of British Fashion 1947–1997* (London, 1996), p.198.
76. Jones, *I-D* (August 1987), p.62.
77. Franklin, *I-D* (March 1987), p.74.
78. Webb, Iain R., 'Why Westwood rules the runways', *Elle* (February 2003), p.121.
79. Steele, Valerie, *The Corset: a cultural history* (Yale, 2001), p.166.
80. Jane Mulvagh's phrase.
81. Jones, *I-D* (August 1987), p.55.
82. Ibid., p.57.
83. Bernardi, *Flash Art* (Jan/Feb 1992), p.161.

84. Hollander, Anne, *Sex and Suits* (New York: Knopf: Distributed by Random House, 1994).
85. Hume, Marion, 'Portrait of a former Punk', *Vogue* (September 1994), p.194.
86. 'Vivienne Westwood: You ask the questions', *The Independent* (21 February 2001), p.7.
87. Museum of London, *Vivienne Westwood: A London Fashion* (London, 2000), p.51.
88. Epilogue by Vivienne Westwood in Marie Simon, *Fashion in Art: The Second Empire and Impressionism* (London, 1995), p.238.
89. De la Haye, ed., *The Cutting Edge*, p.198.
90. Simon, Marie, *Fashion in Art: The Second Empire and Impressionism*, p.234–5.
91. Museum of London, 'Romilly McAlpine in conversation with Moira Gemmill', *Vivienne Westwood: A London Fashion* (London, 2000), pp.15–23.
92. Ash, Juliet, 'Philosophy on the Catwalk', *Chic Thrills: A Fashion Reader* (London, 1992) p.167–8.
93. Ibid., p.171.
94. Ibid., p.172.
95. Hume, *Vogue* (September 1994), pp.187–208.
96. Hollander, Anne, *Seeing through clothes* (Berkeley, Los Angeles & London, 1993), p.452.
97. Arnold, Rebecca, 'Vivienne Westwood's Anglomania', *The Englishness of English Dress* (New York, 2002), pp.164–5.
98. Martin, Richard and Harold Koda, *Christian Dior* (New York, 1996), p.84.
99. Martin, Richard et al, *The Fashion Book* (London, 1998), p.136.
100. Sutton, 'A conversation with Vivienne Westwood'.
101. Arnold, *The Englishness of English Dress*, p.165.
102. *Painted Ladies*, three short films by Gordon Swire, shown on Channel 4 in Spring 1996.
103. Arnold, *The Englishness of English Dress*, p.163.
104. Taylor, Lou, 'Romantic', *The Cutting Edge*, p.83.
105. Martin and Koda, *Christian Dior*.
106. Menkes, Suzy, *International Herald Tribune* (October 1996).
107. Publicity material for Five Centuries Ago (A/W 1997–8) from Vivienne Westwood.
108. Anne Hollander quoted in *Painted Ladies*, 1996.
109. Healey, Murray, 'The Genius', *Pop* (October 2002), p.305.
110. Sharkey, Alix, 'Westwood ho!', *Life, The Observer Magazine* (8 April 2001), p.13.
111. Hume, *Vogue* (September 1994), p.194.
112. Ibid.
113. Frankel, Susannah, *Visionaries: interviews with fashion designers* (London, 2001), p.97.
114. Hume, *Vogue* (September 1994), p.194.
115. Webb, *Elle* (February 2003), p.121.
116. Paul Smith in correspondence with the author, 2003.
117. Valerie Mendes in conversation with the author, 2003.
118. Franklin, *I-D* (March 1987), p.74.
119. Susan North, Curator, Furniture, Textiles and Fashion Department, V&A Museum.
120. Aileen Ribeiro in conversation with the author, 2003.
121. Bernardi, *Flash Art* (Jan/Feb 1992), p.160.
122. Sharkey, *Life, The Observer Magazine* (8 April 2001), p.15.
123. Sutton, 'A conversation with Vivienne Westwood'.

CHRONOLOGY

1941 Vivienne Isabel Swire born on 8 April in Glossop, Derbyshire.

1957 Moves with her family to London, aged 17, and attends Harrow Art School for one term.

1962 Marries Derek Westwood. Aged 21, Vivienne becomes a primary-school teacher in Willesden, North London.

1963 Her first son, Benjamin Arthur Westwood, is born.

1965 Marriage to Westwood ends. Meets 18-year-old Malcolm Edwards (aka McLaren).

1967 With McLaren, a second son is born, Joseph Ferdinand Corré.

1971 McLaren and Westwood's first shop opens at 430 King's Road, London, called 'Let It Rock'.

1972 The shop is redesigned and renamed 'Too Fast To Live, Too Young To Die'.

1974 Shop name is changed to 'SEX'.

1975 Westwood and McLaren are fined for 'exposing to public view an indecent exhibition'.

1976 430 King's Road is renamed 'Seditionaries'.

1979 World's End opens at 430 King's Road.

1981 March: First catwalk show, the Pirate collection (A/W 1981–2), shown at Olympia, followed by Savage (S/S 1982).

1982 Buffalo (A/W 1982–3) and Punkature (S/S 1983) shown in Paris.

Westwood and McLaren open a second London shop, Nostalgia of Mud.

1984 Nostalgia of Mud closes. Westwood moves to Italy.

Invitation to show the Hypnos collection (S/S 1984) in Tokyo at Hanae Mori's 'Best of Five' global fashion awards, with Calvin Klein, Claude Montana and Gianfranco Ferre.

Deal with Giorgio Armani announced.

1987 Westwood designs the Stature of Liberty corset as part of Harris Tweed (A/W 1987–8). It is the first corset to be introduced into outerwear.

1989 November: Westwood's name appears in a list of the world's top six designers in John Fairchild's book, *Chic Savages* (1989), along with Armani, Lagerfeld, Saint Laurent, Lacroix and Ungaro.

1989–91 Appointed Professor of Fashion at Vienna Academy of Applied Arts.

1990 First complete menswear collection, Cut and Slash (S/S 1991) shown in conjunction with Pitti Uomo in Florence.

December: The Vivienne Westwood shop opens at 6 Davies Street, in London's Mayfair. It sells the Gold Label collection.

Westwood is the first fashion designer to be profiled on London Weekend Television's arts programme, 'The South Bank Show'.

1990 and 1991 Awarded Fashion Designer of the Year by the British Fashion Council.

1991 Chosen to show in the Tokyo Fashion Summit, alongside Christian Lacroix, Isaac Mizrahi and Franco Moschino.

1992 Wedding gowns introduced to the collections.

Westwood is made an Honorary Senior Fellow of the Royal College of Art.

Shop opens at 43 Conduit Street, London.

Westwood creates a watch design called 'Putti' for Swatch.

Exhibits at Musée d'Art, Bordeaux, France.

Awarded an O.B.E by Her Majesty Queen Elizabeth II.

Westwood marries Andreas Kronthaler, whom she met whilst teaching in Vienna.

1993 Appointed Professor of Fashion at the Berliner Hochschule der Künste.

Designs 'Orb', a second watch for Swatch.

Westwood commissions her own tartan 'Mac Andreas' for the Anglomania Collection, as a tribute to her husband. It appears in the records of the official Lochcarron Museum.

1994 Invitation by Littlewoods catalogue to design a mail-order range.

May: Westwood wins the first Institute of Contemporary Art Award for outstanding Contribution to Contemporary Culture.

Designs *Ancien Régime* costumes in carpet to celebrate the founding in 1783 of the carpet company Brintons.

1996 Westwood's menswear line, 'Man', is launched in January in Milan.

Spring: The three-part Channel 4 series, *Painted Ladies*, is broadcast.

1998 Debut fragrance, Boudoir, is launched.

Vivienne Westwood Ltd awarded the Queen's Award for Export in recognition of the company's growing export market.

1999 The Red Label is launched in the United States in February, coiniciding with the opening of Westwood's first shop in New York.

Accessories lines are introduced, including the Eyewear collection and the Coquetteries body and bath line.

2000 The Museum of London holds the exhibition *Vivienne Westwood: the collection of Romilly McAlpine* from 7 April to 25 June 2000.

A second fragrance, Libertine, is launched in Europe.

2001 Vivienne Westwood is the first designer to be honoured at the Moët & Chandon Fashion Tribute held at the V&A.

2002 February: Shop opens in Hong Kong, followed by accessories shop in August.

2003 June: Awarded the UK Fashion Export Award for Design.

September: Shop opens in Milan.

October: Shop opens in Liverpool.

2004 Vivienne Westwood retrospective opens at the Victoria and Albert Museum, London.

LIST OF COLLECTIONS

The early collections were presented not on the catwalk but within the shop environment. The name and image of the shop at 430 King's Road changed according to the look of the clothes.

1970 LET IT ROCK
1972 TOO FAST TO LIVE,
 TOO YOUNG TO DIE
1974 SEX
1976 SEDITIONARIES

The World's End Pirate collection coincided with the opening of the World's End shop.

1981 March, PIRATE, A/W 1981–2. Olympia, London.

1981 October, SAVAGE, S/S 1982. Olympia, London.

1982 March, NOSTALGIA OF MUD (BUFFALO), A/W 1982–3. Angelina's, Paris.

1982 October, PUNKATURE, S/S 1983. Cour du Louvre, Paris.

1983 March, WITCHES, A/W 1983–4. Cour du Louvre, Paris.

1983 October, HYPNOS, S/S 1984. Cour du Louvre, Paris.

1984 March, CLINT EASTWOOD, A/W 1984–5. Cour du Louvre, Paris.

1984 October, MINI-CRINI, S/S 1985. Cour du Louvre, Paris.

1987 March, HARRIS TWEED, A/W 1987–8. Apex Room, Olympia, London.

1987 October, PAGAN I, S/S 1988. BFC Tent, Olympia, London.

1988 March, TIME MACHINE, A/W 1988–9. BFC Tent, Olympia, London.

1988 October, CIVILIZADE, S/S 1989. BFC Tent, Olympia, London.

1989 March. VOYAGE TO CYTHERA, A/W 1989–90. Apex Room, Olympia, London.

1989 October, PAGAN V, S/S 1990. BFC Tent, Olympia, London.

1990 March, PORTRAIT, A/W 1990–1. I.O.D., Pall Mall, London.

1990 July, CUT AND SLASH (menswear), S/S 1991. Villa de Gamberaia, Pitti Palace, Florence.

1990 October, CUT AND SLASH (womenswear), S/S 1991. I.O.D., Pall Mall, London.

1991 March, DRESSING UP, A/W 1991–2. Azzedine Aläia showroom, Paris.

1991 October, SALON, S/S 1992. Azzedine Aläia showroom, Paris.

1992 March, ALWAYS ON CAMERA, A/W 1992–3. Le Monde de l'Art, Paris.

1992 October, GRAND HOTEL, S/S 1993. Le Grand Hôtel, Paris.

1993 March, ANGLOMANIA, A/W 1993–4. Le Cercle Républicain, Paris.

1993 October, CAFÉ SOCIETY, S/S 1994. Le Grand Hôtel, Paris.

1994 March, ON LIBERTY, A/W 1994–5. Carrousel du Louvre, Paris.

1994 October, EROTIC ZONES, S/S 1995. Carrousel du Louvre, Paris.

1995 March, VIVE LA COCOTTE, A/W 1995–6. Carrousel du Louvre, Paris.

1995 October, LES FEMMES NE CONNAISSENT PAS TOUTE LEUR COQUETTERIE, S/S 1996. Salle de l'Opéra, Le Grand Hôtel, Paris.

1996 January, MAN, A/W 1996–7. Ex Stabilimento Motta, Milan.

1996 March, STORM IN A TEACUP, A/W 1996–7. Carrousel du Louvre, Paris.

1996 July, MAN, S/S 1997. Ex Stabilimento Motta, Milan.

1996 October, VIVE LA BAGATELLE, S/S 1997. Carrousel du Louvre, Paris.

1997 January, MAN, A/W 1997–8. Teatro Nuovo, Milan.

1997 February, RED LABEL 'TO ROSIE', A/W 1997–8. The Dorchester, London.

1997 March, FIVE CENTURIES AGO, A/W 1997–8. Le Lido, Paris.

1997 July, MAN, S/S 1998. Tenda Palestro, Giardini Pubblici, Milan.

1997 September, RED LABEL 'THE ENGLISH GIRL ABROAD', S/S 1998. Garden of Arden, Shakespeare's Globe, London.

1997 October, TIED TO THE MAST, S/S 1998. Hôtel de Crillon, Paris.

1998 January, MAN, A/W 1998–9. Circolo della Stampa, Milan.

1998 February, RED LABEL, A/W 1998–9. Café de Paris, London.

1998 March, DRESSED TO SCALE, A/W 1998–9. Hôtel de Crillon, Paris.

1998 June, MAN, S/S 1999. Circolo della Stampa, Milan.

1998 September, RED LABEL, S/S 1999. The Tabernacle, London.

1998 October, LA BELLE HELENE, S/S 1999. La Bourse, Paris.

1999 January, MAN, A/W 1999–2000. Circolo della Stampa, Milan.

1999 February, RED LABEL, A/W 1999–2000. Celeste Bartos Forum, New York Public Library.

1999 March, GOLD LABEL. A/W 1999–2000. Vivienne Westwood showroom, Paris.

1999 June, MAN, S/S 2000. Circolo della Stampa, Milan.

1999 August, RED LABEL, S/S 2000. New York.

1999 October, GOLD LABEL 'SUMMERTIME', S/S 2000. Jeu de Paume, Paris.

2000 January, MAN, A/W 2000–1. Circolo della Stampa, Milan.

2000 February, RED LABEL, A/W 2000–1. Bryant Park, The Tents, New York.

2000 March, GOLD LABEL 'WINTER', A/W 2000–1. Carrousel du Louvre, Paris.

2000 October, GOLD LABEL 'EXPLORATION', S/S 2001. Salle Gabriel, Paris.

2001 March, GOLD LABEL 'WILD BEAUTY', A/W 2001–2. Salle Wagram, Paris.

2002 June, MAN, S/S 2002. Chiostro di Palazzo Isimbardi, Milan.

2002 October, GOLD LABEL 'NYMPHS', S/S 2002. Salle Wagram, Paris.

2002 January, MAN, A/W 2002–3. Circolo della Stampa, Milan.

2002 March, GOLD LABEL 'ANGLOPHILIA', A/W 2002–3. Espace de Trocadéro, Paris.

2003 June, MAN, S/S 2003. Via Turati, Milan.

2003 October, GOLD LABEL 'STREET THEATRE', S/S 2003. Espace de Trocadéro, Paris.

2003 January, MAN, A/W 2003–4. Via Turati, Milan.

2003 March, GOLD LABEL 'LE FLOU TAILLÉ', A/W 2003–4. Salle le Nôtre, Paris.

VIVIENNE WESTWOOD IN THE V&A MUSEUM

The following clothes, ensembles and accessories are held in the V&A Museum's collection. Not all items are on display. Enquiries should be addressed to the Furniture, Textiles and Fashion Department. Items are arranged in chronological order of collection. The V&A Museum number is followed by a brief description.

T.91:1-3–2002 Ensemble: pink short-sleeved Day-Glo nylon top; white cotton bondage trousers with front and back zippers, buckles and straps, with attached kilt. SEX, 1974.

T.252:A-H–1989 Bondage suit: black glazed cotton featuring zips, roomy pockets and non-functional straps with snap fastenings, D-rings and spring links. Seditionaries, 1976.

T.94–2002 Cropped long-sleeved jumper. Red, orange and yellow loose-knit mohair. Seditionaries, 1976.

T.93–2002 White muslin long-sleeved top printed with Sex Pistols' 'God Save The Queen' imagery. Seditionaries, 1976.

T.92–2002 Black muslin asymmetric top with slashed sleeves and shoulders with attached hardware. Seditionaries, 1976.

T.90–2002 White muslin shirt with 'tits' print, long sleeves and attached hardware. Seditionaries, 1976.

T.89–2002 Grey linen short sleeved shirt. Seditionaries, 1976.

T.88–2002 Red, pink, green, blue and black mohair long-sleeved jumper. Seditionaries, 1976.

T.82–2002 Silk scarf printed with George Cruikshank cartoon and text. Seditionaries, 1976.

T.104–2002 Sleeveless white top with text on the front and Union Jack printed on the back. Seditionaries, 1976.

T.84:1-3–2002 Ensemble: black cotton top and bondage trousers with black fabric belt, terrycloth 'bum flap' and black wool kilt composed of front and back panels. Seditionaries, 1976.

T.85:1-2/1–2002 Ensemble: black cotton shirt and bondage trousers with black fabric belt, terrycloth 'bum flap' and cerise silk scarf printed with the words 'No Future'. Seditionaries, 1976.

T.82:1-2/1–2002 Black bondage ensemble: bondage top, bondage trousers, loincloth/'bum flap', belt and kilt. Seditionaries, 1976.

T.270:1-2–1991 Suit: striped cotton trousers and jacket. Pirate, A/W 1981–2.

T.367:A-B–1985 Ensemble: checked wool jacket, striped cotton shirt and trousers. Pirate, A/W 1981–2.

T.228:1-2–1991 Black leather shoe with three tongues. Pirate, A/W 1981–2.

T.229–1991 Yellow cotton shirt. Pirate, A/W 1981–2.

T.230–1991 White and red scarf. Pirate, A/W 1981–2.

T.231–1991 Striped cotton shirt. Pirate, A/W 1981–2.

T.232-4–1991 Three sashes. Pirate, A/W 1981–2.

T.235–1991 T-shirt with razor-edge design. Pirate, A/W 1981–2.

T.236:1-2–1991 Jersey stockings with blue and gold print. Pirate, A/W 1981–2.

T.334:A-I–1982 Pirate outfit: red and yellow shirt of plain printed weave cotton; black and yellow figured cotton and rayon waistcoat; yellow printed cotton jacket; matching trousers. Accessorized with a black felt hat, yellow stockings, and suede boots. Pirate, A/W 1981–2.

T.587:1-3–1996 Beige cotton and leather shorts with brown leather braces. Pirate, A/W 1981–2.

T.589–1996 Grey, black and red woven stripe cotton trousers. Pirate, A/W 1981–2.

T.590–1986 Grey, black and red woven stripe cotton scarf. Pirate, A/W 1981–2.

T.591:1-2–1996 Suit: brown and blue herringbone wool tweed jacket and trousers, with horn buttons. Pirate, A/W 1981–2.

T.107:1–2002 Double-breasted jacket, white cotton with three-quarter-length sleeves in military style. Pirate, A/W 1981–2.

T.114:1 and 2–2002 Orange cotton stockings. Pirate, A/W 1981–2.

T.115:1 and 2–2002 Green cotton stockings. Pirate, A/W 1981–2.

T.103:1-2–2002 Ensemble: long-sleeved, loose fitting white cotton shirt with a large ruffle; purple, pink and yellow striped trousers with a folded over waistband. Pirate, A/W 1981–2.

T.113–2002 White culottes with side pockets and drawstring waist. Pirate, A/W 1981–2.

T.112–2002 Long-sleeved, white cotton T-shirt with red jagged snake design and panels of blue striped cotton inserted under the arms. Pirate, A/W 1981–2.

T.111:1-1–2002 Ensemble: white cotton shirt with buckskin collar and yellow cotton trousers with floral motif. Pirate, A/W 1981–2.

T.110–2002 Houndstooth check wool jacket with slashed sleeves and black fabric lining slashes. Pirate, A/W 1981–2.

T.109–2002 Long-sleeved top composed of three differently patterned cotton fabrics. Pirate, A/W 1981–2.

T.106–2002 Red cotton jacket with slashed sleeves in heavy black cotton with embroidered blue and beige polka dots. Pirate, A/W 1981–2.

T.102:1-2–2002 Cotton top with blue and red geometric print with white cotton trousers. Pirate, A/W 1981–2.

T.100:1-3–2002 Ensemble: multicoloured striped cotton waistcoat; frock-style jacket; matching striped scarf. Pirate, A/W 1981–2.

T.99:1-3–2002 Ensemble: oversized white cotton shirt; violet and green striped cotton scarf; white cotton cropped trousers. Pirate, A/W 1981–2.

T.98:1-3–2002 Ensemble: long-sleeved, asymmetrically-cut orange cotton top with a red abstract; matching scarf; white cotton trousers. Pirate, A/W 1981–2.

T.585–1996 White cotton shirt with blue diamond print. Pirate, A/W 1981–2.

T.105:1-3–2002 Ensemble: red felt hat; red and black checked cotton jacket; red cotton trousers. Pirate, A/W 1981–2.

T.586–1996 Blue and yellow cotton jacket fastened with phallus buttons. Savage, S/S 1982.

T.241–1991 Red and white striped cotton shorts. Savage, S/S 1982.

T.242–1991 Red and white striped cotton trousers. Savage, S/S 1982.

T.584–1996 Pink/purple cotton jersey and cotton shirting top. Savage, S/S 1982.

T.135:1-3–2002 Ensemble: blue and white gingham handkerchief; white long-sleeved top with extra sleeve attached across the bust; short white skirt with four cloth balls attached. Savage, S/S 1982.

T.130–2002 Long-sleeved top, white cotton and linen, with turtleneck and hanging panels from the shoulders. Savage, S/S 1982.

T.136–2002 Cream cotton mesh top with mock turtleneck and white/black pinstriped panels. Savage, S/S 1982.

T.134–2002 Long-sleeved dress with long train printed with Campbell's Beef Noodle Soup image. Savage, S/S 1982.

T.133:1-2–2002 White cotton waistcoat; multicoloured trousers with a folded over waistband. Savage, S/S 1982.

T.132–2002 White cotton tubular body with multicoloured long sleeves. Savage, S/S 1982.

T.131:1-2–2002 White cotton and linen polo-neck top with long linen panels hanging from the shoulders and a full-length white knitted cotton skirt. Savage, S/S 1982.

T.129–2002 Long-sleeved white cotton polo neck top with blue and white striped cotton inset and panels hanging from the shoulders. Savage, S/S 1982.

T.128–2002 Olive brown cotton dress with teal strings. Savage, S/S 1982.

T.127:1-3–2003 Ensemble: white cotton mesh jacket with vents; green sleeveless T-shirt with sleeve sewn across the front; high-waisted brown trousers. Savage, S/S 1982.

T.101:1-2–2002 Ensemble: blue and black plaid cotton jacket with large collar and lapels; light grey linen peg-legged trousers. Savage, S/S 1982.

T.138–2002 Shirt with exaggerated cuffs and Velcro fastenings. Savage, S/S 1982.

T.126:1-2–2002 Red, orange and white vertical striped linen jacket and brown cotton trousers. Savage, S/S 1982.

T.125–2002 Sleeveless dress of printed cotton with large geometric patterns in red, yellow, black and purple. Savage, S/S 1982.

T.124–2002 Multicoloured cotton top with long sleeves and 'CHILLY' printed across the chest. Savage, S/S 1982.

T.123–2002 Sleeveless cotton dress with red, blue and orange geometric print. Savage, S/S 1982.

T.137:1-2–2002 Sleeveless white cotton top with sleeves attached across chest; heavy green cotton skirt with a screen-printed figure. Savage, S/S 1982.

T.244–1989 Brown cotton trousers. Buffalo, A/W 1982–3.

T.144:1-2–2002 Brown sheepskin coat with toggle closures and exaggerated cuffs and lapels; lavender and brown striped silk waistcoat. Buffalo, A/W 1982–3.

T.145:1-2–2002 Beige cotton cropped cardigan with slashing and dagging. Worn with a brown linen skirt with a rope belt. Buffalo, A/W 1982–3.

T.72–1992 Multicoloured patterned wool jumper. Buffalo, A/W 1982–3.

T.26–2003 Sheepskin vest. Buffalo, A/W 1982–3.

T.27:1-2–2003 Brown cotton leggings. Buffalo, A/W 1982–3.

T.269–1989 Wool dress. Buffalo, A/W 1982–3.

T.588–1996 Brown cotton mesh top. Buffalo, A/W 1982–3.

T.238–1985 Brown bra, synthetic satin, cotton and leather. Buffalo, A/W 1982–3.

T.243–1991 Jumper, pink and brown synthetic material. Buffalo, A/W 1982–3.

T.244–1991 Black felt hat. Buffalo, A/W 1982–3.

T.264–1991 Brown wool trousers. Buffalo, A/W 1982–3.

T.223:1-4–1991 Ensemble: brown corduroy jacket and trousers, brown lace shirt and grey felt hat. Buffalo, A/W 1982–3.

T.222:3–2002 White cotton mesh sleeveless top with a blue silk-screened design. Buffalo, A/W 1982–3.

T.143:1-2–2002 Ensemble: tan felt hat with a deep, dimpled crown; white long-sleeved cotton top with loose-knit panels under the arms. Buffalo, A/W 1982–3.

T.142–2002 Sleeveless cotton mesh top printed with mauve and green abstract pattern. Buffalo, A/W 1982–3.

T.140:1-2–2002 Double-breasted brown sheepskin jacket and brown wool wraparound skirt. Buffalo, A/W 1982–3.

T.139:1-2–2002 Pink and green cotton hooded top with printed figures in costume with roses, worn with a brown layered Dacron skirt. Buffalo, A/W 1982–3.

T.366–1985 'Kitchen sink' cardigan, purple dyed dishcloth and rusty Vim-lid buttons. Punkature, S/S 1983.

T.157–2002 Black cotton loose-knit skirt with a large fold-over panel at the waist. Punkature, S/S 1983.

T.156:1-2–2002 Blue lycra top with white lining; grey lycra mini skirt. Punkature, S/S 1983.

T.155–2002 Grey cotton trousers worn with a suspender. Punkature, S/S 1983.

T.154–2002 Lavender and white striped cotton shirt with a longer back tail. Punkature, S/S 1983.

T.153:1-2–2002 Brown cotton mesh top with elbow-length sleeves and wide-legged brown wool check trousers. Punkature, S/S 1983.

T.152:1-2–2002 Suit: black velvet hat; green/grey cotton jacket; wrap skirt with a woven checkerboard pattern. Punkature, S/S 1983.

T.151–2002 Unstructured short-sleeved white cotton dress with neckline cinched with string. Punkature, S/S 1983.

T.150:1-2–2002 Pale blue/green jacket and skirt in woven cotton with checkerboard effect. Punkature, S/S 1983.

T.149:1-2–2002 Long-sleeved wide-necked top of white, green and blue cotton worn with green and blue/grey full length cotton tube skirt. Punkature, S/S 1983.

T.148:1-2–2002 Ensemble: yellow knit cotton top; pale green cotton and leather trousers with contoured legs. Punkature, S/S 1983.

T.147:1-2–2002 Ensemble: ivory long-sleeved cotton cropped top with four keyrings attached under the bust; pale blue knitted cotton socks. Punkature, S/S 1983.

T.162:1-2–2002 Suit: dark blue stockings; blue knit wool jacket; tube skirt with a triangle pattern. Witches, A/W 1983–4.

T.71–1992 Green scarf with Keith Haring print. Witches, A/W 1983–4.

T.189:1-2–2002 Ensemble: long-sleeved cropped denim jacket; navy blue knee-length skirt with wide pleats; tube of white knit fabric to fit over the torso. Witches, A/W 1983–4.

T.161:1-2–2002 Grey wool double-breasted coat with exaggerated lapels and pockets worn with high waisted navy blue cotton rounded trousers. Witches, A/W 1983–4.

T.160:1-2–2002 Ensemble: green cotton knit top; tube skirt decorated with a Keith Haring print. Witches, A/W 1983–4.

T.159:1-2–2002 Ensemble: brown sheepskin jacket with a Keith Haring print and pointed shoulders; ivory cotton full length tube skirt with brown sheepskin panels at the hem. Witches, A/W 1983–4.

T.158:1-4–2003 Ensemble: green cotton jacket and top printed with Keith Haring design; trousers with white cotton elastic knitted bands around the ankles; green felt hat. Witches, A/W 1983–4.

T.224–1991 Sheepskin jacket with Keith Haring print. Witches, A/W 1983–4.

T.225-1991 Blue sweat jacket with Keith Haring print. Witches, A/W 1983–4.

T.226–1991 Green sweatshirt with Keith Haring print. Witches, A/W 1983–4.

T.227:1-2–1991 Ensemble: blue/green jacket and trousers with Keith Haring print. Witches, A/W 1983–4.

T.237–1991 Black nylon shorts. Hypnos, S/S 1984.

T.238–1991 Leotard. Hypnos, S/S 1984.

T.239–1991 Pale blue synthetic fabric shirt. Hypnos, S/S 1984.

T.267–1991 Blue denim jacket with rubber design. Hypnos, S/S 1984.

T.268:1-2–1991 Cream cotton raincoat with matching belt. Hypnos, S/S 1984.

T.73–1992 Green plasticized fabric coat. Hypnos, S/S 1984.

T.178–2002 Oversized, long-sleeved crepe shirt with collar, elasticated gathered cuffs and no closures. Hypnos, S/S 1984.

T.177:1-2–2002 Elasticated cotton stockings. Hypnos, S/S 1984.

T.176:1-2–2002 Cream elasticated nylon stockings. Hypnos, S/S 1984.

T.175–2002 Blue textured denim waistcoat gathered at the shoulders with yellow Velcro strips. Hypnos, S/S 1984.

T.174–2002 Cropped orange wool jumper with button flap and penis-shaped button to fasten across lower edge. Hypnos, S/S 1984.

T.173:1-2–2002 Black elasticated cotton, thigh-high stockings. Hypnos, S/S 1984.

T.171:1-2–2002 White suit: white cotton and green lycra oversized, double-breasted jacket with two-way fastening; white cotton trousers elasticated from the shins to the ankles. Hypnos, S/S 1984.

T.169–2002 Dress, top of neon yellow cotton and lycra with elasticated ribbed trim. Hypnos, S/S 1984.

T.168–2002 Navy blue cotton, wide cropped jacket with elbow-length sleeves and asymmetrical closure. Hypnos, S/S 1984.

T.167–2002 Dress of green knit bodice and tan cotton skirt lined with green Day-Glo nylon. Hypnos, S/S 1984.

T.166–2002 Loose blue denim jacket with textured white and blue denim pattern. Hypnos, S/S 1984.

T.165–2002 Sleeveless red nylon top with white elasticated panels at collar, hem and sides. Hypnos, S/S 1984.

T.164–2002 Sleeveless mini dress in orange cotton and lycra with a wide hem and edging. Hypnos, S/S 1984.

T.163:1-2–2002 Green lycra top with white reverse and matching mini skirt. Hypnos, S/S 1984.

T.170:1-3–2002 Ensemble: white nylon long-sleeved top with elasticated cotton bands; red and blue striped silk trousers; orange knit cotton socks with pink and white stripes. Hypnos, S/S 1984.

T.172:1-2/1–2002 Ensemble navy elasticated cotton top with elbow-length sleeves and elasticated waistband; black and white knit cotton socks; black and grey cotton net socks. Hypnos, S/S 1984.

T.188:1-2–2002 Oversized suit, double-breasted brown and tan houndstooth jacket with gold silk applied to the lapels and elbows, exaggerated square sleeves and five penis-shaped buttons. Worn with a matching full-length skirt gathered at the front with a Velcro

fastening. Clint Eastwood, A/W 1984–5.

T.187:1-2–2002 Ensemble: blue wool oversized belted coat in a windowpane check; matching loose trousers with wide cinch belt. Clint Eastwood, A/W 1984–5.

T.186–2002 Full-length, long-sleeved brown wool dress with exaggerated points at elbows and one penis-shaped button fastening under the bust. Clint Eastwood, A/W 1984–5.

T.185–2002 Grey knit wool tube skirt with deep fringed wool hem of tan and black houndstooth pattern. Clint Eastwood, A/W 1984–5.

T.184:1-2–2002 Ensemble: pale blue wool cropped jumper with long sleeves; matching tube skirt with painted hand prints inspired by national flags. Clint Eastwood, A/W 1984–5.

T.183–2002 Grey nylon jacket with knitted wool neck, wrist bands and long waistband. Fastened at the collar with one penis-shaped button. Clint Eastwood, A/W 1984–5.

T.182:1-2–2002 Purple woollen scarf with fringed felt ends painted with hand prints inspired by national flags; matching wool knit full-length skirt. Clint Eastwood, A/W 1984–5.

T.181–2002 Long-sleeved top of white lycra with narrow red vertical stripes. Clint Eastwood, A/W 1984–5.

T.180-2002 Grey nylon top with black stripes and panels of textured grey cotton. Clint Eastwood, A/W 1984–5.

T.252–1991 Shirt with red and cream star print. Mini-Crini, S/S 1985.

T.253–1991 Shirt with yellow and black star print. Mini-Crini, S/S 1985.

T.254:1-2–1991 Suit: red and blue printed denim trousers and jacket. Mini-Crini, S/S 1985.

T.255–1991 Blue diamond and stripe print jeans. Mini-Crini, S/S 1985.

T.107:2–2002 Full-length skirt of yellow cotton with a punched flower pattern. Mini-Crini, S/S 1985.

T.199–2002 Ivory nylon corset with long sleeves. Mini-Crini, S/S 1985.

T.198–2002 Polyester pale blue shirt with large white dots. Mini-Crini, S/S 1985.

T.197–2002 Green cotton shirt with wood-grain print. Mini-Crini, S/S 1985.

T.196–2002 Navy and orange cotton and rayon shirt with star pattern. Mini-Crini, S/S 1985.

T.195–2002 Pink and white cotton jacket with geometric pattern. Mini-Crini, S/S 1985.

T.194–2002 Peach and white top with elbow-length sleeves, sailor collar and red bow. Mini-Crini, S/S 1985.

T.193–2002 Blue cotton top with large white polka dots, scoop neck and elbow length sleeves. Mini-Crini, S/S 1985.

T.192–2002 Navy blue cotton top with large tan polka dots, scoop neck and elbow-length sleeves. Mini-Crini, S/S 1985.

T.191:1-2–2002 Ensemble: blue denim corset; blue rayon three-hooped skirt with pale blue polka dots, drawstring waist and a ruffle round the hem. Mini-Crini, S/S 1985.

T.190:1-2–2002 Ensemble: long-sleeved white lycra corset; red rayon three-hooped skirt with beige polka dots, a drawstring waist and flared hem. Mini-Crini, S/S 1985.

T.398:2–2002 Green cotton bustier with black cotton-lined cups and black mesh sides. Mini-Crini, S/S 1985.

T.845–2000 White cotton shorts with horizontal pattern of narrow blue raised broken stripes. Mini-Crini, S/S 1985.

T.200:1–2002 Blue denim Levi-Strauss jacket with detachable back panel. Triangular detachable panel reads 'Deep Sky' with a safety pin and blue and white lights. For *Blitz* designer collection exhibition of Levi jackets, V&A, July 10–October 13 1986.

T.246:1-3–1991 Suit: grey wool jacket and trousers and white shirt. Harris Tweed, A/W 1987–8.

T.247–1991 Wool blazer. Harris Tweed, A/W 1987–8.

T.248–1991 Silk tie. Harris Tweed, A/W 1987–8.

T.250–1991 Shirt. Harris Tweed, A/W 1987–8.

T.251–1991 Cap. Harris Tweed, A/W 1987–8.

T.261:1-3–1991 Norfolk suit: grey wool trousers and jacket with orb motif buttons, pink and grey cap. Harris Tweed, A/W 1987–8.

T.201–2002 Corset with red velvet front and back panels. Harris Tweed, A/W 1987–8.

T.26–2002 Fuschia wool jacket with red velvet heart-shaped lapels and gold buttons. Harris Tweed, A/W 1987–8.

T.202–2002 Corset of multicoloured silk with floral pattern. Pagan I, S/S 1988.

T.245:1-3–1991 Ensemble: black leather waistcoat and detachable sleeves. Time Machine, A/W 1988–9.

T.205:1-2–2002 Single-breasted blue wool tweed jacket with detachable sleeves attached with buckles. Time Machine, A/W 1988–9.

T.204:1-2–2002 Silver lamé corset with detachable elbow-length sleeves with épaulettes, lined in multicoloured cotton. Time Machine, A/W 1988–9.

T.203:1-2–2002 Gold lamé corset with detachable elbow-length sleeves with épaulettes, lined in multicoloured cotton. Time Machine, A/W 1988–9.

T.21–2002 Black long-sleeved lycra corset decorated with gold. Civilizade, S/S 1989.

T.210:1-2–2002 Long-sleeved corset of metallic lycra and pink lycra trousers. Civilizade, S/S 1989.

T.209:1-2–2002 Black and white cotton body suit with collar and three buttons and black, white and red detachable sleeves with padded elbows. Civilizade, S/S 1989.

T.208–2002 Red and white striped knitted cotton long-sleeved top with a coat tail at the back. Civilizade, S/S 1989.

T.207–2002 Black pinstriped breeches with padded knees and large bows. Civilizade, S/S 1989.

T.206:1-1/2–2002 Ensemble: black wool pinstriped jacket with detachable sleeves; beige cotton breeches. Civilizade, S/S 1989.

T.28–2003 White cotton T-shirt with gold appliqué. Civilizade, S/S 1989.

T.213:1-2/4–2002 Ensemble: long-sleeved black raffia corset ; short skirt of black triacetate with drawstring waist and four black triacetate ball decorations attached to the waist. Pagan V, S/S 1990.

T.212–2002 Long-sleeved beige raffia corset. Pagan V, S/S 1990.

T.188–1991 Triple-strand fake pearl necklace. Portrait, A/W 1990–1.

T.70:1-2–1992 Suit: red wool trousers and jacket. Portrait, A/W 1990–1.

T.221:1-2–2002 Black velvet leggings with silver decoration of classical motifs. Portrait, A/W 1990–1.

T.219:1-2–2002 Black velvet leggings with applied gold metallic decoration of classical motifs. Portrait, A/W 1990–1.

T.220–2002 Black nylon leggings with gold metallic classical motifs. Portrait, A/W 1990–1.

T.218–2002 Nylon corset printed with pastoral scene from a painting by François Boucher. Portrait, A/W 1990–1.

T.217–2002 Knee-length T-shirt dress with short sleeves, printed with a detail from *Daphnis and Chloë* (*Shepherd Watching a Sleeping Shepherdess*) by François Boucher. Portrait, A/W 1990–1.

T.216–2002 Corset printed with a detail from *Daphnis and Chloë* (*Shepherd Watching a Sleeping Shepherdess*) by François Boucher. Shoulder straps feature classical motifs printed in gold and mauve. Portrait, A/W 1990–1.

T.215:1-2–2002 Ensemble: black synthetic velvet long-sleeved corset with gold applied decoration of classical figures and motifs with matching leggings. Portrait, A/W 1990–1.

T.214–2002 Long-sleeved, full-length, fitted brown velour dress with an André-Charles Boulle design painted in silver over the dress. Portrait, A/W 1990–1.

T.193–2001 Rubberized cotton raincoat with 'Boucher' print. Portrait, A/W 1990–1.

T.192:1-2–1991 Black patent platform shoes. Portrait, A/W 1990–1.

T.21:1-3–1991 Suit: Grey wool jacket, skirt and scarf. Portrait, A/W 1990–1.

T.22–1992 Pink stretch satin dress. Portrait, A/W 1990–1.

T.23–1992 Cream silk shirt. Portrait, A/W 1990–1.

T.24–1992 Silk tie with 'Boucher' cherub print. Portrait, A/W 1990–1.

T.25–1992 Silk shawl with 'Boucher' cherub print. Portrait, A/W 1990–1.

T.26:1-2–1992 Brown suede platform shoes. Portrait, A/W 1990–1.

T.27–1992 Orb and satyr pendant, gold and metal. Portrait, A/W 1990–1.

T.28–1992 Pearl choker. Portrait, A/W 1990–1.

T.29–1992 Silk bag with 'Boucher' print. Portrait, A/W 1990–1.

T.246–2002 Blue cotton and lycra long-sleeved bodysuit, for Sock Shop. 1990–2.

T.189:1-2–1991 Platform shoes. Cut and Slash, S/S 1991.

T.187:1-3–1991 Dress and belts, red cotton voile. Cut and Slash, S/S 1991.

T.221:1-2–2002 Brown and white striped silk shirt; trousers with an elasticated waist. Cut and Slash, S/S 1991.

T.229:1-3–2002 Ensemble: loose fitting cream felt hat with multicoloured inner padding; slashed denim jacket with a skirted waist and silver buttons; slashed denim trousers. Cut and Slash, S/S 1991.

T.231:1–2002 Blue slashed satin pants with fabric swags at hips and detachable codpiece. Cut and Slash, S/S 1991.

T.228–2002 White silk corset with applied multicoloured floral silk decoration and scalloped edges. Cut and Slash, S/S 1991.

T.227–2002 Long-sleeved full-length slashed white muslin dress with ruff collar and train. Cut and Slash, S/S 1991.

T.225:1-2–2002 Jacket and trousers in blue denim with small slashes in diamond pattern. Cut and Slash, S/S 1991.

T.224–2002 Long-sleeved white cotton shirt with small slashes. Cut and Slash, S/S 1991.

T.226:1-3–2002 Ensemble: red silk jacket with multicoloured floral silk decoration; matching corset; black full-length nylon skirt with elasticated hem. Cut and Slash, S/S 1991.

T.230:1-2/1–2002 Red slashed silk corset with faux fur trim; red slashed silk pants and slashed silk long gloves. Cut and Slash, S/S 1991.

T.190:1-2–1991 Ensemble: red wool trousers and jacket. Dressing Up, A/W 1991–2.

T.191–1991 Lace and cotton shirt, to be worn with ensemble T.190:1-2–1991–2. Dressing Up, A/W 1991–2.

T.233–2002 Purple and white striped rayon and cotton waistcoat with turquoise polyester lining and a black cinch belt. Dressing Up, A/W 1991–2.

T.257–2002 Animal print faux fur stole. Dressing Up, A/W 1991–2.

T.232:1-4–2002 Ensemble: yellow, brown and black leopard print corset; slashed animal print cotton pants with a sash around the waist; animal print cotton fingerless gloves with a faux fur trim; black spotted animal print platform boots. Dressing Up, A/W 1991–2.

T.256:1-4–2002 Ensemble: faux fur animal print top hat; shirt with three quarter length sleeves and side tails. Dressing Up, A/W 1991–2.

T.234–2002 Ankle-length, long-sleeved black net dress with appliquéd classical motifs and Vivienne Westwood logo motifs incorporated in the net. Salon, S/S 1992.

T.236:1-2–2002 Ensemble: blue and white cotton shirt and trousers with floral motif. Always on Camera, A/W 1992–3.

T.235–2002 Black wool rectangular fringed shawl. Always on Camera, A/W 1992–3.

T.245–2002 Blue and white striped cotton tie with buttons. Grand Hotel, S/S 1993.

T.44:1-3–2002 Ensemble: blue/green/yellow striped cotton shirt ; trousers with elasticated waist and button fly; matching waistcoat. Grand Hotel, S/S 1993.

T.243–2002 Light blue/yellow/pink striped silk shirt. Grand Hotel, S/S 1993.

T.242:1-2–2002 Ensemble: blue/brown/yellow plaid linen shirt and trousers. Grand Hotel, S/S 1993.

T.241–2002 Gold denim corset with red stitching and back zipper closure. Grand Hotel, S/S 1993.

T.240:1-2–2002 Ensemble: printed silk waistcoat; blue and gold denim trousers with red stitching. Grand Hotel, S/S 1993.

T.239:1-2–2002 Ensemble: brown and blue striped silk shirt and loose trousers with elasticated waist. Grand Hotel, S/S 1993.

T.238:1-3–2002 Ensemble: blue and white striped cotton shirt, trousers and waistcoat. Grand Hotel, S/S 1993.

T.237:1-2–2002 Blue and white striped silk shirt; matching trousers with elasticated waist. Grand Hotel, S/S 1993.

T.225:1-2–1993 Blue leather mock-croc platform shoes with blue silk ribbon laces. Anglomania, A/W 1993–4.

T.14:1-4–1997 Debutante's dress: cream flocked tulle bodice, skirt, shawl and apron. Made for the Queen Charlotte's Ball, 1994.

T.396:1-4–2002 Navy and pale blue cotton suit: breeches, jacket, waistcoat and visor. Erotic Zones, S/S 1995.

T.397:1-5–2001 Ensemble: tan cotton double-breasted jacket with exaggerated shoulders and wide pointed lapels; matching short mini skirt lined in pink cotton; matching belt; blue fitted shirt; tan hat. Erotic Zones, S/S 1995.

T.398:1-2–2002 Green cotton knee-length bustier and dress with wide shoulders and stand-up lapels. Erotic Zones, S/S 1995.

T.438:1-4–1996 'Watteau' ensemble: green shot silk faille and taffeta three-piece gown, white deerskin gloves. Les Femmes, S/S 1996.

T.14–2002 White cotton corset with piqué front, lacing across the front and side panels of white mesh. Vive La Cocotte, A/W 1995–6.

The V&A holds an extensive collection of Vivienne Westwood accessories which are not listed here. In addition, the Jamie Reid collection, including designs and artwork for The Sex Pistols, is in the collection of the Theatre Museum, a branch museum of the V&A. Further details about the collection can be found on www.backstage.ac.uk, or by contacting the museum directly at TMenquiries@vam.ac.uk.

PICTURE CREDITS

V&A photography by Richard Davis, V&A Photographic Studio.

Endpapers
Gavin Bond.

Frontispiece
Gavin Bond.

4
Vivienne Westwood as Margaret Thatcher photographed by Michael Roberts, *Tatler*, 1989.

5
Vivienne in Destroy T-shirt, photographer unknown.

6
Jerry Hall backstage at Storm in a Teacup (A/W 1996–7), photographed by Gavin Bond.

8
Linda Evangelista by Niall McInerney.

34–6
'430 King's Road'. Feature by Miles Chapman in *19* magazine with photographs by Will English, Sheila Rock, Olly Ball, Barbara Bellingham and Syndication International.

38
Vivienne and friends outside Let it Rock, photographer unknown.
Vivienne and Malcolm photographed inside Let it Rock, photographer unknown.

40–1
Photographs by Aaron Ghetti and Ed Cooper from *Curious*, March 1975.

42
Simon Barker by Ray Stevenson. Rex Features.

43
Tracy and Little Debs, shop assistants in Seditionaries, photographer unknown.

44
Tracy, styled by Caroline Baker, photographer unknown.

45, 46, 47, 48–9
Photographs by Robyn Beeche. Page 49 shows Vivienne Westwood's son Joe.

50, 51
Photographs by Bruce Weber/Little Bear.

52–3
Photographs by Robyn Beeche.

54–5
Photographs by Robyn Beeche.

56
Page from *Honey* magazine, 1982, photographer unknown.

57
Invitation designed by Vivienne Westwood and Malcolm McLaren.

58
Photograph by Roger Burton.

60
Photograph by François Lamy.

62
Invitation designed by Vivienne Westwood and Malcolm McLaren.

63
Photograph by Robyn Beeche.

64, 65
Photographs by Michel Momy.

66
Photograph by Barry Lategan.

68
Invitation designed by Vivienne Westwood and Malcolm McLaren using Keith Haring artwork. By kind permission of the estate of Keith Haring.

69
Photograph by Steven Meisel. From US *Vogue*, June 1983, pp.162–3.

70
Photograph by Steven Meisel. From Italian *Vogue*, February 1984, p.164.

71
Photograph by Steven Meisel. From Italian *Vogue*, February 1984, p.407.

72
A Century of Punch edited by R. E. Williams (William Heinemann Ltd, London, 1956), p.28.

73
Photograph by Steven Meisel. From Italian *Vogue*, supp. no. 430, January 1986, p.161.

74
Photographer unknown.

75, 76–7, 78–9, 82, 86, 87
Sarah Stockbridge styled by Vivienne Westwood, photographed by Declan Ryan in the British Museum.

80
Photograph by Kim Knott.

81
Photograph by Nick Knight.

84
Photograph by Cindy Palmano.

85
British *Vogue*, August 1987, p.204–5. Snowdon © Vogue/The Condé Nast Publications Ltd.

89
Photograph by Declan Ryan.

92
British *Vogue*, February 1988, p.157. Peter Lindbergh © Vogue/The Condé Nast Publications Ltd.

93
From *Blitz* magazine, March 1988, p.44, photographer unknown.

94, 95, 96, 97
Paul Gobel. From *Blitz* magazine, 1988, pp.48–56.

98
Collage by Vivienne Westwood.

99
Photograph by Cindy Palmano.

100
By kind permission of the estate of Terence Donovan.

102, 103
Photographs by Robyn Beeche.

104
By kind permission of the Trustees of the Wallace Collection.

105
Photograph by Robyn Beeche.

106
By kind permission of the Trustees of the Wallace Collection. Photograph by A. Gonzalez.

107
Photograph by James Moore. From *Harper's Bazaar* France-Italy, October/November 1990.

109
Private Collection/Bridgeman Art Library.

111
British *Vogue* September 1990, p. 359. Eddy Kohli © Vogue/The Condé Nast Publications Ltd.

112–15
Photographs by Robyn Beeche.

116
Photograph by Marc Hispard. From *Elle* Brazil, July 1991, p.104.

117
Photograph by Patrick Feterstonhauch.

118
Sarah Stockbridge and baby Maximilian photographed by Ulla Nyeman.

119
Michael Clark, choreographer of Cut and Slash (S/S 1991), photographer unknown.

120, 121
Photographer unknown.

122–5
Photographs by Robyn Beeche.

126
From British *Vogue*, February 1992, p.159. Sante D'Orazio © Vogue/The Condé Nast Publications Ltd.

128
Photograph by Niall McInerney. Drawing by Gladys Perint Palmer.

129
Sarah Stockbridge and Susie Bick photographed by Ben Westwood.

130
Photograph by Gilles Bensimon.

131
Vivienne Westwood photographed by Snowdon/Camera Press.

132, 133
Photographs by Gilles Bensimon.

135
Christy Turlington photographed by Mario Testino.

136–139 and 141
Kate Moss, Yasmin Le Bon, Linda Evangelista and Christy Turlington photographed backstage at Anglomania (A/W 1993–4) by Gavin Bond.

142, 143
Photographs by Steven Meisel. From Italian *Vogue*, October 1993.

146–7
Courtesy of *Women's Wear Daily*.

148, 149, 150, 151
Photographs by Inez van Lamsweerde and Vinoodh Matadin.

154–5
Eva Herzigova and Linda Evangelista photographed backstage at Erotic Zones (S/S 1995) by Gavin Bond.

157
Christel photographed by Christophe Kutner.

160–3
Photographs by Niall McInerney.

164
Photograph by Wendy Carrig. Styled by Caroline Baker.

165
Guinevere photographed by David Sims.

166
Amy Wesson photographed by Inez van Lamsweerde and Vinoodh Matadin.

168
Photographs by Niall McInerney. Portrait of Vivienne Westwood by Michael Roberts.

169
Photographs by Niall McInerney.

170, 171, 172, 173
Veruschka styled by Vivienne Westwood and Anna Piaggi, photographed by Gian Paolo Barbieri.

175, 176, 177, 179
Photographs by Gian Paolo Barbieri. Styled by Anna Piaggi, set design by Robert Pinnoch.

183
Backstage photographs at Summertime (S/S 2000) by Daniel Mayer.

184
Tracey Emin photographed by Mat Collishaw.

185
Photograph by Inez van Lamsweerde and Vinoodh Matadin.

187
Anita Pallenberg photographed by Mat Collishaw.

189
Stella Tennant photographed by Arthur Elgort.

190, 192
Vivienne Westwood and Andreas Kronthaler photographed by Annie Leibovitz.

194
Photograph by Mikael Jansson.

196
Photograph by Alexei Hay.

197
Photograph by Günter Parth.

200
Anastasia photographed by Günter Parth.

201
Photograph by Günter Parth.

202, 203
Photographs by Corinne Day.

INDEX

Page numbers in italic refer to the illustrations on those pages

ACKNOWLEDGEMENTS

We would like to express our thanks to Vivienne Westwood for her great generosity in making her personal archive available to the Museum for the exhibition *Vivienne Westwood*, for art directing the picture section of this book and for the many hours that she has given to this project. Above all, we thank her for her creativity and contribution to the world of fashion.

Our gratitude also goes to the staff of Vivienne Westwood, in particular to Murray Blewett for his patient commitment to this project and extraordinary memory, and to Andreas Kronthaler for his invaluable contribution to the exhibition. We are also very grateful to Suzanne Beirne, Joe De Campos, Beata De Campos, Maia Guarnaccia, Margherita Protti, Denise Zamarioni and Tim Clifton-Green. We give particular thanks to the Managing Director of Vivienne Westwood Ltd, Carlo D'Amario.

Major exhibitions and publications depend on the hard work of many. The following people have made a particular contribution: Monica Woods, Mary Butler, Clare Davis, Geoff Barlow and Frances Ambler of V&A Publications; the book's designer, Nigel Soper, and editor Catherine Blake; the photographers who kindly allowed us to reproduce their work; Richard Davis of the V&A Photographic Studio; Anna Fletcher, Exhibition Co-ordinator, Linda Lloyd Jones and Emma Kelly of the Exhibitions Department; Victoria Coulson, Rachel Woods, Mark Haworth-Booth, Carolyn Sargentson and Judith Clark of the Research Department; Catharina Holmberg, Holly Restiaux, Helen Carter and Ann Gelbmann for their assistance with research; Sonnet Stanfill, Suzanne Lussier, Susan North, Lucy Johnston, Clare Browne, Suzanne Smith, Linda Parry and Christopher Wilk of the Furniture, Textiles and Fashion Department; Mark Evans and Susan Lambert of the Word and Image Department; Valerie Blythe, Clair Battison and Lara Flecker of Conservation; also Moira Gemmill, Claire Goodwin, Debra Isaac, Patricia O'Connor, Jane Rosier and Damien Whitmore. For the exhibition design we are very grateful to Azman Owens Architects and to Holmes Wood.

Finally, special thanks to Paul Smith, Aileen Ribeiro, Valerie Mendes and Gary Ness.